W9-DAX-899

18TH CENTURY ITALIAN DRAWINGS
IN THE METROPOLITAN MUSEUM OF ART

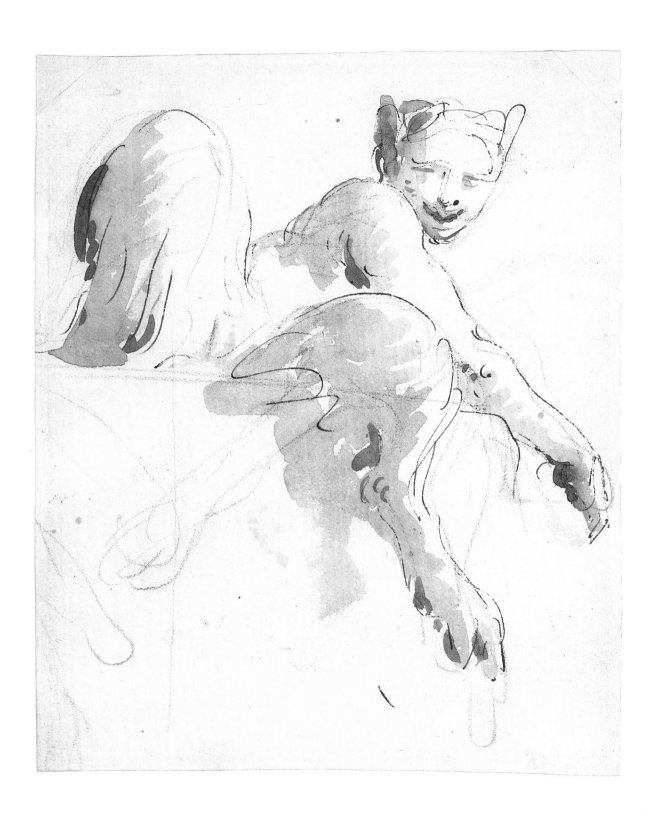

18TH CENTURY ITALIAN DRAWINGS

IN THE METROPOLITAN MUSEUM OF ART

JACOB BEAN and WILLIAM GRISWOLD

The Metropolitan Museum of Art
New York 1990

DISTRIBUTED BY Harry N. Abrams, Inc., Publishers, New York

This publication has been made possible in part by the Samuel I. Newhouse Foundation.

ON THE COVER/JACKET: Reduced detail of Francesco Guardi, No. 100.

FRONTISPIECE: Giovanni Battista Tiepolo, No. 195.

PUBLISHED BY
The Metropolitan Museum of Art, New York

John P. O'Neill, Editor in Chief
Teresa Egan, Managing Editor
Georgette Byk Felix, Editor
Matthew Pimm, Production
Peter Oldenburg, Designer

LIBRARY OF CONGRESS CATALOGING-IN-PUBLICATION DATA

Metropolitan Museum of Art (New York, N.Y.)
 18th century Italian drawings in the Metropolitan Museum of Art/
Jacob Bean and William Griswold.
 p. cm.
 Includes bibliographical references.
 ISBN 0-87099-585-5.—ISBN 0-87099-586-3 (pbk.).—ISBN
0-8109-3250-4 (Abrams)
 1. Drawing, Italian—Catalogs. 2. Drawing—18th century—Italy—
Catalogs. 3. Drawing—New York (N.Y.)—Catalogs. 4. Metropolitan
Museum of Art (New York, N.Y.)—Catalogs. I. Bean, Jacob.
II. Griswold, William. III. Title. IV. Title: Eighteenth century
Italian drawings in the Metropolitan Museum of Art.

NC255.M4 1990
741.945'074'7471—dc20 90-33514
 CIP

Color photography by Malcolm Varon
Black and white photography by Geoffrey Clements
Type set by U. S. Lithograph, typographers, New York
Printed by Meriden-Stinehour Press, Lunenburg, Vermont
Bound by Acme Bookbinding Company, Inc., Charlestown, Massachusetts

Contents

Preface

The first eighteenth-century Italian drawings to enter the museum's collection came more than one hundred years ago. Twenty-eight were the gift of Cornelius Vanderbilt in 1880, and seven were presented by Cephas G. Thompson in 1887. Thirteen drawings of this period were acquired in the first decades of the twentieth century. Then in 1937 the museum purchased in Geneva the collection of the marquis de Biron (Guillaume de Gontaut Biron, 1859–1939), which was extraordinarily rich in Venetian drawings of the eighteenth century. In this catalogue forty-nine of the fifty-six drawings by Giovanni Battista Tiepolo, sixteen of the twenty-three by Giovanni Domenico Tiepolo, and twenty-one of the thirty-two by Francesco Guardi come from the Biron collection. After this major acquisition, purchasing was sporadic until the Department of Drawings was established as a separate curatorial division of the museum in 1961. Since that time 124 drawings—more than forty percent of those included in this catalogue—have been acquired by purchase, gift, or bequest.

All drawings in the collection that we feel may be plausibly attributed to known artists of the period are described and reproduced. Old copies and sheets of (for us) dubious authenticity have been excluded. A question mark after an artist's name in a catalogue heading indicates that there are legitimate doubts concerning the attribution. Six still anonymous drawings of considerable interest are included in the hope that their appearance will elicit new attributions. Descriptive notices are intentionally brief to allow maximum space for reproduction. The entries offer essential bibliographical references and a record of provenance, with dealers indicated in brackets. The Italian drawings of this period in the Robert Lehman Collection at The Metropolitan Museum of Art are not illustrated here because they have been reproduced and described in an exemplary catalogue by James Byam Shaw and George Knox (1987).

This book is dedicated to our late colleague Lawrence Turčić (1949–1988), an exceptionally gifted connoisseur of Italian drawings. At the time of his sudden death he was engaged in the compilation of some of the very first entries for this publication, to which he contributed eight astute new attributions.

We are grateful to Calvin Brown, Helen Mules, and Henrietta Susser, members of the staff of the Department of Drawings, for their invaluable assistance. Helen K. Otis, Conservator in Charge, Paper Conservation, has generously given us useful technical information. We are indebted to the many scholars whose suggestions and attributions are recorded in the entries that follow; particular acknowledgment is due to Henry Bertels, S.J., Leonard Boyle, O.P., James Byam Shaw, Mimi Cazort, Jennifer Montagu, Mary Newcome, and Janos Scholz.

Jacob Bean
Drue Heinz Curator of Drawings

William Griswold
Assistant Curator of Drawings

Works Cited in Abbreviated Form

Affreschi nelle ville venete, 1978
Gli affreschi nelle ville venete dal Seicento all'Ottocento, preface by Rodolfo Pallucchini, texts by Francesca d'Arcais, Franca Zava Boccazzi, and Giuseppe Pavanello, 2 vols., Venice, 1978.

Aikema and Meijer, 1985
Disegni veneti di collezioni olandesi, exhibition catalogue by Bernard Aikema and Bert W. Meijer, Fondazione Giorgio Cini, Venice, and Istituto Universitario Olandese di Storia dell'Arte, Florence, 1985.

Alizeri, *Notizie*
Federigo Alizeri, Notizie dei professori del disegno in Liguria dalla fondazione dell'Accademia, 3 vols., Genoa, 1864–1866.

Ancona, 1956
Paolo d'Ancona, with the collaboration of Francesca Leoni, Tiepolo in Milan. The Palazzo Clerici Frescoes, Milan, 1956.

Andrews, 1968
Keith Andrews, National Gallery of Scotland. Catalogue of Italian Drawings, 2 vols., Cambridge, 1968.

Arisi, 1961
Ferdinando Arisi, Gian Paolo Panini, Piacenza, 1961.

Arisi, 1986
Ferdinando Arisi, Gian Paolo Panini e i fasti della Roma del '700, Rome, 1986.

Art Treasures of the Metropolitan, 1952
Art Treasures of the Metropolitan. A Selection from the European and Asiatic Collections of The Metropolitan Museum of Art Presented by the Curatorial Staff, New York, 1952.

Athens, 1979
Treasures from The Metropolitan Museum of Art, New York. Memories and Revivals of the Classical Spirit, exhibition catalogue by James David Draper and Joan R. Mertens, National Pinakothiki, Alexander Soutzos Museum, Athens, 1979.

Baetjer and Links, 1989
Canaletto, exhibition catalogue by Katharine Baetjer and J. G. Links, The Metropolitan Museum of Art, New York, 1989.

Baltimore, 1944
Three Baroque Masters: Strozzi, Crespi, Piazzetta, exhibition catalogue, The Baltimore Museum of Art, 1944.

Barcham, 1977
William L. Barcham, The Imaginary View Scenes of Antonio Canaletto, New York and London, 1977.

Barigozzi Brini and Garas, 1967
Amalia Barigozzi Brini and Klára Garas, Carlo Innocenzo Carloni, Milan, 1967.

Barroero, 1979
Liliana Barroero, "Andrea Camassei, Giovambattista Speranza e Marco Caprinozzi a San Lorenzo in Fonte in Roma," Bollettino d'Arte, LXIV, 1979, pp. 65–76.

Bean, 1964
Jacob Bean, 100 European Drawings in The Metropolitan Museum of Art, New York, 1964.

Bean, 1966
Italian Drawings in the Art Museum, Princeton University. 106 Selected Examples, exhibition catalogue by Jacob Bean, Princeton, 1966.

Bean, 1972
Drawings Recently Acquired, 1969–1971, exhibition catalogue by Jacob Bean, The Metropolitan Museum of Art, New York, 1972.

Bean, 1975
European Drawings Recently Acquired, 1972–1975, exhibition catalogue by Jacob Bean, The Metropolitan Museum of Art, New York, 1975.

Bean, 1979
Jacob Bean, 17th Century Italian Drawings in The Metropolitan Museum of Art, New York, 1979.

Bean and Stampfle, 1971
Drawings from New York Collections. III. The 18th Century in Italy, exhibition catalogue by Jacob Bean and Felice Stampfle, The Metropolitan Museum of Art, New York, 1971.

Bean and Turčić, 1986
Jacob Bean, with the assistance of Lawrence Turčić, 15th–18th Century French Drawings in The Metropolitan Museum of Art, New York, 1986.

Benesch, 1947
Otto Benesch, Venetian Drawings of the Eighteenth Century in America, New York, 1947.

Benesch, 1961
Disegni veneti dell'Albertina di Vienna, exhibition catalogue by Otto Benesch, with the assistance of Konrad Oberhuber, Fondazione Giorgio Cini, Venice, 1961.

Beretta, 1848
Giuseppe Beretta, Le opere di Andrea Appiani, Milan, 1848.

Bernini, 1981
Giovanni-Pietro Bernini, Splendore e decadenza: le decorazioni pittoriche della Rocca di Sala. Seconda edizione, Parma, 1981.

Bertini, 1957
Aldo Bertini, "Un dipinto inedito di Francesco Guardi," Emporium, CXXVI, 1957, pp. 157–160.

Beschreibender Katalog. I, 1926
Beschreibender Katalog der Handzeichnungen in der Graphischen Sammlung Albertina. I. Die Zeichnungen der venezianischen Schule, compiled by Alfred Stix and L. Fröhlich-Bum, Vienna, 1926.

Beschreibender Katalog. VI, 1941
Beschreibender Katalog der Handzeichnungen in der Staatlichen Graphischen Sammlung Albertina. VI. Die Schulen von Ferrara, Bologna, Parma und Modena, der Lombardei, Genuas, Neapels und Siziliens mit einem Nachtrag zu allen italienischen Schulen, compiled by Alfred Stix and Anna Spitzmüller, Vienna, 1941.

Bettagno, 1959
Disegni e dipinti di Giovanni Antonio Pellegrini, 1675–1741, exhibition catalogue by Alessandro Bettagno, Fondazione Giorgio Cini, Venice, 1959.

Bettagno, 1963
Disegni veneti del Settecento della Fondazione Giorgio Cini e delle collezioni venete, exhibition catalogue by Alessandro Bettagno, Fondazione Giorgio Cini, Venice, 1963.

Bettagno, 1966
Disegni di una collezione veneziana del Settecento, exhibition catalogue by Alessandro Bettagno, Fondazione Giorgio Cini, Venice, 1966.

Bettagno, 1972
Venetian Drawings of the Eighteenth Century. An exhibition in aid of the Venice in Peril Fund, catalogue by Alessandro Bettagno, Heim Gallery, London, 1972.

Bettagno, 1978
Piranesi. Incisioni, rami, legature, architetture, exhibition catalogue edited by Alessandro Bettagno, Fondazione Giorgio Cini, Venice, 1978.

Bettagno, 1982
Canaletto. Disegni, dipinti, incisioni, exhibition catalogue edited by Alessandro Bettagno, Fondazione Giorgio Cini, Venice, 1982.

Bianchi, 1936
Lidia Bianchi, *I Gandolfi,* Rome, 1936.

Binion, 1976
Alice Binion, *Antonio and Francesco Guardi: Their Life and Milieu. With a Catalogue of their Figure Drawings,* New York and London, 1976.

Bjurström, 1974
Disegni veneti del Museo di Stoccolma, exhibition catalogue by Per Bjurström, Fondazione Giorgio Cini, Venice, 1974.

Bolaffi
Dizionario enciclopedico Bolaffi dei pittori e degli incisori italiani dall'XI al XX secolo, 11 vols., Turin, 1972–1976.

Bolger, 1988
Doreen Bolger, "Hamilton Easter Field and His Contribution to American Modernism," *American Art Journal,* XX, 2, 1988, pp. 78–107.

Bordeaux, 1981
Profil du Metropolitan Museum of Art de New York de Ramsès à Picasso, Galerie des Beaux-Arts, Bordeaux, 1981.

Borsi, 1970
Immagini di Montecitorio, edited by Franco Borsi, Rome, 1970.

Borsi, Briganti, and Venturoli, 1985
Franco Borsi, Giuliano Briganti, and Marcello Venturoli, *Il Palazzo di Montecitorio,* 2nd ed., Rome, 1985.

Bottari and Ticozzi, VII, 1822
Raccolta di lettere sulla pittura, scultura ed architettura scritte da' più celebri personaggi dei secoli XV, XVI e XVII pubblicata da M. Gio. Bottari e continuata fino ai nostri giorni da Stefano Ticozzi, 8 vols., Milan, 1822–1825.

Brandolese, 1795
Pietro Brandolese, *Pitture, sculture, architetture ed altre cose notabili di Padova,* Padua, 1795.

Breck, 1913
Joseph Breck, "Paintings and Drawings by Tiepolo in the Metropolitan Museum," *Art in America,* I, 1913, pp. 8–17.

Brescia, 1980
Iconografia e immagini queriniane, exhibition catalogue, Pinacoteca Tosio-Martinengo, Brescia, 1980.

Brugnò, 1985
Francesco Brugnò, "Contributi a Gaspare Serenario," *Le arti in Sicilia nel Settecento. Studi in memoria di Maria Accascina,* Palermo, 1985.

Brussels, 1913
Musées Royaux de Peinture et de Sculpture. Inventaire des dessins et aquarelles donnés à l'État Belge par Madame la douairière de Grez, Brussels, 1913.

Burroughs, 1912
B[ryson] B[urroughs], "Drawings," *Metropolitan Museum of Art Bulletin,* VI [VII], May 1912, pp. 98–100.

Byam Shaw, 1951
J. Byam Shaw, *The Drawings of Francesco Guardi,* London, 1951.

Byam Shaw, 1954
J. Byam Shaw, "The Drawings of Francesco Fontebasso," *Arte Veneta,* VIII, 1954, pp. 317–329.

Byam Shaw, 1955
J. Byam Shaw, "Guardi at the Royal Academy," *Burlington Magazine,* XCVII, 1955, pp. 12–19.

Byam Shaw, 1962
James Byam Shaw, *The Drawings of Domenico Tiepolo,* Boston, 1962.

Byam Shaw, 1971–1
J. Byam Shaw, "The Biron Collection of Venetian Eighteenth-Century Drawings in the Metropolitan Museum," *Metropolitan Museum Journal. Volume 3, 1970,* New York, 1971, pp. 235–258.

Byam Shaw, 1971–2
James Byam Shaw, "Tiepolo Celebrations: Three Catalogues," *Master Drawings,* IX, 3, 1971, pp. 264–276.

Byam Shaw, 1976
J. Byam Shaw, "Guardi Drawings," *Burlington Magazine,* CXVIII, 1976, pp. 856–859.

Byam Shaw, 1983
James Byam Shaw, *The Italian Drawings of the Frits Lugt Collection,* 3 vols., Paris, 1983.

Cailleux, 1952
Tiepolo et Guardi. Exposition de peintures et dessins provenant de collections françaises publiques et privées, exhibition catalogue by Jean Cailleux, Galerie Cailleux, Paris, 1952, 2 vols.

Cailleux, 1974
Jean Cailleux, "L'Art du Dix-huitième Siècle. An Advertisement Supplement to *The Burlington Magazine*. Edited by Jean Cailleux. Centaurs, Fauns, Female Fauns, and Satyrs Among the Drawings of Domenico Tiepolo," *Burlington Magazine*, CXVI, 1974, pp. i–xxviii.

Casale, 1984
Vittorio Casale, "Diaspore e ricomposizioni: Gherardi, Cerruti, Grecolini, Garzi, Masucci ai Santi Venanzio ed Ansuino in Roma," *Scritti di storia dell'arte in onore di Federico Zeri*, Milan, 1984, II, pp. 736–754.

Causa, 1957
Raffaello Causa, *Pittura napoletana dal XV al XIX secolo*, Bergamo, 1957.

Causa, 1970
Raffaello Causa, *Opere d'arte nel Pio Monte della Misericordia a Napoli*, Naples, 1970.

Causa Picone, 1981
Disegni napoletani del Settecento, exhibition catalogue by Marina Causa Picone, Palazzo Reale, Naples, 1981.

Cazort Taylor, 1976
Mary Cazort Taylor, "The Pen and Wash Drawings of the Brothers Gandolfi," *Master Drawings*, XIV, 2, 1976, pp. 159–165.

Cera, 1987
Adriano Cera, *La pittura neoclassica italiana*, Milan, 1987.

Chicago, 1938
Paintings, Drawings and Prints by the Two Tiepolos, exhibition catalogue, The Art Institute of Chicago, 1938.

Chierici, 1978
Umberto Chierici, *La Basilica di S. Bernardino a L'Aquila*, L'Aquila, 1978.

Cianfarani, 1956
Mostra di disegni della Biblioteca dell'Istituto Nazionale d'Archeologia e Storia dell'Arte, exhibition catalogue by Valerio Cianfarani, Palazzo Braschi, Rome, 1956.

Clark, 1967
Anthony M. Clark, "The Portraits of Artists Drawn for Nicola Pio," *Master Drawings*, V, 1, 1967, pp. 3–23.

Clark, 1974
Anthony M. Clark, "Three Ghezzis," *The Minneapolis Institute of Arts Bulletin*, LX, 1971–1973 [1974], pp. 62–67.

Clark and Bowron, 1985
Anthony M. Clark, edited and prepared for publication by Edgar Peters Bowron, *Pompeo Batoni. A Complete Catalogue of His Works with an Introductory Text*, New York, 1985.

Coleman, 1989
Robert Randolf Coleman, "A Cache of Drawings by Giacomo Zoboli," *Drawing*, XI, 2, 1989, pp. 25–30.

Constable, 1962
W. G. Constable, *Canaletto. Giovanni Antonio Canal, 1697–1768*, 2 vols., Oxford, 1962.

Constable, 1964
Canaletto, exhibition catalogue by W. G. Constable, The Art Gallery of Toronto, The National Gallery of Canada, Ottawa, The Museum of Fine Arts, Montreal, 1964.

Constable, 1976
W. G. Constable, *Canaletto. Giovanni Antonio Canal, 1697–1768, Second Edition. Revised by J. G. Links*, 2 vols., Oxford, 1976.

Corboz, 1974
André Corboz, "Sur la prétendue objectivité de Canaletto," *Arte Veneta*, XXVIII, 1974, pp. 205–218.

Corboz, 1985
André Corboz, *Canaletto. Una Venezia immaginaria*, 2 vols., Milan, 1985.

Czére, 1985
Andrea Czére, "Zur Zeichenkunst von Agostino Masucci," *Jahrbuch der Berliner Museen*, XXVII, 1985, pp. 77–100.

Dalmasso, 1972
Franca Dalmasso, "Trompe-l'oeil di Pietro Palmieri e la cultura figurativa in Piemonte a fine '700," *Commentari*, XXIII, 1–2, 1972, pp. 131–138.

Dania, 1967
Luigi Dania, *La pittura a Fermo e nel suo circondario*, Fermo, 1967.

Dee, 1970
The Two Sicilies. Drawings from the Cooper-Hewitt Museum, exhibition catalogue by Elaine Evans Dee, Finch College Museum of Art, New York, 1970.

Denon, 1829
Monuments des arts du dessin chez les peuples tant anciens que modernes, recueillis par le baron Vivant Denon . . ., décrits et expliqués par Amaury Duval, 4 vols., Paris, 1829.

Dessins napolitains, 1983
Dessins napolitains. XVIIᵉ–XVIIIᵉ siècles. Collections des musées de Naples, exhibition catalogue, École nationale supérieure des Beaux-Arts, Paris, 1983.

Detroit, 1952
Venice, 1700–1800, exhibition catalogue with an introduction by E. P. Richardson, The Detroit Institute of Arts and the John Herron Art Museum, Detroit, 1952.

De Vesme, 1971
Stefano della Bella. Catalogue Raisonné. Alexandre De Vesme. With Introduction and Additions by Phyllis Dearborn Massar, 2 vols., New York, 1971.

Domarus, 1915
Kurt von Domarus, *Pietro Bracci. Beiträge zur römischen Kunstgeschichte des XVIII. Jahrhunderts*, Strasbourg, 1915.

Draper, 1969
James David Draper, "The Lottery in Piazza di Montecitorio," *Master Drawings*, VII, 1, 1969, pp. 27–34.

Dreyer, 1979
Peter Dreyer, *I grandi disegni italiani del Kupferstichkabinett di Berlino*, Milan, 1979.

Eisenmann, 1890
O. Eisenmann, *Ausgewählte Handzeichnungen älterer Meister aus der Sammlung Edward Habich zu Kassel*, 3 vols., Lübeck, 1890.

Enggass, 1964
Robert Enggass, "Francesco de Mura alla Nunziatella," *Bollettino d'Arte*, XLIX, 1964, pp. 133–148.

Fahy, 1971
Everett Fahy, "Tiepolo's Meeting of Anthony and Cleopatra," *Burlington Magazine*, CXIII, 1971, pp. 737–738.

Fairfax Murray
C. Fairfax Murray, *J. Pierpont Morgan Collection of Drawings by the Old Masters formed by C. Fairfax Murray*, 4 vols., London, 1905–1912.

Feinblatt, 1967
Ebria Feinblatt, "More Early Drawings by Giovanni Battista Tiepolo," *Master Drawings*, V, 4, 1967, pp. 400–403.

Fenyö, 1965
Disegni veneti del Museo di Budapest, exhibition catalogue by Ivan Fenyö, Fondazione Giorgio Cini, Venice, 1965.

Ferrari, 1963
Oreste Ferrari, "I disegni di Luca Giordano acquistato dall' Albertina di Vienna," *Napoli Nobilissima*, III, 1963, pp. 3–8.

Florence, 1982
Disegni dell'Europa occidentale dall'Ermitage di Leningrado, exhibition catalogue, Gabinetto Disegni e Stampe degli Uffizi, Florence, 1982.

Florence, 1985
Dieci anni di acquisizioni. 1974–1984, exhibition catalogue, Gabinetto Disegni e Stampe degli Uffizi, Florence, 1985.

Focillon, 1918
Henri Focillon, *Giovanni Battista Piranesi. Essai de catalogue raisonné de son oeuvre*, Paris, 1918.

Freeden and Lamb, 1956
Max H. von Freeden and Carl Lamb, *Das Meisterwerk des Giovanni Battista Tiepolo. Die Fresken der Würzburger Residenz*, Munich, 1956.

Fritzsche, 1936
Hellmuth Allwill Fritzsche, *Bernardo Belotto, genannt Canaletto*, Burg bei Magdeburg, 1936.

Frohlich-Bume, 1957
L. Frohlich-Bume, "Old Master Drawings—XI. Four Unpublished Drawings by G. B. Tiepolo," *Apollo*, LXVI, September 1957, pp. 56–57.

Gaeta Bertelà, 1976
Artisti italiani dal XVI al XIX secolo. Mostra di 200 disegni dalla raccolta della Pinacoteca Nazionale di Bologna, Gabinetto dei Disegni e delle Stampe, exhibition catalogue by Giovanna Gaeta Bertelà, Museo Civico, Bologna, 1976.

Gandolfi, 1987
I Gandolfi. Ubaldo, Gaetano, Mauro. Disegni e dipinti, exhibition catalogue by Alessandro Bettagno, Mary Cazort, Andrea Emiliani, and Corinna Giudici, Fondazione Giorgio Cini, Venice, and Palazzo Pepoli Campogrande, Bologna, 1987.

Garms, 1971
Jörg Garms, "Die Briefe des Luigi Vanvitelli an seinen Bruder Urbano in Rom: Kunsthistorisches Material," *Römische Historische Mitteilungen*, XIII, 1971, pp. 201–285.

Garms and Prosperi Valenti Rodinò, 1985
Due raccolte di disegni di recente acquisizione, catalogue by Jörg Garms and Simonetta Prosperi Valenti Rodinò, Istituto Nazionale per la Grafica, Rome, 1985.

Gavazza, 1965
Ezia Gavazza, *Lorenzo de Ferrari (1680–1744)*, Milan, 1965.

Gealt, 1986
Adelheid Gealt, *Domenico Tiepolo. The Punchinello Drawings*, New York, 1986.

Geiger, 1945
Benno Geiger, *I disegni del Magnasco*, Padua, 1945.

Geiger, 1949
Benno Geiger, *Magnasco*, Bergamo, 1949.

Gibbons, 1977
Felton Gibbons, *Catalogue of Italian Drawings in the Art Museum, Princeton University*, 2 vols., Princeton, 1977.

Gillies, 1972
Linda Boyer Gillies, "An Eighteenth-Century Roman View. Panini's Scalinata della Trinità dei Monti," *Metropolitan Museum of Art Bulletin*, XXX, 4, February–March 1972, pp. 176–184.

Goering, 1944
Max Goering, *Francesco Guardi*, Vienna, 1944.

Golden Age of Naples, 1981
The Golden Age of Naples. Art and Civilization under the Bourbons. 1734–1805, exhibition catalogue, The Detroit Institute of Arts and The Chicago Art Institute, 1981, 2 vols.

Goldner, 1988
George R. Goldner, with the assistance of Lee Hendrix and Gloria Williams, *The J. Paul Getty Museum. European Drawings. 1. Catalogue of the Collections*, Malibu, 1988.

Goodison and Robertson, 1967
J. W. Goodison and G. H. Robertson, *Fitzwilliam Museum, Cambridge. Catalogue of Paintings. Volume II. Italian Schools*, Cambridge, 1967.

Gradara, 1920
Costanza Gradara, *Pietro Bracci scultore romano 1700–1773*, Milan, n.d. [1920].

Gregori, 1976
Mina Gregori, "Per il periodo giovanile di Giovan Domenico Ferretti," *Kunst des Barok in der Toscana. Studien zur Kunst unter den letzten Medici*, Munich, 1976, pp. 367–382.

Grigaut, 1967
Alessandro Magnasco (1667–1749), exhibition catalogue by Paul L. Grigaut, J. B. Speed Art Museum, Louisville, Kentucky, and University of Michigan Museum of Art, Ann Arbor, 1967.

Grigorieva and Kantor-Gukovskja
Irina Grigorieva and Asja Kantor-Gukovskja, *I grandi disegni italiani delle collezioni dell'Ermitage di Leningrado*, Milan, n.d.

Griseri, 1963
Mostra del barocco piemontese. II. Pittura, catalogue by Andreina Griseri, Turin, 1963.

Griseri, 1978
Andreina Griseri, *I grandi disegni italiani nella Biblioteca Reale di Torino*, Milan, 1978.

Guerrieri Borsoi, 1984
Maria Barbara Guerrieri Borsoi, *Galleria Marcello Aldega. Disegni di Giacomo Zoboli*, Rome, 1984.

Hadeln, 1928
Detlev, Baron von Hadeln, *The Drawings of G. B. Tiepolo*, 2 vols., Paris, 1928.

Hadeln, 1929
Detlev, Baron von Hadeln, *The Drawings of Antonio Canal, called Canaletto*, translated by Campbell Dodgson, London, 1929.

Hellman, 1916
George S. Hellman, "Drawings by Italian Artists in The Metropolitan Museum of Art," *Print Collector's Quarterly*, VI, 1916, pp. 157–184.

Houston, 1958
The Guardi Family, exhibition catalogue with an introduction by J. Byam Shaw, The Museum of Fine Arts of Houston, 1958.

Indianapolis, 1970
Catalogue of the Inaugural Exhibition of the Indianapolis Museum of Art. Treasures from the Metropolitan, Indianapolis, 1970.

Johnson and Goldyne, 1985
Robert Flynn Johnson and Joseph R. Goldyne, *Master Drawings from the Achenbach Foundation for Graphic Arts, The Fine Arts Museums of San Francisco*, San Francisco, n.d. [1985].

Johnston, 1971
Catherine Johnston, *I disegni dei maestri, Il Seicento e il Settecento a Bologna*, Milan, 1971.

Johnston, 1976
Catherine Johnston, *Biblioteca di disegni. XIII. Maestri emiliani del Sei e Settecento*, Florence, 1976.

Kaufman and Knox, 1969
Fantastic and Ornamental Drawings. A Selection of Drawings from the Kaufman Collection. Catalogue prepared by S. Kaufman and G. Knox, Portsmouth College of Art and Design, 1969.

Knox, 1963
George Knox, "The Paintings by G. B. Tiepolo," *Burlington Magazine*, CV, 1963, pp. 327–328.

Knox, 1965
George Knox, "A Group of Tiepolo Drawings Owned and Engraved by Pietro Monaco," *Master Drawings*, III, 4, 1965, pp. 389–397.

Knox, 1966
George Knox, "Giambattista—Domenico Tiepolo: The Supplementary Drawings of the Quaderno Gatteri," *Bollettino dei Musei Civici Veneziani*, XI, 3, 1966, pp. 3–46.

Knox, 1970
Tiepolo. A Bicentenary Exhibition 1770–1970. Drawings, mainly from American Collections, by Giambattista Tiepolo and the members of his circle, exhibition catalogue by George Knox, Fogg Art Museum, Cambridge, Massachusetts, 1970.

Knox, 1975
George Knox, *Catalogue of the Tiepolo Drawings in the Victoria and Albert Museum*, London, 1975.

Knox, 1980
George Knox, *Giambattista and Domenico Tiepolo. A Study and Catalogue Raisonné of the Chalk Drawings*, 2 vols., Oxford, 1980.

Knox, 1983
Piazzetta. A Tercentenary Exhibition of Drawings, Prints, and Books, exhibition catalogue by George Knox, National Gallery of Art, Washington, D.C., 1983.

Knox, 1989
18th Century Venetian Art in Canadian Collections, exhibition catalogue by George Knox, Vancouver Art Gallery, Vancouver, British Columbia, 1989.

Kozakiewicz, 1972
Stefan Kozakiewicz, *Bernardo Bellotto*, 2 vols., Greenwich, Connecticut, 1972.

Kozloff, 1961
Max Kozloff, "The Caricatures of Giambattista Tiepolo," *Marsyas*, X, 1961, pp. 13–33.

Kultzen, 1968
Rolf Kultzen, *Francesco Guardi in der Alten Pinakothek München. Nachtrag zum Bildband*, Munich, 1968.

Lehman Collection. VI, 1987
James Byam Shaw and George Knox, *The Robert Lehman Collection. VI. Italian Eighteenth-Century Drawings*, New York and Princeton, 1987.

Leningrad, 1971
Projets et dessins d'architectes et ornemanistes français. XVIIIᵉ–début XIXᵉ siècle, exhibition catalogue in Russian, State Hermitage Museum, Leningrad, 1971.

Levey, 1971
Michael Levey, *National Gallery Catalogues. The Seventeenth and Eighteenth Century Italian Schools*, London, 1971.

Levey, 1986
Michael Levey, *Giambattista Tiepolo. His Life and Art*, New Haven and London, 1986.

Lo Bianco, 1985
Anna Lo Bianco, *Pier Leone Ghezzi pittore*, Palermo, 1985.

London, 1987
Master Drawings. The Woodner Collection, exhibition catalogue, Royal Academy of Arts, London, 1987.

Lorenzetti, 1937
Le feste e le maschere veneziane, exhibition catalogue by Giulio Lorenzetti, Ca' Rezzonico, Venice, 1937.

Los Angeles, 1976
Women Artists: 1550–1950, exhibition catalogue by Ann Sutherland Harris, Linda Nochlin, and others, Los Angeles County Museum of Art; University Art Museum, The University of Texas at Austin; Carnegie Institute, Pittsburgh; The Brooklyn Museum, 1976.

Loyd, 1967
The Loyd Collection of Paintings and Drawings at Betterton House, Lockinge near Wantage, Berkshire, London, 1967.

Macandrew, 1980
Hugh Macandrew, *Ashmolean Museum Oxford. Catalogue of the Collection of Drawings. Volume III. Italian Schools: Supplement*, Oxford, 1980.

Macandrew, 1983
Hugh Macandrew, *Italian Drawings in the Museum of Fine Arts, Boston*, Boston, 1983.

Mahon and Turner, 1989
Denis Mahon and Nicholas Turner, *The Drawings of Guercino in the Collection of Her Majesty the Queen at Windsor Castle*, Cambridge, 1989.

Malaguzzi Valeri, 1906
Francesco Malaguzzi Valeri, *Milano*, 2 vols., Bergamo, 1906.

13

Mallè, 1981
Luigi Mallè, *Stupinigi. Un capolavoro del Settecento europeo tra barocchetto e classicismo. Architettura, pittura, scultura, arredamento*, Turin, 1981.

Mallory, 1976
Nina A. Mallory, "Notizie sulla pittura a Roma nel XVIII secolo (1718–1760). Dal Diario Ordinario d'Hungheria," *Bollettino d'Arte*, LXI, 1976, pp. 102–113.

Mariuz, 1971
Adriano Mariuz, *Giandomenico Tiepolo*, Venice, 1971.

Mariuz, 1982
L'opera completa del Piazzetta, preface by Rodolfo Pallucchini, critical catalogue by Adriano Mariuz, Milan, 1982.

Martini, 1964
Egidio Martini, *La pittura veneziana del Settecento*, Venice, 1964.

Martini and Casanova, 1962
A. Martini and M. L. Casanova, *SS. Nome di Maria*, Rome, 1962.

Matthiesen, 1939
Exhibition of Venetian Paintings and Drawings held in aid of Lord Baldwin's Fund for Refugees, exhibition catalogue, Matthiesen, London, n.d. [1939].

Mayor, 1875
A Brief Chronological Description of a Collection of Original Drawings and Sketches by the Old Masters . . . formed by the late Mr. William Mayor . . ., London, 1875.

Meder, 1978
Joseph Meder, *The Mastery of Drawing. Translated and Revised by Winslow Ames*, 2 vols., New York, 1978.

Mena Marqués, 1984
Dibujos italianos de los siglos XVII y XVIII en la Biblioteca Nacional, exhibition catalogue by Manuela B. Mena Marqués, Biblioteca Nacional, Madrid, 1984.

Metropolitan Museum Handbook, 1895
The Metropolitan Museum of Art, Hand-Book No. 8. Drawings, Water-Color Paintings, Photographs and Etchings, Tapestries, etc., New York, 1895. (An unillustrated, summary checklist of the 882 European drawings then in the Museum's collection; apparently they were all on exhibition at that time. The introductory note warns that "the attributions of authorship are by former owners.")

Metropolitan Museum, Italian Drawings, 1942
European Drawings from the Collections of The Metropolitan Museum of Art. I. Italian Drawings, New York, 1942. (A portfolio of sixty collotype reproductions.)

Milkovich, 1966
Sebastiano and Marco Ricci in America, exhibition catalogue by Michael Milkovich, Brooks Memorial Art Gallery, Memphis, Tennessee, and University of Kentucky Art Gallery, Lexington, 1966.

Miller, 1964
Dwight C. Miller, "Felice Torelli, pittore bolognese," *Bollettino d'Arte*, LXIX, 1964, pp. 54–66.

Mirano, 1988
I Tiepolo. Virtuosismo e ironia, exhibition catalogue by Dario Succi, with essays by Madeleine Barbin, Annalia Delneri, Arnoldo Momo, Michelangelo Muraro, and Dario Succi, Barchessa Villa XXV Aprile, Mirano (Venice), 1988.

Modena, 1986
L'arte degli Estensi. La pittura del Seicento e del Settecento a Modena e Reggio, exhibition catalogue, Modena, 1986.

Monbeig-Goguel and Vitzthum, 1967
Le dessin à Naples du XVIe siècle au XVIIIe siècle, exhibition catalogue by Catherine Monbeig-Goguel and Walter Vitzthum, Cabinet des Dessins, Musée du Louvre, Paris, 1967.

Mongan, 1949
One Hundred Master Drawings. Edited by Agnes Mongan, Cambridge, Massachusetts, 1949.

Mongan and Sachs, 1940
Agnes Mongan and Paul J. Sachs, *Drawings in the Fogg Museum of Art*, 3 vols., Cambridge, Massachusetts, 1940.

Montaiglon
Correspondance des directeurs de l'Académie de France à Rome avec les surintendants des bâtiments publiée d'après les manuscrits des Archives nationales par MM. Anatole de Montaiglon et Jules Guiffrey, 18 vols., Paris, 1887–1912.

Montreal, 1953
Five Centuries of Drawings, exhibition catalogue by Regina Shoolman, The Montreal Museum of Fine Arts, 1953.

Morassi, 1949
Antonio Morassi, "Some Drawings by the Young Tiepolo," *Burlington Magazine*, XCI, 1949, p. 85.

Morassi, 1950
Antonio Morassi, "Settecento inedito (II). VIII.—Quattro 'Ville' del Guardi," *Arte Veneta*, IV, 1950, pp. 50–56.

Morassi, 1955
Antonio Morassi, *G. B. Tiepolo. His Life and Work*, London, 1955.

Morassi, 1962
Antonio Morassi, *A Complete Catalogue of the Paintings of G. B. Tiepolo*, London, 1962.

Morassi, 1970
Antonio Morassi, "Sui disegni del Tiepolo nelle recenti mostre di Cambridge Mass. e di Stoccarda," *Arte Veneta*, XXIV, 1970, pp. 294–310.

Morassi, 1973
Antonio Morassi, *Guardi. Antonio e Francesco Guardi*, 2 vols., Venice, n.d. [1973].

Morassi, 1975
Antonio Morassi, *Guardi. Tutti i disegni di Antonio, Francesco e Giacomo Guardi*, Venice, 1975.

Moschini, 1952
Vittorio Moschini, *Francesco Guardi*, Milan, 1952.

Mrozinska, 1958
Disegni veneti in Polonia, exhibition catalogue by Maria Mrozinska, Fondazione Giorgio Cini, Venice, 1958.

Muraro, 1958
Michelangelo Muraro, "An Altar-piece and other Figure Paintings by Francesco Guardi," *Burlington Magazine*, C, 1958, pp. 3–8, 9, 10, 13.

Myers, 1975
Architectural and Ornament Drawings: Juvarra, Vanvitelli, the Bibiena Family, and Other Italian Draughtsmen, exhibition catalogue by Mary L. Myers, The Metropolitan Museum of Art, New York, 1975.

Naples, 1979
Civiltà del '700 a Napoli. 1734–1799, exhibition catalogue, Naples, 1979, 2 vols.

Natale, 1984
Vittorio Natale, "Le opere di Pietro Melchiorre Ferrari in Piemonte e qualche attribuzione," *Scritti di storia dell'arte in onore di Federico Zeri*, Milan, 1984, II, pp. 847–858.

Neilson, 1972
Italian Drawings Selected from Mid-Western Collections, exhibition catalogue by Nancy Ward Neilson, The St. Louis Art Museum, 1972.

Newcome, 1972
Genoese Baroque Drawings, exhibition catalogue by Mary Newcome, University Art Gallery, Binghamton, New York, and Worcester Art Museum, Worcester, Massachusetts, 1972.

Newcome, 1978
Mary Newcome, "Lorenzo de Ferrari Revisited," *Paragone*, XXIX, 335, 1978, pp. 62–79.

Newcome Schleier, 1989
Disegni genovesi dal XVI al XVIII secolo, exhibition catalogue by Mary Newcome Schleier, Gabinetto Disegni e Stampe degli Uffizi, Florence, 1989.

New York, 1938
Tiepolo and His Contemporaries, exhibition catalogue by Harry B. Wehle, The Metropolitan Museum of Art, New York, 1938.

New York, 1959
Great Master Drawings of Seven Centuries. A Benefit Exhibition of Columbia University for the Scholarship Fund of the Department of Fine Arts and Archaeology, exhibition catalogue, M. Knoedler and Co., New York, 1959.

New York, 1990
Woodner Collection. Master Drawings, exhibition catalogue, The Metropolitan Museum of Art, New York, 1990.

Nicodemi, 1915
Giorgio Nicodemi, *La pittura milanese dell'età neoclassica*, Milan, 1915.

Noris, 1982
Fernando Noris, "Bartolomeo Nazari," *I pittori bergamaschi dal XIII al XIX secolo. Il Settecento*. I, Bergamo, 1982, pp. 197–268.

Notable Acquisitions, 1975
The Metropolitan Museum of Art. Notable Acquisitions 1965–1975, New York, 1975.

Olson, 1980
Italian Drawings 1780–1890, exhibition catalogue by Roberta J. M. Olson, National Gallery of Art, Washington, D.C.; The Minneapolis Institute of Arts; California Palace of the Legion of Honor, San Francisco, 1980.

Orloff sale, 1920
Catalogue des tableaux anciens Dessins par G.-B. Tiepolo composant la collection de son excellence feu le prince Alexis Orloff, Galerie Georges Petit, Paris, April 29–30, 1920.

Orsi, 1958
Mario d'Orsi, *Corrado Giaquinto*, Rome, 1958.

Ottawa, 1982
Bolognese Drawings in North American Collections. 1500–1800, exhibition catalogue by Mimi Cazort and Catherine Johnston, National Gallery of Canada, Ottawa, 1982.

Paatz
Walter and Elisabeth Paatz, *Die Kirchen von Florenz. Ein kunstgeschichtliches Handbuch*, 6 vols., Frankfurt am Main, 1940–1954.

Pallucchini, 1943
Rodolfo Pallucchini, *I disegni del Guardi al Museo Correr di Venezia*, Venice, 1943.

Pallucchini, 1948
Rodolfo Pallucchini, "Disegni veneziani del Settecento in America," *Arte Veneta*, II, 1948, pp. 157–158.

Pallucchini, 1949
Rodolfo Pallucchini, "Nota per Giacomo Guardi," *Arte Veneta*, III, 1949, pp. 131–135.

Pallucchini, 1956
Rodolfo Pallucchini, *Piazzetta*, Milan, 1956.

Pallucchini, 1965
Rodolfo Pallucchini, "Note alla Mostra dei Guardi," *Arte Veneta*, XIX, 1965, pp. 215–237.

Panofsky, 1962
Erwin Panofsky, *Studies in Iconology. Humanistic Themes in the Art of the Renaissance*, New York, 1962.

Paris, 1971
Venise au dix-huitième siècle. Peintures, dessins et gravures des collections françaises, exhibition catalogue, Orangerie des Tuileries, Paris, 1971.

Paris, 1974
Le néo-classicisme français. Dessins des musées de province, exhibition catalogue by Jean Lacambre, Arlette Sérullaz, Jacques Vilain, and Nathalie Volle, Grand Palais, Paris, 1974.

Parker, 1948
K. T. Parker, *The Drawings of Antonio Canaletto in the Collection of His Majesty the King at Windsor Castle*, Oxford and London, 1948.

Parker, 1956
K. T. Parker, *Catalogue of the Collection of Drawings in the Ashmolean Museum. Volume II. Italian Schools*, Oxford, 1956.

Parker, 1958
Disegni veneti di Oxford, exhibition catalogue by K. T. Parker, Fondazione Giorgio Cini, Venice, 1958.

Parker, 1960
Karl Parker, *University of Oxford. Ashmolean Museum. Report of the Visitors. 1960*, Oxford, 1960.

Parker and Byam Shaw, 1962
Canaletto e Guardi. Mostra dei disegni, exhibition catalogue by K. T. Parker and J. Byam Shaw, Fondazione Giorgio Cini, Venice, 1962.

Pasculli Ferrara, 1981
Domenica Pasculli Ferrara, "Aggiunta pugliese a Francesco de Mura," *Napoli Nobilissima*, XX, 1981, pp. 49–67.

Pérez Sánchez, 1978
Alfonso E. Pérez Sánchez, *I grandi disegni italiani nelle collezioni di Madrid*, Milan, 1978.

Perina, 1961
Chiara Perina, "Considerazioni su Giuseppi Bottani," *Arte Lombarda*, VI, 1961, pp. 51–59.

Philadelphia, 1980
A Scholar Collects. Selections from the Anthony Morris Clark Bequest, exhibition catalogue edited by Ulrich W. Hiesinger and Ann Percy, Philadelphia Museum of Art, 1980.

Pietrangeli, 1971
Carlo Pietrangeli, *Il Museo di Roma. Documenti e iconografia*, Bologna, 1971.

Pigler, 1974
A. Pigler, *Barockthemen. Eine Auswahl von Verzeichnissen zur Ikonographie des 17. und 18. Jahrhunderts*, 3 vols., Budapest, 1974.

Pignatti, 1959
Terisio Pignatti, "Pellegrini Drawings in Venice," *Burlington Magazine*, CI, 1959, pp. 451–452.

Pignatti, 1964
Disegni veneti del Settecento nel Museo Correr di Venezia, exhibition catalogue by Terisio Pignatti, Fondazione Giorgio Cini, Venice, 1964.

Pignatti, 1965–1
Terisio Pignatti, *I disegni veneziani del Settecento*, Treviso, n.d. [1965].

Pignatti, 1965–2
Eighteenth-Century Venetian Drawings from the Correr Museum. An Exhibition Organised by the Arts Council of Great Britain, catalogue by Terisio Pignatti, Arts Council Gallery, London, and elsewhere, 1965.

Pignatti, 1967
Terisio Pignatti, *Disegni dei Guardi*, Florence, 1967.

Pignatti, 1970
Terisio Pignatti, *I disegni dei maestri. La scuola veneta*, Milan, 1970.

Pignatti, 1974–1
Terisio Pignatti, *Tiepolo. Disegni*, Florence, 1974.

Pignatti, 1974–2
Venetian Drawings from American Collections, exhibition catalogue by Terisio Pignatti, National Gallery of Art, Washington, D.C.; Kimbell Art Museum, Fort Worth; The St. Louis Art Museum, 1974–1975.

Pignatti, 1981
Terisio Pignatti, with the collaboration of Attilia Dorigato, *Disegni antichi del Museo Correr di Venezia. Vol. II (Dall'Oglio–Fontebasso)*, Venice, 1981.

Pignatti, 1983
Terisio Pignatti, with the collaboration of Attilia Dorigato and Filippo Pedrocco, *Disegni antichi del Museo Correr di Venezia. Vol. III (Galimberti–Guardi)*, Venice, 1983.

Pignatti and Romanelli, 1985
Terisio Pignatti and Giandomenico Romanelli, *Drawings from Venice. Masterworks from the Museo Correr, Venice*, exhibition catalogue, The Drawing Center, New York, 1985.

Pilo, 1964
Marco Ricci, exhibition catalogue by Giuseppe Maria Pilo, Palazzo Sturm, Bassano del Grappa, 1964 [1963].

Pinto, 1986
John A. Pinto, *The Trevi Fountain*, New Haven and London, 1986.

Pio, 1977
Nicola Pio. Le vite di pittori scultori et architetti [Cod. ms. Capponi 257] edited and with an introduction by Catherine Enggass and Robert Enggass, Vatican City, 1977.

Pittura a Genova, 1987
La pittura a Genova e in Liguria dal Seicento al primo Novecento, edited by Ennio Poleggi and others, Genoa, 1987.

Poughkeepsie, 1961
Centennial Loan Exhibition. Drawings and Watercolors from Alumnae and Their Families. Vassar College, exhibition catalogue, Vassar College, Poughkeepsie, and Wildenstein and Co., New York, 1961.

Precerutti-Garberi, 1969–1
Andrea Appiani. Pittore di Napoleone, exhibition catalogue by Mercedes Precerutti-Garberi, Galleria d'arte moderna, Milan, 1969.

Precerutti-Garberi, 1969–2
Disegni del Settecento nelle collezioni del Museo d'Arte Antica di Milano, exhibition catalogue by Mercedes Precerutti-Garberi, Castello Sforzesco, Milan, 1969.

Princes Gate, 1959
Italian Paintings and Drawings at 56 Princes Gate London SW7, 2 vols. (Text and Plates), London, 1959.

Problemi guardeschi, 1967
Problemi guardeschi. Atti del convegno di studi promosso dalla Mostra dei Guardi. Venezia 13–14 settembre 1965, Venice, 1967.

Providence, 1983
Old Master Drawings from the Museum of Art, Rhode Island School of Design, exhibition catalogue by Deborah J. Johnson, with the assistance of twelve contributing authors, Providence, 1983.

Ragghianti Collobi, 1963
Disegni della Fondazione Horne in Firenze, summary exhibition catalogue by Licia Ragghianti Collobi, Palazzo Strozzi, Florence, 1963.

Rey, 1922
Robert Rey, "Piazzetta," *L'Amour de l'Art*, III, 1922, pp. 161–164.

Rijksmuseum, 1976
All the Paintings of the Rijksmuseum in Amsterdam. A completely illustrated catalogue, Amsterdam and Maarssen, 1976.

Rizzi, 1965
Disegni del Tiepolo, exhibition catalogue by Aldo Rizzi, Loggia del Lionello, Udine, 1965.

Rizzi, 1971
Aldo Rizzi, *The Etchings of the Tiepolos. Complete Edition*, London, 1971.

Rizzi, 1982
Nicola Grassi, exhibition catalogue by Aldo Rizzi, Palazzo Frisacco, Tolmezzo (Udine), 1982.

Rizzi, 1988
 Giambattista Tiepolo. Disegni dai Civici Musei di Storia e Arte di Trieste, exhibition catalogue by Aldo Rizzi, Civico Museo Sartorio, Trieste, 1988.

Rizzo, 1978
 Vincenzo Rizzo, "L'opera giovanile di Francesco De Mura," *Napoli Nobilissima*, XVII, 1978, pp. 93–113.

Roli, 1977
 Renato Roli, *Pittura bolognese 1650–1800. Dal Cignani ai Gandolfi*, Bologna, 1977.

Roli and Sestieri, 1981
 Renato Roli and Giancarlo Sestieri, *I disegni italiani del Settecento. Scuole piemontese, lombarda, genovese, bolognese, toscana, romana e napoletana*, Treviso, 1981.

Rome in the 18th Century, 1978
 Artists in Rome in the 18th Century: Drawings and Prints, exhibition catalogue, The Metropolitan Museum of Art, New York, 1978.

Romin Meneghello, 1983
 Leonia Romin Meneghello, *Marco Marcola. Pittore veronese del Settecento*, Verona, 1983.

Rosenberg and Michel, 1987
 Subleyras, 1699–1749, exhibition catalogue by Pierre Rosenberg and Olivier Michel, Musée du Luxembourg, Paris, Accademia di Francia, Villa Medici, Rome, 1987.

Rosenberg and Schnapper, 1970
 Choix de dessins anciens, exhibition catalogue by Pierre Rosenberg and Antoine Schnapper, Bibliothèque Municipale, Rouen, 1970.

Rosenberg and Sébastiani, 1977
 Pierre Rosenberg and Odile Sébastiani, "Trois berlines peintes par Mauro Gandolfi," *Antologia di Belle Arti*, I, 3, 1977, pp. 225–245.

Rossi Bortolatto, 1974
 L'opera completa di Francesco Guardi, preface and critical catalogue by Luigina Rossi Bortolatto, Milan, 1974.

Rudolph, 1983
 La pittura del '700 a Roma. A cura di Stella Rudolph, Milan, 1983.

Ruggeri, 1967
 Ugo Ruggeri, "Giulia Lama disegnatrice," *Critica d'Arte*, XIV, 87, 1967, pp. 49–59.

Ruggeri, 1973
 Ugo Ruggeri, *Dipinti e disegni di Giulia Lama*, Bergamo, 1973.

Ruggeri, 1978
 Ugo Ruggeri, "Drawings by Giuseppe Piattoli," *Master Drawings*, XVI, 4, 1978, pp. 414–418.

Russell, 1972
 Rare Etchings by Giovanni Battista and Giovanni Domenico Tiepolo, exhibition catalogue by H. Diane Russell, National Gallery of Art, Washington, D.C., 1972.

Sack, 1910
 Eduard Sack, *Giambattista und Domenico Tiepolo. Ihr Leben und ihre Werke*, Hamburg, 1910.

Salmina, 1964
 Disegni veneti del Museo di Leningrad, exhibition catalogue by Larissa Salmina, Fondazione Giorgio Cini, Venice, 1964.

Santifaller, 1975
 Maria Santifaller, "Zur Graphik Giambattista Tiepolos," *Pantheon*, XXXIII, 1975, pp. 327–334.

Schulz, 1968
 Juergen Schulz, *Venetian Painted Ceilings of the Renaissance*, Berkeley and Los Angeles, 1968.

Selected Works, 1987
 Selected Works from The Snite Museum of Art, The University of Notre Dame, introduction by Dean A. Porter, Notre Dame, Indiana, 1987.

Sestieri, 1988
 Giancarlo Sestieri, *La pittura del Settecento*, Turin, 1988.

Settecento Emiliano, 1979
 L'arte del Settecento Emiliano. La pittura. L'Accademia Clementina, exhibition catalogue, Palazzo del Podestà and Palazzo di Re Enzo, Bologna, 1979.

Shapley, 1979
 Fern Rusk Shapley, *National Gallery of Art, Washington. Catalogue of the Italian Paintings*, 2 vols., Washington, D.C., 1979.

Simonson, 1904
 George A. Simonson, *Francesco Guardi. 1712–1793*, London, 1904.

Simonson, 1913
 George A. Simonson, "Guardi's Drawings and their Relation to his Paintings," *Art in America*, I, 1913, pp. 264–275.

Soufflot à Lyon, 1982
 L'oeuvre de Soufflot à Lyon. Études et documents, Lyon, 1982.

Soufflot et son temps, 1980
 Soufflot et son temps 1780–1980, exhibition catalogue by Michel Gallet and others, Caisse Nationale des Monuments Historiques et des Sites, Paris, 1980.

Spinosa, 1986
 Nicola Spinosa, *Pittura napoletana del Settecento dal Barocco al Rococò*, Naples, 1986.

Spinosa, 1987
 Nicola Spinosa, *Pittura napoletana del Settecento dal Rococò al Classicismo*, Naples, 1987.

Springfield, 1937
 Francesco Guardi. 1712–1793, exhibition catalogue by John Lee Clarke, Jr., Springfield Museum of Fine Arts, Springfield, Massachusetts, 1937.

Storrs, 1973
 The Academy of Europe. Rome in the 18th Century, exhibition catalogue by Frederick den Broeder, William Benton Museum of Art, The University of Connecticut, Storrs, 1973.

Stuttgart, 1970
 Tiepolo. Zeichnungen von Giambattista, Domenico und Lorenzo Tiepolo aus der Graphischen Sammlung der Staatsgalerie Stuttgart, aus württembergischem Privatbesitz und dem Martin von Wagner Museum der Universität Würzburg, exhibition catalogue by George Knox and Christel Thiem, Graphische Sammlung, Staatsgalerie, Stuttgart, 1970.

Stuttgart, 1978

Sammlung Schloss Fachsenfeld. Zeichnungen, Bozzetti und Aquarelle aus fünf Jahrhunderten in Verwahrung der Staatsgalerie Stuttgart, exhibition catalogue by Ulrike Gauss, Heinrich Geissler, Volkmar Schauz, and Christel Thiem, Graphische Sammlung, Staatsgalerie, Stuttgart, 1978.

Sutherland Harris, 1977

Ann Sutherland Harris, *Andrea Sacchi. Complete edition of the paintings with a critical catalogue,* Princeton, 1977.

Thiem, 1982

Bolognesische Zeichnungen 1600–1830 aus der Sammlung Schloss Fachsenfeld mit Leihgaben aus Windsor Castle und der Fondazione Cini Venedig, exhibition catalogue by Christel Thiem, Graphische Sammlung, Staatsgalerie, Stuttgart, 1982.

Thomas, 1954

Hylton Thomas, *The Drawings of Giovanni Battista Piranesi,* London, 1954.

Thomas, 1961

The Eighteenth Century. One Hundred Drawings by One Hundred Artists, exhibition catalogue by Hylton Thomas, University of Minnesota Gallery, Minneapolis, 1961.

Tietze, 1947

Hans Tietze, *European Master Drawings in the United States,* New York, 1947.

Titi, 1763

Filippo Titi, *Descrizione delle pitture, sculture e architetture esposte al pubblico in Roma,* Rome, 1763.

Titi, 1987

Filippo Titi, *Studio di pittura, scoltura et architettura, nelle chiese di Roma (1674–1763). Edizione comparata,* edited by Bruno Contardi and Serena Romano, 2 vols., Florence, 1987.

Toledo, 1940

Four Centuries of Venetian Painting, exhibition catalogue, The Toledo Museum of Art, 1940.

Torgiano, 1989

Memoria storica e attualità tra Rivoluzione e Restaurazione. Bozzetti e modelli dalla fine del XVIII alla metà del XIX secolo, exhibition catalogue edited by Caterina Bon Valsassina, Fondazione Lungarotti, Museo del Vino, Torgiano, 1989.

Toronto, 1981

The Arts of Italy in Toronto Collections, 1300–1800. Based on the Holdings of the Art Gallery of Ontario, the Royal Ontario Museum and Private Collections in the Toronto Area, Art Gallery of Ontario, Toronto, 1981.

Torriti, 1962

Piero Torriti, "Marcantonio Franceschini's Drawings for the Frescoes in the Sala del Maggior Consiglio, Ducal Palace, Genoa," *Burlington Magazine,* CIV, 1962, pp. 423–428.

Trimarchi, 1979

Michele Trimarchi, *Giovanni Odazzi pittore romano (1663–1731),* Rome, 1979.

Turčić, 1982

Lawrence Turčić, "Drawings for Agostino Masucci's *Education of the Virgin,*" *Master Drawings,* XX, 3, 1982, pp. 275–278.

Udine, 1984

Nicola Grassi e il Rococò europeo. Dagli atti del Congresso Internazionale di Studi 20/22 maggio 1982, Udine, 1984.

Valcanover, 1971

Francesco Valcanover, "Un nuovo stendardo di Francesco Guardi," *Studi di Storia dell'Arte in onore di Antonio Morassi,* Venice, 1971.

Vanvitelli, 1973

Renato De Fusco, Roberto Pane, Arnaldo Venditti, Roberto Di Stefano, Franco Strazzullo, Cesare De' Seta, *Luigi Vanvitelli,* Naples, 1973.

Vanvitelli, 1975

Luigi Vanvitelli, Jr., *Vita di Luigi Vanvitelli,* edited by Mario Rotili, Naples, 1975.

Vasari Society

The Vasari Society for the Reproduction of Drawings by Old Masters, first series, 10 parts, Oxford, 1905–1915, second series, 16 parts, Oxford, 1920–1935.

Venice, 1965

Mostra dei Guardi, exhibition catalogue by Pietro Zampetti, Palazzo Grassi, Venice, 1965.

Venice, 1983

G. B. Piazzetta. Disegni-incisioni-libri-manoscritti, exhibition catalogue, Fondazione Giorgio Cini, Venice, 1983.

Viatte, 1988

Françoise Viatte, *Musée du Louvre. Cabinet des Dessins. Inventaire général des dessins italiens. III. Dessins toscans. XVIᵉ–XVIIIᵉ siècles. Tome I (1560–1640),* Paris, 1988.

Videtta, 1962

Antonio Videtta, "Disegni di Corrado Giaquinto nel museo di S. Martino," *Napoli Nobilissima,* II, 1, 1962, pp. 13–28.

Vigni, 1943

Giorgio Vigni, "Note su Giambattista e Giandomenico Tiepolo," *Emporium* [Anno XLIX], XCVIII, 1943, pp. 14–24.

Vigni, 1972

Giorgio Vigni, *Disegni del Tiepolo. Seconda edizione riveduta e ampliata dall'autore,* Trieste, 1972.

Vilain, 1976

Jacques Vilain, "Dessins néo-classiques. Bilan d'une exposition. II. Analogies," *Revue du Louvre et des Musées de France,* XXVI, 2, 1976, pp. 73–76.

Virch, 1962

Claus Virch, *Master Drawings in the Collection of Walter C. Baker,* New York, 1962.

Virch, 1969

Claus Virch, "Dreams of Heaven and Earth. Giambattista and Domenico Tiepolo in the Wrightsman Collection," *Apollo,* XC, September 1969, pp. 172–179.

Vitzthum, 1965

Walter Vitzthum, "Luca Giordano o Francesco Lamarra: una ipotesi," *Paragone,* XVI, 183, 1965, pp. 64–67.

Vitzthum, 1966

Disegni napoletani del Sei e del Settecento nel Museo di Capodimonte, exhibition catalogue by Walter Vitzthum, Museo di Capodimonte, Naples, 1966.

Vitzthum, 1971
Walter Vitzthum, *I disegni dei maestri. Il barocco a Napoli e nell'Italia meridionale*, Milan, 1971.

Wallace, 1979
Richard W. Wallace, *The Etchings of Salvator Rosa*, Princeton, 1979.

Ward-Jackson, 1980
Peter Ward-Jackson, *Victoria and Albert Museum Catalogues. Italian Drawings. Volume Two: 17th–18th century*, London, 1980.

Weeks, 1978
The Tiepolos: Painters to Princes and Prelates, exhibition catalogue by E. F. Weeks, assisted by Barry Hannegan, Birmingham Museum of Art, Birmingham, Alabama, Museum of Fine Arts, Springfield, Massachusetts, 1978.

Wellesley, 1960
Eighteenth Century Italian Drawings. A Loan Exhibition, catalogue by Janet Cox Rearick, Jewett Arts Center, Wellesley College, Wellesley, Massachusetts, and Charles E. Slatkin Galleries, New York, 1960.

Williams, 1938
Hermann W. Williams, Jr., "Tiepolo and His Contemporaries," *Metropolitan Museum of Art Bulletin*, XXXIII, March 1938, pp. 62–66.

Williams, 1939
Hermann W. Williams, "Drawings and Related Paintings by Francesco Guardi," *Art Quarterly*, II, 1939, pp. 265–275.

Williams, 1940
Hermann Warner Williams, Jr., "A Gift of Prints and Drawings," *Metropolitan Museum of Art Bulletin*, XXXV, August 1940, pp. 154–157.

Williams, 1982
C. I. M. Williams, "Lusieri's Surviving Works," *Burlington Magazine*, CXXIV, 1982, pp. 492–497.

Wittkower, 1965
Rudolf Wittkower, *Art and Architecture in Italy 1600 to 1750*, second revised edition, Baltimore, 1965.

Wrightsman Collection. V, 1973
The Wrightsman Collection. Volume V. Paintings, Drawings by Everett Fahy. Sculpture by Sir Francis Watson, New York, 1973.

Wunder, 1965
Architectural and Ornament Drawings of the 16th to the early 19th Centuries in the Collection of The University of Michigan Museum of Art, exhibition catalogue by Richard P. Wunder, Ann Arbor, 1965.

Zeri and Gardner, 1973
Federico Zeri, with the assistance of Elizabeth E. Gardner, *Italian Paintings. A Catalogue of the Collection of The Metropolitan Museum of Art. Venetian School*, New York, 1973.

Zugni-Tauro, 1971
Anna Paola Zugni-Tauro, *Gaspare Diziani*, Venice, 1971.

Notices and Illustrations

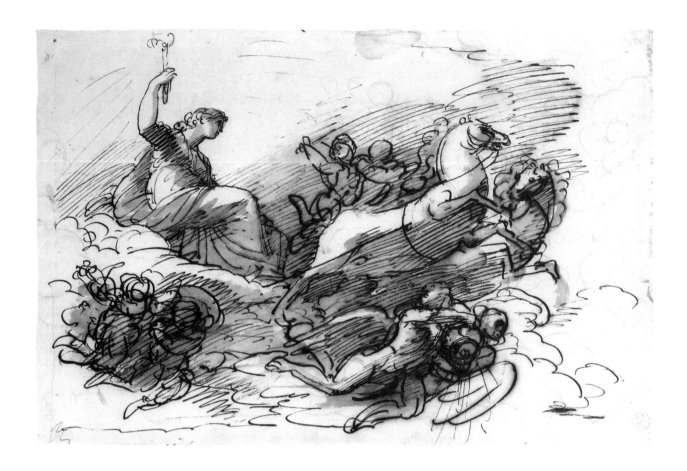

ANDREA APPIANI

Milan 1754–Milan 1817

1. *Aurora Riding in Her Chariot*

Pen and brown ink, brown wash, over black chalk. 18.8 x 29.0 cm. Right margin irregular.

Inscribed in graphite on verso, *Aurora—Andrea Appiani—Fresco in Casa Passalacqua Via Morone—Mila . . / 2.*

PROVENANCE: Francesco Dubini, Milan (Lugt Supp. 987a); [Seiferheld]; Mario Amaya; sale, London, Christie's, December 8, 1987, no. 140, repr.; [Morton Morris]; purchased in New York in 1988.

BIBLIOGRAPHY: Olson, 1980, no. 4, repr.; *Annual Report*, 1987–1988, pp. 22, 24.

Purchase, General Atlantic Corporation and Christina Turcic Latrowski Gifts, in memory of Lawrence Turčić, 1988
1988.150

The drawing comes very close to and is probably preparatory for a fresco of oval format formerly in the Casa Passalacqua, Milan (Beretta, 1848, p. 167). The fresco was engraved by Michele Bisi in 1820. According to the description that accompanies the engraving, the Casa Passalacqua was in the contrada del Morone, and the fresco by Appiani measured 1.19 by 2.42 meters. The building in question must be what is now known as the Palazzo Marchetti, via Morone no. 2, in Milan. This palace suffered grave losses during the bombardments of 1943, and Appiani's fresco appears to have been destroyed at that time.

A study by Appiani for the figure of Aurora with a torch in her raised right hand is in the Gallerie dell'Accademia, Venice (Nicodemi, 1915, pl. XXXIX). In the Philadelphia Museum of Art there is a pen sketch for the whole composition which differs from our drawing and the fresco as executed in that Aurora is represented standing, not seated, in her chariot (1984-56-342; Gernsheim photograph 90446).

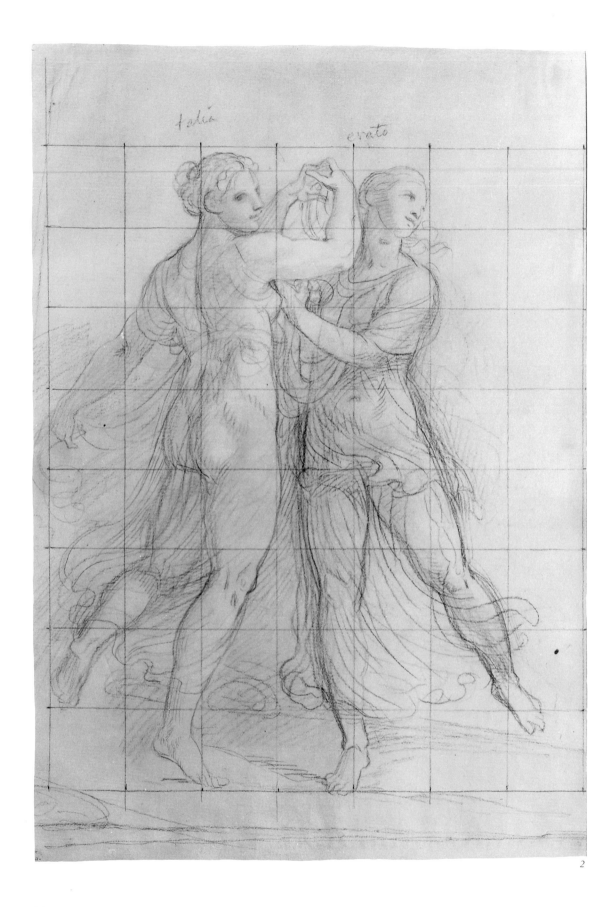

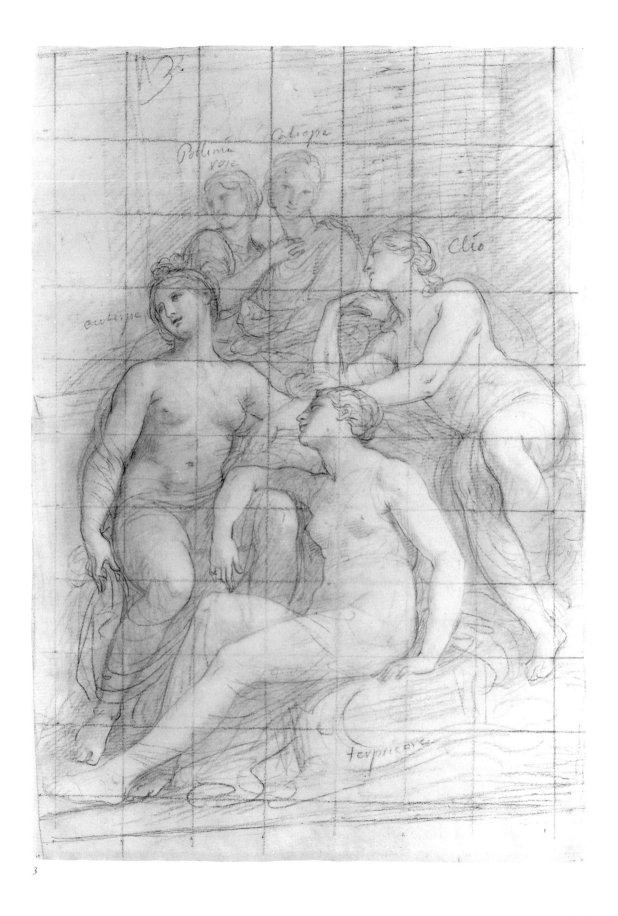

3

ANDREA APPIANI

2. *The Muses Thalia and Erato*

Black chalk, squared in black chalk. 47.9 x 33.9 cm.

Inscribed in black chalk near upper margin, *talia* and *erato*.

PROVENANCE: [Colnaghi]; purchased in London in 1988.

BIBLIOGRAPHY: *Annual Report*, 1987–1988, p. 24.

Purchase, Mrs. Carl L. Selden Gift, in memory of Carl L. Selden, 1988
1988.145

Study for the two dancing muses that appear on the left in Appiani's fresco *Apollo and the Muses on Parnassus*. This painting decorates the ceiling of the *sala da pranzo* of the Villa Reale in Milan, now the seat of the Galleria d'Arte Moderna (Precerutti-Garberi, 1969–1, pl. 1, in color; Cera, 1987, pl. 54). Signed and dated 1811, the *Parnassus* was commissioned from the artist by Eugène de Beauharnais, Viceroy of Italy, and executed in only forty days—a miraculously short time, according to Appiani's principal biographer (Beretta, 1848, pp. 282, 283, 286).

The two muses in our drawing are quite close in pose to those in the fresco. In the painting, however, opaque draperies replace the revealing, transparent veils of this study. The same near-nudity characterizes the figures in No. 3 below.

3. *The Muses Euterpe, Polyhymnia, Calliope, Clio, and Terpsichore*

Black chalk, squared in red chalk. Verso: black chalk sketch of a sleeping child. 47.8 x 33.8 cm.

Inscribed in black chalk, clockwise from upper left, *euterpe, Pollinia, rose, Caliope, Clio, terpsicore, giallo*.

PROVENANCE: [Colnaghi]; purchased in London in 1989.

BIBLIOGRAPHY: *Annual Report*, 1988–1989, pp. 22, 24.

Purchase, Mrs. Carl L. Selden Gift, in memory of Carl L. Selden, 1989
1989.25

Study for the five muses that appear on the right in the *Parnassus* of the Villa Reale in Milan (see No. 2 above). A similar study for Apollo and the muses Melpomene and Urania who appear in the center of the composition must have existed, but its present whereabouts is unknown. The cartoon for the whole fresco that belonged to the Pinacoteca di Brera was unfortunately destroyed in the aerial bombardment of Milan in August 1943 (repr. Malaguzzi Valeri, 1906, IIa, p. 143).

CARLO ALBERTO BARATTA
Genoa 1754–Genoa 1815

4. *Study for the Decoration of a Vault*

Point of brush, gray wash, heightened with white, over traces of black chalk, on gray-green prepared paper. 25.3 x 40.7 cm. All four corners cut away.

PROVENANCE: [Colnaghi]; purchased in London in 1988.

BIBLIOGRAPHY: *Master Drawings Presented by Jean-Luc Baroni*, exhibition catalogue, P. and D. Colnaghi and Co., London, 1988, no. 40, repr. in color; *Annual Report*, 1988–1989, pp. 22, 23.

Purchase, Gifts in memory of Lawrence Turčić, 1988
1988.250

Mary Newcome recognized the drawing as a study for Baratta's fresco in the vault of the chapel of St. Anne in the now-destroyed church of S. Maria della Pace, Genoa. The nineteenth-century Genoese art historian Alizeri gives high praise to Baratta's decorations in this chapel, which he implies were executed about 1796 (Alizeri, *Notizie*, II, pp. 108–109).

According to Alizeri, St. Anne in a glory of angels appeared in the center of the vault, and the spandrels were occupied by four prophets—Isaiah, Job, Ezekiel, and Jeremiah. In this preparatory drawing, King David, with crown and harp, takes the place of one of the prophets.

POMPEO BATONI
Lucca 1708–Rome 1787

5. *Three Nude Male Figures; Study of the Right Hand of the Figure on the Left*

Red chalk. 20.9 x 30.4 cm. Scattered stains. Lined.

PROVENANCE: Madame Galippe; Fritz Haussmann; Countess Finckenstein (see Clark and Bowron, 1985, p. 377); [Yvonne ffrench]; Harry G. Sperling.

BIBLIOGRAPHY: *Exhibition of Old Master and Early English Drawings Presented by Yvonne ffrench*, Alpine Club Gallery, London, 1960, no. 26; *Annual Report*, 1974–1975, p. 50; *Rome in the 18th Century*, 1978, n.pag. [6]; Clark and Bowron, 1985, p. 228, under nos. 63–66, p. 384, no. D 144, with incorrect accession and plate numbers, pl. 60.

Bequest of Harry G. Sperling, 1971
1975.131.5

Nude studies for three of the Apostles that appear on the left in *Christ Giving the Keys to St. Peter*, a painting in the ceiling of the Casino del Giardino, Palazzo del Quirinale, Rome (Clark and Bowron, 1985, pl. 59; Titi, 1987, II, fig. 1092). In the painting, which dates from 1742 to 1743, the Apostles wear heavy draperies.

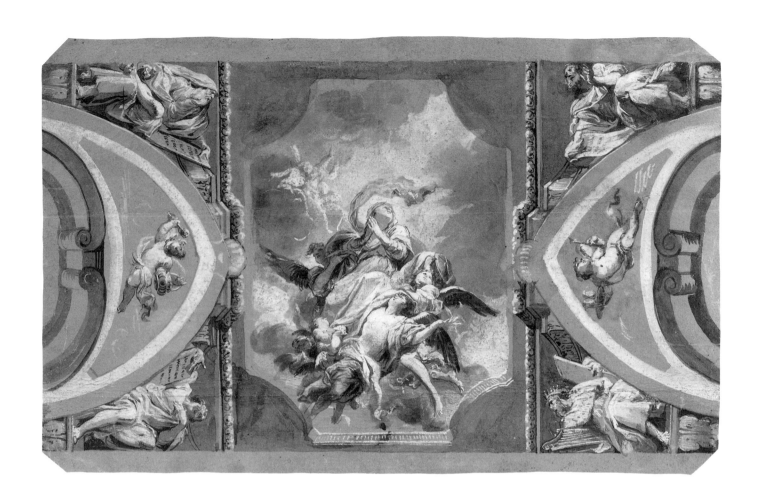

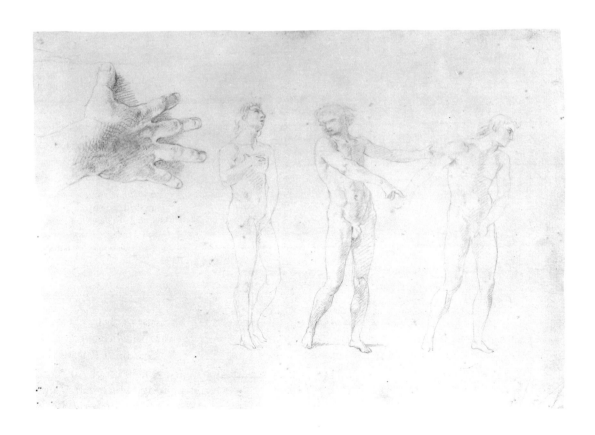

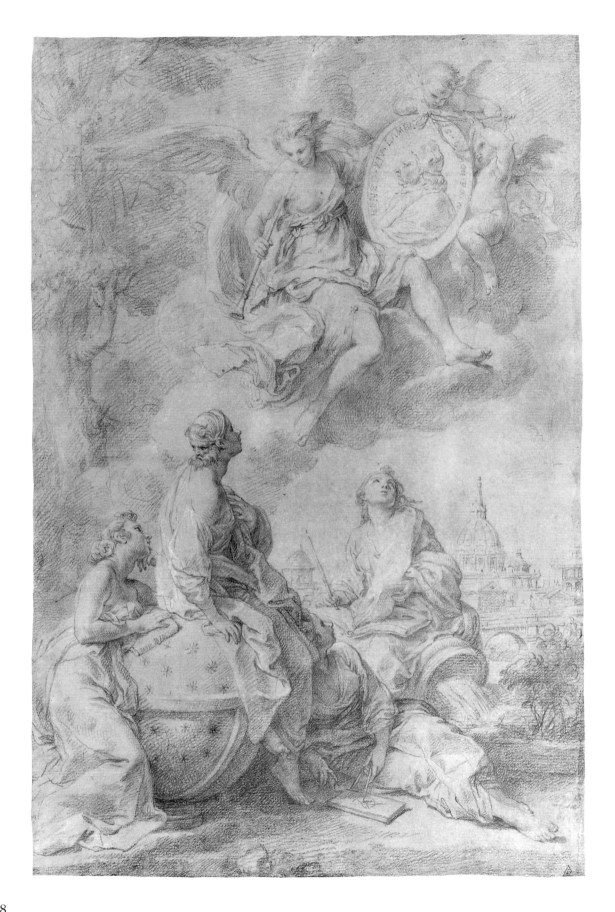

28

6. *Allegory in Honor of Pope Benedict XIV*

Red chalk, heightened with white, on beige paper. 36.1 x 24.9 cm. Lined.

PROVENANCE: Cavaceppi (according to Lagoy); marquis de Lagoy (Lugt 1710; no. 137 in the manuscript inventory of the Lagoy collection); sale, London, Sotheby's, June 19, 1973, no. 229, pl. 3, purchased by the Metropolitan Museum.

BIBLIOGRAPHY: *Annual Report*, 1973–1974, p. 37; Bean, 1975, no. 1; *Rome in the 18th Century*, 1978, n.pag. [7]; Clark and Bowron, 1985, p. 384, no. D 145.

Rogers Fund, 1973
1973.156

The design is an allegorical homage to the highly cultivated Pope Benedict XIV Lambertini, who reigned from 1740 to 1758. The winged figure of Fame with a trumpet is assisted by two putti in holding aloft a portrait medallion of the pontiff. Of the four allegorical figures occupying the foreground, the most conspicuous is that of Theology seated on a celestial globe. She has two visages—the younger looking up to heaven, the older looking down at the earth. Her companions probably represent, from left to right, the Trivium, the Quadrivium, and Philosophy. We are grateful to Michael Evans for suggesting the identification of these three figures.

St. Peter's is in the background at the right, while just to the left of center appears the fifteenth-century octagonal lantern of the Arcispedale di S. Spirito in Sassia. Benedict XIV added a large wing to this ancient hospital. The addition (pulled down in the twentieth century), decorated with frescoes by Gregorio Guglielmi, was completed in time to figure on Giambattista Nolli's 1748 plan of Rome (Titi, 1763, p. 26). The façade of Benedict's addition to the hospital is seen on the right, just beyond the Ponte S. Angelo and below the dome of St. Peter's.

The drawing was engraved in the same direction with the inscriptions *Pomp. Battoni inv. et del.* and *I. Frey inc. Romae 1745*. The Metropolitan Museum possesses an impression of this undescribed print (Department of Prints and Photographs, 1973.648. Gift of Anthony M. Clark).

BERNARDO BELLOTTO

Venice 1721–Warsaw 1780

7. *Padua from the East, with S. Francesco and the Salone*

Pen and brown ink, over graphite. 19.0 x 27.1 cm. Scattered stains.

PROVENANCE: Ludwig Heinrich Bojanus; acquired in 1829 by the Hessisches Landesmuseum, Darmstadt (mark similar to Lugt Supp. 1257c–e on verso, as well as Darmstadt inventory number, *AE2183*); sold or exchanged by that museum between 1936 and 1945; sale, Lucerne, Galerie Fischer, June 2, 1945, no. 10, pl. 2, as Antonio Canale; [Kleinberger]; Walter C. Baker.

BIBLIOGRAPHY: Fritzsche, 1936, p. 130, no. VZ 9; Parker, 1948, p. 46, under no. 80; Constable, 1962, II, p. 501, under no. 680; Virch, 1962, no. 65; Bean and Stampfle, 1971, no. 215, repr.; Kozakiewicz, 1972, II, p. 28, repr., pp. 29–30, no. 33; Constable, 1976, II, p. 548, under no. 680; *Annual Report*, 1979–1980, p. 27.

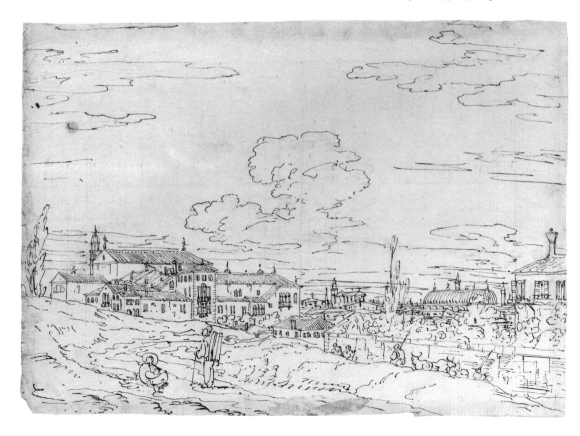

Bequest of Walter C. Baker, 1971
1972.118.242

Free copy of a composition by Bellotto's uncle and master, Canaletto (Giovanni Antonio Canal). Two drawings of this view by Canaletto have survived: one—in pen outline—is at Windsor Castle; the other—in pen and ink with wash—is in the collection of Mrs. Douglas Williams, New York (Constable, 1976, nos. 680 and 681, repr.). Bellotto's drawing is closer to the version at Windsor.

8. *S. Simeone Piccolo, Venice, Seen from the Grand Canal*

Pen and brown ink, over traces of black chalk. 26.6 x 37.4 cm. Scattered stains.

Numbered in pen and brown ink at upper right, *24*; in point of brush and red wash, *10.a*. On verso, several inscriptions including: in pen and brown ink, *lacagion dela mia pene* [?], and in graphite, *S. Simon piccolo.*

PROVENANCE: Ludwig Heinrich Bojanus; acquired in 1829 by the Hessisches Landesmuseum, Darmstadt (mark similar to Lugt Supp. 1257c–e on verso, as well as Darmstadt inventory number, *AE2209*); sold or exchanged by that museum between 1936 and 1948; sale, Lucerne, Galerie Fischer, November 30, 1956, no. 442, repr., as Canaletto; Harry G. Sperling.

BIBLIOGRAPHY: Hadeln, 1929, p. 21, under no. 7467; Fritzsche, 1936, p. 131, no. VZ 29; Parker, 1948, p. 35, under no. 32; Constable, 1962, II, p. 478, no. 622a; Kozakiewicz, 1972, II, p. 444, no. Z 239; *Annual Report*, 1974–1975, p. 50; Bean, 1975, no. 5; Constable, 1976, II, p. 522, no. 622a.

Bequest of Harry G. Sperling, 1971
1975.131.7

Free copy of a drawing by Canaletto in a private collection (Constable, 1976, II, no. 622b; repr. Matthiesen, 1939, no. 126, lent by C. R. and A. P. Rudolf). In a comparable drawn view of S. Simeone Piccolo by Canaletto that is preserved at Windsor Castle the light falls from the left, not from the right as here, and the boats in the foreground differ (Constable, 1976, no. 622, repr.).

VITTORIO MARIA BIGARI

Bologna 1692–Bologna 1776

9. *Allegorical Figure of History*

Black chalk, stumped, heightened with white, on blue paper. 53.5 x 42.5 cm. Vertical and horizontal creases at center; a number of repaired losses.

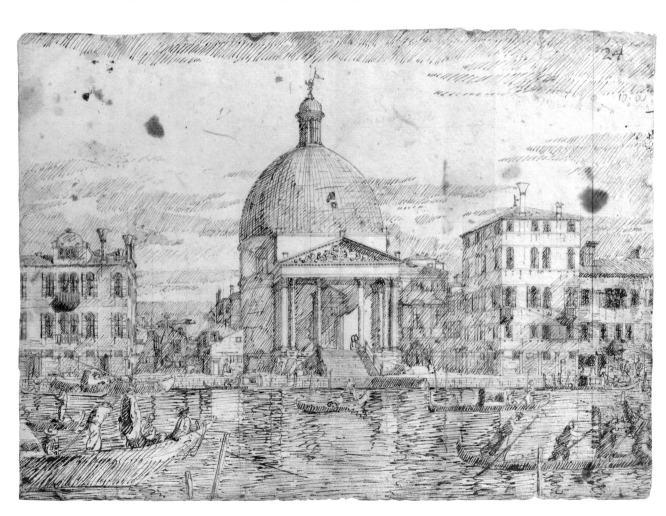

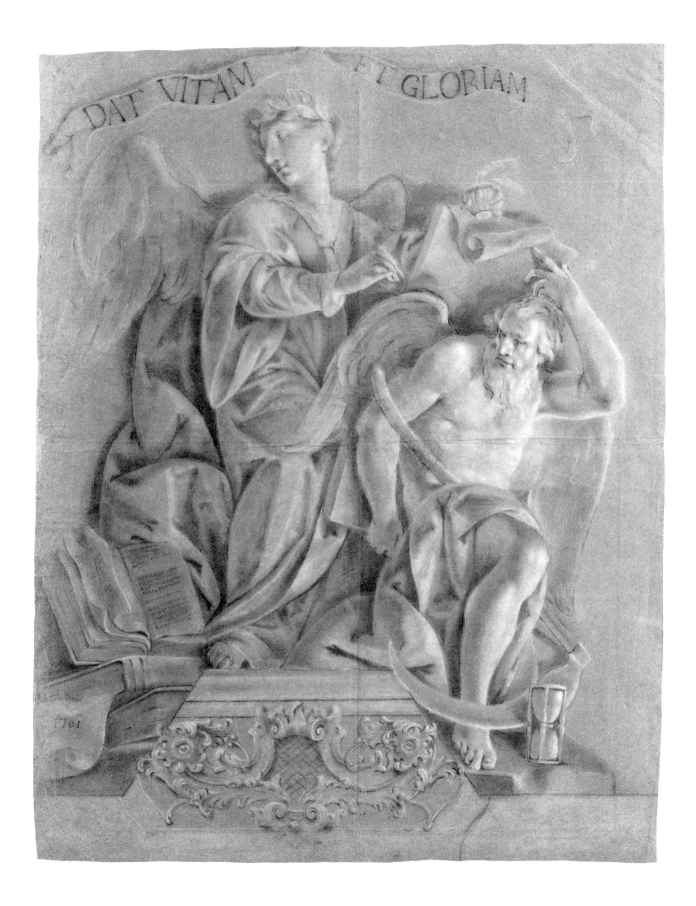

Inscribed in black chalk on banderole above, DAT VITAM ET GLORIAM; dated in black chalk at lower left, *1761*; inscribed in pen and brown ink on verso, *Disegno di Vittorio Bigheri Bolognese fatto per il dipinto a chiaro e scuro sotto le finestre / del camerone de Quadri nell'appartamento a pian tereno. / di Casa Bovio / Dipinto nel 1761. come pure / dal medemo dipinta la Volta.*

PROVENANCE: Unidentified collector's mark (KM within a circle, in purple, on verso; not in Lugt); [Scarpa]; purchased in New York in 1979.

BIBLIOGRAPHY: *Dessins anciens. Pietro Scarpa. Venise*, exhibition catalogue, Grand Palais, Paris, 1978, no. 76, repr.; R. Roli in *Settecento Emiliano*, 1979, p. 88, under no. 178; *Annual Report*, 1979–1980, p. 27; M. Cazort in Ottawa, 1982, no. 102, repr.

Harry G. Sperling Fund, 1979
1979.286.1

History is represented as a winged figure looking backward as she writes on a tablet supported by Time.

In a letter of November 16, 1987, Professor Renato Roli kindly assured us that the old inscription on the reverse of the drawing is accurate. Thus our drawing is a study for one of the allegories painted in chiaroscuro on the walls of a room on the ground floor of the Casa Bovi Tacconi in Bologna, now used as a photographic studio. Most of the wall frescoes have disappeared under coats of whitewash. Only two allegories have survived, although heavily repainted, and Professor Roli points out that in one of these chiaroscuri, facial types and framing motifs are paralleled in our drawing.

Bigari's ceiling fresco, representing Apollo crowning a figure of Painting, is intact (Roli, 1977, pls. 69a and 69b). A pen and watercolor drawing for the ceiling fresco and part of its feigned architectural surround is in a private collection in Bologna (R. Roli in *Settecento Emiliano*, 1979, no. 178, fig. 260).

GIUSEPPE BERNARDINO BISON

Palmanova 1762–Milan 1844

10. *The Rest on the Flight into Egypt*

Pen and brown ink, brown wash, over graphite. 16.3 x 13.0 cm.

PROVENANCE: [Shickman]; Mr. and Mrs. Gordon Douglas III.

BIBLIOGRAPHY: *Annual Report*, 1975–1976, p. 35.

Gift of Mr. and Mrs. Gordon Douglas III, 1975
1975.407.1

11. *Scene of Antique Sacrifice*

Pen and brown ink, brown and pink wash, over traces of black chalk. 23.1 x 34.7 cm.

Inscribed in pen and brown ink at lower left, *G: Bison Veneziano*; numbered in pen and brown ink at lower right, *391*.

PROVENANCE: [Colnaghi]; purchased in London in 1970.

BIBLIOGRAPHY: *Exhibition of Old Master and English Drawings. P. and D. Colnaghi and Co.*, London, 1970, no. 46; *Annual Report*, 1970–1971, p. 16; Bean and Stampfle, 1971, no. 297, repr.; Franca Zava Boccazzi, *Arte Veneta*, XXVII, 1973, pp. 237, 238, fig. 335; Olson, 1980, no. 12, repr.

Rogers Fund, 1970
1970.177

10

Franca Zava Boccazzi has pointed out similarities in style between this drawing and the feigned reliefs painted in monochrome by Bison as overdoors in the Palazzo Manzoni, Padua. These decorations are dated between 1787 and 1790 by Zava Boccazzi (*Arte Veneta*, XXII, 1968, figs. 211 and 215).

12. *Chapel in a Gothic Church*

Pen and brown ink, brown wash, over graphite. 24.0 x 16.2 cm.

PROVENANCE: [Baderou]; purchased in Paris in 1961.

BIBLIOGRAPHY: *Annual Report*, 1961–1962, p. 67.

Rogers Fund, 1961
61.136.5

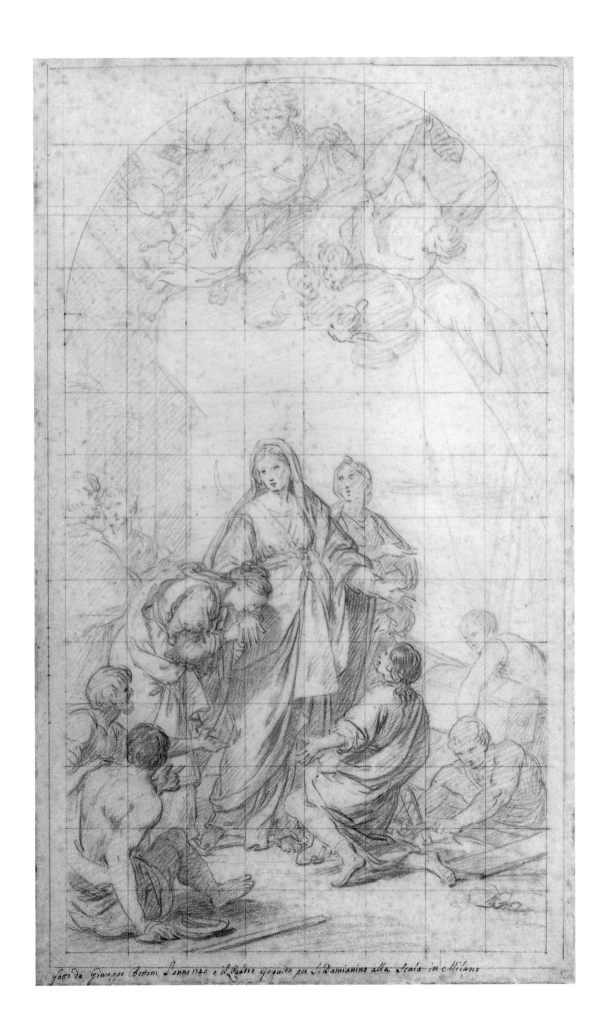

GIUSEPPE BOTTANI

Cremona 1717–Mantua 1784

13. *The Departure of St. Paula and St. Eustochium for the Holy Land*

Red chalk; squared in black chalk. 40.4 x 24.5 cm. The sheet was considerably foxed at the time of its acquisition by the museum; this condition has since been minimized.

Inscribed in pen and brown ink at lower margin, *fatto da Giuseppe Bottani L'anno 1740 e il Quadro eseguito per S. Damianino alla Scala in Milano*; numbered in white chalk on old mount (now detached), *N. 103* and *N. 33*.

PROVENANCE: Carlo Prayer (Lugt 2044); Juan and Felix Bernasconi (according to Christie's); inscribed in pen and blue ink on verso, *Maria . . . Méndez de Bernasconi / 1977*; sale, London, Christie's, April 1, 1987, no. 92, repr., "St. Helena with Attendants"; John Morton Morris.

BIBLIOGRAPHY: *Annual Report*, 1987–1988, p. 22.

Gift of John Morton Morris, 1987
1987.245

To the right of the Roman widow St. Paula stands her daughter St. Eustochium, who accompanied her to the Holy Land to join St. Jerome. Paula's daughter Rufina kisses her mother's hand in farewell, and Paula's son Toxotius kneels at the right. The drawing is a squared study with minor variations for a painting by Bottani, signed and dated 1745, that is now in the Pinacoteca di Brera, Milan (Perina, 1961, p. 52, fig. 1).

The painting, executed in Rome, was commissioned by the Hieronymites for their now-destroyed Milanese church, SS. Cosma e Damiano. For this church the Hieronymites also commissioned a *Holy Family with Saints* from Pompeo Batoni (Clark and Bowron, 1985, cat. no. 29, pl. 32) and a *Vision of St. Jerome* and a *Crucifixion with Saints* from Pierre Subleyras (Rosenberg and Michel, 1987, nos. 66 and 85, repr.). These three paintings are also preserved in the Brera.

An oil sketch by Subleyras in Newcastle-upon-Tyne has been identified by Pierre Rosenberg and Olivier Michel as a study for a representation of the *Departure of St. Paula*, and they suggest that Subleyras may have been considered for the commission that went in fact to Bottani (Rosenberg and Michel, 1987, no. 65, repr.).

An oil sketch for Bottani's *Departure of St. Paula*, closer to the finished painting than to our drawing, is now in a private collection in New York (sale, New York, Sotheby's, January 17, 1986, no. 67, repr.). Stefano Susinno has pointed out that in the Gabinetto Nazionale delle Stampe, Rome, there is a drawing for the group of

angels at the top of the painting (*Antologia di Belle Arti*, II, 7–8, 1978, p. 311, note 11).

PIETRO BRACCI

Rome 1700–Rome 1773

14. *Design for a Tomb*

Pen and brown ink, gray wash, over traces of graphite. 40.0 x 27.0 cm., including the blank borders of the sheet that measure about 3.5 cm.

Inscribed in pen and brown ink at lower left, *Petrus Bracci Rom. F.*; in pen and red ink at lower center, *Scala di Palmi Otto Romani / 1 2 3 4 5 6 7 8*.

PROVENANCE: Archivio di Palazzo Bracci, Rome; [Arturo Pini di San Miniato]; purchased in New York in 1966.

BIBLIOGRAPHY: Gradara, 1920, p. 55; *Annual Report*, 1966–1967, p. 60; Bean and Stampfle, 1971, no. 171, repr.; Storrs, 1973, p. 71, no. 60; *Rome in the 18th Century*, 1978, n.pag. [7].

Purchase, Florence and Carl Selden Foundation, Inc. Gift, 1966
66.139.1

In this and the following drawing, Bracci proposes alternative solutions for the tomb of Cardinal Carlo Leopoldo Calcagnini in S. Andrea delle Fratte, Rome, commissioned by the cardinal's nephew Teofilo. The cardinal died in 1746 and the monument was completed in 1748. The present drawing comes closest to the tomb as executed, where an allegorical female figure of History inscribes the cardinal's epitaph on an obelisk supported by two lions and ornamented by a painted portrait of the deceased prelate (Wittkower, 1965, pl. 168A; Titi, 1987, II, fig. 1201).

15. *Design for a Tomb*

Pen and brown ink, brown and gray wash, heightened with white, over graphite. 39.7 x 26.8 cm., including the blank borders of the sheet that measure about 3.5 cm.

Inscribed in pen and brown ink at lower left, *Petrus Bracci Rom. F.*; in pen and red ink at lower center, *Scala di Palmi Sei / 1 2 3 4 5 6*.

PROVENANCE: Archivio di Palazzo Bracci, Rome; [Arturo Pini di San Miniato]; purchased in New York in 1966.

BIBLIOGRAPHY: Domarus, 1915, p. 33; Gradara, 1920, p. 55, pl. XVI; *Annual Report*, 1966–1967, pp. 59–60, repr.; Bean and Stampfle, 1971, no. 170, repr.; Storrs, 1973, p. 71, under no. 60; *Rome in the 18th Century*, 1978, n.pag. [7].

Purchase, Florence and Carl Selden Foundation, Inc. Gift, 1966
66.139.2

An alternative scheme for the tomb of Cardinal Carlo Leopoldo Calcagnini in S. Andrea delle Fratte, Rome. See No. 14 above.

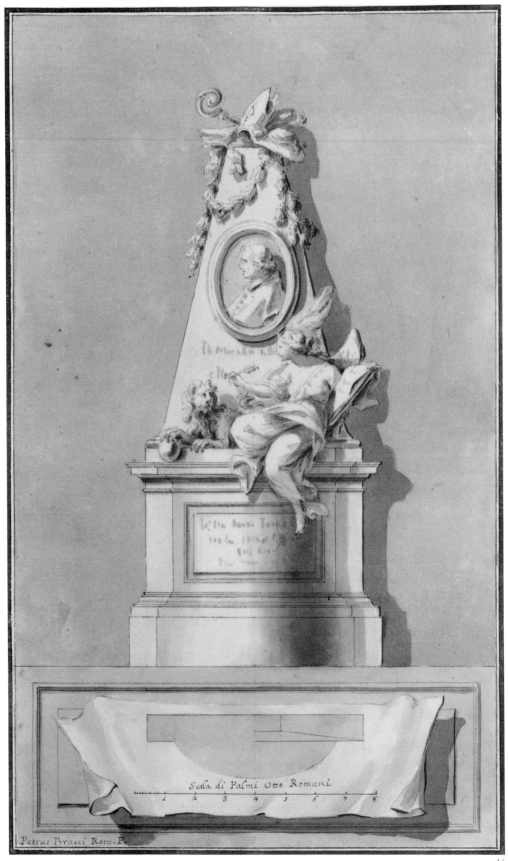

Scala di Palmi Otto Romani
1 2 3 4 5 6 7 8

Petrus Bracci Rom. F.

14

36

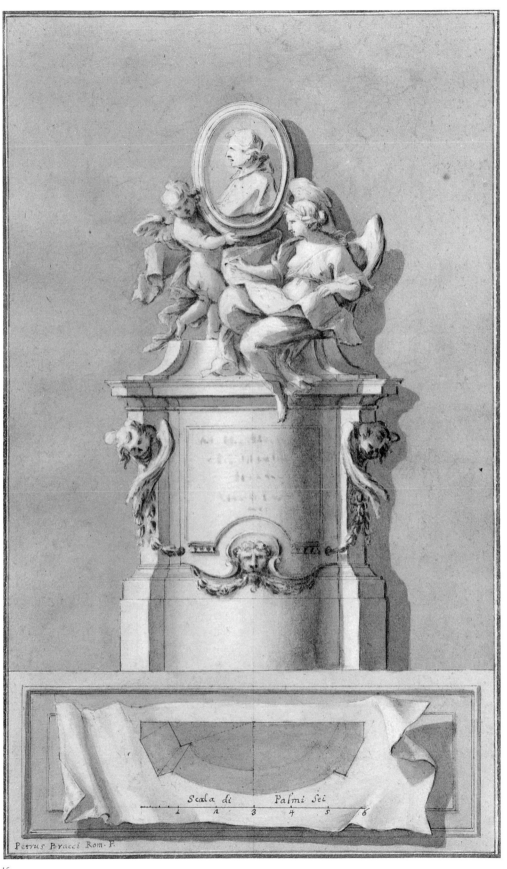

Scala di Palmi Sei

Petrus Bracci Rom·F.

15

GIUSEPPE CADES

Rome 1750–Rome 1799

17. *The Dead Christ Mourned by St. Mary Magdalene*
VERSO. *The Holy Family with an Attendant Angel*

Pen and brown ink, on beige paper (recto); black chalk (verso). 13.2 x 16.1 cm.

Inscribed in pen and brown ink at lower left, *Cadel*; at lower right margin, *Cades* (the lower part cut off); numbered in graphite at lower left, *30*.

PROVENANCE: Cephas G. Thompson.

BIBLIOGRAPHY: *Metropolitan Museum Handbook*, 1895, p. 46, no. 827, "Cadel.—The Dead Christ and Mary."

Gift of Cephas G. Thompson, 1887
87.12.157

Maria Teresa Caracciolo Arizzoli kindly informs us that the inscription *Cades*, in part cut off at the lower right margin, is a signature. The *Cadel* that appears at lower left has been added by a later hand and is a mistaken transcription of the artist's name.

GIOVANNI BATTISTA BUSIRI

Rome 1698 ?–Rome 1757

16. *River Landscape near Narni*

Pen and brown ink, over traces of black chalk. 27.6 x 41.9 cm.

Inscribed in pen and brown ink on verso, *veduta à narnni giu nel fiume / Giovanni Battista Busiri del: 1730 / Romano* (the *u* in the name Busiri has been transformed into an *o* by a later hand).

PROVENANCE: Nathaniel Hone (Lugt 2793); Uvedale Price (Lugt 2048); [Rockman]; Harry G. Friedman.

BIBLIOGRAPHY: *Annual Report*, 1959–1960, p. 57; *Rome in the 18th Century*, 1978, n.pag. [8].

Gift of Harry G. Friedman, 1960
60.66.6

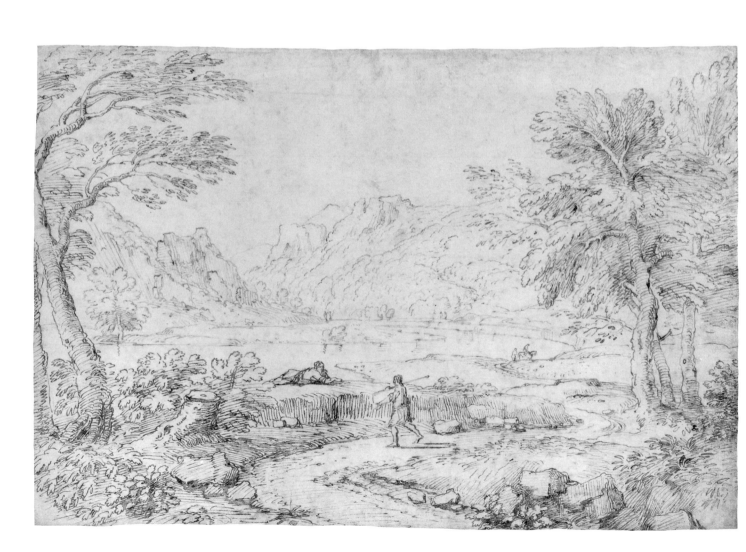

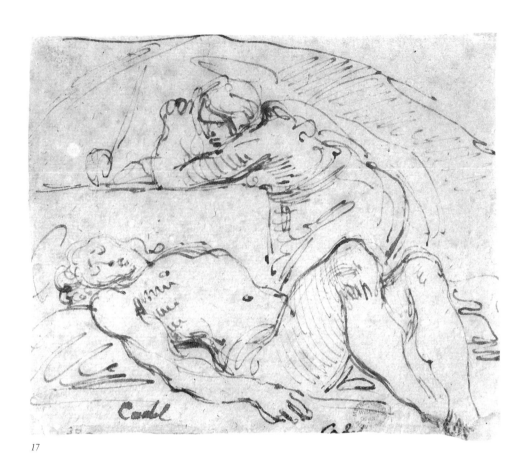

17

17 v.

39

18. *The Virgin Immaculate with the Christ Child*

Pen and brown ink, brown and gray wash, over black chalk. 44.9 x 30.7 cm. Lined.

Inscribed in pen and black ink on reverse of old mount, *Cherubino Alberti. / (Borgheggiano)*.

PROVENANCE: Illegible, unidentified collector's mark (not in Lugt); Anton Schmid; [Tan Bunzl]; purchased in London in 1970.

BIBLIOGRAPHY: *Old Master Drawings and Paintings Presented by Yvonne Tan Bunzl*, London, 1970, no. 13; *Annual Report*, 1970–1971, p. 16; Bean and Stampfle, 1971, no. 295, repr.; Bean, 1972, no. 2; *Rome in the 18th Century*, 1978, n.pag. [8]; A. Sievers in Providence, 1983, p. 96, under no. 29.

Rogers Fund, 1970
1970.113.2

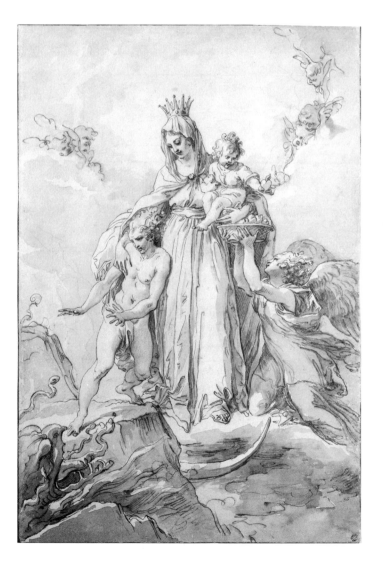

Cades represents the Virgin holding the Christ Child. She stands above the crescent moon, symbolic of her Immaculate Conception, and is attended by an angel, who makes a votive offering of hearts. At the left a youth protected by the Virgin recoils before a dragon.

Anthony M. Clark pointed out some years ago that there is a smaller drawing for this composition in the Museu Nacional de Arte Antiga, Lisbon (Inv. 2093). In the Lisbon drawing, executed in black and white chalk, the handling is broader and the figures are no more than mannequins.

19. *Blessed Francis Venimbeni Celebrating Mass for Souls in Purgatory*

Pen and brown ink, brown wash, over black chalk. 50.9 x 28.1 cm. Lined.

PROVENANCE: The Trustees of the Knole Settled Estates (according to Christie's); sale, London, Christie's, April 1, 1987, no. 108, repr. (subject incorrectly described); [Aldega and Gordon]; purchased in New York in 1988.

BIBLIOGRAPHY: *Marcello Aldega. Margot Gordon. Italian Drawings XVI to XVIII Century*, exhibition catalogue, New York and Rome, 1988, no. 50, repr. in color; *Annual Report*, 1988–1989, p. 23.

Harry G. Sperling Fund, 1988
1988.253

Maria Teresa Caracciolo Arizzoli related this drawing to a painting commissioned from Cades around 1790, which was once in a now-destroyed Franciscan house at Fabriano and is now in the church of St. Catherine in that city. The drawing corresponds quite closely, but not exactly, to the finished painting, for which it must be the definitive preparatory study or *modello*.

Francis Venimbeni of Fabriano (died about 1322) was a Franciscan priest with a particular devotion to holy souls in Purgatory. He was venerated from the time of his death, and his ancient *cultus* was approved by Pius VI in 1775. The Blessed Francis is shown celebrating a votive Mass. Behind him souls rise, with angelic assistance, from the cleansing fires of Purgatory.

20. *Design for a Frieze with Two Women Standing by an Urn*

Pen and brown ink, brown wash, heightened with white, over traces of black chalk. 33.6 x 49.0 cm. Vertical crease at center; surface somewhat abraded, especially at lower center. Lined.

PROVENANCE: [Schatzki]; purchased in New York in 1962.

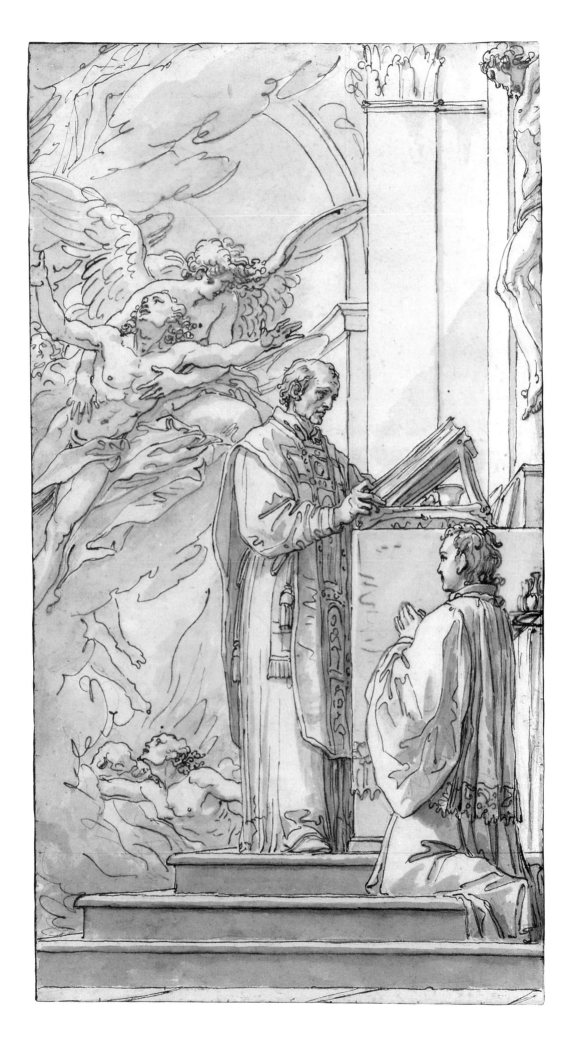

GIUSEPPE CADES (NO. 20)

BIBLIOGRAPHY: *Annual Report*, 1962–1963, p. 64; Vilain, 1976, p. 76, fig. 12, attributed to Moitte; Bean and Turčić, 1986, no. 195, repr., as Moitte.

Rogers Fund, 1962
62.242

This drawing was attributed to Giuseppe Cades when it was purchased in 1962. Its striking stylistic similarity to a drawing of three caryatids in the Musée Vivenel, Compiègne, ascribed in 1974 by Jacques Vilain and Richard J. Campbell to Jean-Guillaume Moitte (Paris, 1974, no. 102, repr.), led to the reattribution of our drawing to Moitte. Maria Teresa Caracciolo Arizzoli (in correspondence, 1988) agrees that both the Compiègne and New York drawings are by the same hand, but she argues very convincingly that they are characteristic examples of the figure style and draughtsmanship of Giuseppe Cades in the years 1770 to 1780.

Drawings such as these obviously had a strong influence on Moitte, who was in Rome at the French Academy from 1771 to 1775. In the Paris Salon of 1789 Moitte showed a highly finished drawing, now in Leningrad, representing the Judgment of Paris in a medallion flanked by caryatids that are clearly influenced by Cades, although they are stockier and less gracefully mannered in pose (Leningrad, 1971, no. 62, repr.).

CANALETTO (Giovanni Antonio Canal)

Venice 1697–Venice 1768

21. *Capriccio with a Roman Triumphal Arch*

Pen and brown ink, gray wash, over traces of graphite. 38.1 x 54.0 cm. Vertical crease at center.

Inscribed in pen and brown ink at lower left margin, *Canaletto*.

PROVENANCE: Dominique-Vivant, baron Denon (Lugt 779); 4th Earl of Warwick (Lugt 2600); [Schaeffer]; purchased in New York in 1946.

BIBLIOGRAPHY: Denon, 1829, II, pl. CL, lithograph in reverse by Delamardelle; *Annual Report*, 1946, p. 32; *Schaeffer Galleries Bulletin*, I, 1947, no. 10, repr.; Constable, 1962, I, pl. 152, II, p. 554, no. 807; Constable, 1964, no. 98, repr.; Bean and Stampfle, 1971, p. 69, under no. 160; Corboz, 1974, pp. 211, 217, note 30; Myers, 1975, no. 20, repr.; Constable, 1976, I, pl. 152, II, p. 603, no. 807; Barcham, 1977, p. 181, fig. 183; Corboz, 1985, I, p. 116, fig. 120, II, p. 738, no. D 143, repr.; Baetjer and Links, 1989, no. 119, repr.

Harris Brisbane Dick Fund, 1946
46.161

The composition is dominated by a structure inspired by the still-extant Arch of the Sergii at Pula (Pola), Istria. This monument was etched by Piranesi, who represented it in a somewhat more dilapidated state (Bettagno, 1978, pl. 121).

22. *Lagoon Capriccio*

Pen and brown ink, gray wash, over traces of graphite. Faint architectural sketch in graphite at left of sheet. Verso: faint sketches in graphite of buildings along a Venetian canal, possibly the Rio S. Barnaba. 25.9 x 41.3 cm.

PROVENANCE: Dominique-Vivant, baron Denon (Lugt 779); Earl of Rosebery (according to Sotheby's); sale, London, Sotheby's, May 28, 1941, no. 83, repr.; [Durlacher]; purchased in New York in 1943.

BIBLIOGRAPHY: Denon, 1829, II, pl. CXLVIII, etching in reverse by Denon; J. L. Allen, *Metropolitan Museum of Art Bulletin*, January 1946, pp. 124–125, repr. (recto and verso); Benesch, 1947, no. 52, repr. (recto); Constable, 1962, I, pl. III (verso), pl. 149 (recto), II, p. 472, no. 608 (verso), pp. 550–551, no. 797 (recto); Bean, 1964, no. 44, repr. (recto); Bean and Stampfle, 1971, no. 155, repr. (recto); Constable, 1976, I, pl. III (verso), pl. 149 (recto), II, p. 516, no. 608 (verso), pp. 599–600, no. 797 (recto); Corboz, 1985, I, p. 309, fig. 369 (recto), II, p. 764, repr. (recto), p. 765, no. D 209; Baetjer and Links, 1989, no. 121, repr. (recto).

Rogers Fund, 1943
43.61

23. *Man Smoking a Pipe*
VERSO. *Standing Man and Two Studies of His Head*

Pen and brown ink, over graphite. 29.8 x 16.4 cm.

Inscribed in pen and brown ink at upper right corners of both recto and verso, 40 / *volta*.

21

22

23

23 v.

44

PROVENANCE: [Kleinberger]; purchased in New York in 1939.

BIBLIOGRAPHY: *Metropolitan Museum, Italian Drawings*, 1942, no. 35, repr. (recto); Parker, 1948, p. 26, note 37; Constable, 1962, I, pl. 159 (recto and verso), II, p. 565, no. 840; Bean, 1964, no. 45, repr. (recto); Bean and Stampfle, 1971, no. 162, repr. (recto and verso); Constable, 1976, I, pl. 159 (recto and verso), II, p. 615, no. 840; Bettagno, 1982, p. 44, under nos. 37, 38; Corboz, 1985, II, p. 761, no. D 189, repr. (recto and verso); Baetjer and Links, 1989, no. 125, repr. (recto and verso).

Purchase, Joseph Pulitzer Bequest, 1939
39.79

There is a double-faced sheet of similar figure studies in the Courtauld Institute of Art, London. Both sides of the London drawing are inscribed, *II / volta*. The word *volta* no doubt indicates that the sheets should be turned, since they bear sketches on both sides (Constable, 1976, I, pl. 159, II, pp. 614–615, no. 839).

A number of pen and ink studies of groups of figures are related in style to the present drawing and the Courtauld sheet. They bear similar inscriptions and may have formed part of a dismembered sketchbook (see Bettagno, 1982, under nos. 37–39).

MARCO CAPRINOZZI ?

Civita Castellana or Vignanello 1711–Rome 1778

24. *The Virgin Appearing to St. Joseph Calasanctius*

Black chalk, heightened with white, on gray prepared paper. 55.6 x 41.1 cm. Horizontal crease at center.

Illegible, partly effaced inscription in pen and brown ink on verso.

PROVENANCE: [Lutz Riester]; purchased in New York in 1986.

BIBLIOGRAPHY: *Annual Report*, 1986–1987, p. 24, as Unidentified Italian artist, 18th century.

Purchase, David L. Klein, Jr. Memorial Foundation, Inc. Gift, 1986
1986.151

Joseph Calasanctius (1556–1648) was beatified in 1748 and canonized in 1767. In 1617 he founded the Piarists (Scolopi), an order of Clerics Regular dedicated to the free education of young boys. Here he is represented commending some of his pupils to the Virgin and Child.

A painting of this subject by Marco Caprinozzi is in SS. Stimmate di S. Francesco, Rome (Rudolph, 1983, pl. 129; Titi, 1987, I, p. 93, II, fig. 661). There the composition is reversed and the figures are differently arranged. The painting has a rounded top, while in the

drawing a shouldered arch is indicated in black chalk at the top of the sheet. Nevertheless, the drawing could be considered an early or alternative project for the painting.

As a draughtsman, Caprinozzi is documented by two drawings representing scenes from the life of St. Lawrence that recently appeared on the art market (sale, New York, Sotheby's, January 14, 1987, no. 148, only the *Martyrdom of St. Lawrence* repr.). They are studies for paintings by the artist in S. Lorenzo in Fonte, Rome (Barroero, 1979, figs. 8 and 9). In these drawings, the soft modeling in black chalk on a gray ground and certain physical characteristics, such as large hands and prominent ears, are to be found in our drawing as well. These features also appear in Caprinozzi's red chalk competition drawing of 1732 for the Accademia di San Luca, Rome, that represents the Zeal of the Modin priest Mattathias (Barroero, 1979, fig. 10).

The drawing was acquired in 1986 as an anonymous Roman work of the eighteenth century; our tentative attribution to Caprinozzi is based above all on its stylistic similarity to the two drawings for S. Lorenzo in Fonte that appeared in the following year.

CARLO INNOCENZO CARLONI

Scaria d'Intelvi (Como) 1686–Scaria d'Intelvi (Como) 1775

25. *The Decapitation of a Male Saint*

Brush and red wash, over red chalk. 36.1 x 26.0 cm.

Inscribed in pen and brown ink at upper left corner, *97. Carloni*; in graphite on verso, CARLO CARLONE.

PROVENANCE: Mathias Komor (Lugt Supp. 1882a); [Komor]; purchased in New York in 1965.

BIBLIOGRAPHY: *Annual Report*, 1965–1966, p. 75.

Rogers Fund, 1965
65.224

The drawing seems to be a preparatory study with variations for a late fresco by Carloni in the cathedral at Asti, said to represent the martyrdom of St. Martinian. There is an oil sketch for the fresco in a private collection in Budapest (Barigozzi Brini and Garas, 1967, pp. 112 and 120, fig. 82).

In the Witt Collection, Courtauld Institute of Art, London, is a drawing of a scene of martyrdom, inscribed

96. *Carloni*, that is close to ours in style, technique, and dimensions (Inv. 1231). The design in London is a study for a pendant fresco by Carloni in the cathedral at Asti that represents the martyrdom of St. Secundus (Barigozzi Brini and Garas, 1967, pp. 112 and 124).

Inscriptions similar to the one on this drawing and No. 26 below—*Carloni*, preceded or followed by a number—occur on drawings by Carlo Carloni in a number of public and private collections (see Byam Shaw, 1983, I, no. 427).

26. *St. Lucy in Glory*

Red and brown wash, over red chalk. 29.9 x 32.3 cm.

Inscribed in pen and brown ink at upper right, *C. carloni 20.*

PROVENANCE: [Agnew]; purchased in New York in 1989.

BIBLIOGRAPHY: *Annual Report*, 1988–1989, p. 24.

Purchase, David L. Klein, Jr. Memorial Foundation, Inc. Gift, 1989
1989.58

St. Lucy stands at the center of the composition with a martyr's palm in her upraised right hand. At her left foot a putto holds her principal attribute, two eyes on a dish. To the right, an angel holds a sword, the instrument of her martyrdom. Above St. Lucy appears Christian Faith, identified by a cross and raised chalice. The drawing is no doubt a design for a ceiling decoration.

GERONIMO CENATIEMPO (or CENATEMPO)

Naples, active 1705–1742

27. *The Virgin and Child Intervening for Victims of the Plague*

Pen and brown ink, gray wash, over black chalk. Verso: small black chalk sketch of a seated female figure. 38.6 x 26.1 cm.

Inscribed in graphite at lower left, *W.3295* (a modern stock number); in pen and brown ink on verso in an old hand, *Cenatiempo / S* [?] *4*.

PROVENANCE: [L'Art Ancien]; purchased in Zurich in 1966.

BIBLIOGRAPHY: *Annual Report*, 1966–1967, p. 60.

Rogers Fund, 1966
66.67

In the right foreground a man kneels in supplication for victims of the plague, personified by the figure of Death that flees to the left.

The old attribution to Cenatiempo of this drawing—marked by rather ragged pen work reflecting the style of

Luca Giordano—seems plausible. No other drawings by Cenatiempo are known to us, but the physical types and gestures here are compatible with those in documented paintings by the artist, such as those in S. Bernardino, L'Aquila (Chierici, 1978, with seven unnumbered plates).

MICHELANGELO CERRUTI

Rome 1663–Rome 1748

28. *The Martyrdom of St. Anastasia*

Pen and brown ink, pale brown wash, heightened with white, over black chalk. 53.2 x 38.3 cm. Lined.

PROVENANCE: Sale, New York, Christie's, January 11, 1989, no. 58, repr., as Circle of Sebastiano Ricci; [Dance]; purchased in New York in 1989.

Van Day Truex Fund, 1989
1989.198

Robert Dance identified this drawing as a study by Cerruti for a ceiling painting in the nave of S. Anastasia, Rome (Rudolph, 1983, pl. 154; Titi, 1987, I, p. 46, II, fig. 385). The outlines of the elaborately shaped field of the canvas are clearly established in the drawing. However, there are significant differences in the placement of all of the principal figures in the complex composition.

The Portuguese Cardinal Nuno da Cunha e Ataíde (1664–1750; created 1712) was named protector of S. Anastasia on June 16, 1721. At that time the church was apparently in a very dilapidated state, and he immediately ordered a new roof and a sumptuous wood ceiling at an initial cost of 4,000 *scudi*. This was followed by the commission given to Cerruti for the large ceiling canvas that he painted in twenty-eight days and which was in place by April 25, 1722 (Mallory, 1976, p. 103).

St. Anastasia was said to have been burned alive, tied to a stake in the ground with arms outstretched, at Sirmium in Pannonia during the persecutions of Diocletian in A.D. 304. She was venerated in Rome at an early date, and her cult became associated with a church known as *titulus Anastasiae* that had been built in the fourth century and named after its founder, a Christian woman called Anastasia. This early foundation, enlarged and embellished over the years, soon came to be called the church of *Saint* Anastasia, the Pannonian martyr.

Until the very recent identification of this drawing, Cerruti was hardly known as a draughtsman. In the

49

Kupferstichkabinett, Berlin-Dahlem, there is an early pen drawing of hunters resting in an inn, signed and dated 1686 (KdZ 451, from the Pacetti collection; Gernsheim photograph 33879), and Cerruti's red chalk self-portrait executed for Nicola Pio is in the National-museum, Stockholm (Clark, 1967, p. 12, no. 10).

Vittorio Casale recently attributed to Cerruti frescoes in the vault of the sacristy of S. Maria in Via Lata, Rome, and he has identified a drawing in the Ambrosiana, Milan (F 253 inf. 983), as a study for the *Assumption of the Virgin* that occupies the center of the ceiling (Casale, 1984, pp. 744, 753–754, note 24).

PLACIDO COSTANZI

Rome 1701–Naples 1759

29. *Unidentified Subject*

Black chalk, heightened with white, on gray-washed paper. 26.5 x 27.7 cm. Octagonal. Lower margin irregular at center, where the bottom of the cartouche has been silhouetted. Scattered creases. Lined.

Inscribed in pen and brown ink at lower center of old mount, *Placido Costanzi*; numbered in pen and brown ink on reverse of old mount, *104*.

PROVENANCE: Joyce Treiman; [M. Pink]; purchased in New York in 1980.

BIBLIOGRAPHY: *Master Prints and Drawings. Marilyn Pink. Spring 1980*, Los Angeles, 1980, no. 2, repr.; *Annual Report*, 1980–1981, p. 27.

Purchase, David L. Klein, Jr. Memorial Foundation, Inc. and Mr. and Mrs. David T. Schiff Gifts, 1980
1980.282

The subject is elusive; the enthroned male figure at right wearing a full wig may be a magistrate offering rewards to a man holding a helmet, who advances from the left. The empty cartouche below was no doubt intended for an explanatory motto, and the scene may have been part of a narrative cycle.

30. *Young Cleric in a Cope Holding a Book*

Black chalk, heightened with white, on gray-washed paper. 36.9 x 25.9 cm. Horizontal creases at center.

Inscribed in pen and brown ink at lower left, *Costanzi*.

PROVENANCE: [Petit-Horry]; Louis-Antoine Prat (his mark, P in a circle, not in Lugt); sale, Paris, Nouveau Drouot, salle 2, December 5, 1984, no. 16, repr.; [Zangrilli and Brady]; purchased in New York in 1985.

BIBLIOGRAPHY: *Annual Report*, 1985–1986, p. 22.

Harry G. Sperling Fund, 1985
1985.215

31

Faith
Study by Otav. Dandini.—

31 v.

OTTAVIANO DANDINI

Florence ca. 1706–Florence 1740

31. *Scene of Abduction*
VERSO. *Allegorical Figure of Christian Faith, Drawn over Faint Landscape Indications*

Brush and pale brown wash (recto); the figure of Faith in red chalk, the landscape in black chalk (verso). 21.3 x 17.9 cm.

Inscribed in pen and dark brown ink on verso, *Faith / Study by Otav. Dandini.* —.

PROVENANCE: Harry G. Sperling.

BIBLIOGRAPHY: *Annual Report*, 1974–1975, p. 50.

Bequest of Harry G. Sperling, 1971
1975.131.23

The old attribution to Ottaviano Dandini seems plausible. Although the composition on the recto of the sheet is confused and the brushwork there rather tentative, the figure of Faith holding a chalice and a cross on the verso is very similar to a red chalk study of Joshua in the British Museum that bears the monogram *O.D.* and a later pen inscription, *Joshua. / Ottav. Dandini* (1930-4-14-34). The inscription on the drawing in London is in the same hand as that on our sheet. Similar English inscriptions appear on drawings by members of the Dandini family, and they may well have come from "A Collection of 152 Clever and Interesting Original Drawings in Red Chalk, Pen and Ink, Pencil, etc., by Vincenzo, Cesare, Pietro and Ottaviano Dandini" that was with E. Parsons and Sons in London in 1931 (their cat. no. 294, Pt. 1, no. 574).

GIOVANNI DAVID

Gabella (Liguria) 1743–Genoa 1790

32. *The Naval Battle of Meloria*

Pen and brown ink, brown wash, over graphite. 34.2 x 53.2 cm.

Inscribed in pen and brown ink at lower left, *N° 12. Collezione Santo Varni;* in graphite at lower left, *N 860.*

PROVENANCE: Santo Varni; [Colnaghi]; purchased in London in 1988.

BIBLIOGRAPHY: *Master Drawings Presented by Jean-Luc Baroni,* exhibition catalogue, P. and D. Colnaghi and Co., London, 1988, no. 41, repr.; David Scrase, "Exhibition Reviews. London," *Burlington Magazine,* CXXX, 1988, p. 546, fig. 64; *Annual Report,* 1988–1989, p. 23; Newcome Schleier, 1989, p. 218, under no. 113; Torgiano, 1989, p. 98.

Harry G. Sperling Fund, 1988
1988.254

Mary Newcome identified this drawing as Giovanni David's study, with many variations, for a lunette in the Sala del Maggior Consiglio, Palazzo Ducale, Genoa (*Pittura a Genova,* 1987, fig. 320; Sestieri, 1988, p. 251, repr. in color). The subject is the victory of the Genoese fleet over the Pisans in 1284 off the island of Meloria in the Ligurian Sea.

David's fresco replaced—but differs from—a representation of this historical subject by Marcantonio Franceschini, painted for the same room in 1702–1704 and destroyed by fire in 1777. Franceschini's treatment of the theme is known from surviving drawings and cartoons (Torriti, 1962, pp. 422–428).

There is a *bozzetto* for David's *Battle of Meloria* in the Galleria di Palazzo Reale, Genoa (Torgiano, 1989, p. 99, fig. a). The sketch is closer to the finished fresco than is our drawing.

GASPARE DIZIANI

Belluno 1689–Venice 1767

33. *The Good Samaritan*

Pen and brown ink, brown wash, heightened with white, on beige paper. 20.4 x 32.2 cm. Lined.

PROVENANCE: Pierre-Jean Mariette (Lugt 2097, without cartouche); Mariette sale, Paris, 1775–1776, part of no. 390, "Gaspar Diziani . . . le Bon Samaritain"; Paul Mathey (Lugt Supp. 2100b); [Calmann]; purchased in London in 1964.

BIBLIOGRAPHY: *Annual Report*, 1964–1965, p. 52.

Rogers Fund, 1964
64.49.2

Diziani treated this subject, with notable variations, in two drawings now in the Museo Correr, Venice (Pignatti, 1981, nos. 363 and 364, repr.).

34. *The Martyrdom of St. Andrew*

Pen and brown ink, gray and brown wash, over slight traces of black chalk. Verso: faint graphite sketch of the back of a woman with a ruff and a full-skirted dress. 50.1 x 32.4 cm.

PROVENANCE: Dr. Edward Peart (Lugt 891); [Rockman]; purchased in New York in 1962.

BIBLIOGRAPHY: *Annual Report*, 1962–1963, p. 64.

Rogers Fund, 1962
62.191

This characteristic example of Diziani's draughtsmanship appeared on the New York market in 1962 with an erroneous modern attribution to Nicola Grassi.

GASPARE DIZIANI

35. *St. John Nepomucen Venerating a Crucifix*

Pen and black ink, gray wash, over traces of black chalk. Framing lines in black wash. 22.7 x 16.8 cm. Lined.

Illegible inscription in pen and brown ink at lower right margin (partly cut away).

PROVENANCE: James Jackson Jarves; Cornelius Vanderbilt.

BIBLIOGRAPHY: *Metropolitan Museum Handbook*, 1895, p. 21, no. 293, "Carlo Cignani.—Cardinal with Crucifix."

Gift of Cornelius Vanderbilt, 1880
80.3.293

The prelate is identified as John Nepomucen by one of his attributes, the seven stars held by putti hovering over his head. Erroneously attributed to Carlo Cignani in the Vanderbilt collection, the drawing was recognized as the work of Gaspare Diziani by Claus Virch in 1959.

36. *The Family of Darius before Alexander* VERSO. *Sketch of a Horse-Drawn Cart, and Studies of Male Heads*

Pen and brown ink, gray wash, over traces of black chalk; squared in black chalk (recto); red chalk (verso). 31.9 x 40.1 cm.

Inscribed in pen and brown ink on verso, *A dresda Lano 1717*; in graphite, *Tent of Darius*.

PROVENANCE: [Colnaghi]; purchased in London in 1965.

BIBLIOGRAPHY: *Exhibition of Old Master Drawings. P. and D. Colnaghi and Co.*, London, 1965, no. 73; *Annual Report*, 1965–1966, p. 75; Pierre Rosenberg in Paris, 1971, p. 58, under no. 45.

Rogers Fund, 1965
65.131.1

The autograph inscription on the verso indicates that the drawing was executed at Dresden in 1717. The young artist worked there for the Saxon court from 1717 to 1720. Similar inscriptions on a drawing in the Museo Correr, Venice, and another in the Museo Civico, Udine, offer further testimony to Diziani's stay in Dresden (Pignatti, 1981, pp. 23–24). However, no paintings from this period seem to have survived (Zugni-Tauro, 1971, p. 30).

In his long career Diziani treated this subject, with many variations, in a number of drawings and paintings. No painting can be connected with this drawing of 1717, but the composition is reflected in a picture in a private collection in Paris, a more mature work datable about 1740–1747 (Zugni-Tauro, 1971, p. 82, pl. 60). All of Diziani's representations of the subject show the influence of Charles Le Brun's *Tente de Darius*, widely known through reproductive engravings.

37. *Hercules and Omphale*

Pen and brown ink, brown wash, over red chalk. Squared in black chalk. 29.6 x 19.7 cm. Large blue wash stain at upper right.

Inscribed in pen and brown ink on verso, *Gaspare Diziani V°.*, and with the text of a letter beginning, *Caro Sig. Padre.*

PROVENANCE: James Jackson Jarves; Cornelius Vanderbilt.

BIBLIOGRAPHY: *Metropolitan Museum Handbook*, 1895, p. 26, no. 384, "Carlo Veronese (?).—Bacchanals"; Thomas, 1961, no. 19, pl. XII; Pignatti, 1965-1, no. 32, repr.; Bean and Stampfle, 1971, no. 50, repr.; P. Rosenberg in Paris, 1971, p. 58, under no. 44; Zugni-Tauro, 1971, pp. 68, 76, pl. 352.

Gift of Cornelius Vanderbilt, 1880
80.3.384

36

36 v. (detail)

Diziani represented this subject in several paintings, all of them horizontal rather than vertical in format. The picture in the Musée d'Art et d'Histoire, Geneva, is close to our drawing, although the composition is reversed (Zugni-Tauro, 1971, pp. 75–76, pl. 245).

A drawing with a similar composition, like ours vertical in format, is in the Museo Correr, Venice, where the subject is described as the Judgment of Paris. This confusion is understandable, since in the Correr drawing neither the attributes of Hercules nor those of Omphale are clearly indicated; there, a muscular male figure seated on the left is shown pointing to a group of three standing female figures (Pignatti, 1981, no. 351, repr.).

37

58

38. *Design for a Ceiling: Venice Receiving Homage*

Pen and black ink, gray-green and blue-gray wash, over black chalk. 30.5 x 20.3 cm.

Inscribed in pen and dark brown ink at lower right, *Gasparo Diziani Bellunese.*

PROVENANCE: "Reliable Venetian Hand" (Lugt Supp. 3005c–d); John MacGowan (Lugt 1496); [Baderou]; purchased in Paris in 1962.

BIBLIOGRAPHY: *Annual Report*, 1962–1963, p. 64; Bettagno, 1966, no. 91, repr.; Bean and Stampfle, 1971, no. 54, repr.; Zugni-Tauro, 1971, pl. 353.

Rogers Fund, 1962
62.121.2

The composition has many points in common with a ceiling fresco, the *Glorification of the Widmann Family*, painted by Diziani in the Palazzo Widmann, Venice, about 1755–1760 (Zugni-Tauro, 1971, pp. 95–96, pls. 232 and 233). Banners and other military paraphernalia occur in both works, as do allegorical figures of Justice, Prudence, and Fame; putti support a tray of scrolls, and Time holds an empty shield flanked by an eagle, which may be emblematic of the Carinthian origins of the family. However, in the upper part of the fresco a winged figure crowns a representative of the Widmann family, while in the drawing a figure kneels before a personification of Venice.

A pen sketch by Diziani for the lower part of our composition, with a few variations, is in the Royal Museum of Fine Arts, Copenhagen. It bears an old inscription, *coregio*, and is classified as the work of Fontebasso (Tu ital mag. VI, 34).

Joseph McCrindle possesses an unpublished pen and wash drawing by Diziani that comes very close to the whole Palazzo Widmann ceiling, and a study for the upper part of the composition is in the Victoria and Albert Museum, London (Ward-Jackson, 1980, no. 1001, repr.).

GASPARE DIZIANI ?

39. *The Virgin Confiding the Christ Child to St. Francis of Assisi*

Red chalk, brown and gray wash, over traces of black chalk, on two sheets of paper joined horizontally above center. 29.8 x 19.2 cm. Lined.

Inscribed in pen and brown ink, *Gasp. Diziano Originale.*; in another hand, *died 1767.*

PROVENANCE: James Jackson Jarves; Cornelius Vanderbilt.

Gasparo Diziani Bellunese.

38

GASPARE DIZIANI ? (NO. 39)

BIBLIOGRAPHY: *Metropolitan Museum Handbook*, 1895, p. 28, no. 433, "Gasparo Diziani.—Design for Altar-Piece."

Gift of Cornelius Vanderbilt, 1880
80.3.433

The old attribution inscribed on the sheet is plausible, if not entirely convincing. Drawings executed in point of brush are very rare in Diziani's extensive drawn oeuvre, but our sheet may be compared with certain passages in a *Flight into Egypt* in the Museo Correr, Venice (Pignatti, 1981, no. 391, repr.).

LORENZO DE FERRARI

Genoa 1680–Genoa 1744

40. *Christ Driving the Money Changers from the Temple*

Black chalk and graphite. 50.5 x 31.8 cm. Horizontal crease above center.

PROVENANCE: Sale, Milan, Finarte, April 26, 1986, no. 149, repr. in reverse, as Carlo Maratta; [Colnaghi]; purchased in New York in 1987.

BIBLIOGRAPHY: *Old Master Drawings Presented by Jean-Luc Baroni. Colnaghi Drawings*, exhibition catalogue, Colnaghi, New York, 1987, no. 28, repr.; M. Newcome, *Master Drawings*, XXV, 2, 1987, p. 158, note 15; *Annual Report*, 1987–1988, p. 23.

Purchase, Karen B. Cohen Gift, 1987
1987.197.2

This composition, conceived on a grand scale, is a work of Lorenzo's maturity. Roman influence is everywhere apparent, and a number of figures derive directly from Raphael's frescoes in the *Stanze*.

41. *The Triumph of Justice*

Brush and brown wash, over black chalk. 24.2 x 20.1 cm.

Inscribed in pen and brown ink at lower margin, *ab.te Lorenzo Defferari*.

PROVENANCE: [Calmann]; purchased in London in 1964.

BIBLIOGRAPHY: *Annual Report*, 1964–1965, p. 52; Gavazza, 1965, pp. 94–95, fig. 47; Bean and Stampfle, 1971, no. 35; Byam Shaw, 1983, I, p. 422, note 1.

Rogers Fund, 1964
64.49.1

Ezia Gavazza identified the drawing as a study for a ceiling fresco in the Palazzo Grimaldi, Piazza San Luca, Genoa.

42. *Design for a Ceiling Decoration* VERSO. *Daphne Pursued by Apollo*

Pen and brown ink, over black chalk (recto); black chalk (verso). 21.8 x 31.5 cm. Small repaired losses.

Inscribed in graphite at upper left margin, *Lz.o De-Ferrari*.

PROVENANCE: Curtis O. Baer.

BIBLIOGRAPHY: *Annual Report*, 1970–1971, p. 15; Bean, 1972, no. 16; Newcome, 1978, p. 79, note 61; Newcome Schleier, 1989, p. 214, under no. 110.

Gift of Curtis O. Baer, 1971
1971.50

40

41

This rococo decoration was no doubt intended to be realized in stucco and in large part gilded. The same volutes, gadrooning, and cornucopia appear in designs preserved in Waddeston Manor and in the Uffizi; those drawings were identified on stylistic grounds as the work of Lorenzo de Ferrari by Mary Newcome (Newcome Schleier, 1989, figs. 146 and 147).

The *Apollo and Daphne* on the reverse of the sheet is treated as an ornamental oval medallion, which could have been executed as a painting or as a gilded stucco relief.

The Metropolitan Museum possesses a drawing of the *Abduction of Cephalus by Aurora* that has been plausibly attributed to Lorenzo de Ferrari. This appears on the reverse of a *Glorification of the Name of Jesus* by Lorenzo's father, Gregorio de Ferrari, and is catalogued and reproduced in *17th Century Italian Drawings in The Metropolitan Museum of Art*, 1979, p. 133, no. 168 verso.

42

42 v.

PIETRO MELCHIORRE FERRARI

Sissa (Parma) 1735–Parma 1787

43. *The Annunciation*

Pen and brown ink, brown and gray-green wash, over traces of black chalk. Lightly squared in black chalk. 33.4 x 25.4 cm. Lined.

Inscribed in pen and black ink on a label affixed to lower margin of old mount, *Pietro Melchiore / Ferrari*; in pen and brown ink on reverse of old mount, *Pietro Melchiore / Ferrari N° 20*; in graphite, *Dalla Collezione dei Conti / Giovanni e Giuseppe Simonetta*.

PROVENANCE: Giovanni and Giuseppe Simonetta (according to inscription on verso); sale, London, Sotheby's, November 25, 1971, no. 140, repr.; [Tan Bunzl]; Harold A. E. Day (his mark, HD in a rectangle; not in Lugt); sale, London, Sotheby's, December 7, 1987, no. 25, repr.; [Dance]; purchased in New York in 1989.

Harry G. Sperling Fund, 1989
1989.115

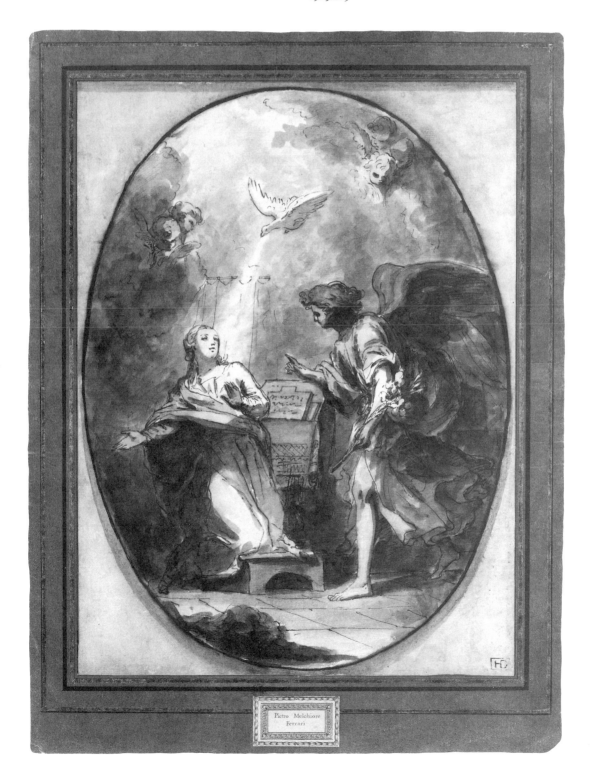

Very few drawings by Pietro Melchiorre Ferrari have survived. The present elegant design bears an old, probably contemporary attribution to the artist. Furthermore, it is a study for an *Annunciation* of similar oval format now in the church of the Annunziata at Vercelli, a painting datable about 1770 (Natale, 1984, fig. 844, pp. 847 and 852). The drawing and the finished painting correspond fairly closely, although in the latter the Virgin and Gabriel are more rigidly posed and have a slightly neoclassic air.

GIOVANNI DOMENICO FERRETTI

Florence 1692–Florence 1768

44. *Ceiling Decoration with Mars, Minerva, and a Dancing Satyr*

Black chalk, gray wash, heightened with white, on pale rose washed paper. Framing lines in pen and black ink. 25.0 x 35.9 cm.

Inscribed in pen and brown ink at lower right, *Pasinelli*.

PROVENANCE: [Colnaghi]; purchased in New York in 1989.

BIBLIOGRAPHY: *Master Drawings Presented by Jean-Luc Baroni*, exhibition catalogue, Colnaghi, New York, 1989, no. 35, repr. in color; *Annual Report*, 1988–1989, p. 24.

Harry G. Sperling Fund, 1989
1989.153

Jean-Luc Baroni recognized this drawing, which bears an erroneous ascription to Pasinelli, as a fine and typical example of Ferretti's graceful style. Mr. Baroni remarked that the dancing satyr on the left occurs in a ceiling fresco by Ferretti in the Villa Puccini, near Pistoia. Furthermore, the airy, spacious character of our drawing is paralleled in the frescoes at the Villa Puccini, which date from 1725 (Gregori, 1976, figs. 18–23).

FEDELE FISCHETTI

Naples 1732–Naples 1792

45. *Manius Curius Dentatus Refusing the Presents of the Samnite Ambassadors*

Black, gray, and white gouache, on paper prepared with gray-brown gouache. 25.1 x 19.0 cm.

Inscribed in graphite on verso, *Manio Curio Dentato*; in another hand, *Fischetti*; in pen and brown ink over graphite in another hand, *Disegno Originale di / D. Fedele Fischetti pittore / di Corte di Ferdinando / quarto / Nativo di martino del regno / di Napoli.*

PROVENANCE: James Jackson Jarves; Cornelius Vanderbilt.

BIBLIOGRAPHY: *Metropolitan Museum Handbook*, 1895, p. 23, no. 323, "Fedele Fischetti (?).—Historical Scene."

Gift of Cornelius Vanderbilt, 1880
80.3.323

The old attribution to Fischetti is entirely plausible, and the inscription on the verso correctly describes the subject. The incorruptible Manius Curius Dentatus refuses the rich offerings of the Samnites, who visit him as he prepares his frugal repast of boiled vegetables.

The physical types and the treatment of drapery are similar to those in Fischetti's frescoes representing scenes from the life of Alexander the Great, now in the Museo di Capodimonte, Naples (Bolaffi, V, p. 15, fig. 15).

46. *Design for a Ceiling: Jason and the Golden Fleece*

Pen and gray ink, gray wash, on pale beige paper. Framing lines in pen and black ink. 45.1 x 33.7 cm. overall; the drawing, excluding the border, measures 36.1 x 30.9 cm.

Inscribed in pen and gray ink at left margin with a scale of measurement that includes numbers from *1* to *24*.

PROVENANCE: [Konstantinoff, Paris]; S. Kaufman; [Jeudwine]; purchased in London in 1971.

BIBLIOGRAPHY: Kaufman and Knox, 1969, no. 30, repr., as Aegidius Schor?; *Annual Report*, 1970–1971, p. 16; Bean, 1972, no. 17.

Rogers Fund, 1971
1971.36

The apotheosis of Jason occupies the central field of the ceiling and is surrounded by four incidents from the legend of the Golden Fleece. Clockwise from the left the subjects are: Jason appearing before his uncle, the usurper Pelias; Medea giving Jason the magic potions; Jason slaying the dragon that guards the Golden Fleece; and the triumphal return of Jason.

45

When in the Kaufman collection, the drawing bore a tentative attribution to Aegidius Schor, but it is clearly the work of Fedele Fischetti. It may be usefully compared with a design in the Janos Scholz Collection at The Pierpont Morgan Library that is a study for a ceiling decoration by Fischetti in the Palazzo Reale, Caserta (Bean and Stampfle, 1971, no. 288, repr.).

FRANCESCO FONTEBASSO

Venice 1707–Venice 1769

47. *Two Standing Male Figures and Seated Woman with a Child*

Pen and brown ink, brown and gray wash, over black chalk. Vertical ruled stylus lines at left and right. 37.6 x 26.2 cm.

Numbered in pen and brown ink at upper right, *41*.

PROVENANCE: [Meatyard]; Henry Scipio Reitlinger (Lugt Supp. 2274a); [Kleinberger]; purchased in New York in 1961.

BIBLIOGRAPHY: Byam Shaw, 1954, p. 323, note 1; Bean, 1966, p. 57, under no. 98; Bean and Stampfle, 1971, no. 181, repr.; Pignatti, 1974–2, p. 43, under no. 86; Gibbons, 1977, I, p. 80, under no. 211, attributed to Francesco Fontebasso; Johnson and Goldyne, 1985, p. 36, under no. 10; George Knox in *Lehman Collection*. VI, 1987, p. 75, under no. 60, as Pietro Antonio Novelli.

Rogers Fund, 1961
61.56.2

This drawing comes from a now-dismembered album of figure studies, the pages of which bear vertical lines traced with a stylus, probably indicating that it was originally intended as a ledger. The album had been broken up by 1920, and pages from it, bearing numbers up to fifty-five, are widely dispersed. In addition to our drawing, ten further sheets are in public collections: four in the Art Museum at Princeton University (Gibbons, 1977, nos. 211–214, repr.); three in the British Museum (1920-9-29-1, 1920-9-29-2, 1920-9-29-3); one in the Robert Lehman Collection, The Metropolitan Museum of Art (George Knox in *Lehman Collection*. VI, 1987, no. 60, repr., as Pietro Antonio Novelli); one in the Gabinetto Disegni e Stampe degli Uffizi (Florence, 1985, no. 80, fig. 78); and one in the Achenbach Foundation for Graphic Arts, The Fine Arts Museums of San Francisco (Johnson and Goldyne, 1985, no. 10, repr. in color).

These sheets were convincingly attributed to Fontebasso by James Byam Shaw before 1954, the date of his

masterful study of Fontebasso's draughtsmanship, and Byam Shaw maintains this attribution today, despite halfhearted attempts by others to assign them to Pietro Antonio Novelli or the Bolognese artist Ercole Graziani.

ANTONIO FRANCHI

Villa Basilica, near Lucca, 1638–Florence 1709

48. *Putto and Angel Holding a Banderole*

Pink and white tempera, over red chalk, on brownish paper. 16.7 x 18.7 cm.

PROVENANCE: Kate Ganz.

BIBLIOGRAPHY: *Old Master Drawings. Kate Ganz Limited*, exhibition catalogue, London, 1984, no. 16, repr.; *Annual Report*, 1987–1988, p. 23.

48

49

ANTONIO FRANCHI (NO. 48)

Gift of Kate Ganz, in memory of Paul H. Ganz, 1987
1987.288

This drawing and No. 49 below were independently
associated by Marco Chiarini and Lawrence Turčić with
frescoed pendentives by Antonio Franchi in the second
chapel on the left in S. Frediano in Cestello, Florence.
Franchi's decorations in this chapel, which is dedicated
to St. John the Baptist, are signed and dated 1706 (Paatz,
II, 1941, pp. 152–153). The putto and angel in this
drawing appear in the pendentive on the right above
the altar.

49. *Angel Holding a Banderole*

Pink and white tempera, over red chalk, on brownish paper. Verso:
red chalk tracing of the angel on recto. 17.4 x 19.9 cm.

PROVENANCE: [Kate Ganz]; purchased in London in 1987.

BIBLIOGRAPHY: *Old Master Drawings. Kate Ganz Limited*, exhibi-
tion catalogue, London, 1984, no. 17, repr.; *Annual Report*,
1987–1988, p. 24.

Van Day Truex Fund, 1987
1987.307

Study for the angel in the pendentive to the left inside
the entrance arch of the chapel of St. John the Baptist,
S. Frediano in Cestello, Florence. See No. 48 above.

The Metropolitan Museum possesses a drawing by
Antonio Puglieschi for the decoration of another chapel
in S. Frediano in Cestello (No. 170 below).

SEBASTIANO GALEOTTI

Florence 1676–Vicoforte, near Mondovì, 1741

50. *Bacchus and Ceres Attended by Putti and a Marine Deity*

Pen and black ink, gray wash. 24.3 x 39.5 cm. Several repaired
tears; scattered stains. Lined.

PROVENANCE: [Baderou]; purchased in Paris in 1965.

BIBLIOGRAPHY: *Annual Report*, 1965–1966, p. 75; Bean, *Mas-
ter Drawings*, VII, 1, 1969, p. 56, pl. 34; Bean and Stampfle, 1971,
no. 24, repr.; Newcome, 1972, p. 51, under no. 136.

Rogers Fund, 1965
65.207.1

In a letter of April 12, 1987, Mary Newcome kindly
pointed out that Galeotti extracted the single figure of

Ceres from this composition for a painted chimneypiece in the Rocca di Sala Baganza, near Parma. There the goddess with her sheaf of wheat appears in exactly the same pose, but attended by only one putto (Bernini, 1981, repr. pp. 253 and 265).

51. *Hector's Farewell to Andromache and Astyanax*

Pen and brown ink, gray wash, heightened with white, on brown-washed paper. 34.1 x 20.3 cm. (overall). A strip of paper averaging .5 cm. in width has been added at left margin; a second strip averaging 1 cm. in height has been added at lower margin.

PROVENANCE: [Shickman]; Eric M. Wunsch.

BIBLIOGRAPHY: *Annual Report*, 1970–1971, p. 15; Bean, 1972, no. 22.

Gift of Eric M. Wunsch, 1970
1970.244.3

GAETANO GANDOLFI
San Matteo della Decima 1734–Bologna 1802

52. *Joshua*

Black chalk, stumped, gray wash, heightened with white, on beige paper. 42.3 x 31.6 cm. Scattered stains and losses; horizontal creases. Lined.

PROVENANCE: Sale, Edinburgh, Messrs. Dowell's, January 22, 1957, part of no. 121; [Colnaghi]; Donald P. Gurney; Jacob Bean.

BIBLIOGRAPHY: *Exhibition of Old Master Drawings. P. and D. Colnaghi and Co.*, London, 1957, under no. 19; Bean and Stampfle, 1971, no. 290, repr.; Johnston, 1976, p. 28, under no. 40; Stuttgart, 1978, p. 132, under no. 61; Macandrew, 1980, p. 163, under no. 1001A; Ottawa, 1982, p. 146, under no. 110; Providence, 1983, p. 79, under no. 23; *Annual Report*, 1988–1989, p. 23.

Gift of Jacob Bean, in memory of Donald P. Gurney, 1989
1989.108.2

Joshua is seen in steep perspective, with drawn sword in his hand. The sun that he commanded to stand still to ensure Israel's victory over the Amorites is reflected on his shield (Joshua 10:12). The drawing is a study for the figure of Joshua that appears in Gaetano Gandolfi's fresco in the cupola above the high altar of S. Maria della Vita, Bologna, painted in 1779. The fresco represents the Virgin in glory surrounded by heroic figures of the Old Dispensation.

Chalk studies for some of the other figures in this fresco have survived. Like the present drawing and No. 53 below, they formed part of an album sold in Edinburgh in 1957. A study for the Virgin in glory is in the Rhode Island School of Design (Providence, 1983, no. 23, repr.); drawings for Noah and for an angel with a palm branch are in The Pierpont Morgan Library (Bean and Stampfle, 1971, no. 289, repr.; Ottawa, 1982, no. 110, repr., respectively); a drawing of two angels is in the Ashmolean Museum, Oxford (Macandrew, 1980, no. 1001A; Gernsheim photograph 48271); and a study of King David is now in the collection of Joseph McCrindle (*Exhibition of Old Master Drawings. P. and D. Colnaghi and Co.*, London, 1966, no. 82) Two further studies were with Colnaghi in 1957, but their present whereabouts are unknown: one represents Judith and Queen Esther, the other the head of Joshua and a priest holding a thurible.

A pen and wash composition study including Joshua and the seated prophet in No. 53 is in the Schloss Fachsenfeld Collection (Stuttgart, 1978, no. 61, repr.). An oil sketch for the same section of the cupola was once in a German private collection (Roli, 1977, fig.

76a), while a *bozzetto* for the opposite half, with a representation of the Sacrifice of Manoah, is now in The Snite Museum of Art, Notre Dame, Indiana (*Selected Works*, 1987, p. 131, repr. in color).

53. *Seated Prophet*

Black chalk, stumped, gray wash, heightened with white, on beige paper. 42.2 x 31.2 cm. Scattered stains and losses; horizontal creases. Lined.

PROVENANCE: Sale, Edinburgh, Messrs. Dowell's, January 22, 1957, part of no. 121; [Colnaghi]; Donald P. Gurney; Jacob Bean.

BIBLIOGRAPHY: *Exhibition of Old Master Drawings. P. and D. Colnaghi and Co.*, London, 1957, under no. 19; Bean and Stampfle, 1971, under no. 290; Johnston, 1976, pp. 27–28, no. 40, repr.; Macandrew, 1980, p. 163, under no. 1001A; Ottawa, 1982, p. 146, under no. 110; Providence, 1983, p. 79, under no. 23; *Annual Report*, 1988–1989, pp. 22–23.

Gift of Jacob Bean, in memory of Donald P. Gurney, 1989
1989.108.1

This turbaned prophet seen from behind appears in a prominent position in Gaetano Gandolfi's fresco in the cupola above the high altar of S. Maria della Vita, Bologna. See No. 52 above.

54. *St. Margaret of Cortona, St. James of the March, and St. Didacus*

Pen and brown ink, brown wash, over black chalk. 29.5 x 18.7 cm. Lined.

PROVENANCE: James Jackson Jarves; Cornelius Vanderbilt.

BIBLIOGRAPHY: *Metropolitan Museum Handbook*, 1895, p. 32, no. 513, "Francisco Zurbaran.—Composition for Altar-Piece."

Gift of Cornelius Vanderbilt, 1880
80.3.513

The crippled figure in the foreground and his attendant invoke the intercession of the three Franciscan saints.

Although the drawing entered the collection with an attribution to Zurbarán, it has for some time been recognized as a typical work by Gaetano Gandolfi. In 1987 Lawrence Turčić identified the sheet as a study for a painting signed and dated 1775 by Gaetano, now in S. Giorgio, Porto San Giorgio, on the Adriatic, near Fermo (Dania, 1967, pp. 20–21, fig. 125).

Mimi Cazort has published a sheet in the Fondazione Giorgio Cini, Venice, with composition studies for the same painting (*Gandolfi*, 1987, p. 44, no. 18, repr.).

54

55. *A Dying Religious Supported by an Angel*

Pen and brown ink, gray wash, over traces of black chalk. 19.9 x 14.6 cm. Lower half of left margin made up.

Inscribed in pen and brown ink on verso, . *Gandolfi*.

PROVENANCE: James Jackson Jarves; Cornelius Vanderbilt.

BIBLIOGRAPHY: *Metropolitan Museum Handbook*, 1895, p. 24, no. 344, "Lo Spagnoletto.—Death of St. Jerome"; Cazort Taylor, 1976, p. 160; Pérez Sánchez, 1978, under no. 62.

Gift of Cornelius Vanderbilt, 1880
80.3.344

Mimi Cazort recognized this drawing, previously given to Ubaldo Gandolfi, as a study for a small painting—perhaps a *bozzetto*—by his brother Gaetano, which is

now in the Pinacoteca Vaticana (Roli, 1977, fig. 272a). The subject has yet to be satisfactorily identified. The author of the first catalogue of the Pinacoteca Vaticana (1934) prudently described the scene as "La morte di un religioso." However, other authors have titled the picture "The Death of St. Andrew Avellino." Andrew Avellino was a Theatine who died in his eighty-eighth year from a fit of apoplexy as he was beginning to celebrate Mass. In the painting and in the preparatory studies the swooning or dying figure, seated at a refectory table, is a relatively young man who is wearing what appears to be a Servite or Benedictine habit.

Further drawings related to this composition are in the Museo del Prado, Madrid (Inv. F.D. 1304; Pérez Sánchez, 1978, no. 62, repr.), in the Pinacoteca Nazionale, Bologna (Inv. 3714; Gaeta Bertelà, 1976, no. 115, repr.), and in a private collection (Gernsheim photograph 115735).

55

56. *The Holy Family*

Red chalk, heightened with white, on beige paper. 25.1 x 20.2 cm. Scattered stains, losses, and abrasions. Lined.

PROVENANCE: James Jackson Jarves; Cornelius Vanderbilt.

BIBLIOGRAPHY: *Metropolitan Museum Handbook*, 1895, p. 18, no. 235, "Unknown.—The Madonna and Child."

Gift of Cornelius Vanderbilt, 1880
80.3.235

The convincing attribution to Gaetano Gandolfi was proposed by Philip Pouncey in 1965.

57. *Alexander the Great Offering His Concubine Campaspe to the Painter Apelles*

Black chalk, stumped, heightened with white, on brownish paper. 30.6 x 42.9 cm. Scattered stains.

Inscribed in black chalk on verso, *G. G fi f. 1797.*

PROVENANCE: [Waddingham and Son, according to vendor]; [Colnaghi]; purchased in London in 1962.

BIBLIOGRAPHY: *Exhibition of Old Master Drawings. P. and D. Colnaghi and Co.*, London, 1962, no. 22; *Annual Report*, 1962–1963, p. 64; Bean and Stampfle, 1971, no. 291, repr.; Athens, 1979, no. 74, repr.; M. Cazort in *Settecento Emiliano*, 1979, p. 135, under no. 285; Olson, 1980, no. 1, repr.; Macandrew, 1983, p. 45, under no. 51.

Rogers Fund, 1962
62.132.3

Anna Ottani Cavina kindly pointed out in 1987 that in a private collection there is a painting of this subject by Gaetano, measuring 98 by 154 centimeters, that corresponds very closely to our drawing. Another painted version of the subject, quite differently composed, with Apelles seated to the right before his canvas and Campaspe and Alexander standing left of center, signed and dated 1793, is in a private collection in Bologna (Bianchi, 1936, p. 159, no. 96, pl. XLVIII).

58. *The Royal Family of Troy Mourning the Death of Hector*

Black chalk. 20.7 x 28.9 cm. Scattered stains; surface considerably abraded. Lined.

Inscribed in black chalk above female figure at left margin, presumably in the artist's hand, *cassandra.*

PROVENANCE: James Jackson Jarves; Cornelius Vanderbilt.

BIBLIOGRAPHY: *Metropolitan Museum Handbook*, 1895, p. 18, no. 236, "School of Domenichino.—Andromache, Priam and the Body of Hector."

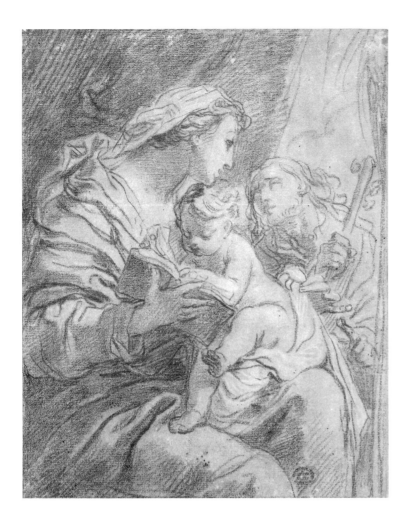

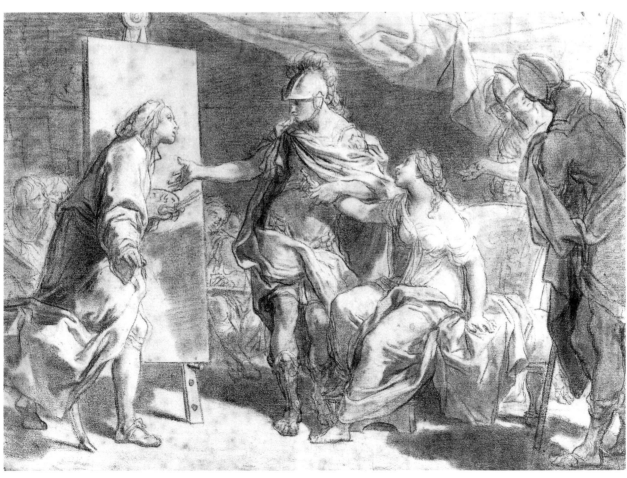

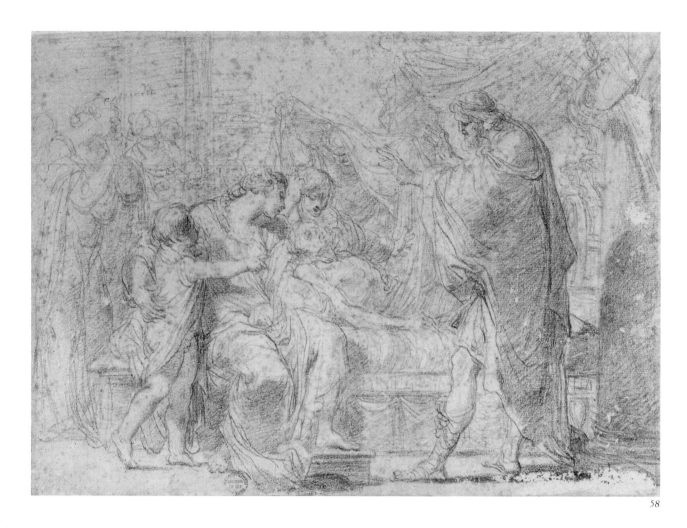

GAETANO GANDOLFI (NO. 58)

Gift of Cornelius Vanderbilt, 1880
80.3.236

The figure of Cassandra on the left is identified by an autograph inscription. Andromache is seated and Priam stands by the bier on which rests the cruelly mutilated body of Hector. A larger, more highly finished black chalk drawing of the same composition was on the London art market in 1962, described as the "Death of Germanicus" (*Exhibition of Old Master Drawings. P. and D. Colnaghi and Co.*, London, 1962, no. 19). This drawing, the subject correctly identified, is now in the collection of Margaret and Ian Ross, Toronto (David McTavish in Toronto, 1981, no. 147, repr.).

59. *Marcus Curtius Leaping into the Chasm*

Black chalk. 26.5 x 20.3 cm. Scattered stains and losses. Lined.

PROVENANCE: James Jackson Jarves; Cornelius Vanderbilt.

BIBLIOGRAPHY: *Metropolitan Museum Handbook*, 1895, p. 32, no. 503, "Velasquez.—Curtius Riding into the Chasm"; M. Cazort in *Settecento Emiliano*, 1979, p. 135, under no. 285.

Gift of Cornelius Vanderbilt, 1880
80.3.503

A much larger and more highly finished drawing by Gaetano of the same composition is in The Cleveland Museum of Art (Mr. and Mrs. Charles G. Prasse Collection, 70.288; repr. *Cleveland Museum Bulletin*, February 1971, p. 39, no. 77).

60. *The Dutch Microscopist Anton van Leeuwenhoek*

Pen and black and brown ink, brown and gray wash. Framing lines in black ink. 20.3 x 14.1 cm.

Inscribed in pen and brown ink in cartouche, *Antonius Leeuweneechius.*

PROVENANCE: [Colnaghi]; purchased in New York in 1987.

BIBLIOGRAPHY: *Old Master Drawings Presented by Jean-Luc Baroni. Colnaghi Drawings*, exhibition catalogue, Colnaghi, New York, 1987,

no. 35, repr. as Mauro Gandolfi; *Annual Report*, 1987–1988, p. 23, as Mauro Gandolfi.

Purchase, Mrs. Carl L. Selden Gift, in memory of Carl L. Selden, 1987
1987.177

This posthumous representation of Anton van Leeuwenhoek (1632–1723) is a free interpretation of Jan Verkolje's painted portrait of 1686, which enjoyed a wide circulation through reproductive prints. Verkolje's painting is now in Amsterdam (Rijksmuseum, 1976, p. 571, no. A597, repr.).

The decorative framing is of Gaetano's own invention. Winged female figures with fish tails flank the cartouche, while a mite and a flea, both subjects of Leeuwenhoek's pioneering investigations, hover to the left and right above the beribboned frame.

The drawing was exhibited by Jean-Luc Baroni in New York in 1987 with three other portrait busts in decorative frames. These represented the French botanist Joseph Pitton de Tournefort (1656–1708), the Neapolitan physicist Giambattista della Porta (1535–1615), and the Bolognese physician Giovan Battista Capponi (1620–1675). In Mr. Baroni's catalogue all four drawings were attributed to Mauro Gandolfi. However, in a letter of November 17, 1989, Mimi Cazort kindly informs us that these drawings are the work of Mauro's father, Gaetano, and are probably part of a series of portraits of *botanici famosi* mentioned in Gaetano's manuscript autobiography.

59

60

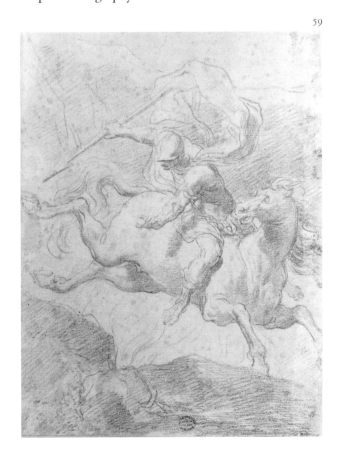

MAURO GANDOLFI

Bologna 1764–Bologna 1834

61. *Vignette with a Figure of Astronomy*

Pen and brown ink, blue, rose, yellow, and brown washes, over black chalk. Framing lines in pen and brown ink. 20.3 x 20.2 cm. Lined.

PROVENANCE: A. D. Pilkington (according to vendor); [Colnaghi]; purchased in London in 1961.

BIBLIOGRAPHY: *Annual Report*, 1961–1962, p. 67, as Gaetano Gandolfi.

Rogers Fund, 1961
61.130.2

The allegorical figure is identified by her sky-blue draperies and by the armillary sphere she consults. The owl,

77

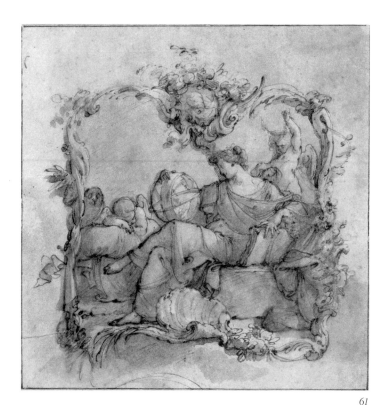

MAURO GANDOLFI (NO. 61)

the sleeping putto, and the putto holding aloft a lamp are also appropriate attributes.

The draughtsmanship appears to be that of Mauro Gandolfi at his most elegant; this representation of Astronomy may be compared with a similar figure painted by the artist on one of the three coaches decorated by him that are now preserved at the Musée national du château de Compiègne (Rosenberg and Sébastiani, 1977, pp. 240–241).

UBALDO GANDOLFI

San Matteo della Decima 1728–Ravenna 1781

62. *The Presentation of the Virgin Mary in the Temple*

Pen and brown ink, pale brown wash, over black chalk. 28.2 x 20.3 cm. Scattered stains and losses. Lined.

PROVENANCE: James Jackson Jarves; Cornelius Vanderbilt.

BIBLIOGRAPHY: *Metropolitan Museum Handbook*, 1895, p. 32, no. 501, "Velasquez.—Figures"; Cazort Taylor, 1976, pp. 161–162, p. 163, fig. 4 (the painting), pl. 36 (our drawing).

Gift of Cornelius Vanderbilt, 1880
80.3.501

In 1976 Mimi Cazort published this drawing as Ubaldo's study for a painting in the Collegiata (S. Giovanni Battista) at San Giovanni in Persiceto, not far from Bologna, and proposed the date 1778 for both the drawing and the painting.

63. *Christ in Glory with St. Lawrence, St. Anthony of Padua, St. Ignatius of Loyola, and St. Eligius*

Pen and brown ink, brown wash, over traces of graphite. 37.3 x 22.5 cm. Top cut to a shouldered arch. Horizontal crease at center; scattered losses. Lined.

Inscribed in pen and brown ink at lower right margin, *Zurbaran f.*

PROVENANCE: James Jackson Jarves; Cornelius Vanderbilt.

BIBLIOGRAPHY: *Metropolitan Museum Handbook*, 1895, p. 32, no. 512, "Francisco Zurbaran.—St. Adrian"; Cazort Taylor, 1976, p. 161, fig. 2 (the painting), pl. 34 (our drawing); Cazort in Ottawa, 1982, no. 105, repr.; Turčić, *Master Drawings*, XXIII–XXIV, 2, 1985–1986, p. 208.

Gift of Cornelius Vanderbilt, 1880
80.3.512

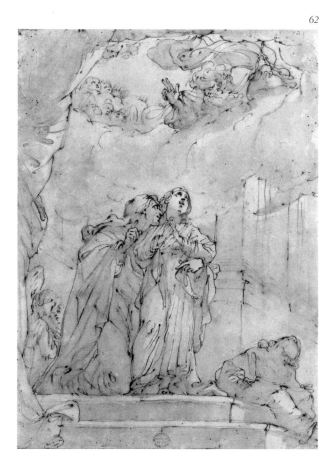

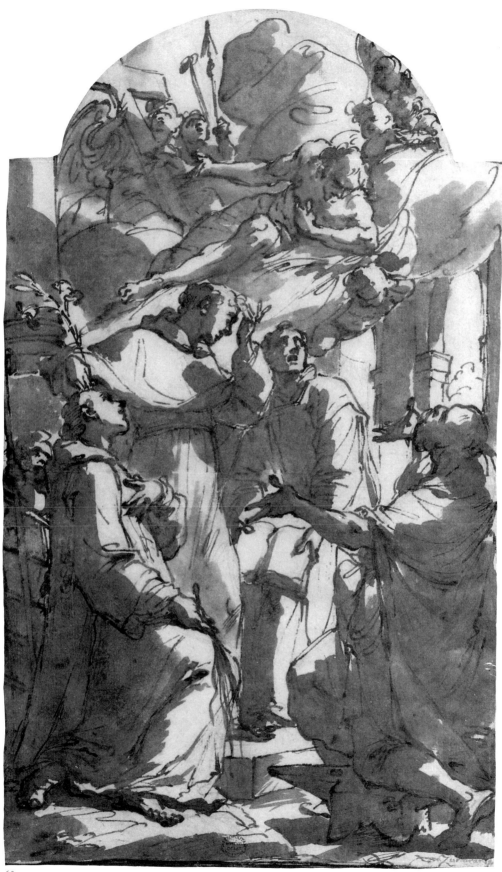

63

The drawing was recognized by Mimi Cazort as a study by Ubaldo that corresponds very closely to his painting of the same subject, dated 1766, in S. Mamante at Medicina, near Bologna. Lawrence Turčić later found in the Kunsthaus Heylshof at Worms, under an attribution to Giacomo Cavedone, another study by Ubaldo for the painting with considerable differences in the attitudes and distribution of the figures (*Master Drawings*, XXIII–XXIV, 2, 1985–1986, p. 208, pl. 15, with incorrect caption).

64. *Decapitation of St. James the Greater*

Pen and brown ink, brown wash, over slight traces of black chalk. 29.3 x 18.1 cm. Top cut to a shouldered arch. Scattered stains and losses. Lined.

PROVENANCE: James Jackson Jarves; Cornelius Vanderbilt.

BIBLIOGRAPHY: *Metropolitan Museum Handbook*, 1895, p. 31, no. 497, "Francisco Pacheco.—A Martyrdom"; Cazort Taylor, 1976, pp. 162–163, fig. 5 (the *bozzetto*), pl. 39 (our drawing).

Gift of Cornelius Vanderbilt, 1880
80.3.497

In 1976 Mimi Cazort identified this drawing, which had been attributed to Gaetano Gandolfi, as Ubaldo's study for a composition known to her only through an old photograph. To judge from a reproduction, that painting may be a *bozzetto* for an altarpiece representing the Martyrdom of St. James the Greater in S. Giacomo Maggiore at Villa Cadè, just outside Reggio nell'Emilia (Modena, 1986, p. 95, repr. in color, p. 324, no. 261, repr.).

65. *Half Figure of a Female Saint*

Pen and brown ink, gray-brown wash. 14.2 x 10.7 cm.

Inscribed in pen and brown ink on verso, [S]*ig Ubaldo Gandolfi*.

PROVENANCE: Mrs. John H. Wright.

Gift of Mrs. John H. Wright, 1949
49.150.6

66. Seated Male Nude

Red chalk, heightened with white. 41.3 x 27.6 cm. Horizontal crease at center; scattered stains.

Inscribed in red chalk at lower right, presumably in the artist's hand, *Ubaldo / Gand . . .* [the rest cut off]; in pen and brown ink, in another hand, ℞ / *Ubaldo Gando . . .* [the rest cut off] / *fece*; in pen and brown ink on verso, *Io Aless Maggiori comprai / a Bologna nel / 1788.*

PROVENANCE: Alessandro Maggiori (Lugt Supp. 3005b); James Jackson Jarves; Cornelius Vanderbilt.

BIBLIOGRAPHY: *Metropolitan Museum Handbook*, 1895, p. 24, no. 335, "Ubaldo Gandolfi.—Study of Nude Figure."

Gift of Cornelius Vanderbilt, 1880
80.3.335

The trimmed inscription at the lower right margin is in the same red chalk as the drawing itself and may be a signature. The pen inscription giving the drawing to Ubaldo Gandolfi is in Alessandro Maggiori's hand; he purchased the drawing in Bologna in 1788, seven years after the artist's death. In 1791 Maggiori purchased in Bologna another academy by Ubaldo, a red chalk drawing of a seated male nude; this was sold in New York by Sotheby's on January 13, 1989 (no. 279, repr.).

67

67 v.

UBALDO GANDOLFI

67. *Reclining Male Nude*
VERSO. *Seated Male Nude*

Red chalk, heightened with white (recto); red and black chalk, heightened with white (verso). 28.2 x 40.9 cm. A few repaired losses.

Inscribed in pen and brown ink at lower right, *Ubaldo Gandolfi fece*; in another hand, *1720–1781*; in pen and brown ink on verso, *Io Aless. Maggiori / comprai a Bolo: / gna nel 1793*; in red pencil, *332*; in graphite, *Gandolfo*.

PROVENANCE: Alessandro Maggiori (Lugt Supp. 3005b); James Jackson Jarves; Cornelius Vanderbilt.

BIBLIOGRAPHY: *Metropolitan Museum Handbook*, 1895, p. 23, no. 332, "Ubaldo Gandolfi.—Study of Nude Figure."

Gift of Cornelius Vanderbilt, 1880
80.3.332

The attribution to Ubaldo is in the hand of Alessandro Maggiori, who purchased the drawing in Bologna in 1793, five years after he acquired No. 66 above.

PIER LEONE GHEZZI

Rome 1674–Rome 1755

68. *Luigi Vanvitelli*

Pen and brown ink, over traces of black chalk. 32.0 x 21.8 cm. Lined.

Inscribed in pen and brown ink in the artist's hand at lower margin, *S.ᵗ Luigio Vanvitelli Architetto della Revd.ᵃ Fabbrica di S. Pietro il quale adornò li 3.Catini della / crociata di S. Pietro di stucchi doratura et altro nell'anno 1749.e fu terminato il tutto nell'apertura / della porta santa nel 1750 da Papa Bened.° XIIII.fatto da Mè Cav Ghezzi del 1749*; in another hand at lower margin on the old mount, *Sig.ʳᵉ Luigi Vanvitelli Architetto di S. M. Siciliana*; numbered in pen and brown ink in upper right corner of the old mount, *17*.

PROVENANCE: 7th Duke of Wellington, Stratfield Saye House, Reading; [Robert M. Light]; purchased in Boston in 1972.

BIBLIOGRAPHY: *Annual Report*, 1971–1972, p. 40; Bean, 1975, no. 21; *Rome in the 18th Century*, 1978, n.pag. [12].

Rogers Fund, 1972
1972.83

This and the following three caricatures (Nos. 69, 70, 71) came from three albums of portrait drawings by Pier Leone Ghezzi that appeared on the market in the early 1970s. Albums I.1 and I.2, which contained eighty-nine full-page caricatures, were dismembered at that time and the drawings scattered in collections here and abroad. Volume II, which presently contains forty-seven full-page portraits and sixty-four caricatured portrait busts mounted four to a page, is now in The Pierpont Morgan Library (*Nineteenth Report to the Fellows . . . 1978–1980*, 1981, p. 194). Six full-page caricatures and eighty portrait busts had been removed from the volume in the Morgan Library before 1972. The binding of Volume I.1, with a title page followed by a eulogy of Ghezzi, is preserved at the Metropolitan Museum. The title reads, DISEGNI ORIGINALI / RAPPRESENTANTI / ALCUNI RITRATTI IN CARICATURA / FATTI DAL CAVALIERE / PIER LEONE GHEZZI / PITTORE ROMANO / TOMO I. / ROMA MDCCLXXX. Volume II has the same title but is designated TOMO II. The bindings with their marbled boards are Italian, and they are lettered on the spine, DISEGNI / ORIGINALI / DI P.L.: GHEZZI. The date 1780 on the title pages indicates that these albums were assembled twenty-five years after the artist's death.

Ghezzi was enormously prolific as a caricaturist. Many such drawings were given or sold by him during his lifetime, but when he died, his widow inherited a number of large albums of portraits. Natoire, director of the French Academy in Rome, wrote to the marquis de

Marigny in 1755 that Ghezzi's widow was unwilling to break up the albums and was asking two sequins for each caricature. The volume with the least number of pages contained ninety-five caricatures, for which Signora Ghezzi's price was thus 190 sequins, and Marigny turned it down as too expensive (Montaiglon, XI, 1901, pp. 91 and 95).

The albums from which our caricatures were removed were made up in 1780, some eighteen years after the death of Ghezzi's widow, perhaps by an antiquarian bookseller. The drawings in the volume bear dates that range from 1749 to 1754, the year before Ghezzi's death. There is no apparent order in the sequence of portraits; they represent secular and religious clergy, Roman aristocrats and their servants, musicians, painters, sculptors, foreign visitors to Rome, and members of the papal court.

It has been suggested that these albums belonged to Charles VII, King of Naples, who took them to Spain when he succeeded to the throne of that country in 1759 as Charles III (see Byam Shaw, 1983, I, pp. 186–187). But the albums—assembled in Rome in 1780—bear no traces of such royal ownership.

Ghezzi's long inscription at the lower margin of this sympathetic caricature refers to the architect Luigi Vanvitelli's designs for the gilded stucco decoration of the half-domes of the two transepts and of the tribune of St. Peter's. These decorations were commissioned in 1749 by Benedict XIV in preparation for the Holy Year of 1750.

It is interesting that the caricature that immediately preceded the present drawing in the album from which they were both removed represents the sculptor Giovanni Battista Maini, who modeled the nine stucco medallions representing scenes from the lives of the Apostles Peter and Paul—after Raphael, Guido Reni, and Alessandro Algardi—that ornament the three half-domes decorated by Vanvitelli. This caricature of Maini is now in the Minneapolis Institute of Arts (Clark, 1974, pp. 64–67, fig. 2).

Somewhat earlier caricatures by Ghezzi of Maini (dated 1742) and Vanvitelli (dated 1744) are in the Biblioteca Apostolica Vaticana (Ottob. lat. 3118, fols. 139 and 144; repr. Pinto, 1986, p. 184, and Vanvitelli, 1975, p. 56, respectively).

Sig.^{re} *Luigi Vanvitelli Architetto di S. M. Siciliana* &.&.

Monsieur de Vandier Direttore delle Fabbriche del Re di. Francia ⓶ L'Abb.ᵉ Bianco ⓷ Monsʳ Sufflò ⓸ Monsʳ Coscian

PIER LEONE GHEZZI

69. *The Marquis de Vandières, Abbé Jean-Bernard Le Blanc, Germain Soufflot, and Charles-Nicolas Cochin, the Younger*

Pen and brown ink, over traces of black chalk. 30.4 x 21.0 cm. Lined.

The figures are numbered from *1* to *4*, following the order of the title at the lower margin. Another set of numbers, arranged differently, has been partially effaced. The mount is inscribed in pen and brown ink at the lower margin, *(1) Monsieur de Vandier Direttore delle Fabbriche del Re di / Francia (2) L'Abb.° Bianco (3) Mons.° Sufflò (4) Mons.° Coscian;* numbered in pen and brown ink in upper right corner of the old mount, *20*.

PROVENANCE: 7th Duke of Wellington, Stratfield Saye House, Reading; [Robert M. Light]; purchased in Boston in 1972.

BIBLIOGRAPHY: *Annual Report*, 1971–1972, p. 40; Bean, 1975, no. 20; *Rome in the 18th Century*, 1978, n.pag. [11]; *Soufflot et son temps*, 1980, no. 76 (a photograph of the drawing exhibited); *Soufflot à Lyon*, 1982, pp. 172 and 228, fig. 88.

Rogers Fund, 1972
1972.84

This caricature records the presence in Rome in 1750 of Abel-François Poisson (1727–1781), younger brother of

the marquise de Pompadour. Poisson was then marquis de Vandières; the title marquis de Marigny was granted later. At this time, Poisson possessed the *survivance* of Lenormant de Tournehem, *directeur général des Bâtiments Royaux*, who dispatched the young man on a thorough tour of all the principal artistic centers of Italy. His learned guides were the critic Le Blanc, the architect Soufflot, and the artist Cochin. Individual caricatured portrait busts of all four of these visitors, three of them dated April 25, 1750, are preserved in the Istituto Nazionale per la Grafica, Rome (repr. *Soufflot et son temps*, 1980, p. 46).

An old and fairly exact copy of our drawing is in the Cabinet des Dessins of the Musée du Louvre (Inv. 3277).

70. *Abbé Jean-Antoine Nollet*

Pen and brown ink, over traces of black chalk. 30.2 x 21.6 cm. Lined.

Inscribed in pen and brown ink at lower margin on the old mount, *Sig.° Abbate Nollet celebre Fisico esperimentale;* numbered in pen and brown ink in upper right corner of the old mount, *34*.

PROVENANCE: 7th Duke of Wellington, Stratfield Saye House, Reading; [Robert M. Light]; purchased in Boston in 1972.

70

Sig.° Abbate Nollet celebre Fisico esperimentale

71

Cavaliere Inglese dilettante delle Antichità

BIBLIOGRAPHY: *Annual Report*, 1971–1972, p. 40; Bean, 1975, no. 22; *Rome in the 18th Century*, 1978, n.pag. [11].

Purchase, David L. Klein, Jr. Memorial Foundation, Inc. Gift, 1972
1972.82

The abbé Nollet (1700–1770) was a French experimental physicist of European reputation. Ghezzi would have drawn this caricature in Rome in 1749 in the course of Nollet's second visit to Italy.

71. *Joseph Henry*

Pen and brown ink, over traces of black chalk. 31.2 x 21.3 cm. Lined.

Inscribed in pen and brown ink in the artist's hand at the lower margin, *S.ᵗ Gioseppe Henrij Inglese huomo assai erudito nelle Antichità e in Letteratura huomo assai...*; in another hand at lower margin on the old mount, *Cavaliere Inglese dilettante delle Antichità*; numbered in pen and brown ink in upper right corner of the old mount, *52*.

PROVENANCE: 7th Duke of Wellington, Stratfield Saye House, Reading; [Robert M. Light]; purchased in Boston in 1973.

BIBLIOGRAPHY: *Annual Report*, 1972–1973, p. 34; Bean, 1975, no. 23; *Rome in the 18th Century*, 1978, n.pag. [12]; Philadelphia, 1980, pp. 24–25, under no. 13; *English Caricature 1620 to the Present*, exhibition catalogue by Richard Godfrey and others, Yale Center for British Art, New Haven, Library of Congress, Washington, D.C., National Gallery of Canada, Ottawa, Victoria and Albert Museum, London, 1984, no. 8, pl. 5 (the drawing exhibited only in New Haven); Clark and Bowron, 1985, p. 250, under no. 147.

Rogers Fund, 1973
1973.67

Anthony M. Clark identified the figure as Joseph Henry, of Straffan, County Kildare, the son of a Dublin banker. He traveled to Rome around 1750 with his uncle Joseph Leeson, 1st Earl of Milltown, and his cousin Joseph, Jr., later the second earl. A caricature by Ghezzi in the Anthony Morris Clark Bequest at the Philadelphia Museum of Art shows Henry taking tea with three other English gentlemen on the Grand Tour (Philadelphia, 1980, no. 13, repr.). Two portrait busts of Henry, both dated 1750, are in the Istituto Nazionale per la Grafica, Rome (F.N. 4738 and F.N. 4739).

Pompeo Batoni painted a half-length portrait of Henry that is now in the Walters Art Gallery, Baltimore (Clark and Bowron, 1985, no. 147, pl. 137).

72. *Angels Supporting a Frame*

Pen and brown ink, gray wash, over traces of black chalk. 12.6 x 16.5 cm. Lined.

Inscribed in pen and brown ink in the artist's hand at the lower margin, *Pensiero delli Angioli che sostengono / La Madonna di Reggio nella nostra Cap / pella nella Chiesa di Marchegiani fatta / . . . Ghezzi*; in another hand at lower right corner, *Julio Romano*.

PROVENANCE: Cephas G. Thompson.

BIBLIOGRAPHY: *Metropolitan Museum Handbook*, 1895, p. 42, no. 729, "Giulio Romano.—Designs for an Altar."

Gift of Cephas G. Thompson, 1887
87.12.59

Once attributed to Giulio Romano, this drawing was recognized in 1959 as the work of Pier Leone Ghezzi by Anthony Blunt, who pointed out that the *Chiesa di Marchegiani* mentioned in the autograph inscription is S. Salvatore in Lauro, from 1669 the "national" church of citizens from Ascoli Piceno in Rome. The Ghezzi family came from that Marchigian city, and they owned a chapel—the second on the left—in S. Salvatore in Lauro. Pier Leone painted an altarpiece, signed and dated 1731, that is still in place in the Ghezzi chapel (Lo Bianco, 1985, no. 61, repr.). The painting represents Joseph, Anne, and Joachim looking upward in veneration. Their gaze was presumably directed toward a votive image of the Virgin held by angels in the lunette above the altarpiece. The framing of this image is the subject of our drawing. Whether this lunette decora-

tion was executed is uncertain; today the lunette contains a simple rectangular panel with the sacred monogram, IHS.

FELICE GIANI

San Sebastiano Curone (Alessandria) 1758–Rome 1823

73. *An Artist and His Model*

Pen and brown ink, brown wash, heightened with white, on gray-brown washed paper. 44.4 x 30.6 cm. Lined.

PROVENANCE: James Jackson Jarves; Cornelius Vanderbilt.

BIBLIOGRAPHY: *Metropolitan Museum Handbook*, 1895, p. 10, no. 109, "Unknown.—Interior of a Studio."

Gift of Cornelius Vanderbilt, 1880
80.3.109

The model may be Campaspe and the artist Apelles, although the figure of Alexander is absent. This tale was the subject of several drawings by Giani; in one of these, now in the Civiche Raccolte d'Arte, Castello Sforzesco, Milan, the artist's canvas or panel rests against a statue of a standing male figure with an Egyptian headdress, as it does here (Gernsheim photograph 100623).

The broad, rather coarse pen work, the heavy drapery, and the treatment of hands and heads in profile are paralleled in a drawing of Charity by Giani in the Minneapolis Institute of Arts (Neilson, 1972, no. 80, repr.).

CORRADO GIAQUINTO

Molfetta 1703–Naples 1766

74. *St. Joseph Presented by the Virgin to the Holy Trinity*

Red chalk, pen and brown ink, brown wash, heightened with white. 26.2 x 40.2 cm.

Inscribed in pen and brown ink at lower right, *Corrado Giaquinto*; on verso, in pen and brown ink, *fatto per Il Re di Sardegna di palmi / 43-28-.*

PROVENANCE: [Colnaghi]; purchased in London in 1965.

BIBLIOGRAPHY: *Exhibition of Old Master Drawings. P. and D. Colnaghi and Co.*, London, 1965, no. 77; *Annual Report*, 1965–1966, p. 75; Monbeig-Goguel and Vitzthum, 1967, p. 51, under no. 90; Bean and Stampfle, 1971, no. 163, repr.; Vitzthum, 1971, p. 91, fig. 30; M. Causa Picone in Naples, 1979, no. 231, repr., our drawing not exhibited; Causa Picone, 1981, p. 74, under no. 31a; *Golden*

74

Age of Naples, 1981, II, p. 246, fig. 85, our drawing not exhibited; R. Causa in *Dessins napolitains*, 1983, p. 196, under no. 67.

Rogers Fund, 1965
65.131.7

In 1965 Anthony M. Clark identified this drawing as a study for Giaquinto's fresco, probably executed in 1735, in the vault of a chapel dedicated to St. Joseph in S. Teresa, Turin (Orsi, 1958, fig. 33). The chapel, designed by Filippo Juvarra, was commissioned by Carlo Emanuele III, the *Re di Sardegna* mentioned in the inscription on the verso. Giaquinto also supplied lateral canvases for the chapel, a *Rest on the Flight into Egypt* and the *Death of St. Joseph* (Orsi, 1958, figs. 34 and 35).

Thirteen further drawings by Giaquinto that may be associated with the vault fresco of St. Joseph in glory are preserved in the Museo Nazionale di San Martino, Naples (Videtta, 1962, pp. 16–19). Some of these come closer than our drawing to the fresco as executed, where both Christ and God the Father are seated on a cloud bank and the Virgin appears to the left, standing behind St. Joseph.

ANTONIO GIONIMA

Venice 1697–Bologna 1732

75. *Belshazzar's Feast*

(Daniel 5:1–29)

Pen and brown ink, brown wash, heightened with white, over black chalk, on brownish paper. 28.5 x 38.0 cm. Scattered losses and stains. Lined.

Inscribed in pen and brown ink at upper right in the artist's hand, MANE THETEL / PHARES.

PROVENANCE: James Jackson Jarves; Cornelius Vanderbilt.

BIBLIOGRAPHY: *Metropolitan Museum Handbook*, 1895, p. 27, no. 425, "Il Tintoretto.—The Writing on the Wall"; Johnston, 1971, p. 91, fig. 21; M. Cazort in Ottawa, 1982, no. 95, repr.

Gift of Cornelius Vanderbilt, 1880
80.3.425

The hand writing on the wall has made a slight error in spelling. According to the Clementine edition of the Vulgate in use in Gionima's time, the mysterious words should be MANE THECEL (not THETEL) PHARES.

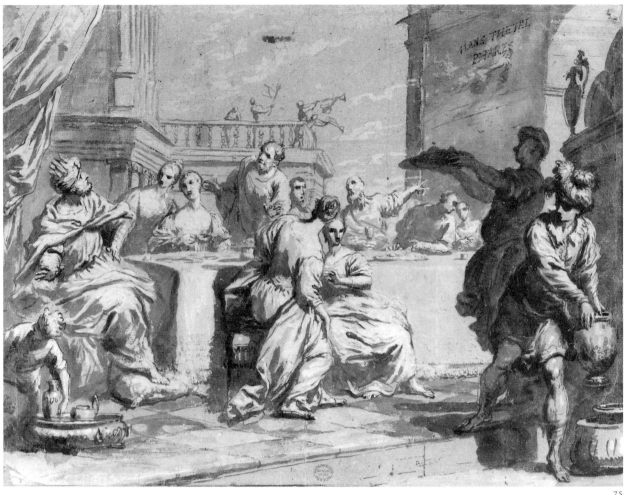

ANTONIO GIONIMA (NO. 75)

The attribution to Gionima was made by Philip Pouncey in 1958. The two servants in the right foreground appear in reverse and to the left in a similarly elaborate drawn composition in the Pinacoteca di Brera, Milan, which represents not the Feast of Belshazzar but the Banquet of Anthony and Cleopatra (Inv. no. 225; Roli and Sestieri, 1981, no. 85, repr.).

76. *The Annunciation*

Pen and brown ink, brown wash, over black chalk. 26.0 x 19.7 cm. Vertical crease near left margin; scattered stains and losses. Lined.

PROVENANCE: James Jackson Jarves; Cornelius Vanderbilt.

BIBLIOGRAPHY: *Metropolitan Museum Handbook*, 1895, p. 14, no. 156, "Federico Baroccio.—The Annunciation."

Gift of Cornelius Vanderbilt, 1880
80.3.156

In 1982 Lawrence Turčić recognized the drawing as the work of Gionima, and his attribution has met with agreement. The drawing is comparable in style with many published examples of the artist's work, to which might be added an unpublished red chalk study of the Holy Family in Joseph's workshop that has on the reverse a letter signed and dated by Gionima in 1731 (Museum of Art, Rhode Island School of Design, Providence, 58.157).

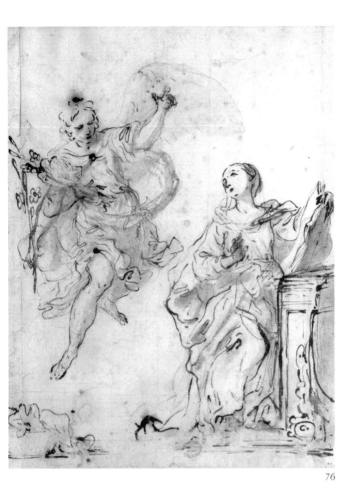

76

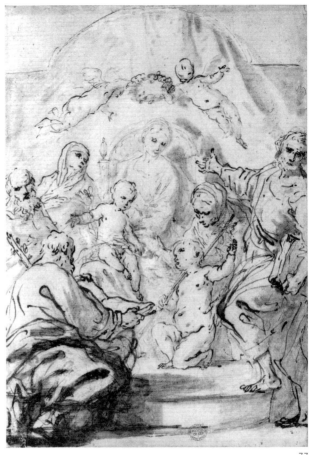

77

77. *Virgin and Child Enthroned with Attendant Saints*

Pen and brown ink, brown wash, over black chalk. 26.2 x 18.7 cm. Scattered losses. Lined.

Inscribed in pen and brown ink on reverse of old mount, *B?. Murillo.*

PROVENANCE: James Jackson Jarves; Cornelius Vanderbilt.

BIBLIOGRAPHY: *Metropolitan Museum Handbook*, 1895, p. 31, no. 495, "Unknown.—The Madonna, Child, and St. John."

Gift of Cornelius Vanderbilt, 1880
80.3.495

In this *sacra conversazione* the Virgin and Child are attended by St. Joseph, St. Joachim, St. Anne, and the infant Baptist with his mother, St. Elizabeth, while a standing male figure holding a book points to the Virgin from the right foreground.

The very plausible attribution to Gionima was proposed by Lawrence Turčić in 1982.

NICOLA GRASSI

Formeaso 1682–Venice 1748

78. *The Virgin and Child Appearing to St. Agatha and St. Lucy*

Red chalk. Framing lines in pen and brown ink. 15.3 x 11.3 cm. Lined.

PROVENANCE: James Jackson Jarves; Cornelius Vanderbilt.

BIBLIOGRAPHY: *Metropolitan Museum Handbook*, 1895, p. 17, no. 219, "Il Moretto.—The Madonna and Child Enthroned, with St. Agatha and Lucia."

Gift of Cornelius Vanderbilt, 1880
80.3.219

The convincing attribution to Nicola Grassi was suggested by James Byam Shaw in 1969. The position of the Virgin and the poses as well as the facial types of the saints below are closely paralleled in a signed altar-

78

piece by Grassi, the *Virgin Appearing to St. Oswald of Northumbria, St. Anthony of Padua, and St. Florian*, in the parish church at Sutrio, near Tolmezzo (Rizzi, 1982, no. 19, repr.). The draughtsmanship is close to that of certain sheets attributed to Nicola Grassi in the "Reliable Venetian Hand," for example a red chalk study of a young woman holding a lamb in the British Museum (1943-11-13-7; Bettagno, 1966, no. 66, repr.).

79. *Studies of Nude Men*

Red chalk. 14.5 x 19.1 cm. Lower left corner made up. Lined.

Inscribed in pen and brown ink at lower right, *Niccola Grassi*.

PROVENANCE: James Jackson Jarves; Cornelius Vanderbilt.

BIBLIOGRAPHY: *Metropolitan Museum Handbook*, 1895, p. 27, no. 410, "Niccola Graffi (?).—Victims of the Plague"; Pignatti, 1965-1, p. 158, pl. 24; T. Pignatti in Udine, 1984, p. 75, fig. 72; Pignatti and Romanelli, 1985, p. 69, under no. 27.

Gift of Cornelius Vanderbilt, 1880
80.3.410

The old ascription to Grassi, in a calligraphy similar to but not quite the same as that of the "Reliable Venetian Hand," is accepted by Terisio Pignatti, who has discussed and reproduced the drawing on several occasions.

ERCOLE GRAZIANI, the younger

Bologna 1688–Bologna 1765

80. *Adoration of the Magi*

Black chalk, stumped, heightened with white, on beige paper. 22.7 x 32.2 cm. Scattered stains and losses. Lower corners made up. Lined.

Partially effaced inscription in graphite at lower right, *T . . . tto*; inscribed in pen and brown ink on verso, *#19 £4- / Donato Creti* (now hidden by old mount).

PROVENANCE: James Jackson Jarves; Cornelius Vanderbilt.

BIBLIOGRAPHY: *Metropolitan Museum Handbook*, 1895, p. 27, no. 424, "Unknown.—Adoration of the Magi"; Mimi Cazort in Ottawa, 1982, p. 137, under no. 99.

Gift of Cornelius Vanderbilt, 1880
80.3.424

In a letter of June 30, 1980, Mimi Cazort proposed the attribution of this drawing to Ercole Graziani, the younger. She suggested comparison with two similar chalk drawings traditionally attributed to the artist in the Schloss Fachsenfeld Collection at Stuttgart, *The Adoration of the Shepherds* and *Christ Falling under the Cross* (Thiem, 1982, nos. 63 and 64, repr.).

The old inscription on the reverse, *Donato Creti*, is not irrelevant, since Graziani owed much to the example of this artist, who was his master.

81

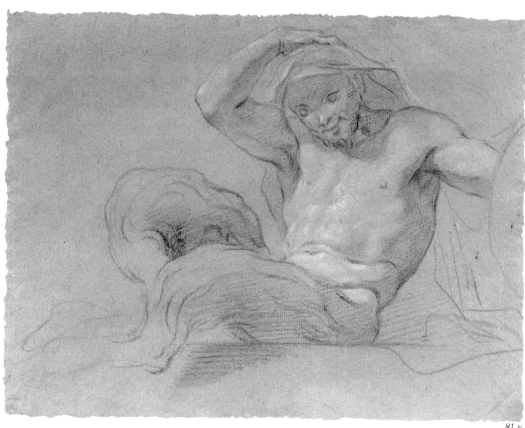

81 v.

JACOPO GUARANA

Verona 1720–Venice 1808

81. *Satyr Reclining on a Ledge, Facing Right* VERSO. *Satyr Reclining on a Ledge, Facing Left*

Black chalk, heightened with white, on blue paper. 26.2 x 34.5 cm.

Inscribed in graphite at lower right corner of recto, *Guarana*.

PROVENANCE: Sale, London, Christie's, April 10, 1985, part of no. 75, recto repr.; [Morton Morris]; purchased in London in 1985.

BIBLIOGRAPHY: *Annual Report*, 1985–1986, p. 22.

Harry G. Sperling Fund, 1985
1985.158.1

The old attribution to Jacopo Guarana of this drawing and No. 82 below seems quite plausible, for the figure types of both the satyrs and the putti resemble those in Guarana's frescoes in the Villa Pisani at Strà (see *Affreschi nelle ville venete*, 1978, II, figs. 824–829 and 903). The draughtsmanship is here freer and more competent than in a red chalk study of a satyress in the Hermitage (Grigorieva and Kantor-Gukovskja, no. 67, repr.). The Leningrad drawing bears an old attribution to *Guaranna Padre* and has been associated with Jacopo Guarana's decorations at Strà.

82. *Two Putti Supporting the Lower Part of a Draped Figure* VERSO. *Two Putti*

Black chalk, heightened with white, on blue paper. 27.1 x 34.8 cm.

Inscribed in graphite at lower right corner of recto, *Guarana*.

PROVENANCE: Sale, London, Christie's, April 10, 1985, part of no. 75, recto repr.; [Morton Morris]; purchased in London in 1985.

BIBLIOGRAPHY: *Annual Report*, 1985–1986, p. 22.

Harry G. Sperling Fund, 1985
1985.158.2

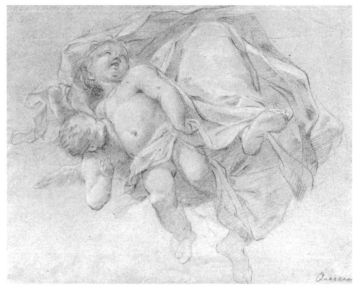

82

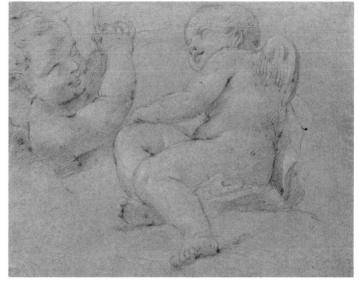

82 v.

ANTONIO GUARDI

Vienna 1699–Venice 1760

83. *The Good Samaritan*

Pen and brown ink, brown wash, over black chalk. Squared in black chalk. Framing lines in pen and brown ink. 34.2 x 25.1 cm.

Inscribed in pen and brown ink at lower right, *Guardi*; in pen and brown ink on verso, *Ant?. Guardi*.

PROVENANCE: Sale, London, Christie's, March 25, 1969, no. 27, repr.; [Colnaghi]; purchased in London in 1969.

BIBLIOGRAPHY: *Exhibition of Old Master and English Drawings. P. and D. Colnaghi and Co. Ltd.*, London, 1969, no. 23; Bean and Stampfle, 1971, no. 165, repr.; Byam Shaw, 1971–1, p. 255, note 43; Morassi, 1975, no. 8, fig. 10.

Rogers Fund, 1969
69.171.2

A good example of Antonio Guardi's idiosyncratic draughtsmanship: light moves over the surface, animating the composition without defining the forms.

FRANCESCO GUARDI

Venice 1712–Venice 1793

84. *The Virgin and Child Holding Scapulars*

Red chalk, heightened with white, on gray paper. 14.3 x 11.8 cm. Lined.

Faint inscription in pen and brown ink at lower right, *Ricci*.

PROVENANCE: James Jackson Jarves; Cornelius Vanderbilt.

BIBLIOGRAPHY: *Metropolitan Museum Handbook*, 1895, p. 31, no. 491, "School of Murillo.—The Madonna and Child"; Muraro, 1958, p. 7, fig. 20; Bean and Stampfle, 1971, no. 187, repr.; Morassi, 1975, no. 134, fig. 140.

Gift of Cornelius Vanderbilt, 1880
80.3.491

The drawing may be a design for a small devotional picture in which the Virgin with the Christ Child, each holding a small scapular, appear in glory surrounded by angels and putti. The mountainous landscape lightly indicated below is dominated by a tower, which is often a symbol of chastity.

The identification of this sketch as an early work by Francesco Guardi is due to Michelangelo Muraro.

84

85. *The Grand Canal above the Rialto*
VERSO. *A Priest Celebrating Mass and St. Vincent Ferrer Preaching*

Pen and brown ink, brown wash, over graphite (recto); red chalk, pen and brown ink, brown wash (verso). 40.6 x 72.3 cm. Three vertical creases at center. Repaired tears and losses.

Inscribed in pen and brown ink at lower right, *Canal. . . .*

PROVENANCE: [J. P. Richter]; purchased in London in 1912.

BIBLIOGRAPHY: Burroughs, 1912, p. 100, the recto as Canaletto, the verso as G. B. Tiepolo; Breck, 1913, pp. 16–17, the recto as Canaletto, the verso as G. B. Tiepolo; Goering, 1944, pp. 33, 79, fig. 45 (recto); Byam Shaw, 1951, pp. 33–34, 59, pls. 9 (verso), 10 (recto); Martini, 1964, p. 290, note 281, fig. 275 (detail of verso with St. Vincent Ferrer); Denis Mahon in *Problemi guardeschi*, 1967, p. 129, note 203; Bean and Stampfle, 1971, no. 190, recto and verso repr.; Byam Shaw, 1971–1, p. 247; Morassi, 1973, I, p. 347, under no. 210, p. 415, under no. 563; Rossi Bortolatto, 1974, p. 114, under no. 420; Morassi, 1975, no. 154, fig. 156 (verso), no. 377, fig. 378 (recto); Binion, 1976, p. 242, no. 6, fig. 122 (verso).

Rogers Fund, 1912
12.56.14

The *veduta* on the recto is a painstakingly accurate view of the Grand Canal from the Fabbriche Nuove on the

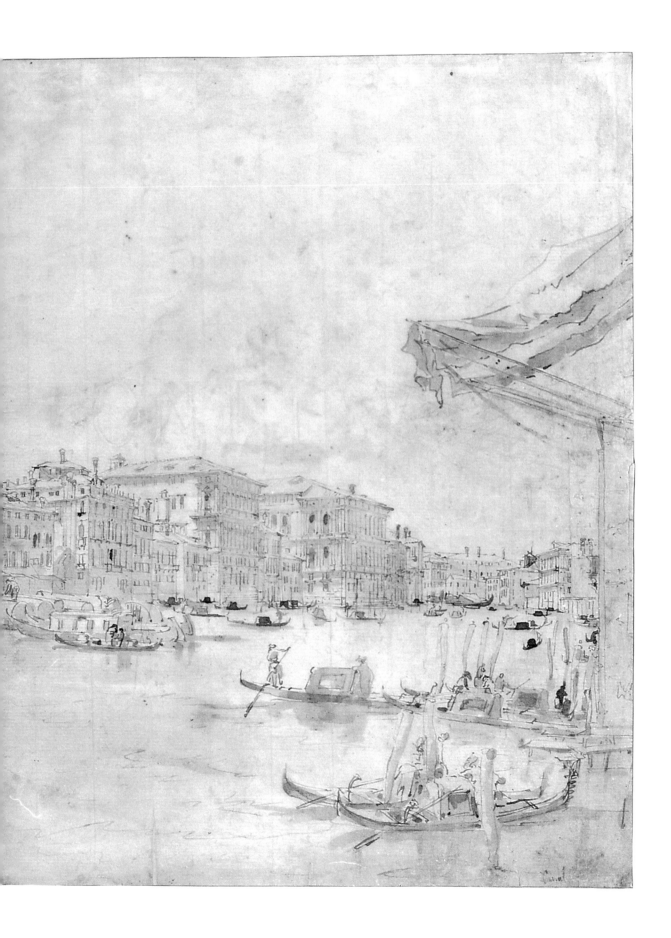

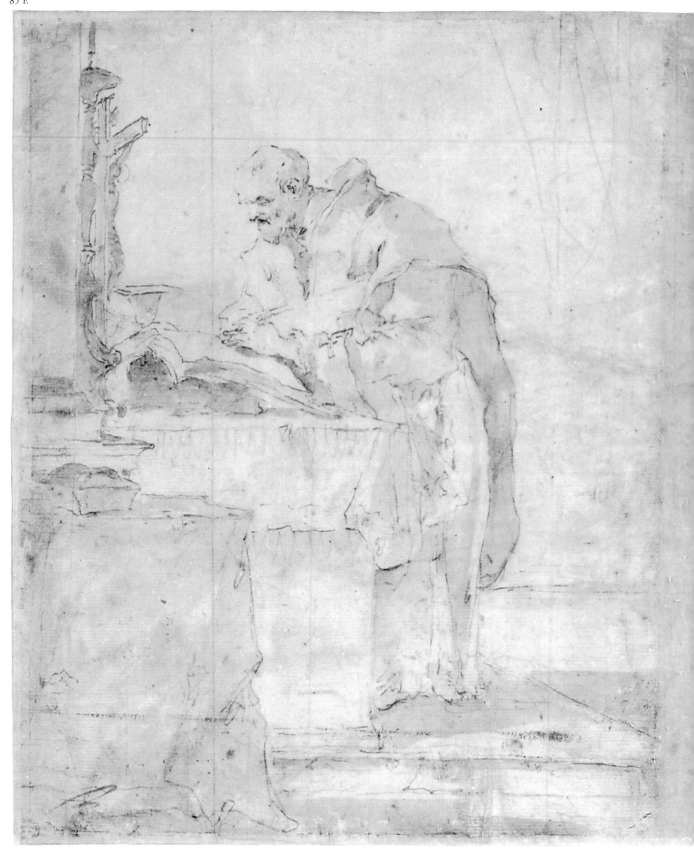

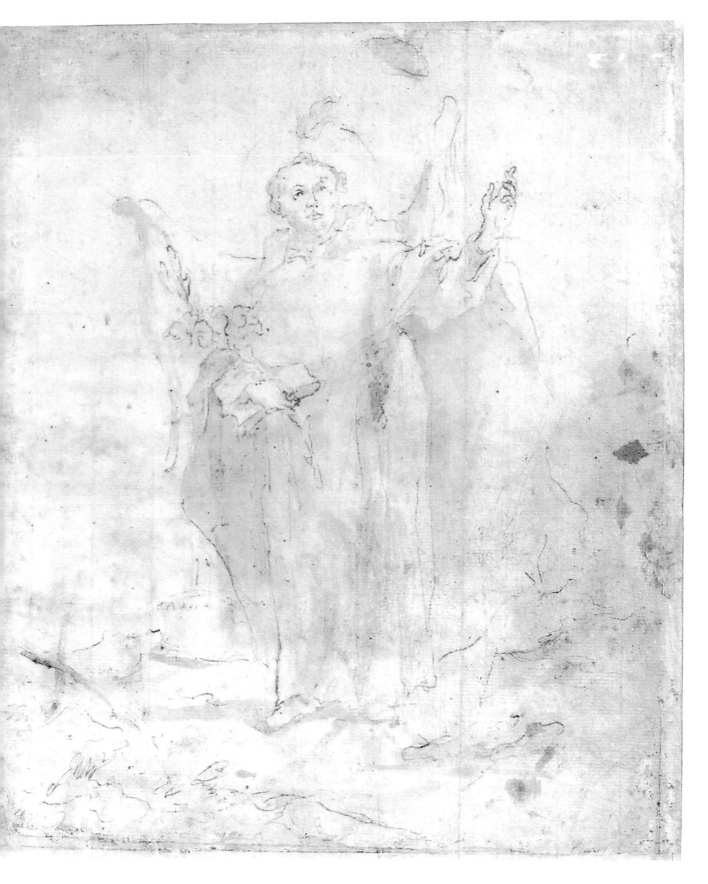

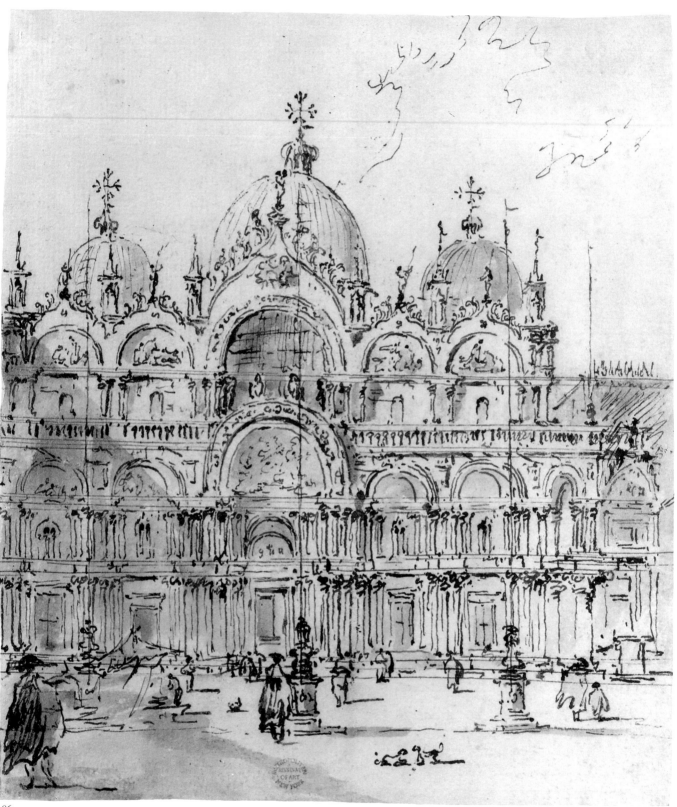

86

extreme left to the Palazzo Pesaro in the distance and including the campanile of S. Cassiano left of center. It is generally dated to the 1760s, when Francesco Guardi, previously a figure painter working under the direction of his elder brother Gianantonio, began to make a specialty of Venetian views. Here and in other large drawings of the same period, Francesco emulates Canaletto, whose early *vedute* were the point of departure for Guardi's career as a painter of the Venetian scene. The drawing, minus the awning in the right foreground, served as the model for a painting in a private collection (Morassi, 1973, I, no. 563, II, fig. 537).

The two figures on the verso were presumably executed at the same time as the *veduta* on the obverse of the sheet. Denis Mahon was the first to recognize the saint at the right as the Dominican Vincent Ferrer with his usual attributes—a branch of lilies, angel wings, a flame and a trumpet above his head. This figure was repeated in a small painting that has been attributed to Francesco Guardi (Martini, 1964, pl. 271; sale, London, Christie's, July 2, 1965, no. 118, repr.).

86. *The Façade of S. Marco, Venice*

Pen and brown ink, brown wash. Framing lines in pen and brown ink at left and right margins. 24.5 x 21.6 cm.

PROVENANCE: [J. P. Richter]; purchased in London in 1912.

BIBLIOGRAPHY: Burroughs, 1912, p. 100; Simonson, 1913, p. 267, fig. 23; Hellman, 1916, p. 182, repr., p. 183; Goering, 1944, p. 81, pl. 71; Benesch, 1947, no. 58, repr.; Bean and Stampfle, 1971, no. 192, repr. (with additional bibliography); Morassi, 1975, no. 327, fig. 327.

Rogers Fund, 1912
12.56.15

87. *The Arcade of the Libreria, Looking Toward S. Giorgio Maggiore*

Pen and brown ink, brown wash. 14.7 x 11.1 cm.

PROVENANCE: [J. P. Richter]; purchased in London in 1912.

BIBLIOGRAPHY: Burroughs, 1912, p. 100; Simonson, 1913, p. 268, fig. 24; Springfield, 1937, no. 42, repr.; Morassi, 1975, no. 538, fig. 529.

Rogers Fund, 1912
12.56.16

88. *The Piazzetta, Looking Toward S. Giorgio Maggiore*

Pen and brown ink, brown wash. Framing lines in pen and brown ink. Pen sketch of two columns on verso. 15.2 x 26.1 cm.

PROVENANCE: [Obach]; marquis de Biron; purchased in Geneva in 1937.

BIBLIOGRAPHY: *Vasari Society*, first series, V, 1909–1910, no. 13, repr.; Williams, 1939, p. 268, fig. 3, p. 271; Goering, 1944, pp. 48, 82, fig. 90; Pignatti, 1965-1, no. 133, repr.; Venice, 1965, p. 316, no. 40, repr.; Pignatti, 1967, pl. LXV; Byam Shaw, 1971-1, pp. 251–252; Morassi, 1973, I, p. 380, under no. 371; Rossi Bortolatto, 1974, p. 101, under no. 197; Morassi, 1975, no. 337, fig. 336.

Rogers Fund, 1937
37.165.78

Francesco Guardi made a number of paintings of this celebrated prospect, none of them corresponding exactly to our spirited drawing.

89. *The Staircase of the Giants, Ducal Palace, Venice*

Pen and brown ink, brown wash, over red chalk. 26.4 x 18.5 cm.

PROVENANCE: Marquis de Biron; purchased in Geneva in 1937.

BIBLIOGRAPHY: Benesch, 1947, no. 59, repr.; Bean, 1964, no. 48, repr.; Bean and Stampfle, 1971, no. 194, repr.; Byam Shaw, 1971-1, p. 252; Morassi, 1975, no. 554, fig. 549.

Rogers Fund, 1937
37.165.85

The principal architectural features of the staircase and the arcaded courtyard have been fairly accurately recorded by the draughtsman, but Jacopo Sansovino's giant nude statues of Mars and Neptune at the top of the stairs have been transformed into twisting, draped figures.

90. *The Fire at S. Marcuola*
VERSO. *Roman Ruins*

Pen and brown ink, brown wash, over black chalk. Framing lines in pen and brown ink (recto); pen and brown ink, brown wash, over black chalk. Framing lines in pen and brown ink (verso). 30.8 x 44.7 cm. Vertical crease at center.

PROVENANCE: Miss Lucy Cohen, London; marquis de Biron; purchased in Geneva in 1937.

BIBLIOGRAPHY: Simonson, 1904, pp. 59, 99, no. 286; New York, 1938, no. 68, repr. (recto); Williams, 1939, pp. 272, 275, fig. 9 (recto); *Metropolitan Museum, Italian Drawings*, 1942, pl. 47

87

88

90

90 v.

(recto); Goering, 1944, pp. 59, 64, 84, fig. 128 (verso); Tietze, 1947, no. 96, repr. (recto); Byam Shaw, 1951, p. 68, no. 40, repr. (recto); Moschini, 1952, p. 26, fig. 163 (recto); Pignatti, 1964, p. 65, under no. 91; Venice, 1965, p. 324, no. 69, repr. (recto); Pignatti, 1967, no. LIII, repr. (recto); Maurizio Bonicatti in *Problemi guardeschi*, 1967, pp. 34–35, note 62, fig. 146 (verso); Kultzen, 1968, pp. 10, 11, 14, repr. (recto); Bean and Stampfle, 1971, no. 210, repr. (recto); Byam Shaw, 1971–1, pp. 247, 249, fig. 13 (recto), p. 252, note 35, p. 255; Morassi, 1973, I, p. 369, under no. 312, p. 444, under no. 719; Rossi Bortolatto, 1974, p. 135, under no. 768, fig. 768 a; Morassi, 1975, no. 314, fig. 314 (recto), no. 481, fig. 479 (verso), p. 188, under no. 638; Byam Shaw, 1976, p. 859, note 1; Pignatti, 1983, pp. 169–170, under no. 655.

Rogers Fund, 1937
37.165.74

This is one of Francesco's most brilliant records of a contemporary Venetian event, very probably drawn on the spot by the aging artist in the quarter of S. Marcuola, where a fire broke out in late November 1789. Another version of this subject with important variations is in the Museo Correr, Venice. The figures in the Correr sheet are in Francesco's hand, while the buildings in the background, drawn in a rather dry and awkward fashion, seem to have been added by the artist's son Giacomo. On the Correr drawing are inscriptions by Giacomo, *Incendio di S. Marcuola L'anno 1789 28 Nbre* and *Guardi F.* (Kultzen, 1968, repr. p. 15; Morassi, 1975, no. 313, fig. 313).

The recto of our drawing served as the model for two paintings by Francesco: one in the Gallerie dell'Accademia, Venice (Kultzen, 1968, repr. p. 16; Morassi, 1973, I, no. 312, II, fig. 337), and the other now in the

Alte Pinakothek, Munich (Kultzen, 1968, repr. in color p. 13; Morassi, 1973, I, no. 313, II, fig. 338).

The Roman ruins on the verso of this sheet were utilized by Francesco for the left half of a painted architectural capriccio now in the collection of the Duke of Alba, another version of which was formerly on the art market in Berlin (Morassi, 1973, I, nos. 719 and 720, II, figs. 677 and 678, respectively). A detail of the Roman arch in our drawing appears on the verso of a pen sketch for a lagoon capriccio by Francesco in the Princes Gate Collection, Courtauld Institute of Art, London (Princes Gate, 1959, text vol., p. 103, no. 141, fig. 39).

91. *The Island of Anconetta*

Pen and brown ink, brown and gray wash, over red chalk. At upper margin of verso appear two feet wearing pointed shoes, pricked for transfer and executed in brown, blue, and yellow wash. 11.6 x 28.8 cm.

Inscribed in pen and brown ink on verso, *Le figura un pocco più grande di questa*.

PROVENANCE: Marquis de Biron; purchased in Geneva in 1937.

BIBLIOGRAPHY: Williams, 1939, p. 268, fig. 4, p. 272; Goodison and Robertson, 1967, p. 72, under no. 184; Byam Shaw, 1971–1, p. 251, fig. 15, pp. 252, 255; Morassi, 1973, I, p. 433, under nos. 659, 660; Rossi Bortolatto, 1974, p. 135, under no. 771; Byam Shaw, 1976, p. 859; James Byam Shaw in *Lehman Collection*. VI, 1987, p. 63, under no. 48.

Rogers Fund, 1937
37.165.84

Francesco Guardi utilized this view in three paintings of the lagoon island of Anconetta, also known as the

Madonnetta. Additional figures and gondolas were added to the paintings: one in the Fogg Art Museum, Cambridge, Mass.; the second in the Gallerie dell'Accademia, Venice (Morassi, 1973, I, nos. 659 and 660, II, figs. 618 and 619, respectively); and the third in the Fitzwilliam Museum, Cambridge (Goodison and Robertson, 1967, p. 72, no. 184, pl. 32).

The feet with pointed shoes and the inscription on the verso are ascribed to Giacomo by Byam Shaw. Thus, Francesco executed his drawing on a portion of a larger sheet already used by his son.

92. *The Fenice Theater in Venice*
VERSO. *Fragment of a Larger Drawing Representing Part of a Column and a Cornice*

Pen and brown ink, brown and gray wash (recto); pen and brown ink, gray wash (verso). 20.1 x 25.7 cm.

PROVENANCE: Marquis de Biron; purchased in Geneva in 1937.

BIBLIOGRAPHY: Goering, 1944, pp. 66, 86, fig. 151 (recto); Benesch, 1947, p. 41, no. 68, repr. (recto); Byam Shaw, 1951, p. 72, under no. 50; Venice, 1965, p. 324, no. 71, repr. (recto); Pignatti, 1967, pl. LXIII (recto); Bean and Stampfle, 1971, no. 211, repr. (recto); Byam Shaw, 1971–1, p. 252; Morassi, 1975, no. 405, fig. 407 (recto); Pignatti, 1983, p. 177, under no. 662; Pignatti and Romanelli, 1985, p. 124, under no. 100; James Byam Shaw in *Lehman Collection*. VI, 1987, pp. 42, 43, note 7, under no. 30.

Rogers Fund, 1937
37.165.73

This view of the Teatro La Fenice is one of Guardi's last drawings. The Fenice, the work of the architect Giovanni Antonio Silva, was begun in 1790 and opened in April 1792, less than a year before Francesco's death. The drawing is well preserved, although James Byam Shaw has suggested that the accents of gray wash, used to strengthen the shadows in the foreground and on the theater and adjacent buildings, may have been added by Giacomo Guardi. In any case the son is entirely responsible for the drawing of architecture on the reverse of the sheet.

A freer view of the Fenice seen from a different angle is in the Museo Correr, Venice (Pallucchini, 1943, fig. 87; Morassi, 1975, no. 404, fig. 406; Pignatti, 1983, no. 662, repr.). A further drawing by Francesco of the theater seen from yet another angle was sold in New York in 1980 (Sotheby Parke Bernet, January 9, 1980,

no. 74, repr.; Morassi, 1975, no. 406, fig. 409). It is interesting to note that on the reverse of this third drawing of the Fenice by Francesco there is an architectural design in the hand of Giacomo Guardi.

93. *The Villa Loredan, near Treviso*

Pen and brown ink, brown wash, touches of white gouache, over black chalk. 39.5 x 76.9 cm. Vertical crease at center.

PROVENANCE: Marquis de Biron; purchased in Geneva in 1937.

BIBLIOGRAPHY: New York, 1938, no. 66, repr.; Williams, 1938, p. 66; Morassi, 1950, p. 54; Byam Shaw, 1951, no. 30, repr.; Parker, 1956, p. 511, under nos. 1015, 1016; Parker, 1958, p. 74, under no. 114; Parker and Byam Shaw, 1962, p. 77, under no. 108; Bean, 1964, no. 46, repr.; Bean and Stampfle, 1971, no. 207, repr.; Byam Shaw, 1971–1, pp. 247, 250, fig. 14, p. 251; Morassi, 1973, I, p. 437, under no. 681; Everett Fahy in *Wrightsman Collection*. V, 1973, p. 112, fig. 7, p. 113; Rossi Bortolatto, 1974, p. 124, under no. 578; Morassi, 1975, no. 422, fig. 424; Pignatti, 1983, p. 159, under no. 644; Laura Giles in Providence, 1983, pp. 73–74, under no. 21.

Rogers Fund, 1937
37.165.69

This large and exceptionally luminous view of a villa in the Veneto was used by Francesco Guardi in a painting of approximately the same dimensions, now in a private collection (Morassi, 1973, I, no. 681, II, figs. 636–638). Figures have been added in the painting; they stand in front of the villa and on the road in the foreground.

A fairly exact copy after this painting, drawn by Francesco himself or by his son Giacomo, is in the Ashmolean Museum, Oxford. This copy bears an inscription that identifies the now-destroyed villa: *View of the Seat of S.E. Loredano at Paese near Treviso at present in the possession of John Strange Esq.'. N.B. grass ground within the Fence, without the post road from Treviso to Bassan* (Parker, 1958, no. 1015, pl. CCXIX; Morassi, 1975, no. 423, fig. 425). John Strange, a patron of the artist, was British Resident in Venice from 1773 to 1790.

Francesco made several drawings at the Villa Loredan. A smaller sketch of the entrance gate and façade is in the Rhode Island School of Design, Providence (Morassi, 1975, no. 421, fig. 421; Laura Giles in Providence, 1983, no. 21, repr.). A view from the front windows of the villa is in the Fodor Museum, Amsterdam (Morassi, 1975, no. 425, fig. 427), and a view from the back windows is in the Ashmolean Museum (Parker, 1958, no. 1016; Morassi, 1975, no. 424, fig. 426).

The painted view of the villa corresponding to our drawing is one of a series of four pictures formerly in

92

92 v.

III

94

FRANCESCO GUARDI (NO. 93)

Lord Rothermere's collection. The others represent the garden façade of the Villa Loredan (Everett Fahy in *Wrightsman Collection.* V, 1973, pp. 106–112, no. 12, repr. in color; Morassi, 1973, I, no. 682, II, figs. 640 and 642), the façade and garden of the neighboring "Villa dal Timpano Arcuato," and the gardens of the Palazzo Contarini dal Zaffo in Venice (Morassi, 1973, I, nos. 683 and 680, II, figs. 639 and 635, respectively).

Byam Shaw has suggested that our drawing probably dates from 1778, when the painter undertook a journey from Venice to a family property in the Val di Sole.

94. *Gardens of the Villa Correr, near Strà* VERSO. *The Transverberation of St. Teresa of Jesus and a Study of Hands*

Pen and brown ink, brown wash, over black chalk (recto); black chalk (verso). 23.0 x 39.4 cm. Vertical crease at center.

Inscribed in pen and brown ink at lower right, *Guardi f.* Inscribed on verso in graphite, *Villa di Correr a Fiesso vicino a Strà.*

PROVENANCE: Marquis de Biron; purchased in Geneva in 1937.

BIBLIOGRAPHY: Benesch, 1947, no. 61, repr. (recto); Pallucchini, 1948, p. 158; Muraro, 1958, pp. 8, 10, fig. 15 (verso); Bean and Stampfle, 1971, no. 206, repr. (recto); Byam Shaw, 1971–1, pp. 252, 255; Valcanover, 1971, pp. 318, 319, fig. 3 (verso); Rossi Bortolatto, 1974, p. 136, under no. 783; Morassi, 1975, nos. 158 (verso), 431 (recto), figs. 161 (verso), 437 (recto); Binion, 1976, p. 262, no. 33, p. 427, fig. 150 (verso); Pignatti, 1983, p. 159, under no. 644.

Rogers Fund, 1937
37.165.77

James Byam Shaw said of this drawing that, if rather scratchy in the pen work and not of the highest quality, it must certainly be by Francesco, though the inscription, *Guardi f.*, below the margin line is in Giacomo's hand. Another drawing of these gardens, with hedges clipped into architectural forms, taken from a different point of view, is in the Museo Correr, Venice (Morassi, 1975, no. 432, fig. 438; Pignatti, 1983, no. 644, repr.).

The delicate chalk sketch of St. Teresa on the left half of the verso is unrelated in style—and perhaps even in date—to the landscape on the recto.

95. *Bullbaiting in a Venetian Piazza*

Pen and brown ink. 13.6 x 33.4 cm.

Signed in pen and brown ink at lower left, *f.º Guardi.*

PROVENANCE: [R. Langton Douglas]; purchased in London in 1911.

BIBLIOGRAPHY: Simonson, 1913, p. 268, fig. 25; Hellman, 1916, p. 183; Springfield, 1937, no. 40, repr.; Goering, 1944, pp. 58, 60, 84, fig. 124; Byam Shaw, 1951, p. 69, under no. 43; Princes Gate, 1959, text vol., p. 101, under no. 139; Bean and Stampfle, 1971, no. 209, repr.; Byam Shaw, 1971–1, p. 247; Rossi Bortolatto, 1974, p. 131, under no. 689; Morassi, 1975, no. 269, fig. 271; Byam Shaw, 1976, p. 858.

Rogers Fund, 1911
11.66.12

The drawing may record the bullbaiting that took place in the Piazza S. Marco in 1782, on the occasion of the visit to Venice of the Russian archduke Paul Pavlovitch and his archduchess Maria Feodorovna, the "Conti del Nord." Two further sketches by Francesco of bullbaiting are preserved in the Princes Gate Collection, Courtauld Institute Galleries, London (Princes Gate, 1959, nos. 139 and 140, pls. XCIX, C; Morassi, 1975, nos. 268 and 270, figs. 270 and 272, respectively).

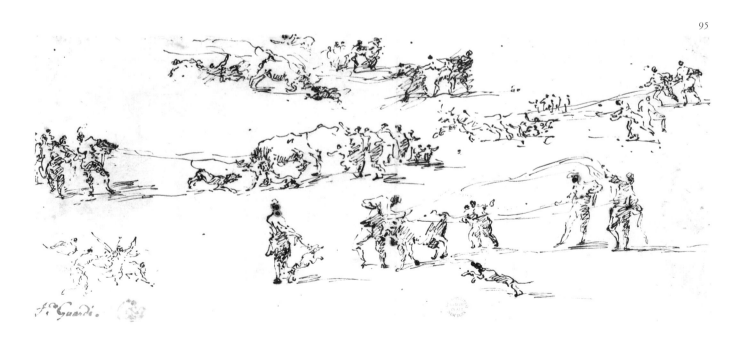

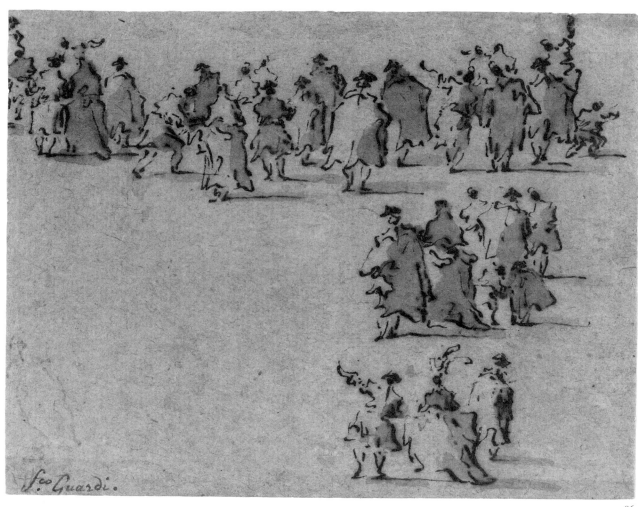

FRANCESCO GUARDI

96. *Figure Studies*

Pen and brown ink, brown wash, on blue paper. 16.3 x 21.9 cm.

Signed in pen and brown ink at lower left, *f.co Guardi.*

PROVENANCE: [R. Ederheimer]; Harold K. Hochschild.

BIBLIOGRAPHY: Hermann Warner Williams, Jr., in *Metropolitan Museum of Art Bulletin*, XXXV, August 1940, p. 156; Goering, 1944, pp. 58, 62; Byam Shaw, 1951, no. 51, repr.; Bean, 1964, no. 47, repr.; Bean and Stampfle, 1971, no. 189, repr.; Byam Shaw, 1971–1, p. 253, note 43; Morassi, 1975, no. 206, fig. 204.

Gift of Harold K. Hochschild, 1940
40.91.3

Francesco Guardi was in the habit of making abbreviated sketches for accessory figures—known as *macchiette* —that he used over and over again in his paintings.

97. *Figure Studies*

Pen and brown ink, brown wash, on blue paper. 15.1 x 28.0 cm.

Signed in pen and brown ink at lower left, *F.co Guardi.*

PROVENANCE: [R. Ederheimer]; Harold K. Hochschild.

BIBLIOGRAPHY: Hermann Warner Williams, Jr., in *Metropolitan Museum of Art Bulletin*, XXXV, August 1940, p. 156; *Metropolitan Museum, Italian Drawings*, 1942, pl. 54; Goering, 1944, pp. 58, 62, 84, fig. 127; Byam Shaw, 1951, no. 50, repr.; Detroit, 1952, p. 35, no. 37; Houston, 1958, no. 35; Bean, 1964, under no. 47; Bean and Stampfle, 1971, p. 80, under no. 189; Byam Shaw, 1971–1, p. 253, note 43; Morassi, 1975, no. 205, fig. 205.

Gift of Harold K. Hochschild, 1940
40.91.2

98. *Figure Studies*
VERSO. *Figures along a Canal and on a Bridge; to the right, a Curtain and a Stool* (?)

Black chalk, the architecture drawn in pen and brown ink. Framing lines in pen and brown ink (recto). Black chalk (verso). 19.5 x 25.3 cm.

Inscribed in pen and brown ink at lower right, *Guardi*; inscribed in pen and brown ink on verso, *Guardi.*

PROVENANCE: Lady Harcourt; Harry G. Sperling.

BIBLIOGRAPHY: Springfield, 1937, nos. 32 (recto), 33 (verso), both repr.; Byam Shaw, 1951, no. 48, repr. (recto); Montreal, 1953, no. 72, repr. (recto); Byam Shaw, 1955, p. 14, fig. 16 (detail of the drawing), fig. 17 (detail of the related painting), p. 15; Houston, 1958, no. 36, repr.; Wellesley, 1960, no. 28, pl. 12 (recto); Venice,

1965, p. 313, no. 24, repr. (recto); Bean and Stampfle, 1971, no. 188 (with additional bibliography), repr. (recto); Morassi, 1973, I, p. 408, under no. 524; Morassi, 1975, no. 223, figs. 225 (recto), 226 (verso).

Bequest of Harry G. Sperling, 1971
1975.131.31

The three men on the left wear cloaks and tricornes, while the figure on the right sports a tricorne and what may be a carnival mask. Byam Shaw has pointed out that the two figures on the right appear in a painting by Francesco, *The Grand Canal below the Rialto*, in the collection of Lord Iveagh (Morassi, 1973, I, no. 524, II, fig. 510).

99. *The Bucintoro Moving to the Left*
VERSO. *The Bucintoro Moving to the Right*

Pen and brown ink, brown and red-brown wash (recto); pen and brown ink (verso). 11.9 x 23.9 cm. Scattered stains.

PROVENANCE: [R. Langton Douglas]; purchased in London in 1919.

BIBLIOGRAPHY: Mongan and Sachs, 1940, I, p. 161, under no. 317; Benesch, 1947, no. 67, repr. (verso); Byam Shaw, 1951, pp. 72–73, no. 52, repr. (recto); Moschini, 1952, fig. 181 (verso); Pignatti, 1965–1, p. 221, under no. 136; Bean and Stampfle, 1971, no. 197, repr. (recto); Byam Shaw, 1971–1, p. 247; Morassi, 1975, no. 291, fig. 294 (recto).

Rogers Fund, 1919
19.151.2

97

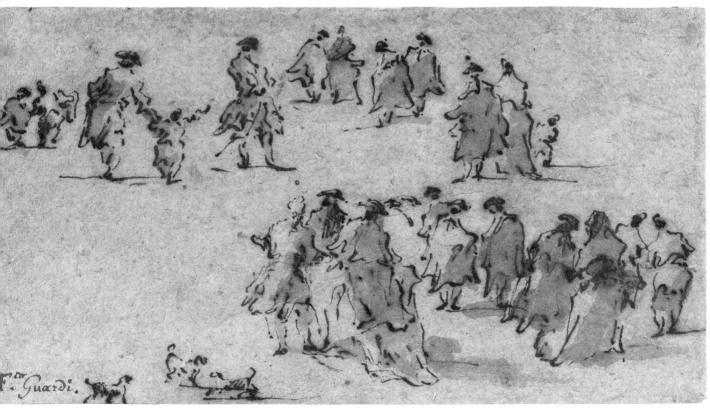

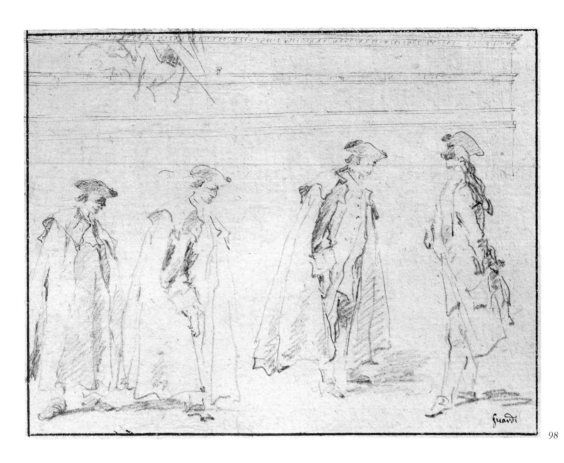

98

98 v.

116

FRANCESCO GUARDI (NO. 99)

On the Feast of the Ascension, the Doge was rowed in his state barge, the Bucintoro, to S. Nicolò di Lido to perform the traditional ceremony of Wedding the Adriatic by throwing a ring into the sea. The Bucintoro Guardi sketched here was the last of its kind; launched in 1729, it was destroyed by the French for its gold decoration after the fall of the Venetian Republic in 1797.

Benesch suggested that the colored washes on the recto are not "original," but Byam Shaw rightly insists that these watercolor accents are entirely characteristic of Francesco.

99

99 v.

100. *Dice Players in a Venetian Square*

Pen and brown ink, brown wash, over traces of black chalk. Framing lines in pen and brown ink. 37.6 x 26.8 cm.

PROVENANCE: Alfred Beurdeley (Lugt 421); marquis de Biron; purchased in Geneva in 1937.

BIBLIOGRAPHY: New York, 1938, no. 64, repr.; *Metropolitan Museum, Italian Drawings*, 1942, pl. 52; Goering, 1944, p. 84, fig. 122; Moschini, 1952, fig. 183; Loyd, 1967, p. 22, under no. 29; Bean and Stampfle, 1971, no. 198, repr.; Byam Shaw, 1971–1, p. 252, fig. 16; Morassi, 1973, I, p. 453, under no. 769; Rossi Bortolatto, 1974, p. 128, under no. 645; Morassi, 1975, no. 527, fig. 524; James Byam Shaw in *Lehman Collection*. VI, 1987, p. 50, under no. 34.

Rogers Fund, 1937
37.165.70

The drawing corresponds very closely to a painting in the Loyd collection at Lockinge (Loyd, 1967, no. 29, repr.; Morassi, 1973, I, no. 769, II, fig. 703). A smaller painted version, with a less successful horizontal format, was once in the collection of George Blumenthal, Paris. This was sold at Sotheby's, New York, on June 2, 1989 (part of no. 71, repr. in color).

101. *Architectural Capriccio: A Vaulted Passageway*

Pen and brown ink, brown wash. Framing lines in pen and brown ink. Verso: sketch of a ruined loggia in pen and pale brown ink. 16.2 x 12.7 cm.

PROVENANCE: Charles Gasc (Lugt 543); marquis de Biron; purchased in Geneva in 1937.

BIBLIOGRAPHY: Byam Shaw, 1951, pp. 75–76, no. 64, repr.; Bertini, 1957, pp. 157, 159, fig. 2; Byam Shaw, 1971–1, p. 253; Morassi, 1973, I, p. 460, under no. 809; Rossi Bortolatto, 1974, p. 128, under no. 646; Morassi, 1975, no. 581, fig. 573.

Rogers Fund, 1937
37.165.82

This rather confused architectural composition was used by Francesco in a small painting now in an Italian private collection (Morassi, 1973, I, no. 809, II, fig. 733). The same composition reappears in horizontal format, with architectural additions at upper right, in a free pen and wash sketch at the Stanford Museum of Art (Morassi, 1975, no. 582, fig. 577).

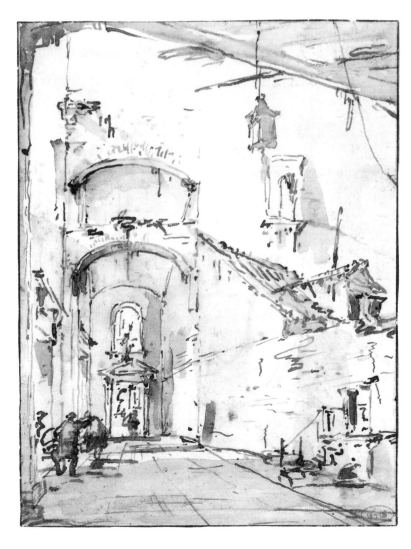

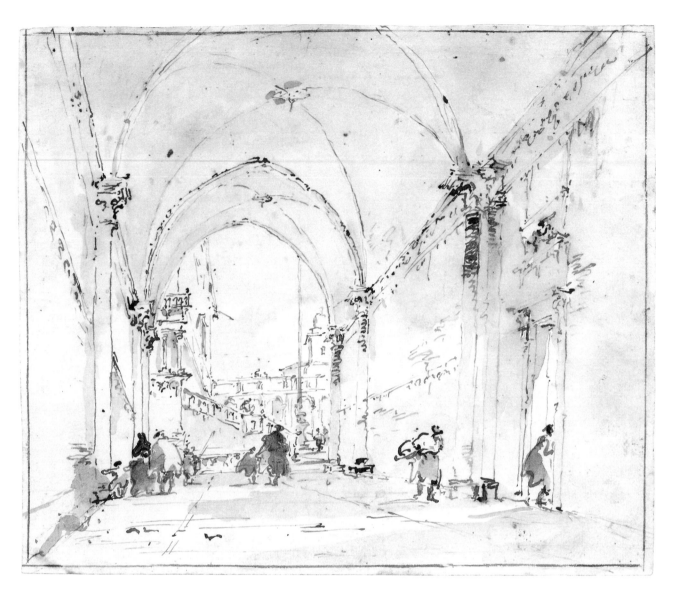

FRANCESCO GUARDI

102. *Architectural Capriccio: Vaulted Passage-way Leading to a Square*

Pen and brown ink, brown wash, over traces of black chalk. Framing lines in pen and brown ink. 20.3 x 24.5 cm.

PROVENANCE: Marquis de Biron; purchased in Geneva in 1937.

BIBLIOGRAPHY: Benesch, 1947, no. 60, repr.; Morassi, 1973, I, p. 458, under no. 797; Rossi Bortolatto, 1974, p. 133, under no. 745; Morassi, 1975, no. 550, fig. 543.

Rogers Fund, 1937
37.165.83

A small painting corresponding fairly closely to our drawing was formerly on the art market in New York (Morassi, 1973, I, no. 797, II, fig. 728).

103. *Architectural Capriccio: Vaulted Colonnade of a Palace*

Pen and brown ink, over red chalk. 18.0 x 25.3 cm.

Signed in pen and brown ink at lower left, *f.º Guardi*.

PROVENANCE: Marquis de Biron; purchased in Geneva in 1937.

BIBLIOGRAPHY: Mongan and Sachs, 1940, I, p. 162, under no. 319; Byam Shaw, 1951, p. 74, no. 59, repr.; Bean and Stampfle, 1971, no. 201, repr.; Byam Shaw, 1971-1, p. 253; Morassi, 1973, I, p. 458, under no. 795; Rossi Bortolatto, 1974, p. 133, under no. 745; Morassi, 1975, no. 569, fig. 562.

Rogers Fund, 1937
37.165.88

The architecture and the mountainous landscape background in this drawing are repeated fairly exactly in

a very small painting—smaller, in fact, than our drawing—in the Accademia Carrara, Bergamo (Morassi, 1973, I, no. 795, II, fig. 727).

104. *Architectural Capriccio: Grand Staircase Seen through an Archway*

Pen and brown ink, brown wash, over black chalk. 34.8 x 27.9 cm. Foxed.

PROVENANCE: Marquis de Biron; purchased in Geneva in 1937.

BIBLIOGRAPHY: New York, 1938, no. 61, repr.; Williams, 1939, pp. 266, 267, fig. 1, p. 271; *Metropolitan Museum, Italian Drawings*, 1942, pl. 48; Goering, 1944, p. 82, fig. 96; Mongan, 1949, pp. 104, 105, repr.; Pallucchini, 1949, pp. 132, 133, fig. 150; Indianapolis, 1970, no. 49, repr.; Bean and Stampfle, 1971, no. 202, repr.; Byam Shaw, 1971–I, p. 253; Levey, 1971, pp. 130–132, under no. 2523; Morassi, 1973, I, p. 456, under no. 784; Morassi, 1975, no. 548, fig. 537; Byam Shaw, 1976, p. 859; Bordeaux, 1981, no. 137, repr.

Rogers Fund, 1937
37.165.79

The composition was repeated by Francesco in a small painting in the National Gallery, London (Morassi, 1973, I, no. 784, II, fig. 715). In the Kupferstichkabinett,

Berlin-Dahlem, there is a rather elaborate drawn copy —after the painting rather than our drawing—that Pallucchini attributes to Giacomo Guardi (Pallucchini, 1949, pp. 132 and 133, fig. 151).

105. *Architectural Capriccio: Courtyard of a Palace*

Pen and brown ink, brown wash, over red chalk. 27.1 x 18.8 cm. Foxed.

On verso a letter in pen and brown ink from a certain Domenico Tosti dated from Caprarola in 1761.

PROVENANCE: Marquis de Biron; purchased in Geneva in 1937.

BIBLIOGRAPHY: Williams, 1939, p. 267, fig. 2, pp. 271, 274, note 3; Goering, 1944, pp. 42, 81, fig. 72; Byam Shaw, 1951, p. 40; Bean and Stampfle, 1971, no. 199, repr.; Byam Shaw, 1971–I, pp. 253, 255; Levey, 1971, pp. 125, 126, under no. 2519; Morassi, 1973, I, p. 457, under no. 791; Morassi, 1975, no. 551, fig. 544; Pignatti and Romanelli, 1985, p. 120, under no. 95.

Rogers Fund, 1937
37.165.71

This architectural fantasy and the following drawing are inspired by, but differ conspicuously from, the great

103

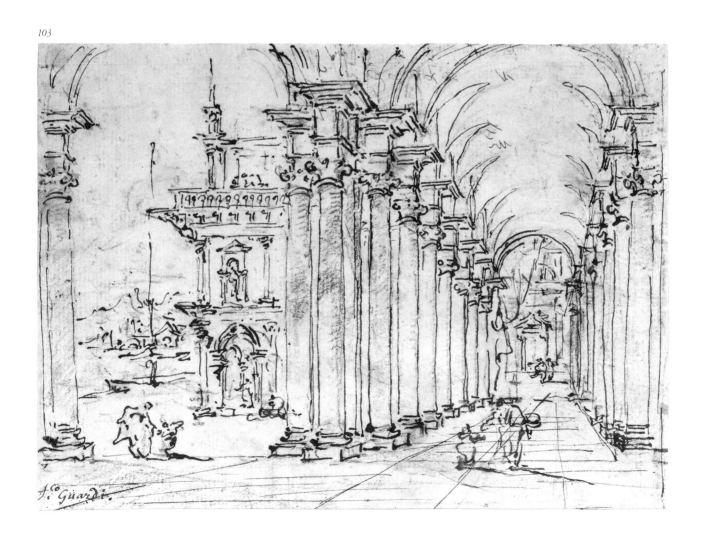

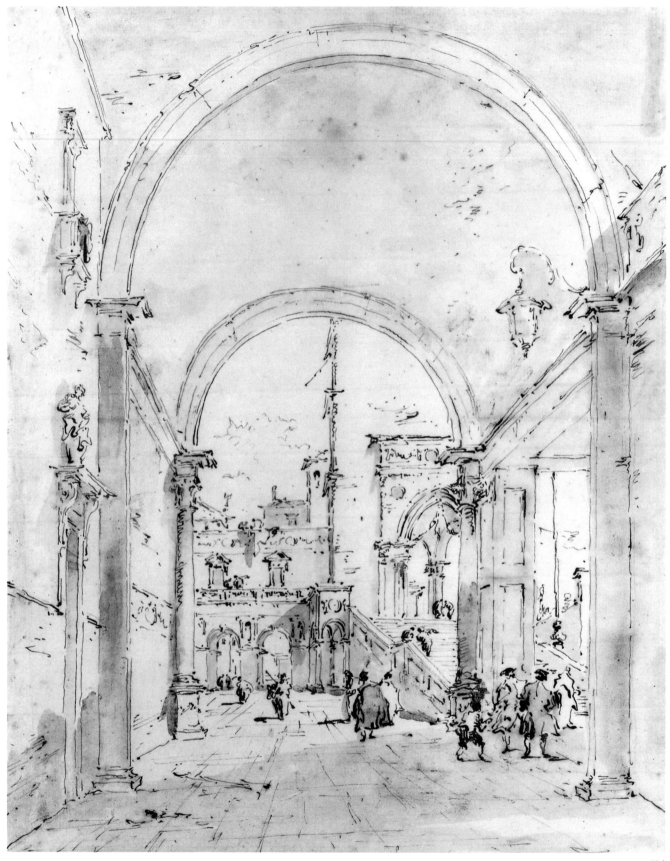

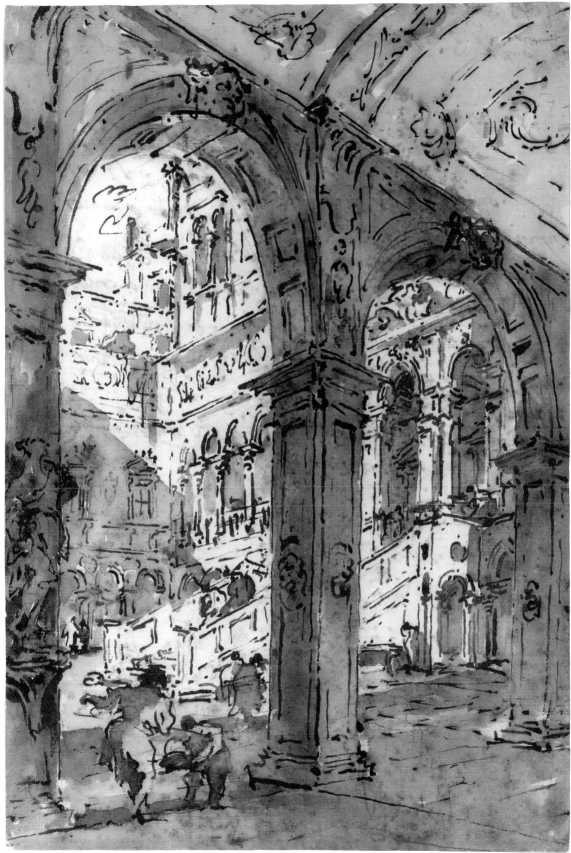

105

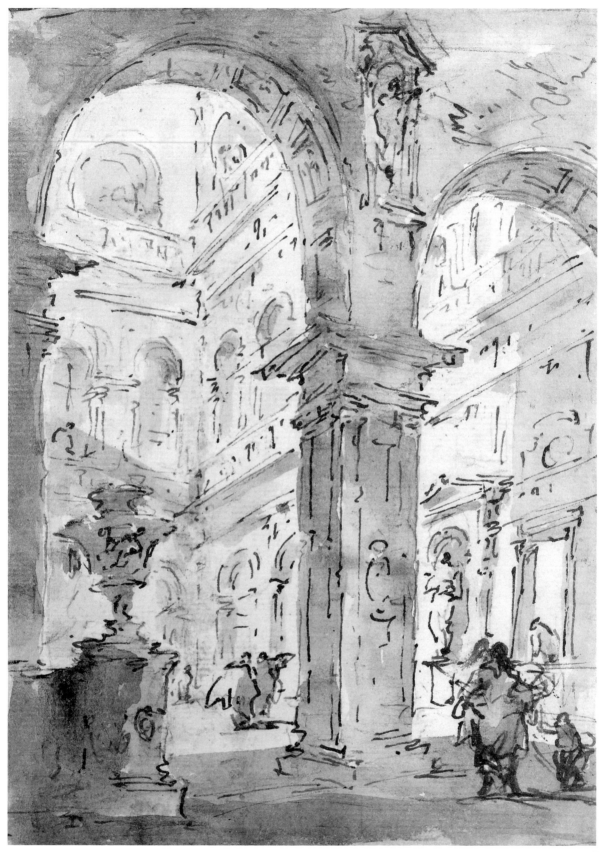

courtyard of the Palazzo Ducale in Venice. A monumental staircase figures prominently in both drawings, which were used with variations by Francesco Guardi in three paintings. One is in the Accademia Carrara, Bergamo, another in the National Gallery, London, and a third in the Wallace Collection, London (Morassi, 1973, I, nos. 791, 790, 789, II, figs. 722, 719, 718, respectively).

A fairly exact replica or old copy of our drawing, from the collection of William Mitchell (Lugt 2638), was recently on the art market in Paris (Nouveau Drouot, salle 9, June 13, 1986, no. 37, repr.). Another copy was sold at Christie's, London, on April 18, 1989 (no. 46, repr., as the work of Francesco and Giacomo Guardi).

106. *Architectural Capriccio: Courtyard of a Palace*

Pen and brown ink, brown wash, over black chalk. Verso: faint graphite sketch of St. Aloysius Gonzaga holding a crucifix. 27.9 x 20.3 cm.

PROVENANCE: Marquis de Biron; purchased in Geneva in 1937.

BIBLIOGRAPHY: New York, 1938, no. 62, repr.; Williams, 1939, pp. 271, 274, note 2; Goering, 1944, pp. 42, 43, 81, fig. 73; Bean and Stampfle, 1971, p. 84, under no. 199; Byam Shaw, 1971–1, pp. 253, 255; Levey, 1971, pp. 125, 126, under no. 2519; Morassi, 1973, I, p. 457, under nos. 791, 792; Rossi Bortolatto, 1974, p. 117, under no. 462; Morassi, 1975, no. 553, fig. 542.

Rogers Fund, 1937
37.165.80

This capriccio differs from the preceding two examples in that the great courtyard lacks a monumental staircase. In this respect and also in the presence of the ornamental vase on a pedestal in the left foreground, the drawing is related to a painting by Francesco in the National Gallery, Prague (Morassi, 1973, I, no. 792, II, fig. 721).

The graphite sketch on the verso, too faint to be reproduced, is presumably by Francesco, who has copied an oval painting of St. Aloysius Gonzaga by Domenico Tiepolo, one version of which is in the Pinacoteca di Brera, Milan (Mariuz, 1971, p. 126, pl. 178).

107. *Architectural Capriccio: Courtyard of a Palace*

Pen and brown ink, brown wash, over black chalk. Framing lines in pen and brown ink. 27.7 x 18.1 cm.

Sums of figures in pen and brown ink on verso.

PROVENANCE: Marquis de Biron; purchased in Geneva in 1937.

BIBLIOGRAPHY: Williams, 1939, pp. 271, 274, note 2; *Metropolitan Museum, Italian Drawings*, 1942, pl. 51; Goering, 1944, pp. 42, 43, 81, fig. 74; Bean and Stampfle, 1971, no. 200, repr.; Levey, 1971, pp. 125, 126, under no. 2519; Morassi, 1973, I, p. 457, under no. 791; Morassi, 1975, no. 552, fig. 545.

Rogers Fund, 1937
37.165.87

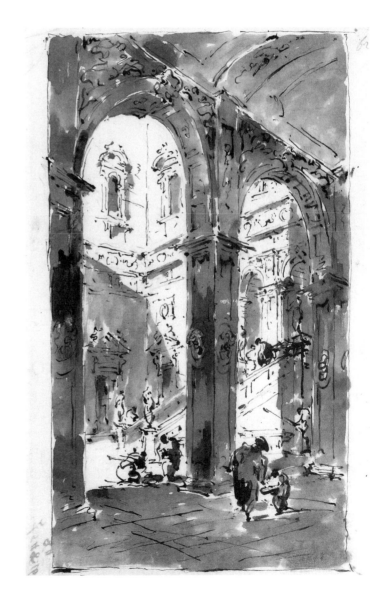

108. *Architectural Fantasy: Figures on a Grand Staircase*

Pen and brown ink, brown wash. Framing lines in pen and brown ink. 26.6 x 15.9 cm.

Note in Latin in pen and brown ink, dated *26 Novembris 1713*, on verso.

PROVENANCE: Marquis de Biron; purchased in Geneva in 1937.

BIBLIOGRAPHY: Williams, 1938, p. 65, repr.; New York, 1959, pp. 48–49, under no. 40; Venice, 1965, p. 322, no. 61 (incorrectly

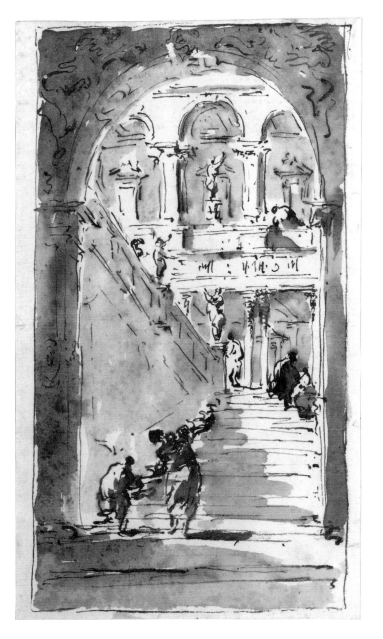

catalogued), repr.; Bean and Stampfle, 1971, p. 82, under no. 194; Byam Shaw, 1971–1, pp. 253, 255; Morassi, 1975, no. 555, fig. 547.

Rogers Fund, 1937
37.165.72

109. *Architectural Fantasy: Figures on a Grand Staircase* VERSO. *Studies for the Frame of a Shaped Field*

Pen and brown ink, brown wash, over red chalk (recto); pen and brown ink, brown wash (verso). 25.3 x 15.8 cm.

PROVENANCE: Marquis de Biron; purchased in Geneva in 1937.

BIBLIOGRAPHY: New York, 1938, no. 63, repr. (recto); *Metropolitan Museum, Italian Drawings*, 1942, pl. 50 (recto); New York, 1959, no. 40, pl. XLIV (recto); Byam Shaw, 1971–1, p. 253; Morassi, 1975, no. 556, fig. 546 (recto).

Rogers Fund, 1937
37.165.86

The designs on the reverse of the sheet have never before been mentioned or reproduced. They are no doubt projects for ceiling or overdoor decorations, probably intended to be executed in stucco or painted in imitation thereof.

110. *Architectural Capriccio: Colonnade of a Palace*

Pen and brown ink, brown wash. Framing lines in pen and brown ink. 27.4 x 19.1 cm.

PROVENANCE: Edward Habich (Lugt 862); Habich sale, Stuttgart, H. G. Gutekunst, April 27–28, 1899, no. 335; marquis de Biron; purchased in Geneva in 1937.

BIBLIOGRAPHY: Eisenmann, 1890, II, pl. 7; Williams, 1939, p. 270, fig. 7, p. 272; *Metropolitan Museum, Italian Drawings*, 1942, pl. 49; Goering, 1944, pp. 48, 82, fig. 85; *Art Treasures of the Metropolitan*, 1952, p. 71, fig. 65, p. 222, no. 65; Detroit, 1952, no. 36; Byam Shaw, 1971–1, pp. 253, 254, fig. 18; Morassi, 1975, no. 560, fig. 551; Barcham, 1977, p. 217, fig. 228.

Rogers Fund, 1937
37.165.76

Francesco Guardi based this composition on a painted architectural capriccio by Canaletto now in the Gallerie

109

dell'Accademia, Venice (Constable, 1976, I, pl. 93, II, no. 509). The painting had been presented by Canaletto to the Venetian Academy on his election in September 1763.

A smaller and sketchier drawing by Francesco after the same painting by Canaletto is in the Janos Scholz Collection at The Pierpont Morgan Library (Morassi, 1975, no. 561, fig. 554).

111. *Architectural Capriccio: Garden Entrance to a Palace*
VERSO. *Three Masked and Costumed Figures and Other Figure Studies*

Pen and brown ink, brown wash, over black chalk. Framing lines in pen and brown ink (recto); pen and light brown ink for costumed figures; dark brown ink for the other figures (verso). 18.3 x 11.5 cm.

PROVENANCE: Marquis de Biron; purchased in Geneva in 1937.

BIBLIOGRAPHY: Goering, 1944, pp. 55, 83, fig. 113 (recto); Benesch, 1947, no. 63, repr. (recto); Maurizio Bonicatti in *Problemi guardeschi*, 1967, p. 36, note 65, figs. 147 (verso), 148 (recto); Byam Shaw, 1971–1, p. 255, fig. 19 (recto); Morassi, 1973, I, p. 450, under no. 752; Rossi Bortolatto, 1974, p. 133, under no. 739, fig. 739 a (recto); Morassi, 1975, no. 508.

Rogers Fund, 1937
37.165.81

The very free, rather erratic pen work of this sketch makes it a particularly lively example of Francesco's capriccios; Morassi's reservations about its authenticity are unjustified. The crude figure studies on the reverse of the sheet are given to Giacomo Guardi by James Byam Shaw.

111

111 v.

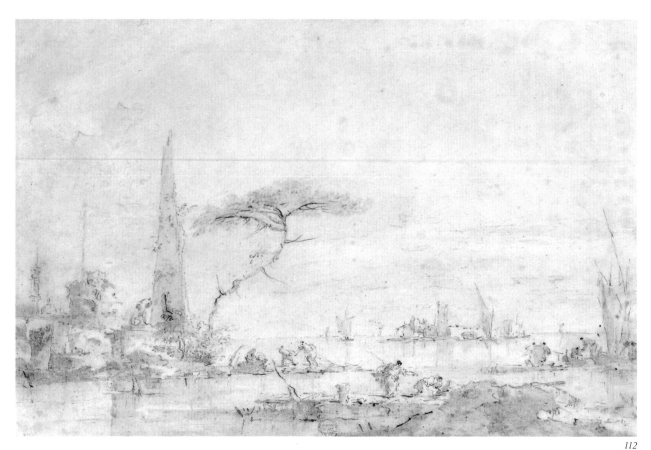

112

113

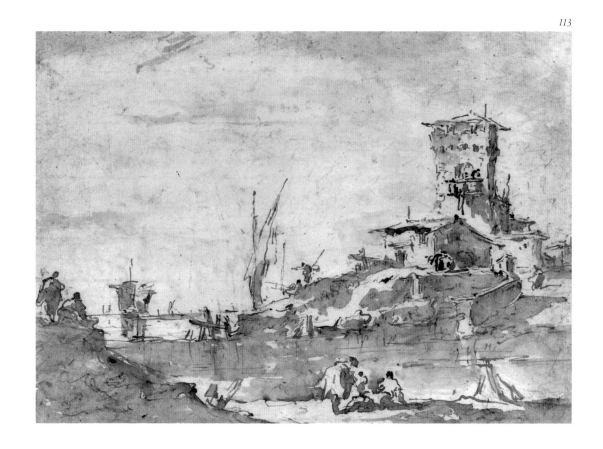

112. *Lagoon Capriccio with an Obelisk*

Pen and brown ink, gray wash, over black chalk. 23.8 x 36.6 cm.
Faded. Scattered stains. Lined.

PROVENANCE: [Parsons]; purchased in London in 1907.

BIBLIOGRAPHY: Roger Fry, *Metropolitan Museum of Art Bulletin*, II, December 1907, p. 200; Simonson, 1913, p. 269, fig. 26; Springfield, 1937, no. 31, repr.; Byam Shaw, 1951, p. 77, under no. 69; Parker and Byam Shaw, 1962, p. 62, under no. 81; Byam Shaw, 1971–1, p. 247, note 29; Morassi, 1973, I, p. 478, under no. 911; Rossi Bortolatto, 1974, p. 110, under no. 350; Morassi, 1975, no. 627.

Rogers Fund, 1907
07.282.9

Three further versions of this drawing have survived, all with slight variations. One is in the Kupferstichkabinett, Berlin-Dahlem (Parker and Byam Shaw, 1962, no. 81, repr.; Morassi, 1975, no. 625, fig. 602), the second is in the Kramarsky collection (Byam Shaw, 1951, p. 77, no. 69, repr.; Morassi, 1975, no. 626), while a third was once in the George Blumenthal collection (sale, London, Sotheby's, November 26, 1970, no. 69, repr.; Morassi, 1975, no. 628, fig. 603).

The present example was already rather faded at the time of its acquisition in 1907, when Roger Fry commented that "the force of tone has been somewhat obliterated by age."

This capriccio subject seems to have been popular with Guardi's clientele, for as many as six paintings of it are recorded by Morassi (1973, I, nos. 911–916).

113. *Lagoon Capriccio with a Tower*

Pen and brown ink, brown wash, over black chalk. 19.1 x 26.9 cm.

PROVENANCE: Marquis de Biron; purchased in Geneva in 1937.

BIBLIOGRAPHY: New York, 1938, no. 65, repr.; Williams, 1939, p. 269, fig. 6, pp. 271–272; *Metropolitan Museum, Italian Drawings*, 1942, pl. 53; Goering, 1944, pp. 38, 80, fig. 63; Byam Shaw, 1971–1, pp. 252, 253, fig. 17; Morassi, 1973, I, p. 464, under no. 828; Rossi Bortolatto, 1974, p. 110, under no. 345; Morassi, 1975, no. 588, fig. 591.

Rogers Fund, 1937
37.165.75

The paintings by Francesco that come closest to this drawing are in Italian private collections (Morassi, 1973, I, nos. 827 and 828, figs. 752 and 754, respectively).

114. *Capriccio with a Seaport and Classical Ruins*

Pen and brown ink, brown wash, over black chalk. 24.9 x 46.9 cm.
Lightly foxed. Lined.

PROVENANCE: Ernest May; Paul M. May; Valentine Moroni (all according to Virch); [Durlacher]; Walter C. Baker.

BIBLIOGRAPHY: Virch, 1962, no. 62; Venice, 1965, no. 44, repr.; Morassi, 1973, I, p. 462, under no. 817; Morassi, 1975, no. 611, fig. 596; Shapley, 1979, I, pp. 241–242, under no. 717.

Bequest of Walter C. Baker, 1971
1972.118.255

The drawing corresponds very closely to a large painting attributed to Francesco Guardi, *Seaport and Classical*

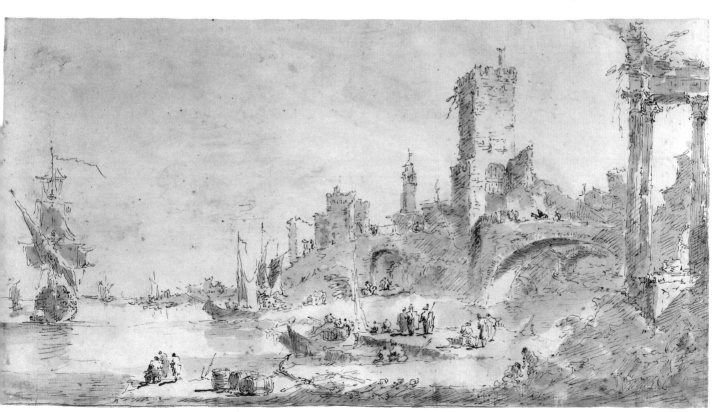

Ruins in Italy, now in the National Gallery of Art, Washington, D.C. (Morassi, 1973, I, no. 817, II, fig. 745; Shapley, 1979, I, no. 717, II, pl. 162).

115. *Design for a Framing Motif*

Pen and brown ink, light and dark green watercolor, over traces of black chalk. Framing lines in pen and brown ink. 41.2 x 43.2 cm. Three vertical creases and one horizontal crease. Brown stain at lower margin right of center. Lined.

PROVENANCE: Marquis de Biron; purchased in Geneva in 1937.

BIBLIOGRAPHY: Bean and Stampfle, 1971, no. 213, repr.; Byam Shaw, 1971–1, pp. 255, 256, fig. 20; Morassi, 1975, no. 469, fig. 466.

Rogers Fund, 1937
37.165.101

Light, foliate scroll motifs arranged in curves and countercurves compose the left half of a rectangular frame that was probably intended for overdoor ornamentation. This large and graceful design testifies to Francesco's very considerable gifts as a decorator.

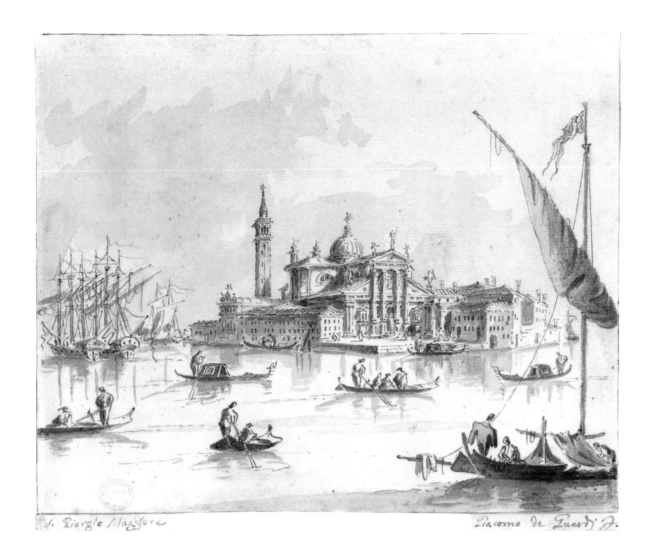

GIACOMO GUARDI

Venice 1764–Venice 1835

116. *The Island of S. Giorgio Maggiore, Venice*

Pen and brown ink, gray wash. Framing lines in pen and brown ink. 18.0 x 21.9 cm. Lower margin irregular.

Inscribed in pen and brown ink at lower left, *S. Giorgio Maggiore*; signed at lower right, *Giacomo de Guardi F.*

PROVENANCE: Mrs. Gutekunst, London; Harry G. Sperling.

BIBLIOGRAPHY: Byam Shaw, 1951, pp. 50, 80, no. 79, repr.; Montreal, 1953, no. 75, repr.; Houston, 1958, no. 45, repr.; Wellesley, 1960, no. 31; Parker and Byam Shaw, 1962, p. 79, under no. 110; *Annual Report*, 1974–1975, p. 50; Attilia Dorigato in Pignatti, 1983, p. 247, under no. 794, p. 253, under no. 812; James Byam Shaw in *Lehman Collection*. VI, 1987, p. 67, under no. 53 (mistakenly said to be in the Ashmolean Museum).

Bequest of Harry G. Sperling, 1971
1975.131.32

Like the six drawings that follow, this is a good, signed example of Giacomo Guardi's rather pedestrian style as a draughtsman of Venetian views. The island and church of S. Giorgio Maggiore were often represented by Francesco and his son Giacomo. There are two larger drawings of this subject by Giacomo in the Museo Correr, Venice (Pignatti, 1983, nos. 794, 812, repr.), another large version is in the Museo d'Arte Antica, Castello Sforzesco, Milan (Precerutti-Garberi, 1969–2, no. 34, repr.), and one that is smaller than the present sheet is in the Robert Lehman Collection, The Metropolitan Museum of Art (James Byam Shaw in *Lehman Collection*. VI, 1987, no. 53, repr.).

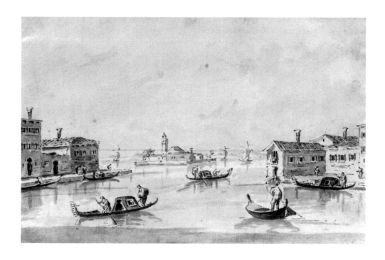

117. *The Punta di S. Giobbe, with the Island of S. Secondo in the Distance*

Pen and brown ink, gray wash, 12.6 x 19.9 cm.

Inscribed by the artist in pen and brown ink on verso, *Veduta della Punta di S. Giobe di facia S. 2do,* and *Giacomo de Guardi.*

PROVENANCE: Alexandrine Sinsheimer.

BIBLIOGRAPHY: Byam Shaw, 1971–1, pp. 253–255, note 43.

Bequest of Alexandrine Sinsheimer, 1958
59.23.48

A pen and wash drawing of the same view, with a different grouping of gondolas, is in the Robert Lehman Collection, The Metropolitan Museum of Art (James Byam Shaw in *Lehman Collection.* VI, 1987, no. 45, repr.). A larger gouache drawing of the view is in the Museo Correr, Venice (Pignatti, 1983, no. 880, repr.), and a small oil painting on canvas, also by Giacomo, is in the Fitzwilliam Museum, Cambridge (Goodison and Robertson, 1967, p. 74, no. 187).

118. *Quinta Valle at Castello*

Pen and brown ink, gray wash. 12.3 x 19.9 cm. Scattered stains.

Inscribed by the artist in pen and brown ink on verso, *Veduta di Quinta Valle a Castello,* and *Giacomo de Guardi.*

PROVENANCE: Alexandrine Sinsheimer.

BIBLIOGRAPHY: Byam Shaw, 1971–1, pp. 253–255, note 43.

Bequest of Alexandrine Sinsheimer, 1958
59.23.47

In the Museo Correr there are a pen sketch and a more finished gouache drawing of the same Venetian view (Pignatti, 1983, nos. 823 recto, 887, repr., respectively).

119. *The Tower at Marghera*

Pen and brown ink, gray wash, over traces of black chalk. 12.0 x 19.5 cm.

Inscribed by the artist in pen and brown ink on verso, *Veduta della Palluda ossia Tore di Mestre,* and *Giacomo de Guardi.*

PROVENANCE: Alexandrine Sinsheimer.

BIBLIOGRAPHY: Byam Shaw, 1971–1, pp. 253–255, note 43.

Bequest of Alexandrine Sinsheimer, 1958
59.23.51

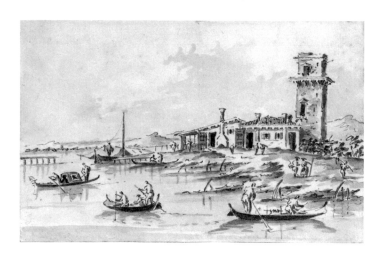

Another drawn view by Giacomo of the now-destroyed tower at Marghera is in the National Museum, Warsaw (Mrozinska, 1958, no. 80, repr.).

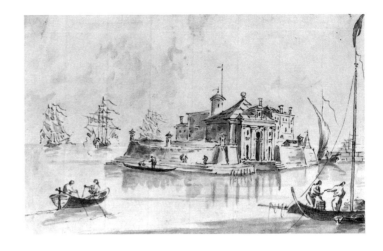

120. *A Port near Venice: Chioggia* (?)

Pen and brown ink, gray wash. 11.6 x 18.5 cm.

Inscribed by the artist in pen and brown ink on verso, *Veduta del Porto di Chioga* [?], and *Giacomo de Guardi*.

PROVENANCE: Alexandrine Sinsheimer.

BIBLIOGRAPHY: Byam Shaw, 1971–1, pp. 253–255, note 43.

Bequest of Alexandrine Sinsheimer, 1958
59.23.46

A slightly smaller representation in gouache of the same port was sold at Sotheby's, London, on October 2, 1975 (part of no. 71, repr. pl. 3).

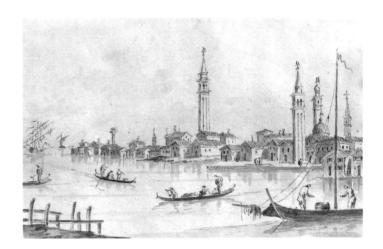

121. *The Island of Burano*

Pen and brown ink, gray wash. 11.6 x 18.7 cm.

Inscribed by the artist in pen and brown ink on verso, *Veduta di Burano*, and *Giacomo de Guardi*.

PROVENANCE: Alexandrine Sinsheimer.

BIBLIOGRAPHY: Byam Shaw, 1971–1, pp. 253–255, note 43.

Bequest of Alexandrine Sinsheimer, 1958
59.23.49

122. *S. Biagio on the Giudecca*

Pen and brown ink, gray wash, on pale gray paper. 11.6 x 18.6 cm.

Inscribed by the artist in pen and brown ink on verso, *Veduta della Giudeca a S. Biagio*, and *Giacomo de Guardi*.

PROVENANCE: Alexandrine Sinsheimer.

BIBLIOGRAPHY: Byam Shaw, 1971–1, pp. 253–255, note 43.

Bequest of Alexandrine Sinsheimer, 1958
59.23.50

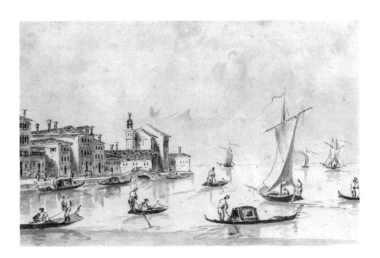

GIACOMO GUARDI ?

123. *Piazza S. Marco Decorated for the Festa della Sensa*

Pen and brown ink, gray and brown wash, over black chalk. Framing lines in pen and brown ink. 38.8 x 54.8 cm. (sheet); 29.5 x 45.6 cm. (image).

PROVENANCE: Comte Henri de Greffulhe (1848–1932); Greffulhe sale, London, Sotheby's, July 22, 1937, no. 25, pl. VIII, as Francesco Guardi; Viscount Rothermere (according to Virch); Walter C. Baker.

BIBLIOGRAPHY: Virch, 1962, no. 63, repr., as Francesco Guardi; Venice, 1965, p. 317, no. 43, repr., as Francesco Guardi; Pallucchini, 1965, p. 236, "una derivazione, forse di Giacomo"; Morassi, 1973, I, p. 362, under no. 279, as Francesco Guardi; Rossi Bortolatto, 1974, p. 130, under no. 681, fig. 681 a, as Francesco Guardi; Morassi, 1975, no. 278, fig. 281, as Francesco Guardi.

Bequest of Walter C. Baker, 1971
1972.118.254

This rather pedestrian drawing corresponds, with slight variations, to a painting by Francesco in the Kunsthistorisches Museum, Vienna (Morassi, 1973, I, no. 279, II, fig. 308). Although the drawing has been published as a preparatory study by Francesco for the painting, Pallucchini's observation that it is a derivation, probably from the somewhat heavy hand of Giacomo Guardi, seems to us very plausible. Another drawing, even closer in detail to the Vienna painting, was formerly in the Salting collection (Simonson, 1904, repr. opp. p. 60; Morassi, 1975, no. 279, fig. 280).

FRANCESCO LAMARRA

Documented in Naples in 1792

124. *Abraham Entertaining the Three Angels*
(Genesis 18:1–15)
VERSO. *A Couple Embracing, and Other Figure Studies*

Pen and brown ink, over black chalk (recto and verso). 35.3 x 22.5 cm. The sheet is made up of seven irregularly shaped pieces of paper pasted together.

Inscribed in pen and pale brown ink at lower left corner, *Baccio / Ciarpi*; in pen and brown ink on the verso, *5 giugno 69*, followed by a column of figures.

PROVENANCE: H. M. Calmann.

BIBLIOGRAPHY: *Annual Report*, 1961–1962, p. 65; Vitzthum, 1965, p. 66, pl. 63.

Gift of H. M. Calmann, 1961
61.158.2

Abraham's "tent" is here a sumptuous palace, before which the three angels are entertained in style. At upper right, Sarah looks on laughing, as the biblical text specifies.

The drawing entered the collection with an attribution to Baccio Ciarpi, based on the old inscription. It was soon apparent, however, that it is close in style to a large group of drawings that have been attributed to Luca Giordano; more than forty of these are in the Albertina, Vienna (*Beschreibender Katalog.* VI, 1941, nos. 603–604, 606–608, repr.; Ferrari, 1963, pp. 3–8, figs. 1–11). In 1965 Walter Vitzthum identified the draughtsman as the late eighteenth-century Neapolitan *pasticheur* Francesco Lamarra, whose work reflects the styles of both Luca Giordano and Francesco Solimena. A curious feature of some of Lamarra's drawings is that they are patchworks of many pieces of paper irregularly joined together.

124

124 v.

GREGORIO LAZZARINI ?

Venice 1655–Villa Bona (near Polesine) 1730

125. *Draped Male Figure Standing in a Niche*

Pen and brown ink, brown and gray wash, on light brown washed paper. 32.1 x 21.3 cm.

Inscribed in pen and brown ink at lower left, *G. Lazarini.*

PROVENANCE: Dan Fellows Platt (Lugt 750a and 2066b); Janos Scholz (Lugt 2933b); [Colnaghi]; purchased in London in 1962.

BIBLIOGRAPHY: *Exhibition of Old Master Drawings. P. and D. Colnaghi and Co.*, London, 1962, no. 16; *Annual Report*, 1962–1963, p. 63.

Rogers Fund, 1962
62.132.4

The old inscription assigning the drawing to Gregorio Lazzarini could well be correct. Lazzarini's personality as a draughtsman is somewhat indistinct, and no drawings attributed to him can be associated with documented paintings. However, the physical type of the bearded old man in our drawing, his stubby, foreshortened feet, and the heavy drapery broken into many folds are paralleled in two paintings by Lazzarini in S. Maria della Salute, Venice: *Elijah Visited by an Angel* and *Elijah Fed by Ravens* (photographs P. Fiorentini, Venice, 766 and 767).

The rather lax pen work used to indicate the candelabra ornament on the pilasters flanking the niche is not incompatible with that in a drawing for an altarpiece in the collection of Ralph Holland, Newcastle-upon-Tyne (Bettagno, 1966, no. 44, repr.). Mr. Holland's drawing is attributed to Lazzarini in the "Reliable Venetian Hand."

FRANCESCO LONDONIO

Milan 1723–Milan 1783

126. *Kneeling Milkmaid*

Black chalk, heightened with white, on brown paper. 27.3 x 30.7 cm. Lined.

PROVENANCE: 7th Earl of Dartmouth; sale, London, Sotheby's, May 5, 1964, part of no. 170, as Dutch School, 18th century; [Colnaghi]; purchased in London in 1965.

BIBLIOGRAPHY: *Annual Report*, 1965–1966, p. 75.

Rogers Fund, 1965
65.66.5

The milkmaid appears at work in a painting of a barnyard scene by Londonio that was engraved by Filippo Caporali (1794–after 1848).

This drawing was part of one of three lots of studies of animals and figures sold at Sotheby's, London, in 1964 as "Dutch School, 18th century." At the time of the sale, they were recognized as typical genre studies by Francesco Londonio. Two drawings from this group are now in the Ashmolean Museum, Oxford (Macandrew, 1980, no. 1021–2A, pl. LXXXVI, 1021–2B).

GIOVANNI BATTISTA ("TITTA") LUSIERI

Rome ? ca. 1755–Athens 1821

127. *Peasant on a Donkey*

Watercolor, over graphite. 34.1 x 43.5 cm. (a strip measuring 3.6 cm. folded under along top edge).

Inscribed in graphite on verso, *Lady Palmerston.*

PROVENANCE: Purchased in 1824 from Lusieri's heirs by the 7th Earl of Elgin; then by inheritance, Lord Bruce; sale, London, Christie's, July 6, 1965, part of no. 104; [Colnaghi]; purchased in London in 1966.

BIBLIOGRAPHY: *Exhibition of Old Master Drawings. P. and D. Colnaghi and Co.*, London, 1966, no. 57; *Annual Report*, 1966–1967, p. 60; Olson, 1980, no. 27, repr.; Williams, 1982, p. 494, fig. 21 ("Present whereabouts unknown"), p. 495.

Rogers Fund, 1966
66.93.1

Lusieri intended to use this figure on a reduced scale in the foreground of a large, panoramic watercolor, *View of*

the Castle and Gulf of Baia, also from the Elgin collection, that was sold at Sotheby's, London, on June 30, 1986 (no. 117, repr.). Silhouetted against trees, the same young peasant on a donkey appears in pencil outline in the center of the unfinished foreground. Our drawing may be a preparatory study, although donkey and rider are a little more than twice the size of the group sketched in the panoramic view.

128. *Standing Neapolitan Girl*

Watercolor, over graphite. 37.5 x 28.2 cm.

Inscribed in graphite on verso, *M^r Palmerston*.

PROVENANCE: Purchased in 1824 from Lusieri's heirs by the 7th Earl of Elgin; then by inheritance, Lord Bruce; sale, London, Christie's, July 6, 1965, no. 105; [Colnaghi]; purchased in London in 1966.

BIBLIOGRAPHY: *Annual Report*, 1966–1967, p. 60; Olson, 1980, under no. 27.

Rogers Fund, 1966
66.53.2

This watercolor study and No. 127 above came from a group of twenty-two figure studies by Lusieri sold from the Elgin collection in 1965. From the same group came a study of a standing Neapolitan woman and another of a Neapolitan man holding a long staff; these are now in Louisville, Kentucky (*Bulletin of the J. B. Speed Art Museum*, XXV, June 1966, p. 7, repr.).

129. *Classical Landscape with Hunters in the Foreground*

Graphite. Framing lines in pen and brown ink and gray wash. 34.5 x 49.0 cm. (overall). The drawing, excluding the border, measures 32.4 x 46.7 cm.

Signed in black chalk within the upper left margin of the drawn surface, *Lusier f.*, in pen and pale brown ink in another hand on a folded tab of paper below lower left margin, *For His Majesty*.

PROVENANCE: Martin Birnbaum.

BIBLIOGRAPHY: *Annual Report*, 1965–1966, p. 74, as Jean Pillement.

Gift of Martin Birnbaum, 1966
66.117.1

This and the following highly finished drawing, both inspired by the landscapes of Claude, came to the Museum in 1966 with an attribution to Jean Pillement

(1728–1808). This was not implausible, since such a meticulous use of graphite and refined shading is to be found in the work of that French draughtsman.

It was not until 1983 that Lawrence Turčić detected the almost hidden signature at the upper left margin of this drawing. The form used in the signature, *Lusier f.* (i.e., without the final *i* of the artist's name), occurs on two very large watercolor views of Naples by Lusieri from the Elgin collection that were sold at Sotheby's, London, on June 30, 1986: no. 105, signed and dated *Titta Lusier f. 1783*, and no. 106, signed and dated *Titta Lusier 1782*. The very large *View of the Bay of Naples* now at the J. Paul Getty Museum, Malibu, is signed and dated *G. B. Lusier 1791*.

The identification of our drawing reveals a previously unknown aspect of Lusieri's work. These imaginary classical landscapes are quite different in technique and conception from Lusieri's highly detailed and realistic watercolor panoramas. The apparent influence of Pillement can be explained by the high reputation that the French artist's work enjoyed throughout Europe. Lusieri could have seen drawings by Pillement in Rome or Naples.

130. *Classical Landscape with Herdsmen in the Foreground*

Graphite. 36.4 x 47.5 cm.

PROVENANCE: Martin Birnbaum.

BIBLIOGRAPHY: *Annual Report*, 1965–1966, p. 74, as Jean Pillement.

Gift of Martin Birnbaum, 1966
66.117.2

Though not signed, this drawing is clearly by the same hand as No. 129 and, like the above drawing, entered the Museum's collection with an attribution to Jean Pillement.

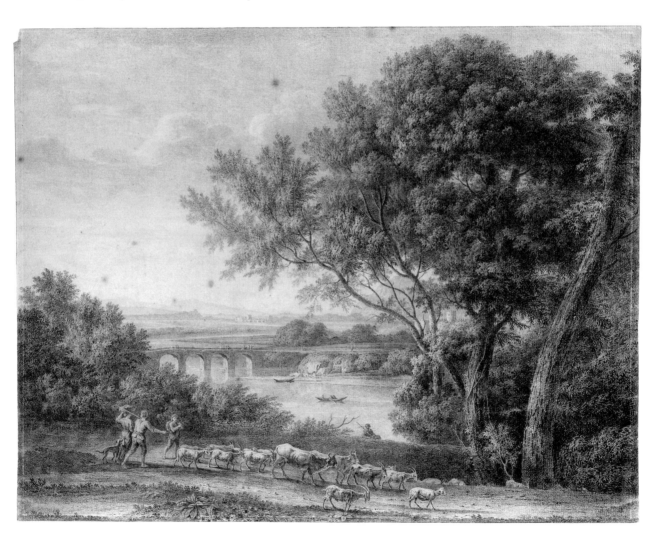

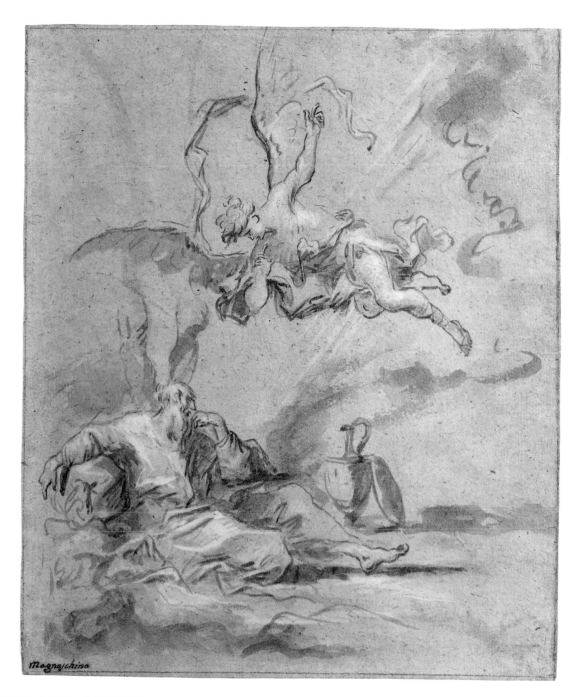

ALESSANDRO MAGNASCO

Genoa 1667–Genoa 1749

131. *Elijah Visited by an Angel in the Wilderness*

(1 Kings 19:4–8)

Brush and brown wash, heightened with white, over traces of black chalk, on beige paper. Framing lines in black chalk. 26.3 x 22.3 cm. Repaired loss at lower left margin.

Inscribed in pen and dark brown ink at lower left margin, *Magnaschino.*

PROVENANCE: Johann Amman, Zurich; [J. Hansegger]; purchased in New York in 1953.

BIBLIOGRAPHY: *Annual Report*, 1953, p. 23; Grigaut, 1967, no. 13, repr.; Bean and Stampfle, 1971, no. 16, repr.; Dreyer, 1979, under no. 69.

Rogers Fund, 1953
53.169

This subject, the angel awakening the sleeping Elijah and ordering him to eat and drink of the round cake and the jar of water that had miraculously appeared in the wilderness, was treated by Magnasco in other wash drawings. A sheet in the Kupferstichkabinett, Berlin-Dahlem, is close to ours, although the figure of Elijah is reversed (Geiger, 1945, pl. 68; Dreyer, 1979, no. 69, repr.). In two drawings formerly in the Hessisches Landesmuseum, Darmstadt, Elijah is awakened by the touch of the angel's right hand (Geiger, 1945, pls. 66, 67).

A painting of this subject in a landscape setting in which the meager shrubbery of the biblical account is replaced by much richer vegetation was on the market in Munich some years ago (Geiger, 1949, pl. 209).

MARCO MARCOLA

Verona ca. 1740–Verona 1793

132. *Gaius Mucius Scaevola Thrusting His Right Hand into Fire*

Pen and black ink, gray-brown wash. 28.0 x 40.6 cm. Scattered stains.

Inscribed in pen and light brown ink on verso, *Di Marco Marcola*.

PROVENANCE: Unidentified collector's mark on verso (the letters A and G superimposed, in red; not in Lugt); [Baderou]; purchased in Paris in 1964.

BIBLIOGRAPHY: *Annual Report*, 1964–1965, p. 52, as Giovanni Battista Marcola; Bean and Stampfle, 1971, p. 78, under no. 183, as Giovanni Battista Marcola.

Rogers Fund, 1964
64.132.2

Although this design comes very close in linear style to drawings assigned with confidence to Giovanni Battista Marcola, the eighteenth-century inscription *Di Marco Marcola* on the reverse should be respected.

The drawing is thus an example of the work of Marco in which the influence of his father, Giovanni Battista, is predominant.

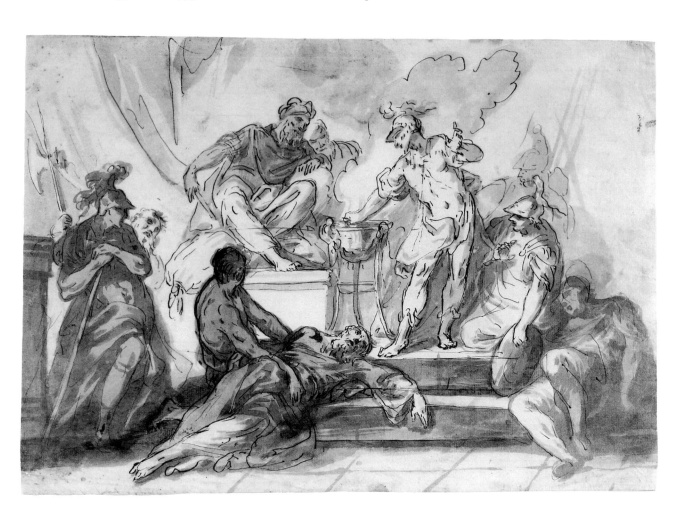

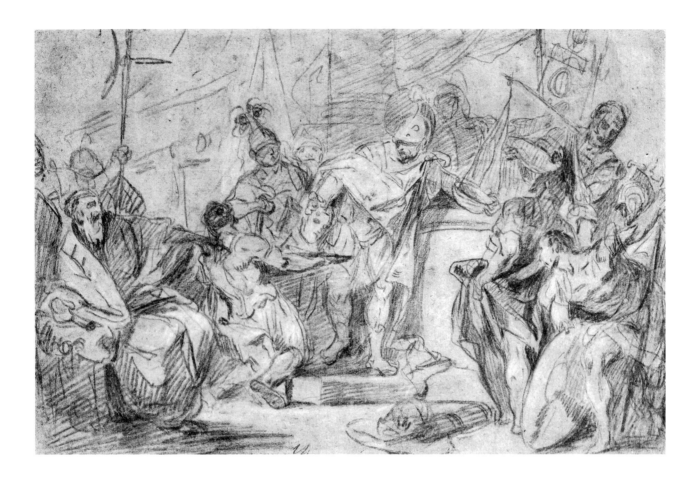

NICOLA MARCOLA

Verona 1738–Verona 1770

133. *Scene from Ancient History*
VERSO. *Leg and Arm of a Nude Male Figure*

Red chalk, heightened with white, on beige paper (recto); red chalk, stumped (verso). 25.2 x 39.1 cm.

Inscribed in brush and black ink on verso, *Di Nicola Marcola*; in graphite at upper margin, *91. Z. f 40x.*

PROVENANCE: Unidentified collector's mark on verso; [Victor Spark]; purchased in New York in 1968.

BIBLIOGRAPHY: *Annual Report*, 1967–1968, p. 87.

Rogers Fund, 1968
68.9

The eldest son of Giovanni Battista, Nicola Marcola had a brief career as an artist, dying at the age of thirty-two, and only a few of his paintings and drawings seem to have survived. Two sheets in the Biblioteca Civica, Verona, have been assigned to him (Romin

Meneghello, 1983, p. 120, pls. 208–210). These are stylistically compatible with our drawing, which bears an old and probably contemporary inscription, *Di Nicola Marcola*, on the verso.

The mysterious subject, a scene from ancient history in which a severed head is about to be placed in a scale, has not yet been identified, although many learned colleagues have been consulted.

AGOSTINO MASUCCI

Rome 1692–Rome 1758

134. *Studies for the Education of the Virgin*

Pen and brown ink. 21.5 x 22.7 cm. Vertical crease right of center.

Inscribed in pen and brown ink at lower right margin, *m 231*.

PROVENANCE: Walter C. Baker.

BIBLIOGRAPHY: Virch, 1962, no. 17, "Florentine, 16th century"; *Rome in the 18th Century*, 1978, n.pag. [14]; Bean, 1979, under no. 221; Turčić, 1982, pp. 275–278, pl. 24; Czére, 1985, p. 88, fig. 15, p. 91; Rosenberg and Michel, 1987, p. 285, under no. 90.

Bequest of Walter C. Baker, 1971
1972.118.12

The sheet bears six pen sketches for the group of St. Anne teaching the Virgin to read in one of Masucci's last paintings, the *Education of the Virgin*, signed and dated 1757, in SS. Nome di Maria, Rome (Martini and Casanova, 1962, p. 75, fig. 15; Titi, 1987, II, fig. 1000). Other drawings for this altarpiece have survived: a chalk study for the head of St. Anne identified by Anthony M. Clark in the Held collection and now in the Na-tional Gallery of Art, Washington, D.C., and a pen and wash study for the whole composition discovered by Lawrence Turčić in the Martin von Wagner Museum, Würzburg (repr. Turčić, 1982, fig. 2 and pl. 25, respectively).

The sheet is numbered *m 231* at lower right. Clark has pointed out that such inventory (?) numbers, preceded by a lowercase *m*, occur on drawings by eighteenth-century Roman artists such as Batoni, Cades, Ghezzi, and Masucci; the highest number so far recorded is *m 1014* on a drawing in Edinburgh attributed by Clark to Masucci (Andrews, 1968, fig. 261, as Circle of the Carracci).

135. *The Virgin Appearing at Mass*

Red chalk, pen and brown ink. Squared in red chalk. Framing lines in pen and brown ink. 34.7 x 25.2 cm. Lined.

PROVENANCE: [Claude Kuhn]; [Lutz Riester]; purchased in New York in 1989.

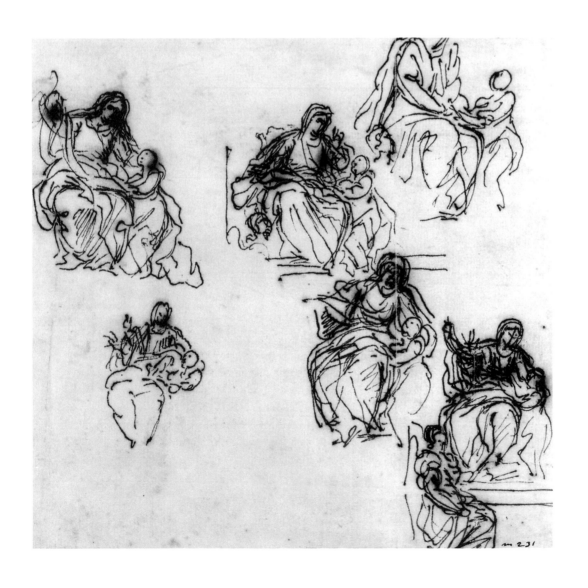

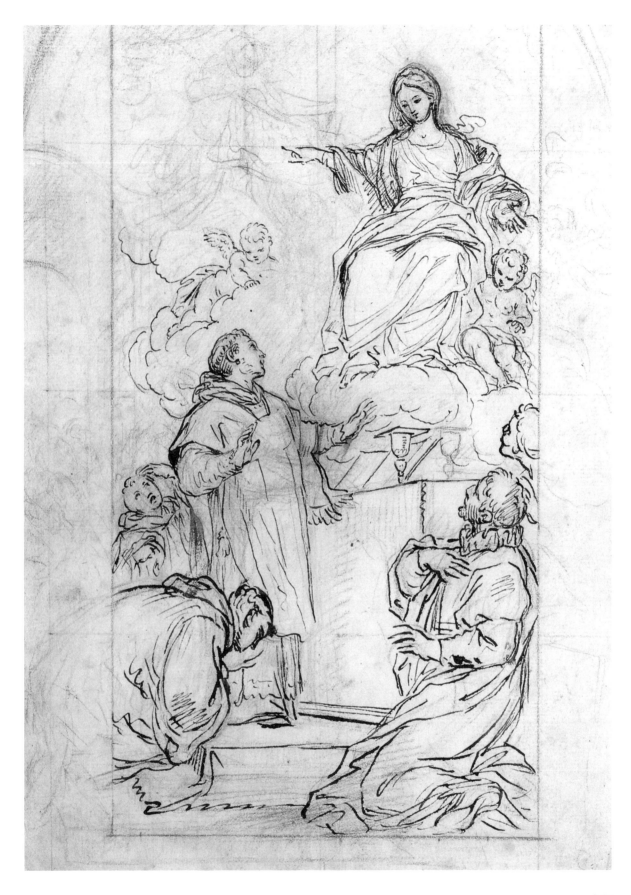

147

AGOSTINO MASUCCI (NO. 135)

BIBLIOGRAPHY: *Claude Kuhn. Handzeichnungen alter Meister*, exhibition catalogue, Basel, 1989, no. 10, repr. in color.

Van Day Truex Fund, 1989
1989.285

The attribution to Masucci is due to Manuela Mena Marqués, who pointed out that the same composition is studied in a drawing in the Biblioteca Nacional, Madrid, also recognized by her as the work of Masucci (Mena Marqués, 1984, no. 162, repr.). In both these designs the Virgin appears above an altar to a vested priest, who raises his hands in wonder. The presence of a covered chalice and open missal on the altar indicates that the vision occurs during the celebration of Mass. In both drawings the Virgin raises her right arm, and in our design she points at what seems to be an angel holding a large scapular, lightly indicated in red chalk at upper left.

ALESSANDRO MAURO

Venice ?–Turin before 1737

136. *Design for a Festival Gondola*

Pen and brown ink, over graphite. Framing lines in pen and brown ink. 33.2 x 48.2 cm. Vertical crease at center.

Inscribed in pen and brown ink at lower right, *bizona*; in light brown ink, *Alessan.º Mauro fe In.'*.

PROVENANCE: [Armando Neerman]; John Steiner.

BIBLIOGRAPHY: *Old Master Drawings. Armando Neerman*, exhibition catalogue, The National Book League, London, 1975, no. 31, repr.; *Annual Report*, 1976–1977, p. 45.

Gift of John Steiner, 1976
1976.343

Minerva seated, holding a spear and a helmet, presides over a *bissona* filled with trophies. An allegorical figure of Fortune stands on a globe at the prow of the festival craft.

Alessandro Mauro was one of a family of decorators and stage designers active in Italy and South Germany in the eighteenth century. The present sheet is, to our knowledge, the only signed drawing by Alessandro to have survived. The inscription *fe In.'* suggests that the drawing was meant to be engraved. An even more elaborate design for a *bissona* decorated in the "Chinese" manner for the regatta in honor of the Prince Elector of Saxony on May 27, 1716, was in fact engraved by Andrea Zucchi (Lorenzetti, 1937, p. 45, no. 12, fig. 78).

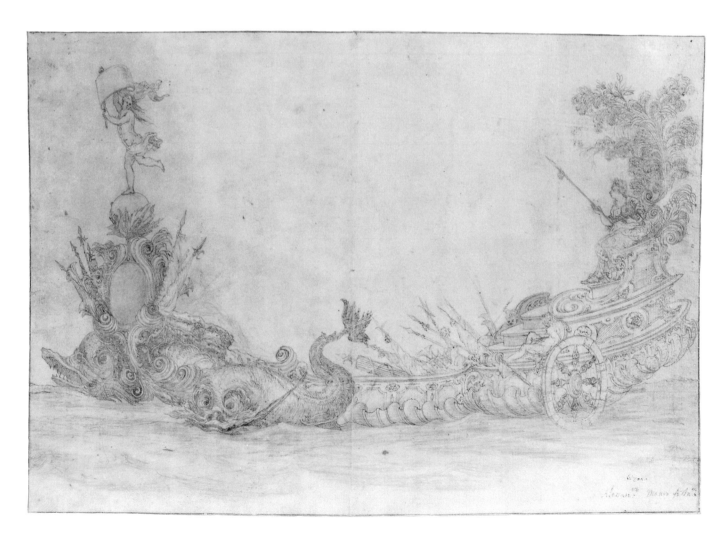

DOMENICO MONDO

Capodrise (Caserta) 1723–Naples 1806

137. *The Virgin Immaculate in Glory*

Point of brush and dark brown ink, brown wash, white gouache, over black chalk. 28.4 x 16.9 cm.

PROVENANCE: [Colnaghi]; purchased in London in 1964.

Rogers Fund, 1964
64.38.1

The attribution to Domenico Mondo was made in 1964 by James Byam Shaw. The subject is treated in other drawings by the artist; one is in a private collection in New York (Frick Art Reference Library photograph 38723), and another was on the art market in London in 1978 (Roli and Sestieri, 1981, no. 202, repr.).

FRANCESCO DE MURA

Naples 1696–Naples 1784

138. *The Assumption of the Virgin*

Pen and black ink, gray wash, over black chalk. 43.6 x 25.4 cm. Cut to shape of field.

Inscribed in graphite on verso, *J. Jouvenet.*

PROVENANCE: [Adolphe Stein]; purchased in London in 1971.

BIBLIOGRAPHY: *Old Master Drawings Presented by Lorna Lowe and Adolphe Stein*, exhibition catalogue, London, 1971, no. 80, "Neapolitan School (18th century)"; *Annual Report*, 1971–1972, p. 40.

Purchase, Howard J. and Saretta Barnet, Mr. and Mrs. Carl L. Selden and Mrs. Barbara K. Caturani Gifts and Rogers Fund, 1971
1971.243

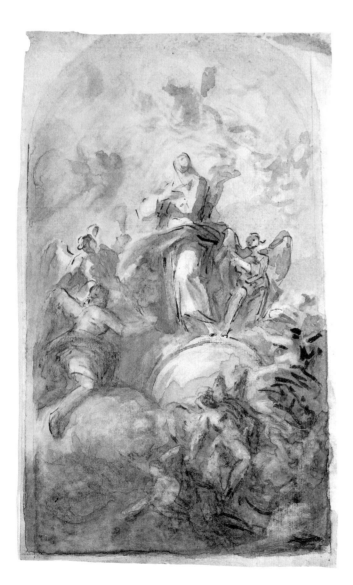

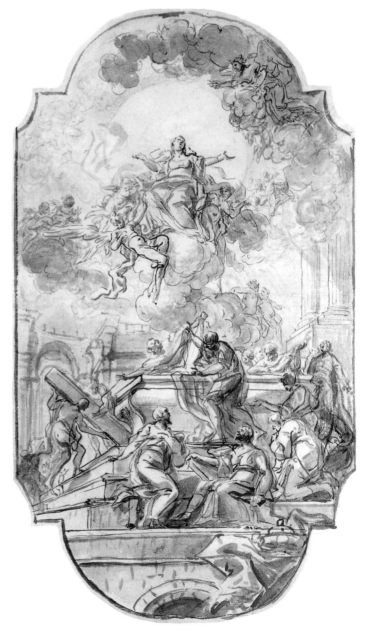

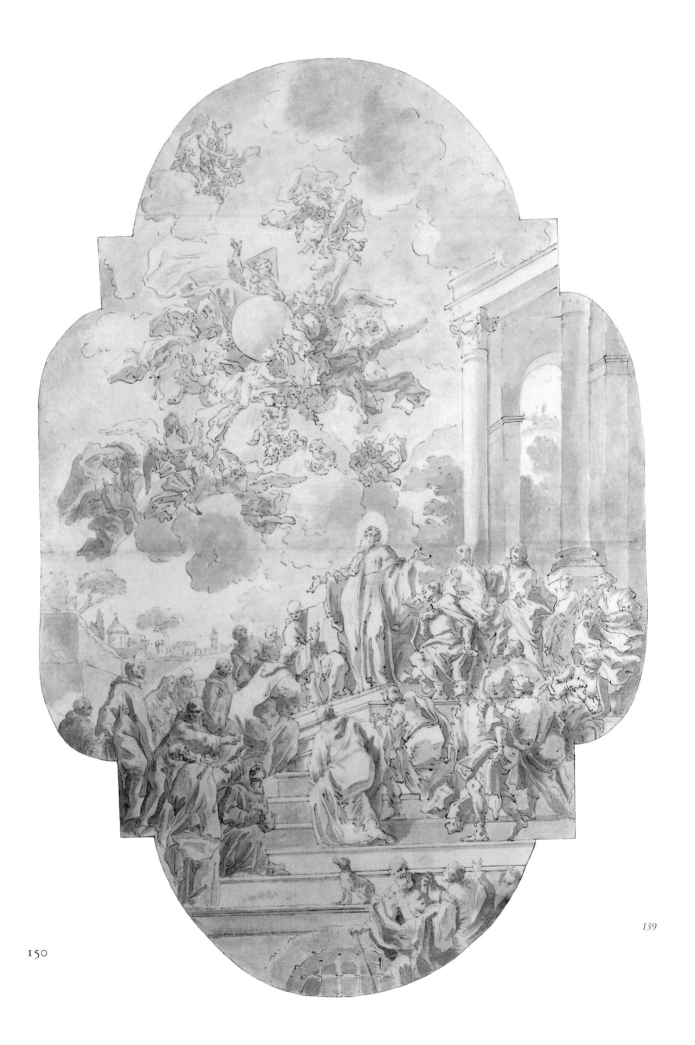

139

Francesco de Mura executed three major ceiling paintings representing the Assumption of the Virgin, all of them much influenced by the example of Francesco Solimena. The first of these was an *Assumption* painted about 1727 on the vault of the sacristy of the Annunziata in Airola, near Benevento (Rizzo, 1978, p. 97, fig. 5, p. 99). An oil sketch for this fresco is in the Pio Monte della Misericordia, Naples (Causa, 1970, pl. 31). In 1737 De Mura signed and dated a ceiling painting on canvas destined for a church in Gallipoli and now in the episcopal palace of that city (Pasculli Ferrara, 1981, p. 49, fig. 1, p. 64, note 4). Domenica Pasculli Ferrara cites three oil sketches for the Gallipoli *Assumption*. In 1986 Lawrence Turčić identified a pen and wash drawing by De Mura in the Louvre as a study for the Gallipoli picture; the Louvre drawing had been classified as a work of the studio of Francesco Solimena (Inv. 9787; Monbeig-Goguel and Vitzthum, 1967, no. 83).

The most ambitious *Assumption of the Virgin* by De Mura is that painted in 1751 on the ceiling of the Nunziatella in Naples (Enggass, 1964, fig. 7). An oil sketch for this fresco is preserved in the Museo di Capodimonte, Naples (Causa, 1957, pl. 36), and a presumably autograph replica of the Capodimonte sketch is in the Art Gallery of Ontario, Toronto (Enggass, 1964, fig. 8). Our drawing may be an early preparation for the monumental Nunziatella fresco. There are, however, notable differences between the drawing and the fresco. The apparition of the Holy Trinity at the summit of the painting is lacking in the drawing, where there are fewer figures in the foreground. In the drawing the setting is architectural, while in the fresco the background is a landscape. There are also differences in the shape of the field.

The attribution of this drawing to De Mura, made at the time of its acquisition in 1971, seems justified by comparing the facial types and the indications of drapery, hands, and feet with those in No. 139 below, which is certainly a study for a painting by the artist.

139. *The Vision of St. Benedict*

Pen and brown and gray ink, gray wash, over graphite. 56.5 x 38.2 cm. Cut to shape of field. Horizontal crease at center. Repaired losses.

PROVENANCE: [Colnaghi]; purchased in New York in 1987.

BIBLIOGRAPHY: *Old Master Drawings Presented by Jean-Luc Baroni. Colnaghi Drawings*, exhibition catalogue, Colnaghi, New York, 1987, no. 26, repr.; "New York. Four exhibitions of drawings," exhibition review by Lawrence Turčić, *Burlington Magazine*, CXXIX, 1987, p. 622; *Annual Report*, 1987–1988, p. 23.

Harry G. Sperling Fund, 1987
1987.191

St. Benedict stands at the center of the composition, looking upward at an apparition of the Holy Trinity. Around the saint are gathered members of the male and female religious orders that follow his monastic Rule, as well as lay men and women devoted to his cult.

The drawing is a study with a number of variations for a ceiling fresco, signed and dated 1740, at the center of the nave of SS. Severino e Sossio, Naples (Spinosa, 1986, no. 252, fig. 299). In the number and in the placement of the figures, an oil sketch at Capodimonte in Naples is closer to the finished fresco than our drawing (Naples, 1979, no. 89, repr.).

FRANCESCO NARICE (NARICI)

Genoa, documented in Naples 1751–1779

140. *The Assumption of the Virgin*

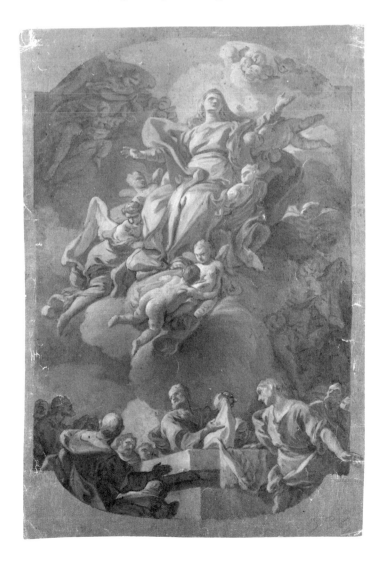

Brush, gray and cream tempera, on gray washed paper. 33.8 x 23.5 cm. Scattered abrasions.

Inscriptions in graphite on verso, an unidentified paraph followed by *Francesco Narice / 29 marzo 1839 –*.

PROVENANCE: [Colnaghi]; purchased in London in 1962.

BIBLIOGRAPHY: *Annual Report*, 1962–1963, p. 64, as Francesco de Mura.

Rogers Fund, 1962
62.130.4

The drawing was acquired in 1962 with a not implausible attribution to Francesco de Mura. It was not until 1986 that Lawrence Turčić deciphered the inscription dated 1839 on the verso that gives the drawing to Narice, an artist who was indeed strongly influenced by the style of De Mura, particularly in his monochrome sketches in oil or tempera. Drawings comparable in style and technique, some of them connected with paintings executed by Narice in his native Genoa, are in the National Gallery of Scotland, Edinburgh (Andrews, 1968, fig. 560), in the Bibliothèque Municipale, Rouen (Rosenberg and Schnapper, 1970, nos. 69–72, repr.), and in the Istituto Nazionale per la Grafica, Rome (Garms and Prosperi Valenti Rodinò, 1985, nos. 59 and 60, repr.).

Mary Newcome kindly points out that many of the significant features of our tempera sketch are to be found in an *Assumption* now in the church of the Immacolata, Genoa.

BARTOLOMMEO NAZARI ?

Clusone (Bergamo) 1699–Milan 1758

141. *Portrait of a Man in a Monastic Habit*

Black chalk, stumped, heightened with white, on gray-green paper. 29.6 x 22.4 cm.

PROVENANCE: Ferruccio Asta (Lugt Supp. 116a); Mr. and Mrs. Janos Scholz; transferred from the Department of Prints and Photographs, 1988.

Gift of Mr. and Mrs. Janos Scholz, 1952
52.218.1

This and the following two drawings were part of a large group of portraits, most of them with elaborate surrounds and cartouches, that come from an album that had been broken up by the Venetian dealer Ferruccio Asta before 1944. Janos Scholz still possesses nine of

141

these portraits and a title page with the inscription *Familia Agudia e Sormani*, indicating a Lombard provenance (one portrait repr. Pignatti, 1965–1, no. 106; another Bean and Stampfle, 1971, no. 169). In 1952 Mr. Scholz presented another portrait to the Rhode Island School of Design, Providence (Noris, 1982, p. 267, fig. 5). Two further portraits from the Asta album are in the Rijksprentenkabinet, Amsterdam (one repr. Aikema and Meijer, 1985, no. 104). Another is in the Frits Lugt Collection, Fondation Custodia, Paris (Byam Shaw, 1983, I, no. 293, III, pl. 342).

The attribution of these portrait drawings to Bartolommeo Nazari was first proposed by Janos Scholz and has been generally accepted. However, in 1985 Bernard Aikema pointed out that an even larger group of stylistically similar portraits in the Biblioteca Ambrosiana and in the Gabinetto delle Stampe del Comune, Milan, were attributed, without documentary evidence, by Franco Arese to the engraver Benigno Bossi (*Storia di Milano*, XII, Milan, 1959, 186 figs. throughout the vol-

142

143

ume). In style, these portraits are unlike drawings that can be attributed with certainty to Bossi.

Many of these portrait drawings are rather stiff and awkward, and the heads are often ill connected to the shoulders. A number of Bartolommeo Nazari's painted portraits—some of them now lost—were reproduced in engravings by Carlo Orsolini, Pietro Monaco, Marco Pitteri, Francesco Zucchi, and others. For these reproductive prints, often intended for book illustrations, the engraver supplied rich frames and cartouches similar in form and elaboration to those found on these portrait drawings (Noris, 1982, pp. 238–239, six such engravings repr. pp. 262 and 264). The importance of these ornamental surrounds and the weakness of the portraits themselves seem to suggest the work of an engraver-copyist. Nonetheless the issue is complicated by the fact that almost nothing is known of Nazari himself as a draughtsman, except for a pen and wash study of heads in the Albertina, Vienna, ascribed to him in the "Reliable Venetian Hand" (Bettagno, 1966, no. 108, repr.).

142. *Portrait of a Man Wearing a Wig*

Black chalk, stumped, heightened with white, on gray-green paper. 29.8 x 22.4 cm.

PROVENANCE: Ferruccio Asta (Lugt Supp. 116a); Mr. and Mrs. Janos Scholz; transferred from the Department of Prints and Photographs, 1988.

Gift of Mr. and Mrs. Janos Scholz, 1952
52.218.2

143. *Portrait of a Man in a Cap*

Black chalk, stumped, heightened with white, on faded gray-green paper. 30.0 x 22.4 cm.

PROVENANCE: Ferruccio Asta (Lugt Supp. 116a); marchese Antonio Roi, Vicenza (according to Virch); Walter C. Baker.

BIBLIOGRAPHY: Virch, 1962, no. 60; Bean and Stampfle, 1971, under no. 169; *Annual Report*, 1979–1980, p. 27; Byam Shaw, 1983, I, p. 304, under no. 293.

Bequest of Walter C. Baker, 1971
1972.118.262

PIETRO ANTONIO NOVELLI

Venice 1729–Venice 1804

144. *Diana Visiting the Sleeping Endymion*

Pen and brown ink, gray wash, over black chalk. 29.0 x 38.0 cm. overall, including an area 3.6 cm. wide on which the drawing is continued on the right in the artist's hand.

PROVENANCE: James Jackson Jarves; Cornelius Vanderbilt.

BIBLIOGRAPHY: *Metropolitan Museum Handbook*, 1895, p. 29, no. 456, "Sir Anthony Vandyck.—Selene and Endymion."

Gift of Cornelius Vanderbilt, 1880
80.3.456

In the past the drawing has been attributed to Van Dyck, no doubt because of the elegance of the figures. However, it is a typical example of the draughtsmanship of Pietro Antonio Novelli. The parallel hatching on the figures, the use of broad diagonal shading in the back-

ground, and the contrast between brown pen lines and gray wash are all characteristic.

145. *Enchained Nude Prisoner*

Pen and brown ink, brown, gray, and black wash, heightened with white, over black chalk, on faded violet washed paper. 27.2 x 15.5 cm.

PROVENANCE: Marquis Jean de Bailleul (Lugt 335); vicomte Bernard d'Hendecourt; Hendecourt sale, London, Sotheby's, May 8–10, 1929, no. 267, as Pietro Tacca; [Savile Gallery]; Mr. and Mrs. R. Kirk Askew, Jr.

BIBLIOGRAPHY: *Drawings by Old Masters. Savile Gallery*, exhibition catalogue, London, 1930, no. 25, repr. in color, as Pietro Tacca; Parker, 1960, pp. 58–59; Poughkeepsie, 1961, no. 31, repr., as Pietro Tacca; Macandrew, 1980, p. 179, under no. 1029A; *Annual Report*, 1981–1982, p. 22; George Knox in *Lehman Collection*. VI, 1987, pp. 79–80, under no. 64.

145

The drawing belongs to a large group of studies by Novelli that are copied after or derived from sculptural models. Some of these—including ours—seem to be very free copies after the chained bronze slaves, *I Mori*, by Pietro Tacca that surround the base of the monument to Ferdinand I de' Medici in Livorno (1626). Novelli may have copied metal or plaster reductions of these celebrated figures. One such drawing is in the Robert Lehman Collection at the Metropolitan Museum (George Knox in *Lehman Collection.* VI, 1987, no. 64, repr.); another, like ours on a violet preparation, is in the Ashmolean Museum, Oxford (Macandrew, 1980, pp. 179–180, no. 1029A). All three of these drawings were attributed to Pietro Tacca in the past, though the draughtsmanship seems clearly that of Pietro Antonio Novelli.

GIOVANNI ODAZZI

Rome 1663–Rome 1731

146. *St. Gregory the Great Interceding for Souls in Purgatory*

Pen and brown ink, brown wash, over black chalk. 31.2 x 20.3 cm. Arched top. Horizontal crease at center.

PROVENANCE: Cephas G. Thompson.

BIBLIOGRAPHY: *Metropolitan Museum Handbook*, 1895, p. 41, no. 712, "Lanfranco.—The Pope Offering a Prayer to the Father."

St. Gregory the Great, pope, is identified by the dove that hovers at his ear and the papal tiara held by a putto. On clouds above, the Virgin also intercedes with Christ for souls in Purgatory. Below, angels lift these souls from the cleansing fires.

This drawing was identified as a characteristic work

of Giovanni Odazzi by Lawrence Turčić in 1987; it had previously been classified amongst the anonymous Italian drawings. The physical types and the pen work here, which owe a great deal to the example of Gaulli, are paralleled in a large design by Odazzi in the University of Michigan Museum of Art that is a study for the cupola of the Elci Chapel, S. Sabina, Rome (Wunder, 1965, no. 14, repr.; for the cupola, see Trimarchi, 1979, no. 19, figs. 21, 22).

SANTE PACINI

Florence 1735–Florence ca. 1790

147. *Saints and Prophets in Glory, after Bernardino Poccetti*

Black chalk. Framing lines in pen and brown ink and gray wash. 21.2 x 31.8 cm. Lined.

Inscribed in pen and black ink on Mariette mount, *Pictum sacello domestico Marchion. Geriniorum Florentiae a Bern. Poccetti*; in cartouche, DELINEABAT / SANTES PACINI

PROVENANCE: Pierre-Jean Mariette (Lugt 2097); Mariette sale, Paris, 1775–1776, part of no. 607, Poccetti: "Huit Sujets d'une grande composition, peints et exécutés à Florence par cet Auteur, dans les Monastères de l'Annonciade et autres, dessinés, d'après les Tableaux, à la pierre noire, par Pacini"; [Colnaghi]; purchased in London in 1966.

BIBLIOGRAPHY: *Annual Report*, 1966–1967, p. 60.

Rogers Fund, 1966
66.201

Pierre-Jean Mariette possessed—and may even have commissioned—a good many copies by Sante Pacini after paintings by earlier Florentine masters. These copies record major works, often frescoes, by Cristofano Allori (Mariette sale, no. 122), Giovanni da S. Giovanni (no. 476; now Darmstadt AE 2082), six after Masaccio in the Brancacci Chapel (no. 497), Santi di Tito (no. 548; now Darmstadt AE 2081), and Cosimo Ulivelli (no. 547). Under no. 607, the Mariette sale catalogue lists eight copies by Pacini after Poccetti. Four of these are now in the Cabinet des Dessins, Musée du Louvre (Viatte, 1988, nos. 360–363, repr.). Our drawing accounts for one more in the group of eight; the remaining three copies have not been located.

As the old inscription on the mount attests, our drawing reproduces decorations by Poccetti in the private chapel of the Palazzo Gerini, Florence. Stefania Vasetti kindly informs us in a letter of October 10, 1988, that Pacini has copied the fresco by Poccetti on the left wall of the chapel. On the opposite wall, Poccetti painted the Fathers of the Church discoursing on the Holy Sacrament.

PIETRO GIACOMO PALMIERI

Bologna 1737–Turin 1804

148. *Trompe-l'Oeil Exercise: Prints on a Table Top*

Pen and brown ink, brown wash, over traces of graphite. 41.3 x 56.1 cm.

Signed and dated at lower center, *Pietro Giacomo Palmieri Disegnò a Penna L'anno 1766—.*; various inscriptions by Palmieri identifying prints represented.

PROVENANCE: Sir Bruce Ingram (Lugt Supp. 1405a on old mount); Carl Winter (his mark, CWR, at lower right, not in Lugt); sale, London, Sotheby's, July 1, 1965, no. 82; [Schab]; purchased in New York in 1969.

BIBLIOGRAPHY: *Annual Report*, 1968–1969, p. 67; Bean and Stampfle, 1971, no. 293, repr.; Bean, 1972, no. 33; Dalmasso, 1972, p. 132, fig. 2; Griseri, 1978, under no. 79; Mahon and Turner, 1989, pp. 106–107, under no. 246.

Rogers Fund, 1969
69.14.1

Palmieri was both a painter and a printmaker, but he was above all a virtuoso draughtsman capable of brilliant trompe-l'oeil effects. The prints that figure here—inscribed with the names of Berchem, Della Bella, Callot, and Jean Pesne (after Guercino)—are in most cases copied fairly exactly. However, Della Bella's mustachioed Pole sports an earring added by Palmieri. The illusionistic effect is heightened by the bent corners of the prints with their cast shadows.

This and the following drawing are signed and dated

PIETRO GIACOMO PALMIERI (NO. 148)

1766, while Palmieri was still in Bologna. He continued to produce similar amusing calligraphic exercises after he settled in Turin in 1778. In the Biblioteca Reale of that city there is a trompe l'oeil with prints that is dated 1780 (Griseri, 1978, no. 79, repr.).

149. *Trompe-l'Oeil Exercise: Prints on a Table Top*

Pen and brown ink, brown wash, over traces of graphite. 41.7 x 56.9 cm.

Signed and dated at lower left, *Pietro Giacomo Palmieri Inventò, e fece a Penna 1766*; various inscriptions by Palmieri identifying prints represented.

PROVENANCE: Sir Bruce Ingram (Lugt Supp. 1405a on old mount); Carl Winter (his mark, CWR, at lower right, not in Lugt); sale, London, Sotheby's, July 1, 1965, no. 81; [Schab]; purchased in New York in 1969.

BIBLIOGRAPHY: *Annual Report*, 1968–1969, p. 67; Bean and Stampfle, 1971, no. 294, repr.; Bean, 1972, no. 34; Dalmasso, 1972, p. 131, fig. 1, p. 132; Griseri, 1978, under no. 79.

Rogers Fund, 1969
69.14.2

Unlike the previous illusionistic display of prints, in which earlier masters were honored, Palmieri here takes credit for most of the work shown. At lower left appears the corner of a musical manuscript with a rolled-up edge, the score for a *Messa a 4 Voci con Stromenti*.

GIOVANNI PAOLO PANINI

Piacenza 1691/1692–Rome 1765

150. *The Lottery in Piazza di Montecitorio*

Pen and black ink, watercolor, over graphite. Framing lines in pen and black ink at left, right, and upper margins. 34.0 x 54.5 cm. Repaired loss at lower right margin.

Dated in pen and black ink at lower right, *1743*. Inscribed in pen and brown ink on fragment of old mount, *Bozzetto Originale del Caval.ᵉ Giō Pauolo Panini del Quadro dell'Estrazione del Lotto di Roma, da esso eseguito per L.Emō Cardinale Domenico Orsini.*

PROVENANCE: Illegible, unidentified collector's mark at lower right corner of old mount; [Zabert, Turin]; [Agnew]; purchased in London in 1968.

BIBLIOGRAPHY: *Apollo*, LXXXV, May 1967, advertisement supplement, p. lxv, repr.; *Annual Report*, 1968–1969, pp. 66, 67; Draper, 1969, pp. 27–34, pls. 15–17; Borsi, 1970, pp. 96, 97, pl. XLIV; Bean and Stampfle, 1971, no. 55, repr.; Pietrangeli, 1971, p. 129; *Notable Acquisitions*, 1975, p. 58, repr.; *Rome in the 18th Century*, 1978, n.pag. [15]; Borsi, Briganti, and Venturoli, 1985, repr. in color on dust jacket; Arisi, 1986, p. 404, under no. 346, repr.; Pinto, 1986, pp. 173, 174, fig. 127.

Rogers Fund, 1968
68.53

James David Draper was the first to give a complete account of the subject and purpose of this exceptional drawing. As the contemporary inscription attached to the lower margin of the sheet attests, this large view is a *bozzetto* for a painting in a private collection in London representing the drawing of the Roman lottery on the balcony of the Palazzo di Montecitorio (Draper, 1969, figs. 1–3). The painting is said to have been commissioned by Cardinal Domenico Orsini (1719–1789; created September 9, 1743), and the inscription itself cannot predate October 1749, when Panini was granted the title *Cavaliere dello Sperone d'oro*.

The view is very accurate, although Panini has taken certain liberties in showing on the right the whole Column of Marcus Aurelius, which in fact at the time was obscured by buildings separating the Piazza Colonna from the Piazza di Montecitorio. At the right is the base of the Column of Antoninus Pius, excavated near the Palazzo di Montecitorio in 1703 and in 1705 set up by Carlo Fontana in the square, where it remained until 1764. Today it is in the Cortile della Pigna of the Vatican. The obelisk that now stands in the center of the square was erected there between 1788 and 1792.

In composition the drawing corresponds quite closely to the painting, but in the latter the figures are larger in scale and differently grouped. Edward Croft-Murray

identified two chalk figure studies by Panini for the painting in a sketchbook preserved in the British Museum (*Old Master Drawings*, XI, March 1937, p. 61, pl. 57), and James Draper found further figure studies in the Kupferstichkabinett, Berlin-Dahlem, in the Witt Collection at the Courtauld Institute, London, and in a Swiss private collection (Draper, 1969, pp. 29–33, pls. 18–24).

151. *Scalinata della Trinità dei Monti*

Pen and black ink, gray wash, watercolor, over graphite. 34.8 x 29.3 cm. Lined.

Inscribed in pen and brown ink on verso, *g. p. panini*, and *N° 110.*

PROVENANCE: Jacques-Laure Le Tonnelier de Breteuil, le bailli de Breteuil; posthumous sale, January 16–25, 1786, no. 76; Jean-Baptiste-Pierre Lebrun; Lebrun sale, March 11–30, 1791, no. 260; marquis de Lagoy (Lugt 1710); no. 136 in manuscript inventory of Lagoy collection; Maldwin Drummond (according to Christie's); sale, London, Christie's, June 23, 1970, no. 152, repr.; [Calmann]; purchased in London in 1971.

BIBLIOGRAPHY: *Annual Report*, 1970–1971, p. 16; *Apollo*, XCVI, November 1972, p. 450, fig. 8; Bean, 1972, p. 14, no. 35; Gillies, 1972, pp. 176–184, fig. 1, repr. in color on back cover; *Rome in the 18th Century*, 1978, n.pag. [15].

Rogers Fund, 1971
1971.63.1

The Scalinata was built in 1723–1725 on the designs of the architect Francesco De Sanctis. Constructed with funds supplied by a French diplomat, it leads from the Piazza di Spagna up to SS. Trinità dei Monti, a church of French foundation then served by the Minims. The view is essentially the same today, although an obelisk was set up at the top of the steps by Pius VI in 1786, and the Hassler Hotel has replaced most of the low buildings to the right of the church.

Paintings of the Scalinata appear in two versions of Panini's *Vedute di Roma moderna*, one in the Boston Museum of Fine Arts, the other in The Metropolitan Museum of Art, both of which are dated 1757 (Arisi, 1986, nos. 471 and 475, repr., respectively). No independent painting of the Scalinata has survived, and it is possible that the scene incorporated in the composite views in Boston and New York is based on our watercolor.

The drawing has a distinguished provenance, and its ownership can be traced back to Jacques-Laure Le

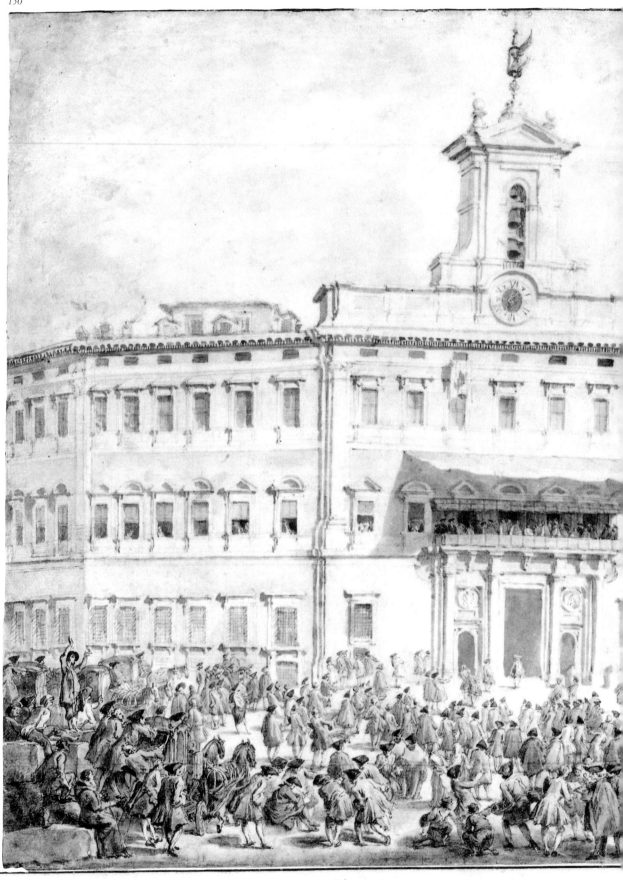

Il Bozzetto Originale del Caval.re Giō Paolo Panini del Quadro dell'Estrazion...

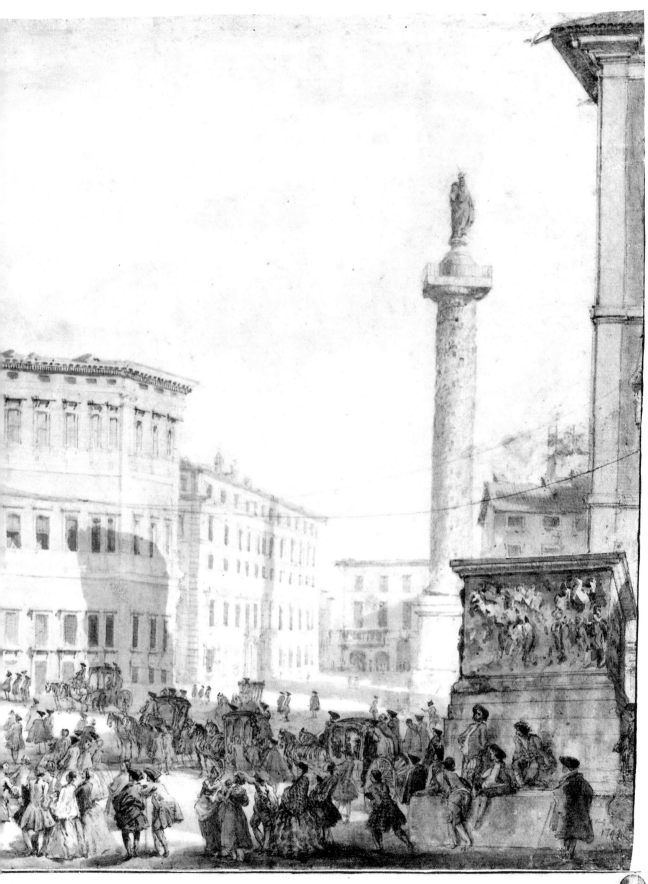

di Roma, da esso eseguito per S. Em̃o Cardinale Domenico Orsini.

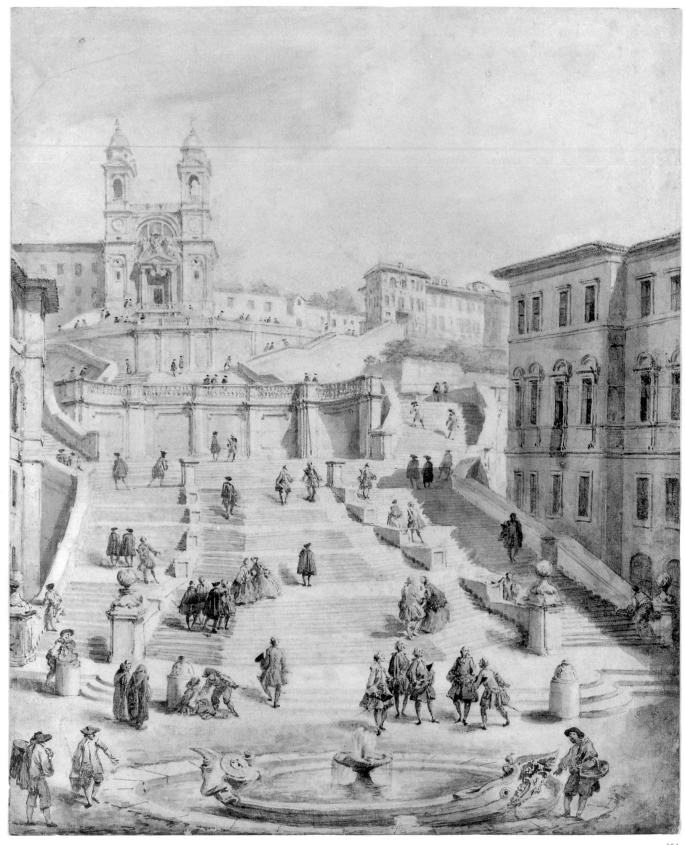

162

GIOVANNI PAOLO PANINI (NO. 151)

Tonnelier de Breteuil, bailli-grand-croix of the Sovereign Order of Malta from 1757 and ambassador of the order in Rome from 1758 to 1777. As ambassador, Breteuil would have officiated in the Palazzo di Malta on the via Condotti that leads out of the Piazza di Spagna at the foot of the Scalinata.

An old and fairly exact copy of our drawing is in the Biblioteca dell'Istituto Nazionale d'Archeologia e Storia dell'Arte, Rome (Cianfarani, 1956, p. 40, no. 170, pl. VII).

152. *St. Paul Preaching in Athens*
(Acts 17:22–34)

Pen and brown ink, pale gray wash, over graphite. 38.9 x 27.8 cm.

Inscribed in pen and brown ink in the artist's hand at lower left corner, I.P PANINI INV / *1733*.

PROVENANCE: [Schaeffer]; purchased in New York in 1946.

Rogers Fund, 1946
46.80.2

The inscription IGNOTO DEO on the altar in the left background toward which the orator gesticulates identifies

the scene as St. Paul preaching on the Areopagus. There the Apostle of the Gentiles had found an altar dedicated to an "unknown god," which became the subject of a discourse recorded in the Acts of the Apostles.

The drawing is related to but does not correspond exactly with several paintings by Panini that also date from the 1730s and represent St. Paul preaching (Arisi, 1986, nos. 213, 235, 262, 263, repr.).

153. *Man Shading His Face with a Tricorne*

Pale brown wash, over graphite. 21.6 x 10.6 cm. Scattered small stains. Lined.

PROVENANCE: Duke of Aosta, Turin; Harry G. Sperling.

BIBLIOGRAPHY: Wellesley, 1960, no. 1, "Anonymous Italian, ca. 1750"; Bean and Stampfle, 1971, no. 56, repr.; *Annual Report*, 1974–1975, p. 50; Goldner, 1988, p. 70, under no. 25.

Bequest of Harry G. Sperling, 1971
1975.131.42

Panini made many such studies for the accessory figures in his painted views of Rome. The Kupferstichkabinett, Berlin-Dahlem, and the British Museum, London, possess substantial groups of sketches of this sort, executed in black chalk, red chalk, or a combination of the two (Arisi, 1961, Dis. 37–40, 70–72, 77–78, 111–116, 136–146, 148–154, 163–167, 171–193, 197–203 [Berlin]; 217–355 [London]). The present example is unusual in technique; the figure is modeled in transparent brown wash over summary graphite contours. In spite of this difference in technique and the fact that the attribution to Panini is of recent date, our figure sketch seems compatible with those in Berlin and London.

A sheet of similar figure studies, in gray wash over summary black chalk contours, has recently been acquired by The J. Paul Getty Museum, Malibu (Goldner, 1988, no. 25, repr.).

FILIPPO PEDRINI

Bologna 1763–Bologna 1856

154. *Orpheus and Eurydice*

Pen and brown ink, brown wash, over black chalk. 27.8 x 19.6 cm. Lined.

Inscribed in pen and brown ink at lower left margin of old mount, *Gaetano Gandolfi.*

PROVENANCE: Cephas G. Thompson.

4

BIBLIOGRAPHY: *Metropolitan Museum Handbook*, 1895, p. 41, no. 718, "Gaetano Gandolfi.—Orpheus and Eurydice"; Nora Clerici Bagozzi in *Settecento Emiliano*, 1979, p. 145, under no. 310.

Gift of Cephas G. Thompson, 1887
87.12.48

Orpheus guides Eurydice out of the Underworld as the three-headed Cerberus barks savagely at lower left. The drawing, attributed in the past to Gaetano Gandolfi, was ascribed to Filippo Pedrini by Mimi Cazort, who associates it with a small painting by the artist in the Pinacoteca Nazionale, Bologna (Bolaffi, VIII, p. 383, fig. 540).

In the Pinacoteca di Brera, Milan, there is a pen and wash sketch of the same subject, in which Eurydice raises both hands in fright and Orpheus is seen from behind (no. 135). The pen work in the Milan version is somewhat confused, but it might also be the work of Pedrini.

FILIPPO PEDRINI ?

155. *Allegorical Figure of Chastity*

Pen and brown ink, brown wash, over graphite. 28.9 x 20.6 cm.

Inscribed in pen and brown ink at lower center, *Castità*; in graphite at bottom right, *Pedrini Giuseppe / 20*; inscribed in pen and brown ink on verso, *Per Sua E . . . il Sig. C. Opizoni fatto da . . Pedr . . .* ; in graphite, *Pedrini Gius. Venezia discepolo del Maggioto*.

PROVENANCE: Unidentified collector's mark (a coat of arms stamped blind); H. M. Calmann.

BIBLIOGRAPHY: *Annual Report*, 1970–1971, p. 15, as Giuseppe Pedrini.

Gift of H. M. Calmann, 1971
1971.100

Chastity is identified by her attributes: the column at left, the scepter she holds, the snake at her foot, the putto with a pair of doves, and a stylized cinnamon tree in the background.

156

FILIPPO PEDRINI ? (NO. 155)

The partial illegibility of the old inscription on the verso led a modern collector to attribute the drawing to the very obscure Venetian artist Giuseppe Pedrini. However, the work is clearly Bolognese and may reasonably be given to Filippo Pedrini or, perhaps, to his father, Domenico (Bologna 1728–1800)—there is as yet no clear distinction between the work of father and son.

GIOVANNI ANTONIO PELLEGRINI

Venice 1675–Venice 1741

156. *Head of Pompey Presented to Julius Caesar* VERSO. *Study for an Elaborate Door Frame*

Pen and brown ink, brown wash, over red and black chalk (recto); pen and brown ink, brown wash, over black chalk (verso). 28.7 x 37.3 cm.

Inscribed on verso in pen and brown ink, *N 152—second . . .* ; in graphite, *più antico*; in another hand, *Pellegrini.*

156 v. (detail)

PROVENANCE: Private collection, Venice; John S. Newberry.

BIBLIOGRAPHY: Pignatti, 1959, pp. 451, 453, fig. 51; *Annual Report*, 1961–1962, pp. 64–66, repr.; Pignatti, 1965–1, no. 6, repr.; Bean and Stampfle, 1971, no. 23, repr.; Paris, 1971, pp. 104–105, under no. 128; Pigler, 1974, II, p. 374.

Gift of John S. Newberry, 1961
61.210

The scene is presented as a grand historical pageant. A similar friezelike composition was utilized by Pellegrini in a painting representing the body of Darius brought before Alexander, formerly in a villa near Padua (Martini, 1964, fig. 69). Two preparatory drawings for this painting have survived (Bettagno, 1959, nos. 64 and 65, repr.). They share with our sketch the same extraordinarily excited and abbreviated pen work.

Pellegrini treated the present subject, the head of Pompey presented to Caesar, in a painting that is very differently composed: only four figures are included, and they are seen in half-length, crowded into the foreground of a field that is almost square (Paris, 1971, no. 128, repr.; sale, Monte Carlo, Sotheby's Monaco, November 29, 1986, no. 315, repr.).

GIUSEPPE PIATTOLI

active in Florence 1785–1807

157. *The Sword of Damocles*

Pen and brown ink, brown wash, over black chalk, on pale green washed paper. 42.1 x 59.8 cm. Vertical crease at center. Repaired losses at upper left and lower right corners. Lightly foxed. Lined.

Inscribed in pen and black ink at lower right corner, *P. Veronese— / 1528–1588—*.

PROVENANCE: James Jackson Jarves; Cornelius Vanderbilt.

BIBLIOGRAPHY: *Metropolitan Museum Handbook*, 1895, p. 25, no. 373, "Paolo Veronese.—The Sword of Damocles"; Ruggeri, 1978, pp. 415–418, pl. 27; Knox, 1989, p. 52, under no. 34.

Gift of Cornelius Vanderbilt, 1880
80.3.373

When Damocles, a servile courtier of Dionysius I of Syracuse, fawningly extolled the tyrant's riches and happiness, the latter feasted him with a sword hung by a hair above his head (Cicero, *Tusculan Disputations*, V, 61–62). This subject is rare in Italian art.

In 1976 Ugo Ruggeri recognized this drawing as the work of Piattoli.

GIUSEPPE PIATTOLI

158. *Scene from Ancient History*

Pen and brown ink, brown wash, over black chalk. Framing lines in pen and brown ink at left, upper, and right margins. 39.4 x 50.4 cm. Lined.

Inscribed in pen and brown ink at lower margin of old mount, *S. Rosa. 1615–1673.*

PROVENANCE: James Jackson Jarves; Cornelius Vanderbilt.

BIBLIOGRAPHY: *Metropolitan Museum Handbook*, 1895, p. 24, no. 352, "Salvator Rosa.—Torture of a Prisoner"; Ruggeri, 1978, pp. 415–417, pl. 28; Knox, 1989, p. 52, under no. 34.

Gift of Cornelius Vanderbilt, 1880
80.3.352

We have been unable to find the literary source for this cruel scene of summary military justice. An oriental monarch, identified by a crowned turban that has fallen to the ground, is about to lose his right foot to the axe wielded by the figure kneeling in the center.

Both the composition and the physical types owe much to the example of Salvator Rosa, to whom the drawing was attributed in the past. Rosa's etching, the *Death of Atilius Regulus* (Wallace, 1979, no. 110, repr.), seems to have been a primary source for this drawing by Piattoli. The attribution to this artist was proposed by Ugo Ruggeri in 1976.

GIOVANNI BATTISTA PIAZZETTA

Venice 1683–Venice 1754

159. *David with the Head of Goliath*
VERSO. *Lower Leg and Right Foot*

Black chalk, on gray-blue paper. 19.1 x 25.9 cm. Scattered stains. Surface somewhat abraded.

Inscribed in pen and dark brown ink at lower left margin by the "Reliable Venetian Hand," *Giambatista Piazzetta Veneziano.*

159

PROVENANCE: "Reliable Venetian Hand" (Lugt Supp. 3005c–d); [Colnaghi]; purchased in London in 1966.

BIBLIOGRAPHY: *Annual Report*, 1966–1967, p. 60; Bettagno, 1966, no. 74, repr. (not in exhibition); Ruggeri, 1967, p. 58, as Giulia Lama; Ruggeri, 1973, pp. 39–40, 46, no. 183, pl. 140, as Giulia Lama; Mariuz, 1982, p. 82, under no. 29; Knox, 1983, pp. 78–79, no. 21, repr.

Rogers Fund, 1966
66.53.4

This vigorous figure study and No. 160 below bear convincing attributions to Piazzetta in the "Reliable Venetian Hand." Such inscriptions, in neat, slanting letters, giving the artist's name and place of origin, are the work of a still-unidentified Venetian collector of the eighteenth century whose taste and exceptional erudition were the subject of an instructive exhibition organized by Alessandro Bettagno in 1966. Other drawings that belonged to this collector are Nos. 38, 166, and 273 in this catalogue.

Piazzetta reversed this figure of David holding the severed head of Goliath in two paintings: one in a private collection (Mariuz, 1982, no. 29, repr.), the other in the Gemäldegalerie, Dresden (Pallucchini, 1956, fig. 61; Mariuz, 1982, pl. X, in color, no. 30).

159 v.

160. *Executioner Holding Up a Severed Head*

Black chalk, heightened with white, on gray-blue paper. 40.5 x 26.6 cm.

Inscribed in pen and brown ink at lower right margin by the "Reliable Venetian Hand," *Giamba . . . Piazzetta Venez?* (partially abraded); in graphite at lower left, *Sebastiano Piombo,* and *Piombo.*

PROVENANCE: "Reliable Venetian Hand" (Lugt Supp. 3005c–d); [Victor Spark]; purchased in New York in 1961.

BIBLIOGRAPHY: *Annual Report,* 1961–1962, p. 67; Pignatti, 1965–1, no. 47, repr.; Bettagno, 1966, no. 75, repr.; Ruggeri, 1967, p. 58, as Giulia Lama; Rodolfo Pallucchini, *Arte Veneta,* XXII, 1968, p. 128, note 3, as Giulia Lama; Bean and Stampfle, 1971, no. 37, repr.; Ruggeri, 1973, pp. 20, 39, 46, no. 182, pl. 142, as Giulia Lama; Sutherland Harris in Los Angeles, 1976, p. 166, under no. 43; Knox, 1983, pp. 25, 80–81, no. 22, repr.

Rogers Fund, 1961
61.204

A similar mustachioed executioner, posed somewhat differently, appears in Piazzetta's painting *The Martyrdom of St. Paul,* now in an Italian private collection (Pallucchini, 1956, pl. 113; Mariuz, 1982, no. 156, repr.). Ugo Ruggeri was the first to point out that the figure in this drawing was copied in a small Piazzettesque painting, *The Martyrdom of St. Eurosia,* in the Ca' Rezzonico, Venice (Ruggeri, 1973, p. 24, fig. 21; Los Angeles, 1976, p. 165, repr.). The painting is generally ascribed to Giulia Lama, and Ruggeri was led to attribute the present drawing and No. 159 above to this rather derivative artist. However, both our drawings display a vigor and authority that is absent in the graphic material presented by Ruggeri as the work of Lama. If she was indeed the painter of the Ca' Rezzonico picture, Giulia Lama must have simply borrowed this executioner from Piazzetta's repertory of figures.

161. *Feeding the Dog*

Black chalk, heightened with white, on blue-gray paper faded to brown. 39.3 x 52.3 cm. Scattered losses. Vertical crease at center.

PROVENANCE: [Giuseppe Cellini, Rome]; Walter C. Baker.

BIBLIOGRAPHY: New York, 1959, no. 37, pl. XL; Claus Virch, *Metropolitan Museum of Art Bulletin,* XVIII, June 1960, p. 312, fig. 3; Virch, 1962, no. 56, repr.; Bean and Stampfle, 1971, no. 40, repr.; Meder, 1978, II, pl. 187; Mariuz, 1982, no. D 16, repr.; Knox, 1983, p. 132, no. 49, repr.

Bequest of Walter C. Baker, 1971
1972.118.266

GIOVANNI BATTISTA PIAZZETTA (NO. 161)

No. 162 below is probably the pendant to this brilliant and exceptionally well-preserved drawing. Both are dated about 1740 by George Knox.

162. *Boy with an Egg, Girl with a Hen, and a Watching Woman*

Black chalk, heightened with white, on blue-gray paper faded to brown. 39.7 x 52.7 cm. Vertical crease at center. Upper corners made up.

PROVENANCE: [Giuseppe Cellini, Rome]; Walter C. Baker.

BIBLIOGRAPHY: Virch, 1962, no. 57; Bean and Stampfle, 1971, no. 41, repr.; Mariuz, 1982, no. D 17, repr.; Knox, 1983, p. 133, no. 50, repr.

Bequest of Walter C. Baker, 1971
1972.118.267

Probably the pendant to No. 161 above, and thus also datable about 1740.

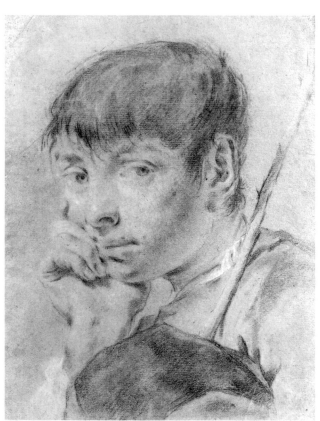

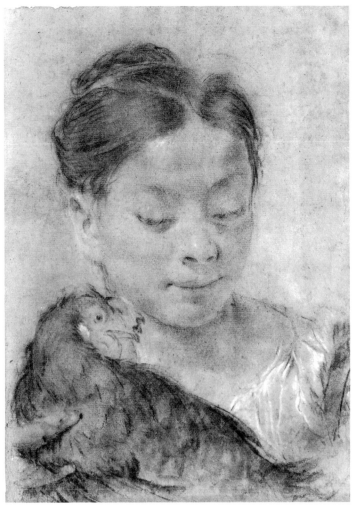

164

163. *Boy with a Staff*

Black chalk, heightened with white, on blue-gray paper faded to light brown. 31.9 x 25.0 cm. Upper right corner made up.

PROVENANCE: Unidentified collector's mark on verso (arrow through an oval, in violet); [V. A. Heck]; purchased in Vienna in 1936.

BIBLIOGRAPHY: Margaretta M. Salinger, *Metropolitan Museum of Art Bulletin*, XXXII, February 1937, pp. 38–40, repr.; Baltimore, 1944, no. 46; Knox, 1983, pp. 114–115, no. 39, repr.; Knox in Venice, 1983, no. 51, repr.

Fletcher Fund, 1936
36.144

Margaretta Salinger called attention to two copies of this drawing, one in the Albertina, Vienna (*Beschreibender Katalog*, I, 1926, no. 252, repr.), and another, the present whereabouts of which is unknown (Rey, 1922, p. 163, repr.). George Knox dates the drawing about 1715–1718.

164. *Girl with a Hen*

Black chalk, heightened with white, on blue-gray paper faded to light brown. 37.8 x 27.1 cm.

PROVENANCE: Dan Fellows Platt; [Ferargil Gallery]; purchased in New York in 1938.

BIBLIOGRAPHY: *Metropolitan Museum of Art Bulletin*, XXXIV, April 1939, p. 101; Baltimore, 1944, no. 47; Knox, 1983, pp. 112–113, no. 38, repr.; Knox in Venice, 1983, no. 50, repr.

Harris Brisbane Dick Fund, 1938
38.179.5

George Knox dates this drawing about 1715–1718.

GIOVANNI BATTISTA PIRANESI

Mogliano (Mestre) ? 1720–Rome 1778

165. *Two Men Holding Long Staffs*
VERSO. *Proof impression of part of an etching, and scribbles in the artist's hand*

Pen and brown ink. 16.6 x 21.3 cm. Scattered stains.

PROVENANCE: Unidentified collector (Lugt Supp. 735a); unidentified collector's mark (stamped in blue at lower left of recto, not in Lugt); Walter C. Baker.

BIBLIOGRAPHY: Virch, 1962, no. 64; Bean and Stampfle, 1971, no. 238, repr.

Bequest of Walter C. Baker, 1971
1972.118.269

The roughly drawn figure studies on the recto probably date from the mid-1770s. Many such drawings from this period survive, and another typical example is *Two*

Standing Men in the Ashmolean Museum, Oxford (Thomas, 1954, p. 62, no. 77, repr.).

Andrew Robison has kindly identified the fragmentary print on the reverse of the drawing as a proof impression of the bottom right corner of Plate XII (Focillon, 1918, no. 566) of Piranesi's *Trofeo o sia magnifica colonna coclide*. . . . What appears to be a grassy hillock when the print is read vertically is actually the irregular surface of an eroded channel in the marble base of the Column of Trajan. In the finished plate the vertical parallel lines, broken in our proof impression, were corrected, and the number *12.7* and a dotted line and an arrow were added at the lower margin. Robison points out that the undated print was probably executed in about 1775, a date compatible with the style of the figure studies on the recto of the sheet.

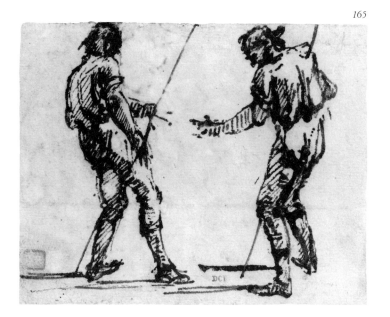

165

165 v.

GIOVANNI BATTISTA PIVA

Belluno, died ca. 1750

166. *Head of a Woman*

Black chalk, heightened with white, on gray-blue paper. 17.1 x 14.7 cm.

Inscribed in pen and brown ink by the "Reliable Venetian Hand" at lower right, *Giambatista Piva Bellunese*; in pen and brown ink on verso, *L. 29—2—d* [?].

PROVENANCE: "Reliable Venetian Hand" (Lugt Supp. 3005c–d); mark mistakenly associated with Pierre Crozat (Lugt 474); sale, London, Sotheby's, March 30, 1987, no. 109, pl. 12; Jak Katalan.

BIBLIOGRAPHY: *Annual Report*, 1988–1989, p. 23.

Gift of Jak Katalan, in memory of Lawrence Turčić, 1989
1989.172

Giovanni Battista Piva (sometimes called Biva) is a rather shadowy figure, a painter and etcher said to have been a pupil of Giovanni Battista Tiepolo. The eighteenth-century collector gifted with the "Reliable Venetian Hand" possessed three drawings ascribed to Piva, all of them small. In addition to the present example, there are an *Infant Hercules Strangling a Serpent*, presented by James Byam Shaw to the Cini Foundation, Venice (Bettagno, 1966, no. 126, repr.), and a *Moses and Aaron*, presented by Jean-Luc Baroni to the Frits Lugt Collection, Fondation Custodia, Paris (Byam Shaw, 1983, I, no. 299 A, III, pl. 510).

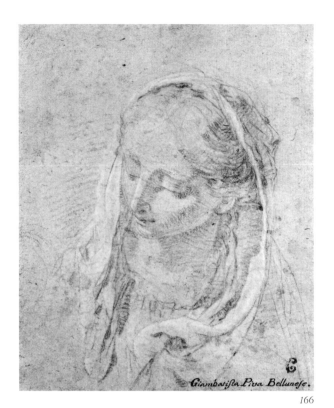

166

STEFANO POZZI

Rome 1699–Rome 1768

167. *The Contest of Elijah and the Prophets of Baal on Mount Carmel*
(I Kings 18:20–40)

Black chalk, heightened with white, on blue paper faded to brown. Framing lines in pen and black ink. 29.4 x 48.0 cm. Lined.

Inscribed in pen and brown ink at lower right, *Stefano Pozzi.*

PROVENANCE: Cephas G. Thompson.

BIBLIOGRAPHY: *Metropolitan Museum Handbook*, 1895, p. 45, no. 801, "Stefano Pazzi.—Elijah and the Prophets of Bael at Mt. Carmel"; Stefano Susinno in Philadelphia, 1980, p. 59, note 5 (mistakenly said to be a study for a work in the Quirinal Palace).

Gift of Cephas G. Thompson, 1887
87.12.131

In this somewhat confused and crowded composition, King Ahab is enthroned at upper right. Before him stands Elijah, who orders the massacre of the prophets of Baal, unsuccessful in their attempt to bring rain to the parched land. In the foreground smolder the remains of Elijah's sacrifice, which was acceptable to the Lord.

168

169

176

STEFANO POZZI

168. *Venus Disguised as a Huntress Appears to Aeneas*
(Aeneid I: 305ff.)

Black chalk, heightened with white, on blue paper. 31.5 x 42.1 cm. (overall); 24.4 x 32.9 cm. (the oval).

Inscribed in graphite at lower right corner, *D27479* (Colnaghi stock number).

PROVENANCE: 7th Earl of Dartmouth (according to vendor); [Colnaghi]; purchased in London in 1965.

BIBLIOGRAPHY: *Annual Report*, 1965–1966, p. 75; *Rome in the 18th Century*, 1978, n.pag. [15], "Diana encountering a horseman."

Rogers Fund, 1965
65.66.9

Anthony M. Clark made the convincing attribution to Stefano Pozzi of this elegant drawing and No. 169 below when they were on the art market in London in 1965.

169. *Venus in the Forge of Vulcan*
(Aeneid VIII: 370ff.)

Black chalk, heightened with white, on slightly faded blue paper. 32.3 x 43.3 cm. (overall); 23.3 x 33.0 cm. (the oval).

Inscribed in graphite at lower right corner, *D27478* (Colnaghi stock number).

PROVENANCE: 7th Earl of Dartmouth (according to vendor); [Colnaghi]; purchased in London in 1965.

BIBLIOGRAPHY: *Annual Report*, 1965–1966, p. 75; *Rome in the 18th Century*, 1978, n.pag. [15].

Rogers Fund, 1965
65.66.10

ANTONIO PUGLIESCHI
Florence 1660–Florence 1732

170. *Exaltation of the Holy Cross*

Black chalk, traces of white heightening, on beige paper. Faint figure studies in black chalk on verso. 41.2 x 76.3 cm. The sheet composed of two pieces of paper joined vertically. Four vertical creases.

Inscribed in pen and brown ink at center of verso, *d'Ant. Puglieschi / disegno della Capp.ª di Cestello*; at lower right, *acheté à florence 1812*; illegible pen inscription at upper left.

PROVENANCE: Sale, Monte Carlo, Sotheby's Monaco, December 8, 1984, no. 47, repr.; [Morton Morris]; purchased in New York in 1985.

BIBLIOGRAPHY: *Annual Report*, 1984–1985, p. 26.

Harry G. Sperling Fund, 1985
1985.101

At the center of the composition Christ in glory points to the Holy Cross supported by angels. In the foreground are seated, among angels and putti, St. Peter, the Blessed Virgin, Eve, Adam, St. John the Baptist, and another Apostle, probably St. Paul. The old inscription on the reverse of the sheet correctly identifies the

purpose of the drawing: it is a study for the central section of the frescoed cupola in the chapel dedicated to the Holy Cross and the Passion of Christ, the second on the right in S. Frediano in Cestello, Florence. This chapel was endowed in 1700 (Paatz, II, 1941, p. 150).

See Nos. 48 and 49 above for other drawings related to S. Frediano in Cestello.

VITTORIO AMEDEO RAPOUS

Turin ca. 1728–Turin ca. 1797

171. *The Vision of St. Hubert*

Pen and brown ink, brown wash, over black chalk. The paper washed blue outside framing lines. 29.6 x 19.0 cm.

Inscribed in pen and brown ink at lower margin, *Di Vittorio Amedeo Rapos Pittore del Acade.ᵃ Reale di Torino.*

PROVENANCE: [Goldschmidt]; purchased in New York in 1983.

BIBLIOGRAPHY: *Annual Report*, 1982–1983, p. 24; Bean, 1986, p. 258, under no. 291.

Harry G. Sperling Fund, 1983
1983.131.2

The conversion of St. Hubert, later to be bishop of Liège, is ascribed to the miraculous apparition of a crucifix between the horns of a stag while he was out hunting on Good Friday. A similar vision figures in the legend of the Early Christian martyr St. Eustace.

The drawing is a study with a number of slight variations for an altarpiece by Rapous, datable 1768, in an oratory dedicated to St. Hubert in the Palazzina di Caccia at Stupinigi, near Turin (Griseri, 1963, pl. 192; Mallè, 1981, p. 209, repr. in color opp. p. 206).

GIOVANNI AGOSTINO RATTI

Savona 1699–Genoa 1775

172. *St. Nicholas of Bari Resuscitating Three Children Discovered in a Tub of Brine*

Red chalk. Contours incised. Verso rubbed in red chalk. 42.3 x 30.4 cm.

Inscribed in pen and brown ink at lower left, *Ovalo in Maiolica che feci / al Sig. Giuseppe Gualtieri di / Albisola*; at lower right, *Gian Agosⁿᵒ Ratti fece.*

PROVENANCE: [Jeudwine]; purchased in London in 1965.

BIBLIOGRAPHY: *Exhibition of Old Master Drawings. W. R. Jeudwine*, London, 1965, no. 19; St. John Gore, *Apollo*, LXXXI, May 1965, p. 397; *Annual Report*, 1965–1966, p. 75.

Rogers Fund, 1965
65.112.5

As the old and no doubt autograph inscription indicates, this is a design for an oval maiolica plaque, and "Giuseppe Gualtieri di Albisola" may have been the patron who commissioned the work. In the early part of his career, Giovanni Agostino Ratti was active as a painter of maiolica in his native Savona and presumably in nearby Albisola, both of which were important centers of faience manufacture in the seventeenth and eighteenth centuries. Signed paintings on maiolica by Giovanni Agostino bear the dates 1720 and 1721.

The rubbing of the reverse in red chalk suggests that the contours were meant to be transferred directly onto the unfired plaque as a guide for the painter.

Ovato in Maiolica che fu
al S.p Giuseppe Quattini di
Albisola.

Franc.pico Ravasfico



172

c

c

179

173

174

MARCO RICCI

Belluno 1676–Venice 1729

173. *Extensive Pastoral Landscape*

Gouache, on kidskin. 30.8 x 45.7 cm. Lined.

PROVENANCE: Sale, London, Christie's, March 29, 1966, no. 96, repr.; [Bier]; purchased in London in 1966.

BIBLIOGRAPHY: *Annual Report*, 1967–1968, p. 87; Jacob Bean, *Metropolitan Museum of Art Bulletin*, XXVI, March 1968, p. 303, repr. p. 302; Bean and Stampfle, 1971, no. 28, repr.

Rogers Fund, 1967
67.67

This landscape and No. 174 below are characteristic examples of one of Marco Ricci's specialties, highly picturesque imaginary views executed in bright, opaque gouache on kidskin—a technique that Marco may indeed have invented. The nonporous, slightly granular surface of the kidskin serves as an ideal support for thick applications of gouache in a lively gamut of colors. The subjects of these drawings, really small paintings intended to be framed and hung as such, are extremely varied.

174. *Mountainous Landscape with Hermits*

Gouache, on kidskin. 29.9 x 43.9 cm. Lined.

PROVENANCE: [Colnaghi]; Harry G. Sperling.

BIBLIOGRAPHY: *Exhibition of Old Master Drawings. P. and D. Colnaghi and Co.*, London, 1954, no. 22, pl. II; Milkovich, 1966, no. 30, repr.; Bean and Stampfle, 1971, no. 29, repr.; *Annual Report*, 1974–1975, p. 50; Bean, 1975, no. 28.

Bequest of Harry G. Sperling, 1971
1975.131.46

175. *Capriccio with Roman Ruins*

Gouache. 30.7 x 44.0 cm. Lined.

PROVENANCE: Reverend J. Green (according to inscription on old mount); [Kleinberger]; purchased in New York in 1954.

BIBLIOGRAPHY: Milkovich, 1966, no. 89, repr. (not in exhibition; mistakenly described as gouache on kidskin); Bean and Stampfle, 1971, p. 30, under no. 28.

Rogers Fund, 1954
54.118

This gouache was executed on paper rather than kidskin, and it consequently lacks the coloristic brilliance

175

of Nos. 173 and 174 above. Marco Ricci excelled in the invention of architectural capriccios, and such compositions had a marked influence on Canaletto and Francesco Guardi. The ruined circular temple with Corinthian columns seen here at the right reappears in an etching by Marco Ricci (Pilo, 1964, no. 227, repr.).

176. *Clearing in a Wooded Landscape*

Pen and brown ink, over traces of graphite. Framing lines in pen and dark brown ink. 29.2 x 19.8 cm.

PROVENANCE: Anton Schmid; [L'Art Ancien]; purchased in Zurich in 1969.

BIBLIOGRAPHY: *Annual Report*, 1969–1970, p. 72; Bean, 1972, p. 18, no. 45.

Rogers Fund, 1969
69.126.2

Marco Ricci executed a great many landscape studies in pen and ink. This is a fine and typical example, and it shows his very considerable debt to the woodcuts of Titian and Domenico Campagnola.

NICOLÒ RICCIOLINI

Rome 1687–Rome 1772

177. *The Virgin Appearing to St. Bernard of Clairvaux*

Pen and brown ink, brown and gray wash, over red chalk. Squared in red chalk. 27.2 x 19.9 cm. Lined.

Inscribed in pen and brown ink along left margin, *Il quadro esiste alla Madona de Fornari detta di Loreto*; in pen and brown ink at lower center of old mount, *Riccio*... (the rest cut away).

PROVENANCE: [Kate Ganz]; purchased in London in 1988.

BIBLIOGRAPHY: *Annual Report*, 1987–1988, p. 24.

Purchase, David L. Klein, Jr. Memorial Foundation, Inc. Gift, 1988
1988.28

Study, with minor variations, for an altarpiece by Nicolò Ricciolini, signed and dated 1751, in SS. Nome di Maria, Rome (Martini and Casanova, 1962, p. 80, fig. 18; Titi, 1987, II, fig. 1004). St. Bernard, a Doctor of the Church, is represented writing under the inspiration of the Blessed Virgin, who points toward the emblem of her Holy Name. At the lower left, putti hold the crosier and mitre that symbolize St. Bernard's abbatial authority at Clairvaux.

The drawing was identified as the work of Ricciolini by Lawrence Turčić when it appeared on the art market in London in 1987. Not long before, Turčić had found a larger and more finished study by the artist for the same painting, catalogued under the name of Carlo Maratti in the De Grez Collection at the Musées Royaux de Peinture et de Sculpture, Brussels (Brussels, 1913, no. 2413). The drawing in Brussels was independently recognized as the work of Ricciolini by Maria Barbara Guerrieri Borsoi (*Bollettino d'Arte*, LXXIII, July–October 1988, pp. 172 and 175, fig. 26).

178. *The Death of St. Joseph*

Pen and brown ink, brown wash, over traces of black chalk. Lightly squared in black chalk. 18.0 x 10.7 cm.

Inscribed in pen and brown ink at lower margin, *Oncie 55 1/3* [?]; at right margin, *Oncie*; in another hand at lower right, *Andrea Procaccini*.

PROVENANCE: Harry G. Friedman.

BIBLIOGRAPHY: Bean, 1979, no. 316, repr., as Andrea Procaccini.

Gift of Harry G. Friedman, 1956
56.225.5

This drawing, clearly the work of a follower of Carlo Maratti, had been catalogued under the name of Andrea Procaccini on the basis of the old inscription. Quite recently, however, Maria Barbara Guerrieri Borsoi convincingly identified the sheet as a study by Nicolò Ricciolini for his altarpiece of this subject in the left

transept of the Duomo at Mantua. Dottoressa Guerrieri Borsoi plans to publish this drawing and the painting in a forthcoming issue of *Bollettino d'Arte*.

NICOLA MARIA ROSSI

Naples ca. 1690–Naples 1758

179. *The Virgin Nursing the Christ Child, in a Glory of Angels*

Pen and brown ink, brown wash, over red chalk. Verso: faint red chalk studies for seated figures of Christ and God the Father seen in steep perspective. 29.0 x 25.2 cm. Scattered stains.

Inscribed in graphite at lower right, *Solimena*.

PROVENANCE: Don Sebastien Gabriel de Borbón y Braganza (1811–1875); Don Pedro Alcántara de Borbón y Borbón, Duke of Dúrcal (1862–1892); Dúrcal sale, New York, American Art Galleries, April 10, 1889, no. 160 (2); Henry Walters.

Gift of Henry Walters, 1917
17.236.25

In the catalogue of the 1889 Dúrcal sale, this and the following sheet were listed as works of "Nicolas Rossi, Seventeenth century. Pupil of Luca Giordano." There was in fact a pupil of Giordano called Nicola Russo or Rosso (Naples 1647–1702), and he was often confused with Nicola Maria Rossi because of their similar names. Our drawings seem more likely to be by the latter. Nicola Maria was a pupil of Solimena, whose influence—albeit in a rather diluted form—is apparent in both drawings. The modern inscription *Solimena* on each sheet testifies to this stylistic connection.

A considerable group of drawings by Nicola Maria Rossi has been identified in the Cabinet des Dessins of the Musée du Louvre (see Monbeig-Goguel and Vitzthum, 1967, pp. 42, 50–51, nos. 88 and 89). Many of these sheets in Paris have close stylistic affinities with our drawings.

180. *Two Kneeling and Two Standing Figures*

Pen and brown ink, gray wash, over black chalk. Scribbled figure studies in pen and black chalk on verso. 16.8 x 23.8 cm. Foxed. Stains at lower margin.

Inscribed in graphite on verso, *Solimena*.

PROVENANCE: Don Sebastien Gabriel de Borbón y Braganza (1811–1875); Don Pedro Alcántara de Borbón y Borbón, Duke of Dúrcal (1862–1892); Dúrcal sale, New York, American Art Galleries, April 10, 1889, no. 160 (1); Henry Walters.

Gift of Henry Walters, 1917
17.236.26

FRANCESCO MARIA SALVETTI

Florence 1691–Florence 1758

181. *The Apostles at the Tomb of the Virgin, and Studies for Two Pendentives*

Pen and brown ink, brown and gray wash, over black chalk. The perimeter of the lunette incised with a compass. An embossed parochial stamp affixed with sealing wax at top center of sheet. 20.9 x 26.7 cm. Abraded. Scattered stains and losses.

Inscribed in pen and brown ink at lower margin, *Io Franc.° Maria Salvetti ho fatto il Sud.° disegno per la Chiesa della SS. Vergine delle Vedutte, . questo va eseguito.*, followed by two signatures, *Io Gio: Santi montanelli operaio mano propria* / *. o Corenzo Aleotti operaio mano propria.*

PROVENANCE: [Jeudwine]; purchased in London in 1966.

BIBLIOGRAPHY: *Annual Report*, 1966–1967, pp. 60–61.

Rogers Fund, 1966
66.136

The artist's own inscription identifies the drawing as a study for part of the decoration of a church dedicated to S. Maria delle Vedute. It was W. R. Jeudwine who pointed out in 1966 that this church is in the town of Fucecchio, near Empoli. In the frescoed half-dome of the apse of this church a group of Apostles is gathered around the tomb of the Virgin, but the scale and attitudes of the figures are quite different from those in our drawing.

However, confirmation of the connection of this drawing with the work in S. Maria delle Vedute is supplied by a large study in the Albertina, Vienna (*Beschreibender Katalog. VI, 1941, no. 760, repr.*), which represents the Virgin in glory and bears the following inscription: *Io*

Franc? Maria Salvetti ho fatto / il presente disegno per la cupola / della SS. Vergine delle Vedutte / Gio. Santi montanelli / operaio mano propria. On the reverse of the drawing is a further inscription, . . . *settembre 1738 cominciai a attacare la carta per disegnare . . . ottobre principii a dipingere.* The central section of the Albertina drawing, which is very close in style to ours, corresponds almost exactly with Salvetti's fresco in the cupola above the choir of the church. Beneath the cupola are four pendentives with Evangelists such as those studied in our drawing.

Salvetti was a faithful follower of Antonio Domenico Gabbiani, whose style is reflected in both the drawings and in the fresco in the cupola of S. Maria delle Vedute. The differences between our drawing and the painting in the half-dome could be accounted for by later restoration.

Drawings by Salvetti are very rare. In addition to our drawing and that in the Albertina, we know only a signed black chalk representation of his master Gabbiani on his deathbed (Gabinetto Disegni e Stampe degli Uffizi, 3709 F).

GASPARE SERENARIO

Palermo 1707–Palermo 1759

182. *St. Benedict Orders the Destruction of Idols at Montecassino*

Pen and brown ink, brown wash, heightened with yellow and white gouache, over black chalk, on beige paper. 20.9 x 12.0 cm.

Inscribed in graphite on verso, *Conca.*

PROVENANCE: Don Sebastien Gabriel de Borbón y Braganza (1811–1875); Don Pedro Alcántara de Borbón y Borbón, Duke of Dúrcal (1862–1892); Dúrcal sale, New York, American Art Galleries, April 10, 1889, no. 197 (2), "Domingo Gargiolo. Destruction of pagan statues by a saint"; Henry Walters.

Gift of Henry Walters, 1917
17.236.22

The drawing figured in the Dúrcal sale as the work of Domenico Gargiulo, in spite of the old attribution to Conca on the verso. In 1968 Philip Pouncey noted on the mount, "seems close to Sebastiano Conca." Nearly two decades later, Lawrence Turčić pointed out that the drawing appears to be a preparatory study with significant variations for a painting of the same subject by a faithful Palermitan follower of Conca, Gaspare Serenario. This painting was executed in Rome in 1739 and sent to Palermo, where it is now in the Chiesa dell'Origlione (Brugnò, 1985, pp. 461 and 483, no. 2, p. 493, fig 2).

FRANCESCO ANTONIO SIMONINI

Parma 1686–Florence ? after 1755 ?

183. *A Cavalry Battle before a City*

Pen and brown ink, gray wash, over black chalk. 35.4 x 66.4 cm.
Vertical fold at center.

PROVENANCE: [Colnaghi]; purchased in London in 1966.

BIBLIOGRAPHY: *Exhibition of Old Master Drawings. P. and D. Colnaghi and Co.*, exhibition catalogue, London, 1966, no. 70; *Annual Report*, 1966–1967, p. 61.

Rogers Fund, 1966
66.93.3

A similar large battle scene with fortifications atop a cliff on the right was recently sold in Paris (Nouveau Drouot, salle 1, March 6, 1986, no. 188, repr.).

GIROLAMO STARACE

Naples ca. 1730–Naples 1794

184. *Christ Falls under the Cross*

Black chalk, stumped, pen and black ink, gray wash. Framing lines in pen and black ink at top and sides of sheet. 23.1 x 29.9 cm. Vertical crease at center.

PROVENANCE: Serge Michel (according to vendor); [Mia Weiner]; purchased in New York in 1986.

BIBLIOGRAPHY: *Annual Report*, 1985–1986, p. 23.

Purchase, David L. Klein, Jr. Memorial Foundation, Inc. Gift, 1986
1986.50

Giancarlo Sestieri identified this accomplished drawing as the work of Starace. It is a study for a painting above a niche on the left wall of the left transept of Ave Gratia Plena in Marcianise, near Caserta. In both drawing and painting, the lower margin is shaped to an arch to fit above the pediment of the niche. A *Crowning with Thorns* by Starace hangs above the niche on the opposite wall of the transept.

Nicola Spinosa has published oil sketches, monogrammed and dated 1773, for both these paintings (Spinosa, 1987, p. 132, no. 194, figs. 247 and 248). Drawings by Starace for the *Crowning with Thorns* were identified by Walter Vitzthum in the Museo di Capodimonte, Naples (Vitzthum, 1966, no. 62, pl. 39, no. 63; the latter drawing repr. Roli and Sestieri, 1981, no. 208).

SEMPRONIO SUBISSATI

Urbino ca. 1680–Madrid 1758

185. *Portrait of Francesco Albani*

Red chalk, stumped in the portrait medallion, over traces of black
chalk. 41.8 x 25.5 cm. Foxed. Lined.

Inscribed in red chalk in cartouche, FRANCISCVS . ALBANO . / PICTOR
. EGREGIVS . BONONIENSIS . NATVS . / ANNO . MDLXXVII . AD .
ALIAM . / GLORIOSAM . VITAM . MIGRAVIT . ROMAE / ANNO . MDCLX.

PROVENANCE: Nicola Pio; Victor Sordan.

BIBLIOGRAPHY: Clark, 1967, p. 21, no. 214; *Annual Report*,
1970–1971, p. 15, mistakenly as G. D. Piastrini; Bean, 1972, no.
38, mistakenly as G. D. Piastrini; *Pio*, 1977, p. 34; *Rome in the 18th
Century*, 1978, n.pag. [17].

Gift of Victor Sordan, 1970
1970.293

Nicola Pio commissioned from a number of Roman
draughtsmen 225 portrait drawings to illustrate his *Vite*,
and each of the 225 Lives concludes with the identification
of the artist responsible for the portrait. Thus, the brief
Life of Francesco Albani ends, "Il di lui ritratto è stato
fatto e delineato da Sempronio Subissati." In addition,
portraits of Andrea Sacchi and Carlo Maratti were sup-
plied by Subissati, but these are now lost.

Pio's manuscript, the title page of which is dated
1724, came to the Vatican in 1746, but it was not until
1977 that it was printed by the Biblioteca Apostolica
Vaticana. The author's collection of drawings and prints
was in large part dispersed during his lifetime, and over
140 of the portraits of artists found their way to the
Nationalmuseum, Stockholm, having previously figured
in the collections of Pierre Crozat and Carl Gustav Tessin.
Our drawing does not seem to share this Crozat/Tessin
provenance and must have been separated from the group
at some early date.

Subissati's image of Albani is copied from the por-
trait by Andrea Sacchi that is now in the Museo del
Prado, Madrid (Sutherland Harris, 1977, no. 44, pl.
74). Subissati was a pupil of Maratti, who owned the
Sacchi portrait until his death, when it was purchased
by Philip V of Spain.

FRANCISCVS. ALBANO.
PICTOR. EGREGIVS. BONONIENSIS. NATVS.
ANNO. MDLXXVIII. AD. ALIAM.
GLORIOSAM. VITAM. MIGRAVIT. ROMÆ.
ANNO. MDCLX.

192

GIOVANNI BATTISTA TIEPOLO

Venice 1696–Madrid 1770

186. *Sheet of Studies: Five Angels*
VERSO. *Youth in Clerical Garb and Other Studies*

Pen and brown ink, brown wash (recto); pen and brown and black ink (verso). 22.1 x 21.9 cm. A patch of brownish paper measuring 7.4 x 6.3 cm. has been added at right margin and the drawing continued in a later hand. Repaired loss at lower center.

Inscribed in pen and brown ink on verso, *Al Molto S.*

PROVENANCE: James Jackson Jarves; Cornelius Vanderbilt.

BIBLIOGRAPHY: *Metropolitan Museum Handbook*, 1895, p. 25, no. 363, "Tiepolo.—Design for Ceiling"; Breck, 1913, p. 16, "little or no connection with Tiepolo."

Gift of Cornelius Vanderbilt, 1880
80.3.363

The traditional attribution to Tiepolo is no doubt correct, and the sheet, although slight and perhaps in part reworked by a later hand, is close in style to drawings which have been associated with the artist's work at Udine in the mid-1720s (for example, Rizzi, 1965, nos. 8–11, repr., and Feinblatt, 1967, figs. 1 and 2, pls. 34–38).

186 v.

193

187. *Beheading of Two Male Saints*

Pen and brown ink, brown wash, heightened with white, over black chalk; traces of red chalk at upper and lower right. Framing lines in pen and brown ink. 50.0 x 36.8 cm. Lined.

Blind stamp, a mounter's mark, at lower right corner, FR (Lugt 1042).

PROVENANCE: Marquis de Biron; purchased in Geneva in 1937.

BIBLIOGRAPHY: Williams, 1938, p. 66; Benesch, 1947, no. 12, repr.; Morassi, 1949, p. 85; Cailleux, 1952, p. 35, under no. 1; Benesch, 1961, under no. 107; Bean, 1964, no. 40, repr.; Bean and Stampfle, 1971, no. 61, repr.; Byam Shaw, 1971-1, p. 244; Weeks, 1978, no. 41, repr. p. 4; Macandrew, 1980, p. 161, under no. 997A.

Rogers Fund, 1937
37.165.14

Nos. 187 and 188, both drawings of exceptional size and elaborate finish, must have been executed as independent works of art, rather than as preparatory studies. In any case, they do not relate directly to any of Giambattista's paintings. They are nonetheless strikingly similar in style to frescoes in the Colleoni Chapel at Bergamo, where Giambattista worked in 1732–1733.

The vigorous physical types, the steep perspective, and the dramatic Piazzettesque chiaroscuro that characterize the drawings are all to be found in the Bergamo fresco *The Beheading of St. John the Baptist* (Morassi, 1962, p. 3, fig. 44; Levey, 1986, fig. 69, in color).

The scene represented here may be the beheading in Milan of St. Nazarius and his youthful companion, St. Celsus, during the persecutions of Nero. Nazarius and Celsus were martyrs venerated in Lombardy and the Veneto, but we know of no earlier representations of their deaths. The composition may be simply a variation on a given theme, the dramatic representation of a scene of martyrdom. The martyrs in No. 188 below cannot be satisfactorily identified, nor can the victim in a drawing of similar dimensions and finish that once belonged to Prince Alexis Orloff and is now in a private collection in Milan (Orloff sale, 1920, no. 162, repr.).

An old copy of the present drawing is in the Hermitage, Leningrad (L. Salmina in *Trudy*, VIII, 3, 1964, p. 246, repr.).

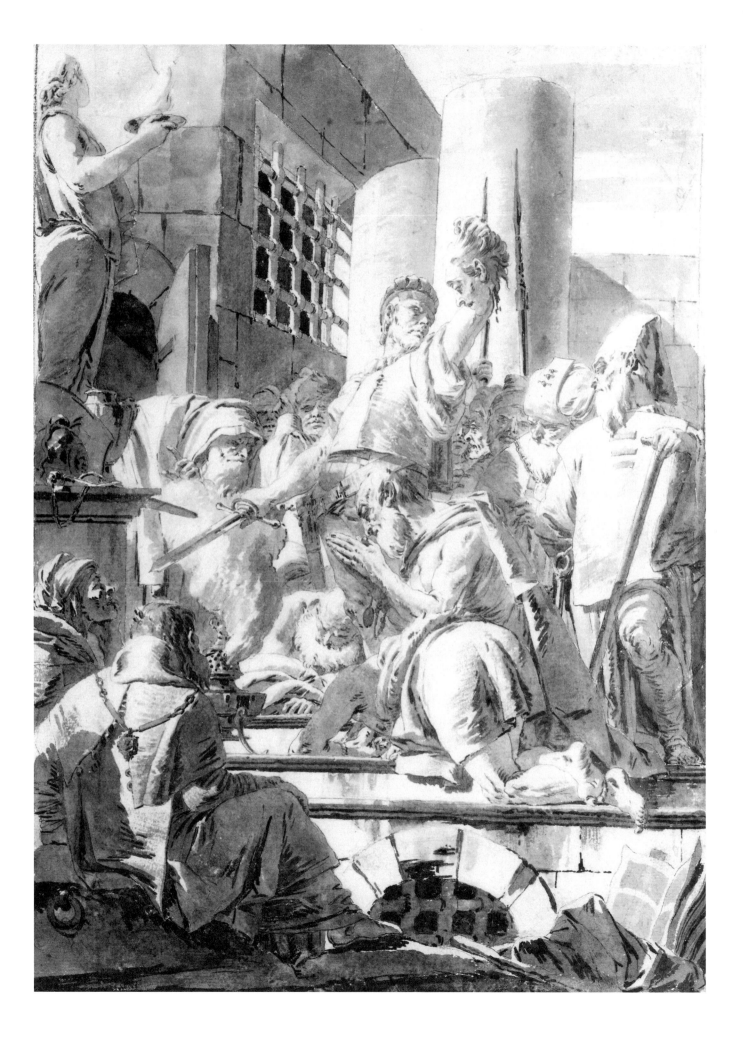

GIOVANNI BATTISTA TIEPOLO

188. *The Beheading of a Male and a Female Saint*

Pen and brown ink, brown wash, heightened with white, over black chalk. Framing lines in pen and brown ink. 49.8 x 36.3 cm. Lined.

Blind stamp, a mounter's mark, at lower right corner, FR (Lugt 1042).

PROVENANCE: Marquis de Biron; purchased in Geneva in 1937.

BIBLIOGRAPHY: New York, 1938, no. 37, repr.; Williams, 1938, p. 66; *Metropolitan Museum, Italian Drawings*, 1942, no. 36, repr.; Benesch, 1947, under no. 12; Cailleux, 1952, p. 35, under no. 1; Benesch, 1961, under no. 107; Bean, 1964, under no. 40; Bean and Stampfle, 1971, no. 62, repr.; Byam Shaw, 1971–1, pp. 244, 245, fig. 9; Knox, 1975, p. 93, under no. 311; Macandrew, 1980, p. 161, under no. 997A; Rizzi, 1988, p. 46, under no. 4.

Rogers Fund, 1937
37.165.15

It has been suggested that the martyrdom represented here is that of St. Cyprian and St. Justina at Nicomedia, but there does not seem to be any iconographic or geographic reason for this identification. Like No. 187 above, this impressive sheet may be dated in the early 1730s.

An old and fairly exact copy of the drawing is in the Musée Départemental des Vosges, Épinal (Cailleux, 1952, no. 1, repr.).

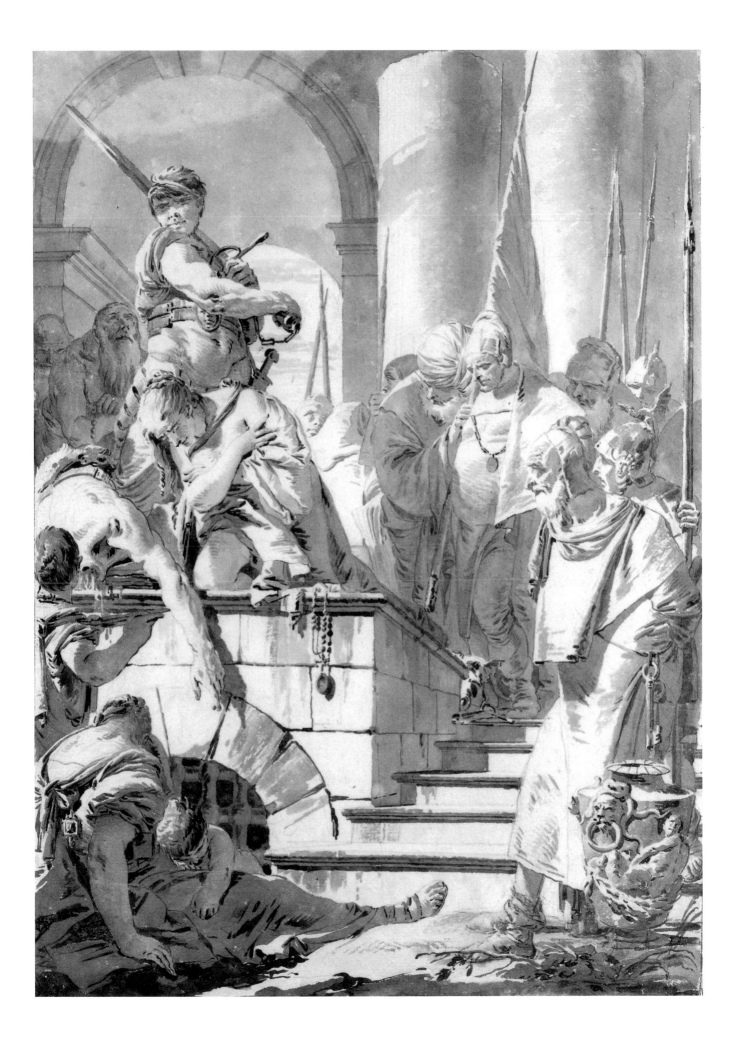

GIOVANNI BATTISTA TIEPOLO

189. *The Virgin and Child Enthroned with St. Sebastian and a Franciscan Saint*

Pen and brown ink, brown wash, heightened with white, over black chalk, on beige paper. Framing lines in pen and brown ink. 30.8 x 24.8 cm.

PROVENANCE: Marquis de Biron; purchased in Geneva in 1937.

BIBLIOGRAPHY: New York, 1938, no. 38, repr.; Williams, 1938, p. 66; *Metropolitan Museum, Italian Drawings*, 1942, no. 37, repr.; Benesch, 1961, under no. 107; Knox, 1970, p. xix, and under nos. 11, 27; Bean and Stampfle, 1971, no. 63, repr.; Byam Shaw, 1971–1, p. 244; Byam Shaw, 1971–2, pp. 267–268; Knox, 1975, p. 39, under no. 9.

Rogers Fund, 1937
37.165.6

This highly finished drawing, probably not a study for a painting but a work of art in its own right, may be dated in the early 1730s on the basis of its stylistic affinity with Nos. 187 and 188 above.

A fairly exact old copy of our drawing in the Martin von Wagner Museum, Würzburg, is inscribed *Gio Batti. Tiepolo inv. / Fran.º Lorenzi delin'* (Knox, 1970, p. 222, fig. 4).

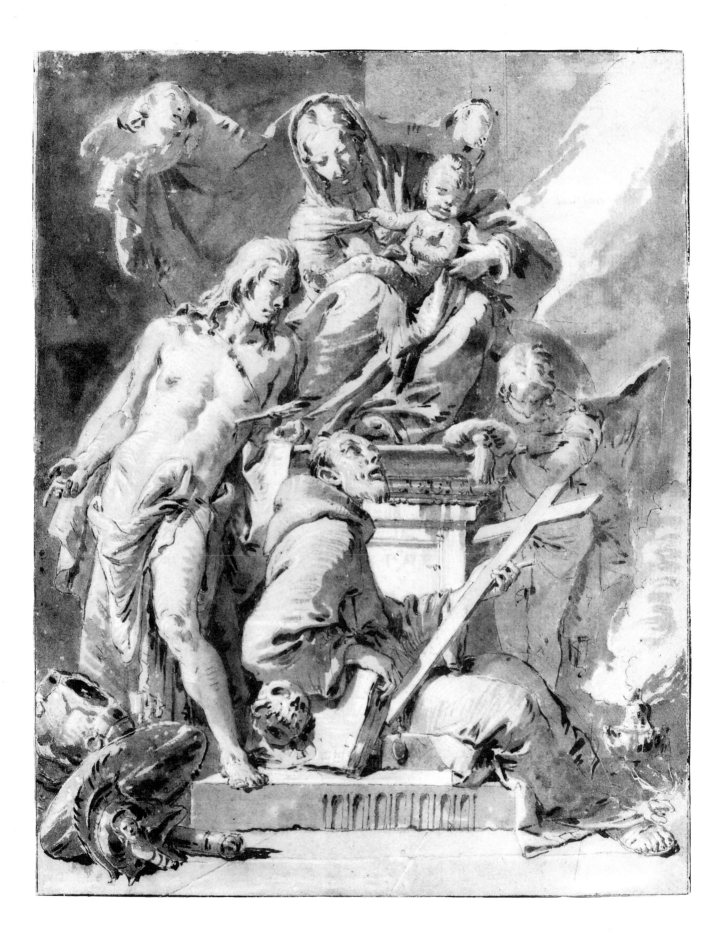

GIOVANNI BATTISTA TIEPOLO

190. *Adoration of the Magi*

Pen and brown ink, pale and dark brown wash, over black chalk. 41.8 x 29.0 cm.

Inscribed in graphite on verso, *n 6*.

PROVENANCE: Marquis de Biron; purchased in Geneva in 1937.

BIBLIOGRAPHY: Benesch, 1947, no. 15, repr.; Bean, 1964, no. 41, repr.; Bean and Stampfle, 1971, no. 68, repr.; Byam Shaw, 1971–1, pp. 244, 246; Russell, 1972, pp. 28–29, repr.; Dreyer, 1979, under no. 74.

Rogers Fund, 1937
37.165.16

A brilliant, highly pictorial exercise that may date from the late 1730s. The same Magi, similarly costumed but quite differently placed in relation to the Virgin and Child, appear in drawings of this subject in the Kupferstichkabinett, Berlin-Dahlem (Dreyer, 1979, no. 74, repr. in color), in the Cleveland Museum of Art (repr. Cleveland *Bulletin*, XXXIII, 1, 1946, p. 1), and in the Achenbach Foundation for Graphic Arts, San Francisco (Knox, 1970, no. 21, repr.).

GIOVANNI BATTISTA TIEPOLO

191. *Marine Deity with Attendant Female Figure*

Pen and brown ink, brown wash, heightened with white, over black chalk. 29.6 x 25.1 cm. Lined.

Inscribed in pen and brown ink on verso, *Gio: Batta: Tiepolo Veneto.*

PROVENANCE: James Jackson Jarves; Cornelius Vanderbilt.

BIBLIOGRAPHY: *Metropolitan Museum Handbook*, 1895, p. 25, no. 370, "Tiepolo.—Designs for Ceilings"; Breck, 1913, p. 16; Morassi, 1970, p. 296, fig. 430; Byam Shaw, 1971–1, p. 239, note 12.

Gift of Cornelius Vanderbilt, 1880
80.3.370

Antonio Morassi was the first to point out the close stylistic similarity of this drawing to Giambattista's preparatory studies for decorations datable to late 1734 in the Villa Loschi at Biron di Monteviale, near Vicenza. These two allegorical figures do not appear in the frescoes, but the physical types and summary graphic treatment are closely paralleled in a drawing at the Yale University Art Gallery, New Haven, *Industry Triumphing over Idleness*, which is certainly preparatory for the Villa Loschi (Knox, 1970, no. 13, repr.). Other studies for the Villa Loschi are to be found in Trieste (Vigni, 1972, nos. 27–42, repr.), the Victoria and Albert Museum, London (Knox, 1975, nos. 10–14, repr.), and the Robert Lehman Collection at the Metropolitan Museum (George Knox in *Lehman Collection.* VI, 1987, no. 73, repr.).

192. *Apollo Supported by a Winged Genius*

Pen and brown ink, pale and dark brown wash, over black chalk. 26.8 x 21.7 cm.

Numbered in graphite on verso, *30.*

PROVENANCE: Marquis de Biron; purchased in Geneva in 1937.

BIBLIOGRAPHY: Benesch, 1947, no. 25, repr.; Knox, 1970, under no. 19; Bean and Stampfle, 1971, no. 74, repr.

Rogers Fund, 1937
37.165.21

This and the following forty-one drawings form a stylistically coherent group, many of them associated with Giambattista's plans for the ceiling fresco in the gallery of the Palazzo Clerici, Milan.

An album, the binding of which is labeled VARI / PENSIERI / T.I., is preserved in the Horne Foundation, Florence. Forty drawings by Giambattista mounted on thirty-three folios remain in the album; seven have been removed and are kept separately. A pencil inscription on the first page indicates that there were only forty-seven drawings in the album when Horne purchased it in London at the end of the nineteenth century. Internal evidence, such as stubs in the binding and wide skips in the sequence of folio numbers, suggests that the album may originally have contained at least seventy additional drawings.

Like ours, the Horne drawings consist in large part of studies datable on stylistic grounds about 1740. Thus it is possible—though not certain—that Nos. 192–233 of this catalogue may have been removed from the album VARI PENSIERI T.I. and purchased by Guillaume de Gontaut Biron, marquis de Biron (1859–1939), before Herbert Horne acquired the drawings and the binding now in Florence. The original album may have formed one volume in the rich repertory of visual motifs that Giambattista is said to have presented to the Venetian convent of the Somaschi, a religious order of which his son Giuseppe was a member.

This study of Apollo with his lyre, supported by a winged genius, was used with slight variations by Giambattista in an oil sketch (now in the Kimbell Art Museum, Fort Worth) that is generally accepted as the only surviving *modello* for the Palazzo Clerici ceiling (Morassi, 1962, fig. 319). A related study of Apollo in The Pierpont Morgan Library is not so close to the figure in the oil sketch (IV, 112a; Bean and Stampfle, 1971, no. 75, repr.). An old and quite exact copy of our drawing is in the National Gallery of Art, Washington, D.C. (1956.9.23. Gift of Howard Sturges).

192

GIOVANNI BATTISTA TIEPOLO

193. *Apollo Seated on Clouds, Two Figures at Left*

Pen and brown ink, pale and dark brown wash, over black chalk. 21.8 x 22.4 cm.

Numbered in graphite on verso, *47*.

PROVENANCE: Marquis de Biron; purchased in Geneva in 1937.

BIBLIOGRAPHY: Bean and Stampfle, 1971, no. 76, repr.

Rogers Fund, 1937
37.165.52

Another study, with many variations, for the seated Apollo that appears in the center of the Fort Worth sketch for the Palazzo Clerici ceiling.

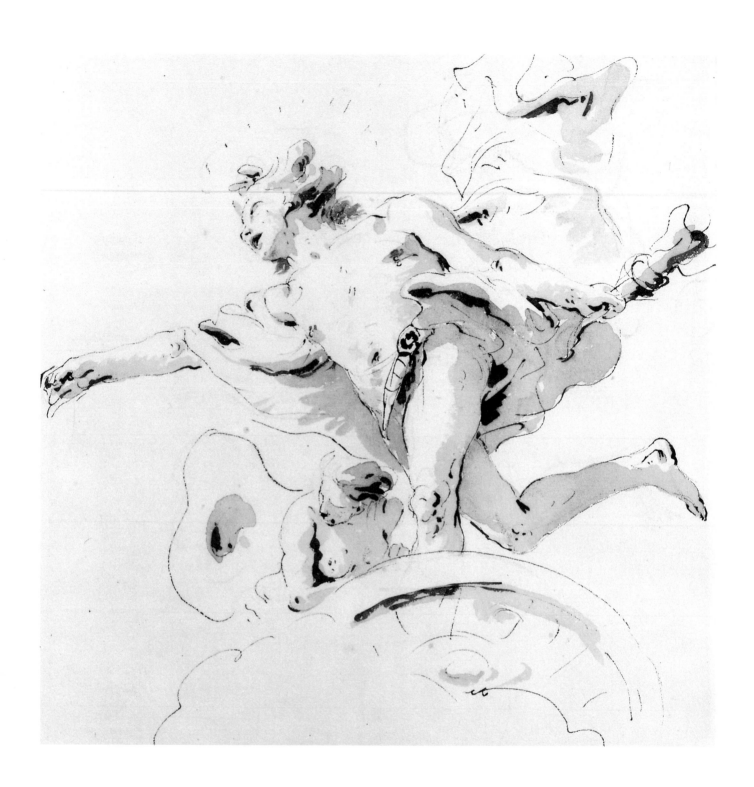

GIOVANNI BATTISTA TIEPOLO

194. *Apollo Standing in His Chariot*

Pen and brown ink, pale and dark brown wash, over black chalk. 24.2 x 24.3 cm.

PROVENANCE: Marquis de Biron; purchased in Geneva in 1937.

BIBLIOGRAPHY: New York, 1938, no. 41, repr.; Bean and Stampfle, 1971, no. 77, repr.; Byam Shaw, 1971–1, p. 242, fig. 4.

Rogers Fund, 1937
37.165.35

A further study for the Palazzo Clerici Apollo, closer to the fresco, where the sun god, facing the spectator, races his quadriga across the width of the gallery (Ancona, 1956, pl. 12, in color).

195. *Seated Satyress*

Pen and brown ink, pale and dark brown wash, over red chalk. 19.0 x 16.1 cm. Upper corners made up.

Inscribed in graphite on verso, *Tiepolo 100 /*.

PROVENANCE: Marquis de Biron; purchased in Geneva in 1937.

BIBLIOGRAPHY: Knox, 1970, no. 20, repr.; Byam Shaw, 1971–1, p. 243, fig. 7.

Rogers Fund, 1937
37.165.38

At the narrow north and south ends of the long gallery in the Palazzo Clerici appear two satyrs and two satyresses seen in steep perspective perched on feigned cornices. The satyress in the southwest corner of the fresco corresponds very closely to the one in this drawing (Morassi, 1955, pl. 26).

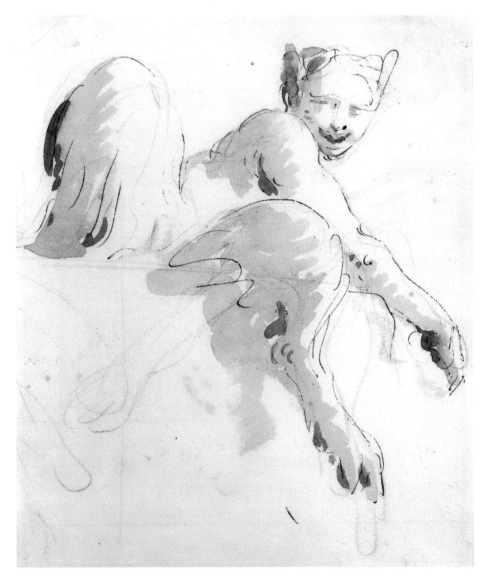

196. *Seated Satyr Holding a Garland*

Pen and brown ink, pale and dark brown wash, over black chalk. 20.5 x 22.9 cm. Lower left corner made up.

Numbered in graphite on verso, 52.

PROVENANCE: Marquis de Biron; purchased in Geneva in 1937.

BIBLIOGRAPHY: Bean and Stampfle, 1971, no. 88, repr.; Paris, 1971, p. 166, under no. 253.

Rogers Fund, 1937
37.165.47

A satyr in a very similar pose appears in the southeast corner of the Palazzo Clerici gallery (Morassi, 1955, pl. 26).

197. *Seated Satyr Holding a Garland*

Pen and brown ink, pale and dark brown wash, over black chalk. 19.8 x 19.8 cm. Lower left corner made up.

Numbered in graphite on verso, 54.

PROVENANCE: Marquis de Biron; purchased in Geneva in 1937.

BIBLIOGRAPHY: Bean and Stampfle, 1971, no. 90, repr.; Paris, 1971, p. 166, under no. 253.

Rogers Fund, 1937
37.165.49

This satyr may have been a study for the ceiling decoration of the Palazzo Clerici, but the figure was not used.

198. *Two Seated Satyrs and a Satyr Child*

Pen and brown ink, pale and dark brown wash, over red chalk. 20.9 x 25.0 cm.

Inscribed in graphite on verso, *Tiepolo 30 /.*

PROVENANCE: Marquis de Biron; purchased in Geneva in 1937.

BIBLIOGRAPHY: Chicago, 1938, no. 67; New York, 1938, no. 43, repr.; Bean and Stampfle, 1971, no. 89, repr.; Paris, 1971, p. 166, under no. 253.

Rogers Fund, 1937
37.165.33

These figures may have been studies for the Palazzo Clerici ceiling, but were not utilized. Fifteen such "unused" studies of satyrs and satyresses in the Horne Foundation, Florence, testify to Giambattista's seemingly inexhaustible inventive powers. Many of these drawings in Florence are very close in style and technique (with spirited accents added in brush and dark brown wash) to the Clerici studies in our collection (Museo Horne, Inv. 6324, 6336–6348, 6350; some repr. Ragghianti Collobi, 1963, pls. 88, 100–103).

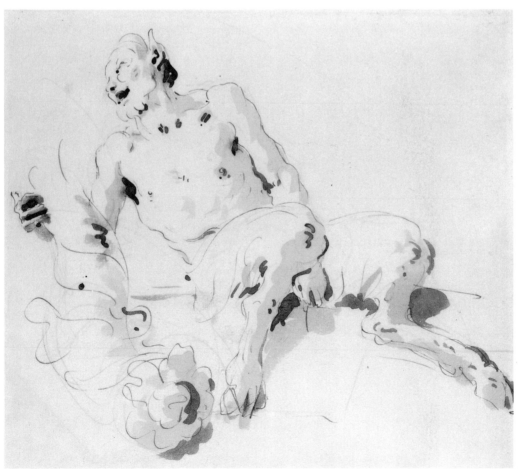

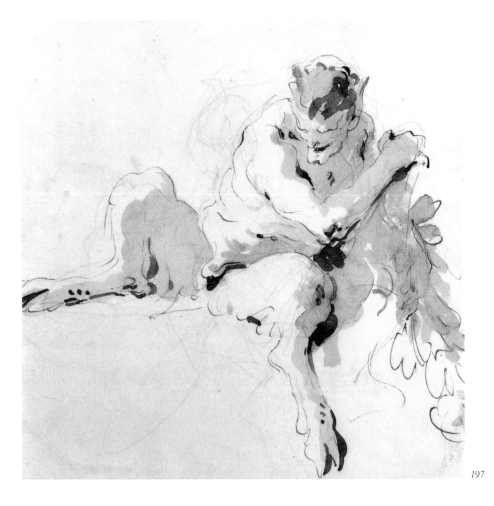

197

198

199. *Seated River God, Nymph with an Oar, and Putto*

Pen and brown ink, pale (golden) and dark brown wash, over black chalk. 23.5 x 31.3 cm.

Inscribed in graphite on verso, *8.*

PROVENANCE: Marquis de Biron; purchased in Geneva in 1937.

BIBLIOGRAPHY: Chicago, 1938, no. 70, repr.; New York, 1938, no. 45, repr.; *Metropolitan Museum, Italian Drawings*, 1942, no. 41, repr.; Freeden and Lamb, 1956, pl. 44; Bean, 1964, no. 42, repr.; Knox, 1970, under no. 19; Bean and Stampfle, 1971, no. 78, repr.

Rogers Fund, 1937
37.165.32

These figures appear at the bottom of the Fort Worth sketch, and the river god and nymph, without the oar and the accompanying putto, are perched on the top-most cornice at the south end of the Palazzo Clerici gallery (Ancona, 1956, pl. 35, in color). A little more than ten years later the nymph and river god were repeated in the frescoed ceiling of the Kaisersaal in the Würzburg Residenz (Freeden and Lamb, 1956, pl. 79, in color).

The transparent washes of this drawing are of a pale golden tone to be found in other drawings by Giambattista, many of them associable with the Palazzo Clerici project. Nos. 200–203, 212–213, and 217–220 below are executed in this golden wash, as are some thirty-seven in the Horne Foundation and ten in The Pierpont Morgan Library.

200. *Three Winged Female Figures*

Pen and brown ink, pale (golden) and dark brown wash, over black chalk. 23.2 x 24.5 cm.

Inscribed in graphite on verso, 5.

PROVENANCE: Marquis de Biron; purchased in Geneva in 1937.

BIBLIOGRAPHY: Chicago, 1938, no. 66.

Rogers Fund, 1937
37.165.46

At the center of the Palazzo Clerici ceiling, these three figures hail Apollo's arrival in his quadriga (Ancona, 1956, pl. 12, in color).

GIOVANNI BATTISTA TIEPOLO

201. *Standing Figure of Prudence and a Seated River God*

Pen and brown ink, pale (golden) and dark brown wash, over black chalk. 30.4 x 29.8 cm.

PROVENANCE: Marquis de Biron; purchased in Geneva in 1937.

BIBLIOGRAPHY: Benesch, 1947, no. 21, repr.; Knox, 1970, under no. 19; Bean and Stampfle, 1971, no. 84, repr.; Pignatti, 1974–1, pl. XX, in color.

Rogers Fund, 1937
37.165.44

A very similar figure of Prudence, seen in steep perspective, holding a large mirror and fitted out with her usual attribute, an extra masklike face on the back of her head, appears in one of the lateral canvases in the ceiling of

the Scuola dei Carmini, Venice, on which Tiepolo worked intermittently from 1740 to 1744 (Morassi, 1962, fig. 205). In the Carmini canvas, however, Prudence is attended not by a river god but by allegorical female figures representing Grace and Innocence.

The stance of Prudence in our drawing, and even her skirt, looped over the thigh and caught by a clip in the form of a mask, reappear in the Fort Worth oil sketch for the Clerici ceiling (Morassi, 1962, fig. 319) and in the ceiling itself, where the figure is reversed (Ancona, 1956, pl. 22, in color). However, in both these instances Prudence has become Ceres. Mirror and mask have disappeared, and the standing female figure holds a luxuriant symbolic plant. The same figure reappears more than twenty years later with the attributes of Prudence in the ceiling fresco of the throne room in the Royal Palace, Madrid (Morassi, 1955, pl. 89).

202. *River God with an Oar, Woman Holding a Serpent, and a Standing Nude Boy*

Pen and brown ink, pale (golden) and dark brown wash, over black chalk. 25.6 x 23.7 cm.

Inscribed in graphite on verso, 37, in a circle.

PROVENANCE: Marquis de Biron; purchased in Geneva in 1937.

BIBLIOGRAPHY: Knox, 1970, under no. 19.

Rogers Fund, 1937
37.165.30

The serpent identifies the female figure as Prudence. A stylistically similar drawing in the Horne Foundation, Florence, shows Prudence with a mirror, reclining beside a standing nude boy, while the symbolic serpent is entwined around a staff at the left (Inv. 6326; Ragghianti Collobi, 1963, pl. 90).

203. *Seated Woman with a Winged Putto*

Pen and brown ink, pale (golden) and dark brown wash, over black chalk. 28.8 x 25.5 cm.

Inscribed in graphite on verso, *Tiepolo* 30 /–.

PROVENANCE: Eugène Rodrigues (Lugt 897); marquis de Biron; purchased in Geneva in 1937.

BIBLIOGRAPHY: Bean and Stampfle, 1971, no. 85, repr.; Byam Shaw, 1971–1, p. 244, note 16.

Rogers Fund, 1937
37.165.45

The woman seated by a vase holds a convex mirror, emblematic of Prudence, while the winged putto clutches a serpent, another attribute of this Virtue. A river god with an oar appears at lower right, beneath the cloud.

204. *Seated Figure of Time*

Pen and brown ink, light and dark brown wash, over black chalk. 23.9 x 41.1 cm.

Numbered in graphite on verso, 9.

PROVENANCE: Marquis de Biron; purchased in Geneva in 1937.

BIBLIOGRAPHY: Chicago, 1938, no. 68; Benesch, 1947, no. 28, repr.; Bean and Stampfle, 1971, no. 92, repr.; Byam Shaw, 1971–1, p. 241.

Rogers Fund, 1937
37.165.9

Time holds an hourglass, and his scythe extends to the right. At the left are a chariot wheel and a dragon's wing and tail. In the Clerici ceiling Time is seen from the back, with wings spread. This solution is adumbrated in a drawing at The Pierpont Morgan Library (IV, 125; Bean and Stampfle, 1971, no. 91, repr.).

205. *Time Seated, Clutching a Putto*

Pen and brown ink, pale and dark brown wash, over black chalk. 25.5 x 32.4 cm.

Numbered in graphite on verso, 4.

PROVENANCE: Marquis de Biron; purchased in Geneva in 1937.

BIBLIOGRAPHY: Chicago, 1938, no. 69; New York, 1938, no. 42, repr.; *Metropolitan Museum, Italian Drawings*, 1942, no. 42, repr.; Benesch, 1947, under no. 30; Bean and Stampfle, 1971, no. 93, repr.; Byam Shaw, 1971–1, p. 240, fig. 2, p. 241.

Rogers Fund, 1937
37.165.7

203

204

205

GIOVANNI BATTISTA TIEPOLO

206. *Time Seated, with Two Attendant Figures*

Pen and brown ink, pale and dark brown wash, over black chalk.
24.7 x 35.4 cm. Upper left corner made up.

Inscribed in graphite at lower right, *Tiepolo*.

PROVENANCE: Eugène Rodrigues (Lugt 897); marquis de Biron;
purchased in Geneva in 1937.

BIBLIOGRAPHY: Panofsky, 1962, p. 92, note 81a, repr. frontis-
piece; Byam Shaw, 1971-1, p. 244, note 16; Levey, 1971, pp.
228-229, 230, note 5, under no. 6387.

Rogers Fund, 1937
37.165.12

Erwin Panofsky interpreted this drawing as a represen-
tation of "Time sending the Future on its way, with the
gloomy figure turning its back upon the beholder per-
sonifying the past."

207. *Time and Truth*

Pen and brown ink, pale and dark brown wash, over black chalk.
25.3 x 22.1 cm. Upper left and right corners made up.

Inscribed in graphite on verso, *19*.

PROVENANCE: Marquis de Biron; purchased in Geneva in 1937.

BIBLIOGRAPHY: Benesch, 1947, no. 22, repr.; Bean and Stampfle,
1971, no. 119, repr.; Byam Shaw, 1971-2, p. 274; Bordeaux, 1981,
no. 139, repr.

Rogers Fund, 1937
37.165.23

Time and a nude figure of Truth, identified by the sun
symbol that she either holds in her hand or that appears
above her, are a standard allegorical couple in Giambat-
tista's iconographic repertory. However, neither this nor
the following two variations on the theme are clearly
associated with a painting.

The present drawing is perhaps earlier, and it differs
stylistically from Nos. 208 and 209 below, which have
in common a looser, more transparent handling of pen

and wash, as does a related representation of Time and Truth in The Pierpont Morgan Library (Fairfax Murray, IV, 101, repr.). Two other drawings of this subject should be mentioned: one formerly in the Bateson collection, and the other now in the Rijksprentenkabinet, Amster-

dam (Hadeln, 1928, 1, pls. 20 and 33, respectively).

A copy of our drawing was sold at Sotheby's, London, on October 21, 1963, no. 169. In this copy the whole scythe appears at the bottom of the sheet, which suggests that our drawing may have been trimmed.

208. *Time and Truth*

Pen and brown ink, pale and dark brown wash, over black chalk. 26.2 x 25.8 cm.

Inscribed in graphite on verso, *Tiepolo 30 /*.

PROVENANCE: Marquis de Biron; purchased in Geneva in 1937.

BIBLIOGRAPHY: New York, 1938, no. 40, repr.; *Metropolitan Museum, Italian Drawings*, 1942, no. 39, repr.; Bean and Stampfle, 1971, no. 121, repr.; Byam Shaw, 1971–2, p. 274.

Rogers Fund, 1937
37.165.42

See No. 207 above.

209. *Time and Truth*

Pen and brown ink, pale and dark brown wash, over black chalk. 25.4 x 23.0 cm.

Inscribed in graphite on verso, *Tiepolo*.

PROVENANCE: Marquis de Biron; purchased in Geneva in 1937.

BIBLIOGRAPHY: Bean and Stampfle, 1971, no. 120, repr.; Byam Shaw, 1971–2, p. 274; Bordeaux, 1981, no. 138, repr.

Rogers Fund, 1937
37.165.19

See No. 207 above.

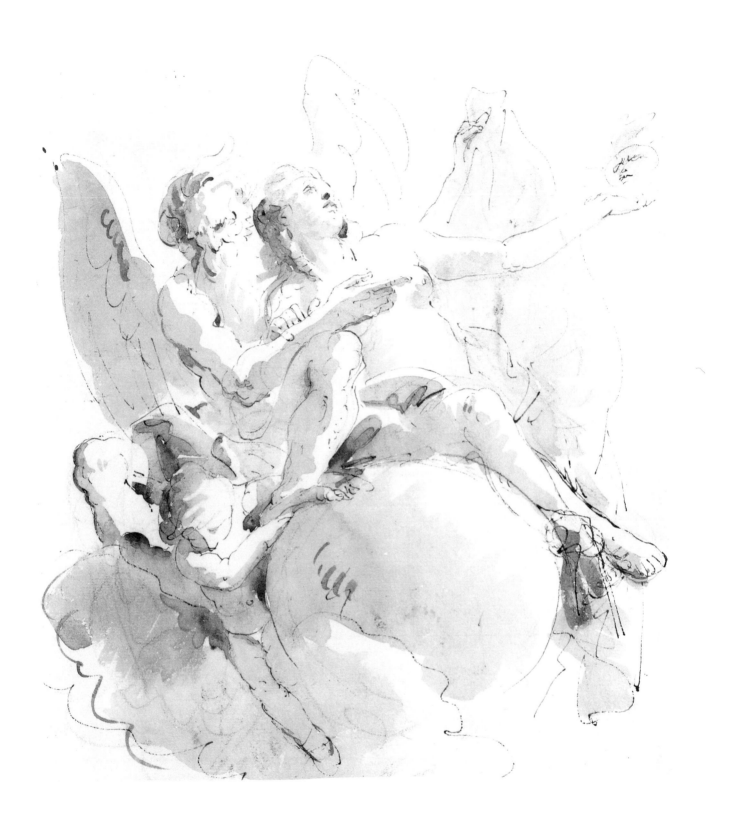

219

GIOVANNI BATTISTA TIEPOLO

210. *Time Holding a Nude Woman, a Putto at Right*

Pen and brown ink, pale and dark brown wash, over black chalk. Contours of drawing on recto traced in black chalk on verso, by a later hand. 22.2 x 19.9 cm.

Partly effaced number (39 ?) in graphite on verso.

PROVENANCE: Marquis de Biron; purchased in Geneva in 1937.

BIBLIOGRAPHY: New York, 1938, no. 49, repr.; Freeden and Lamb, 1956, pl. 44; Bean and Stampfle, 1971, no. 109, repr.; Knox, 1975, p. 17.

Rogers Fund, 1937
37.165.31

The three figures in this drawing appear in reverse above the *Banquet of Anthony and Cleopatra* in the Palazzo Labia, Venice. In the fresco, the old man is without wings, and Michael Levey has identified the subject as the Rape of Proserpina by Pluto (Levey, 1986, p. 144, pl. 141, in color). The Palazzo Labia frescoes date from the mid-1740s.

211. *Venus Entrusting an Infant to Time*

Pen and brown ink, brown wash, over black chalk. 30.5 x 25.4 cm.

Numbered in graphite on verso, 7.

PROVENANCE: Marquis de Biron; purchased in Geneva in 1937.

BIBLIOGRAPHY: Benesch, 1947, no. 34, repr.; Bean and Stampfle, 1971, no. 125, repr.; Byam Shaw, 1971-1, p. 241, fig. 3; Levey, 1971, pp. 229, 230, note 6, under no. 6387.

Rogers Fund, 1937
37.165.11

This group, somewhat altered and reversed, appears in a shaped ceiling painting, *An Allegory with Venus and Time*, now in the National Gallery, London (Levey, 1971, no. 6387; *The National Gallery. January 1969—December 1970*, London, 1971, pl. 1, in color). The painting was probably executed between 1754 and 1758.

212. *Two Women and a Winged Boy on Clouds*

Pen and brown ink, pale (golden) and dark brown wash, over black chalk. 20.5 x 28.1 cm.

Inscribed in graphite on verso, *26*, in a circle.

PROVENANCE: Marquis de Biron; purchased in Geneva in 1937.

BIBLIOGRAPHY: Knox, 1970, under no. 19.

Rogers Fund, 1937
37.165.39

The central standing figure, seen in steep perspective, appears without her attendants in the Fort Worth oil sketch for the Palazzo Clerici ceiling. With a brush in hand, she reappears as Painting in the *Apotheosis of the Pisani Family*, a fresco in the Villa Pisani at Strà, datable 1761–1762 (Morassi, 1955, pl. 78). Shortly thereafter, we find her again, without a brush, in the Washington, D.C., oil sketch for the ceiling of the throne room in the Royal Palace, Madrid (Morassi, 1955, pl. 79), although she does not appear in the ceiling itself.

213. *Two Seated Women and a Boy on Clouds*

Pen and brown ink, pale (golden) and dark brown wash, over black chalk. 21.1 x 24.2 cm.

Inscribed in graphite on verso, *28*.

PROVENANCE: Marquis de Biron; purchased in Geneva in 1937.

BIBLIOGRAPHY: Bean, 1966, p. 49, under no. 78; Bean and Stampfle, 1971, no. 86, repr.; Gibbons, 1977, I, p. 188, under no. 588.

Rogers Fund, 1937
37.165.36

The central seated female figure reappears in a stylistically similar drawing in the Art Museum, Princeton University, where she is companion to a seated satyr (Gibbons, 1977, no. 588, repr.).

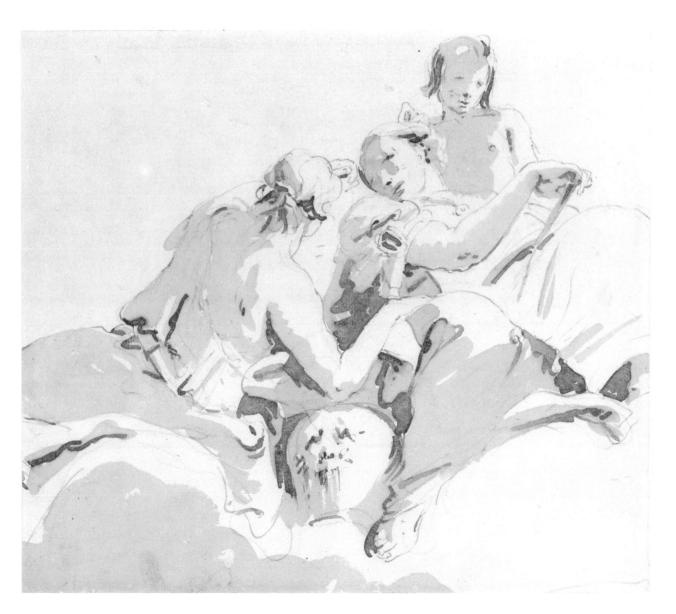

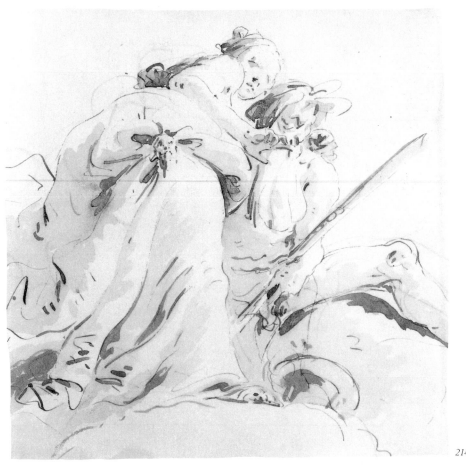

214

215

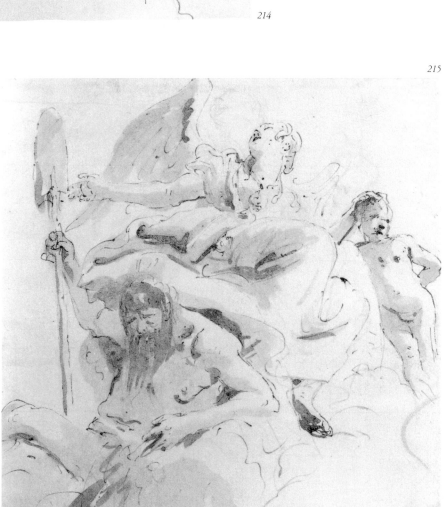

224

214. *Seated River God and Standing Female Attendant*

Pen and brown ink, pale and dark brown wash, over black chalk. 23.3 x 23.4 cm.

Inscribed in graphite on verso, *No 19.*

PROVENANCE: Marquis de Biron; purchased in Geneva in 1937.

Rogers Fund, 1937
37.165.40

215. *Winged Female Figure, River God, and a Nude Boy*

Pen and brown ink, pale and dark brown wash, over black chalk. 21.8 x 21.5 cm.

Inscribed in graphite on verso, *34.*

PROVENANCE: Marquis de Biron; purchased in Geneva in 1937.

BIBLIOGRAPHY: Knox, 1970, no. 18, repr.; Morassi, 1970, p. 296.

Rogers Fund, 1937
37.165.50

A similar group of figures appears at the lower right corner in the Fort Worth study for the Palazzo Clerici ceiling, and again in the southeast corner of the fresco itself (Ancona, 1956, pl. 33, in color). In both paintings the female figure is without wings.

216. *Mercury Appearing to a Marine Deity and a Nymph*

Pen and brown ink, pale and dark brown wash, over black chalk. Ruled vertical line in graphite at left margin. 25.9 x 21.1 cm. Upper corners made up.

PROVENANCE: Marquis de Biron; purchased in Geneva in 1937.

BIBLIOGRAPHY: Benesch, 1947, no. 23, repr.; Freeden and Lamb, 1956, pl. 44.

Rogers Fund, 1937
37.165.28

216

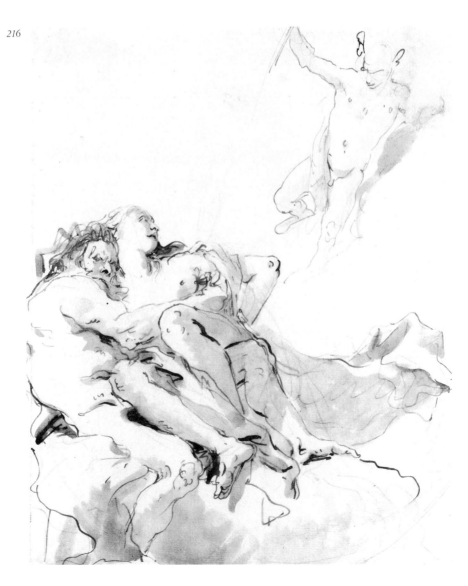

GIOVANNI BATTISTA TIEPOLO

217. *Two Women, a Lion, and a Putto on Clouds*

Pen and brown ink, pale (golden) and dark brown wash, over black chalk. 23.5 x 26.5 cm.

Inscribed in graphite on verso, 25.

PROVENANCE: Marquis de Biron; purchased in Geneva in 1937.

Rogers Fund, 1937
37.165.37

218. *Two Women, One Holding an Anchor, and a Putto on Clouds*

Pen and brown ink, pale (golden) and dark brown wash, over black chalk. 18.8 x 22.0 cm.

Inscribed in graphite on verso, 53.

PROVENANCE: Marquis de Biron; purchased in Geneva in 1937.

BIBLIOGRAPHY: Bean and Stampfle, 1971, no. 87, repr.

Rogers Fund, 1937
37.165.34

Since she holds an anchor, the woman on the right may represent Hope. A comparable group of figures with an emblematic anchor is in the Horne Foundation, Florence (Inv. 6330; Ragghianti Collobi, 1963, no. 142, fig. 94).

GIOVANNI BATTISTA TIEPOLO

219. *Seated Woman Holding Aloft a Sword,
and Supported by Two Putti*

Pen and brown ink, pale (golden) and dark brown wash, over black
chalk. 25.6 x 20.3 cm. Upper corners made up.

Inscribed in graphite on verso, *Tiepolo 11 /*.

PROVENANCE: Marquis de Biron; purchased in Geneva in 1937.

Rogers Fund, 1937
37.165.41

The sword and broken column suggest that the figure
may be an allegorical representation of Fortitude.

220. *Two Women Seated on a Cloud, and Two Putti*

Pen and brown ink, pale (golden) and dark brown wash, over black chalk. 23.9 x 24.2 cm.

Inscribed in graphite on verso, *Tiepolo 30 /.*

PROVENANCE: Marquis de Biron; purchased in Geneva in 1937.

Rogers Fund, 1937
37.165.22

The figure on the left holds up what is perhaps a small sword.

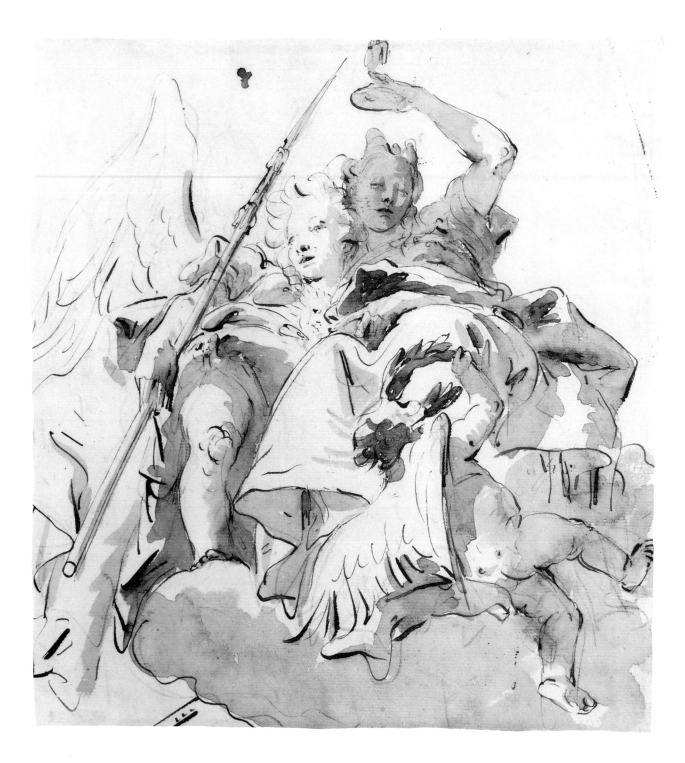

GIOVANNI BATTISTA TIEPOLO

221. *Virtue and Nobility*

Pen and brown ink, brown wash, over black chalk. 26.5 x 24.8 cm.

Inscribed in graphite on verso, *29*, in a circle.

PROVENANCE: Marquis de Biron; purchased in Geneva in 1937.

BIBLIOGRAPHY: New York, 1938, no. 44, repr.; Bean and Stampfle, 1971, no. 108, repr.; Byam Shaw, 1971–1, p. 243, fig. 6; Rizzi, 1988, p. 126, under no. 44.

Rogers Fund, 1937
37.165.29

Virtue (*Virtù*) is identified by her attributes: wings, a staff, and a crown of laurel, which is held by a flying putto at the right. Nobility (*Nobiltà*) holds aloft her emblem, a small statue of Minerva. Widely differing solutions for the pairing of these two allegorical figures are proposed in other drawings by Giambattista, five in The Pierpont Morgan Library (IV, 107; IV, 106; IV, 108; IV, 112; IV, 133a; Bean and Stampfle, 1971, nos. 103–107, repr., respectively) and one in Trieste (Vigni, 1972, no. 111, repr.). There are equally significant compositional differences in Giambattista's six painted representations of Virtue and Nobility (Morassi, 1962, figs. 343–348).

222. *Winged Putto Crowning a Seated Woman Who Looks Upward*

Pen and brown ink, pale and dark brown wash, over black chalk. 23.7 x 19.8 cm.

Inscribed in graphite on verso, *33*, in a circle.

PROVENANCE: Marquis de Biron; purchased in Geneva in 1937.

BIBLIOGRAPHY: Indianapolis, 1970, no. 50, repr.

Rogers Fund, 1937
37.165.24

223. *Winged Putto Crowning a Seated Woman Who Looks to the Left*

Pen and brown ink, pale and dark brown wash, over black chalk. 22.5 x 17.4 cm. Upper left and right corners made up.

Inscribed in graphite on verso, *3*.

PROVENANCE: Marquis de Biron; purchased in Geneva in 1937.

Rogers Fund, 1937
37.165.25

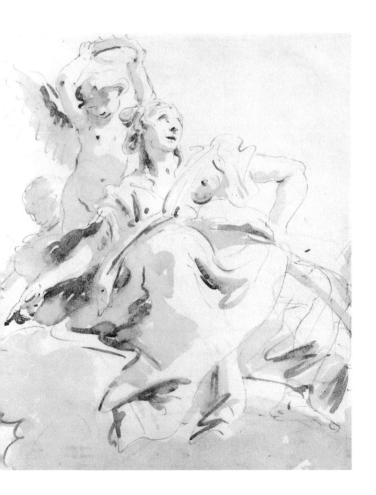

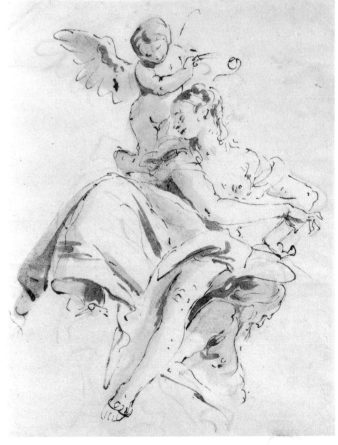

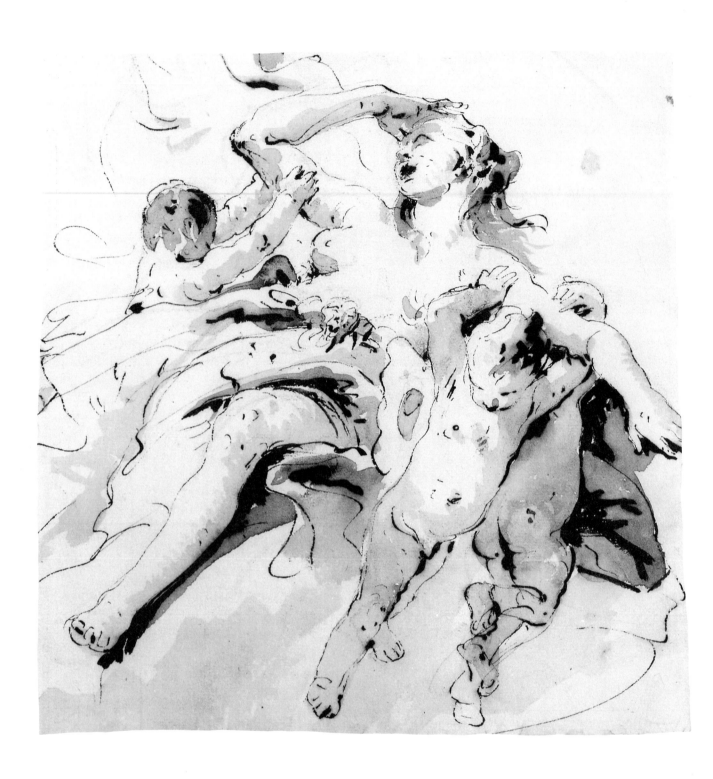

224. *Woman Transported by Three Putti*

Pen and brown ink, pale and dark brown wash, over black chalk. 22.2 x 21.7 cm.

Inscribed in graphite on verso, *No 19*, and *Tiepolo 30 /*.

PROVENANCE: Marquis de Biron; purchased in Geneva in 1937.

BIBLIOGRAPHY: *Metropolitan Museum, Italian Drawings*, 1942, no. 40, repr.; Bean and Stampfle, 1971, no. 101, repr.; Byam Shaw, 1971-1, p. 243, fig. 5; Byam Shaw, 1971-2, p. 274.

Rogers Fund, 1937
37.165.20

The female figure shades her eyes, as she does in a drawing in the collection of Mrs. Rudolf Heinemann, where the composition is reversed and the woman is being carried aloft by only two putti (Bean and Stampfle, 1971, no. 100, repr.). It has been suggested that these drawings represent Psyche being transported to Olympus, although Giambattista is not known to have painted the subject.

225. *Zephyr and Flora*

Pen and brown ink, pale and dark brown wash, over black chalk. 22.9 x 22.8 cm. Upper left and right corners made up.

Inscribed in graphite on verso, *40*.

PROVENANCE: Marquis de Biron; purchased in Geneva in 1937.

BIBLIOGRAPHY: Knox, 1970, under no. 36; Bean and Stampfle, 1971, no. 115, repr.

Rogers Fund, 1937
37.165.51

This subject was depicted by Giambattista on the ceiling of one of the subsidiary rooms in the Palazzo Labia, Venice (Morassi, 1962, fig. 257). There the composition is reversed, and Zephyr is seen frontally at the right, reclining on clouds. A drawing in the Barber Institute of Fine Arts, Birmingham, is close to this painted version (Sack, 1910, fig. 113).

GIOVANNI BATTISTA TIEPOLO

226. *Bacchus and Ariadne*

Pen and brown ink, brown wash, over black chalk. 25.3 x 19.3 cm. All four corners made up.

Inscribed in graphite on verso, 35, in a circle.

PROVENANCE: Marquis de Biron; purchased in Geneva in 1937.

BIBLIOGRAPHY: Knox, 1970, under no. 36; Bean and Stampfle, 1971, no. 111, repr.

Rogers Fund, 1937
37.165.27

A similar group appears in a ceiling fresco in the Palazzo Labia, Venice (Morassi, 1962, fig. 265). Bacchus grasps a wine flask in his left hand, and with his right holds a diadem of stars above Ariadne's head. Two other drawings by Giambattista are related to this fresco: one is in the collection of Joan K. Davidson, New York (Knox, 1970, no. 36, repr.), the other—closest to the finished work—is in a French private collection (Cailleux, 1952, no. 23, pl. 6).

227. *Virtue Crowning a Bearded Man*

Pen and brown ink, pale and dark brown wash, over black chalk.
25.8 x 25.6 cm.

Inscribed in graphite on verso, *14.*

PROVENANCE: Marquis de Biron; purchased in Geneva in 1937.

BIBLIOGRAPHY: Benesch, 1947, no. 24, repr.

Rogers Fund, 1937
37.165.48

Wings, staff, and a laurel crown held aloft identify the
female figure as Virtue, while the owl must symbolize
the wisdom of the old man.

228. *Apotheosis of a Warrior*

Pen and brown ink, brown wash, over black chalk. 25.0 x 31.7 cm.
Upper corners made up.

Illegible number in graphite on verso.

PROVENANCE: Marquis de Biron; purchased in Geneva in 1937.

BIBLIOGRAPHY: Knox, 1970, under no. 77; Bean and Stampfle,
1971, no. 139, repr.

Rogers Fund, 1937
37.165.26

A similar laurel-crowned warrior, with one hand on the
neck of a lion and a baton in the other, a trumpet-
bearing figure of Fame above him, occurs at the center
of the *Glorification of Francesco Barbaro*, a ceiling paint-
ing executed about 1745–1750 for the Palazzo Barbaro,
Venice, now in The Metropolitan Museum of Art
(23.128. Anonymous Gift in memory of Oliver H. Payne,
1923; Morassi, 1955, fig. 27; Zeri and Gardner, 1973,
pp. 56–57, pl. 61).

229. *Aged Dignitary Attended by Mercury and Prudence*

Pen and brown ink, pale and dark brown wash, over black chalk. 29.6 x 24.8 cm. Upper margin made up.

Inscribed in graphite on verso, *10*.

PROVENANCE: Marquis de Biron; purchased in Geneva in 1937.

BIBLIOGRAPHY: Bean and Stampfle, 1971, no. 126, repr.

Rogers Fund, 1937
37.165.43

The figures stand on a cornice and are seen in very steep perspective. Mercury is identified by his caduceus and winged cap, Prudence by the serpent entwined around her staff.

230. *Scherzo di Fantasia: Standing Warrior and King with Five Attendants*

Pen and brown ink, pale and dark brown wash, over black chalk. 35.2 x 27.8 cm. Scattered stains.

PROVENANCE: Marquis de Biron; purchased in Geneva in 1937.

BIBLIOGRAPHY: Benesch, 1947, no. 20, repr.; Bean and Stampfle, 1971, no. 96, repr.; Byam Shaw, 1971–1, p. 244; Santifaller, 1975, pp. 328, 353, note 18, fig. 5; Florence, 1982, p. 37, under no. 34; Grigorieva and Kantor-Gukovskja, under no. 63.

Rogers Fund, 1937
37.165.17

This and the following two drawings are related in format, figure style, mysterious subject matter, exotic costumes and accessories to Giambattista's series of twenty-three etchings entitled *Scherzi di Fantasia* (Rizzi, 1971, nos. 4–26, repr.). However, none of the drawings is a study for a specific *scherzo* and all three are a good deal larger than the etchings. George Knox has identified a group of smaller and more summary sketches in the Victoria and Albert Museum, London, as studies for the *Scherzi di Fantasia*, as well as for the *Vari Capricci*, another etched series by Giambattista.

231. *Scherzo di Fantasia: Two Standing Orientals and a Standing Youth with a Sword*

Pen and brown ink, pale and dark brown wash, over traces of black chalk. 34.7 x 25.2 cm.

PROVENANCE: Marquis de Biron; purchased in Geneva in 1937.

BIBLIOGRAPHY: Chicago, 1938, no. 80, repr.; New York, 1938, no. 53, repr.; *Metropolitan Museum, Italian Drawings*, 1942, no. 43, repr.; Bean and Stampfle, 1971, no. 97, repr.; Byam Shaw, 1971–1, p. 244; Florence, 1982, p. 37, under no. 34; Grigorieva and Kantor-Gukovskja, under no. 63.

Rogers Fund, 1937
37.165.13

232. *Scherzo di Fantasia: Seated Warrior Holding a Serpent, and Standing Youth*

Pen and brown ink, pale and dark brown wash, over black chalk. 34.9 x 27.3 cm.

PROVENANCE: Marquis de Biron; purchased in Geneva in 1937.

BIBLIOGRAPHY: New York, 1938, no. 52, repr.; *Metropolitan Museum, Italian Drawings*, 1942, no. 44, repr.; Bean and Stampfle, 1971, no. 98, repr.; Byam Shaw, 1971–1, p. 244, fig. 8; Weeks, 1978, no. 45, repr.; Florence, 1982, p. 37, under no. 34; Grigorieva and Kantor-Gukovskja, under no. 63.

Rogers Fund, 1937
37.165.18

233. *The Meeting of Anthony and Cleopatra*

Pen and brown ink, pale and dark brown wash, over black chalk. 40.8 x 29.1 cm.

PROVENANCE: Marquis de Biron; purchased in Geneva in 1937.

BIBLIOGRAPHY: *Metropolitan Museum, Italian Drawings*, 1942, no. 38, repr.; Bean, 1964, no. 43, repr.; Virch, 1969, p. 173, fig. 2, p. 175; Pignatti, 1970, p. 85, pl. XXVIII, in color; Bean and Stampfle, 1971, no. 110, repr.; Fahy, 1971, p. 737, fig. 47; Everett Fahy in *Wrightsman Collection*. V, 1973, p. 225, fig. 6, p. 226; Pignatti, 1974–1, pl. XXIV, in color; Pignatti and Romanelli, 1985, p. 41, fig. 27; Levey, 1986, pp. 156–158, pl. 146; London, 1987, p. 104, under no. 32, New York, 1990, p. 120, under no. 40.

Rogers Fund, 1937
37.165.10

Anthony bows to kiss the hand of Cleopatra, as he does in an oil sketch by Giambattista in a private collection in New York (Everett Fahy in *Wrightsman Collection*. V, 1973, no. 24, repr. in color). A stylistically similar pen and wash drawing of this subject is now in the Woodner collection, New York (New York, 1990, no. 40, repr. in color). Mr. Woodner's drawing comes even closer to the group in the oil sketch, where Cleopatra's head is seen in profile.

The New York oil sketch is now generally considered to be a study for Giambattista's splendid fresco in the Palazzo Labia, Venice, *The Meeting of Anthony and Cleopatra*, though in the fresco Anthony greets Cleopatra without kissing her hand (Levey, 1986, p. 146, pl. 136, in color).

229

GIOVANNI BATTISTA TIEPOLO

234. *The Holy Family*

Pen and brown ink, brown wash, over black chalk. Red chalk scribbles on verso. 26.6 x 19.3 cm.

PROVENANCE: Probably convent of the Somaschi, S. Maria della Salute, Venice, suppressed in 1810; conte Leopoldo Cicognara; Antonio Canova, the sculptor; his half brother, Monsignor Giovanni Battista Sartori-Canova; Francesco Pesaro, Venice; purchased from him in 1842 by Edward Cheney, Badger Hall, Shropshire; by inheritance to his brother-in-law, Colonel Alfred Capel Cure, Blake Hall, Ongar, Essex; sale, London, Sotheby's, April 29, 1885, from lot 1024, nine volumes, to Parsons at £15; then possibly to an Irish private collector, and subsequently to William Fagg of Sydenham; [Batsford]; sale, London, Christie's, July 14, 1914, from lot 49, three albums, to Parsons at £120; [Parsons]; [Savile Gallery]; Alexandrine Sinsheimer.

BIBLIOGRAPHY: *Drawings by Giovanni Battista Tiepolo*, Savile Gallery, London, 1928, probably no. 16, "St. Joseph Standing by the Mother and Child"; Pignatti, 1965, no. 66, repr.; Pignatti, 1974–1, pl. LIX, in color; Byam Shaw, 1983, I, p. 290, under no. 278.

Bequest of Alexandrine Sinsheimer, 1958
59.23.81

Giambattista executed, probably in the 1750s, a long series of variations on the theme of the Holy Family. More than sixty such designs were in an album said to have been presented by the artist to the convent of the Somaschi at S. Maria della Salute in Venice. This album was broken up in the 1920s, and the contents widely

dispersed in Europe and America. Two studies of the Holy Family from this source are in the Robert Lehman Collection at the Metropolitan Museum (George Knox in *Lehman Collection.* VI, 1987, nos. 93 and 94, repr.).

235. *Standing Man in a Turban, Holding a Sword*

Pen and brown ink, brown wash, over black chalk. 23.9 x 14.7 cm.

PROVENANCE: Dan Fellows Platt (Lugt Supp. 750a); Harry G. Sperling.

BIBLIOGRAPHY: Chicago, 1938, no. 76, repr.; Toledo, 1940, no. 87; Wellesley, 1960, no. 62; *Annual Report*, 1974–1975, p. 50.

Bequest of Harry G. Sperling, 1971
1975.131.52

This and very probably the following drawing come from a group of at least twenty-six studies of single standing draped figures that belonged to Dan Fellows Platt, who may well have purchased them from Parsons in London.

These drawings were dispersed in the late 1930s, but seven are in the Art Museum, Princeton University (Bean, 1966, nos. 86–88, repr.; Gibbons, 1977, nos. 590, 619–622, 626, 627, repr.). These figure studies that once belonged to Platt are very similar in subject and style to eighty-nine drawings preserved in an album with the title *Sole Figure Vestite T:I*, once in the collection of Edward Cheney and now in the Victoria and Albert Museum, London (Knox, 1975, nos. 43, 131–176, 187–194, 212–221, 252–254, 261, 276–295, repr.).

236. *Standing Man in a Full Coat and High Hat with a Medallion*

Pen and brown ink, brown wash. 23.8 x 14.9 cm.

PROVENANCE: Dan Fellows Platt (according to Virch; without the Platt mark); Walter C. Baker.

BIBLIOGRAPHY: Virch, 1962, no. 59, repr.

Bequest of Walter C. Baker, 1971
1972.118.274

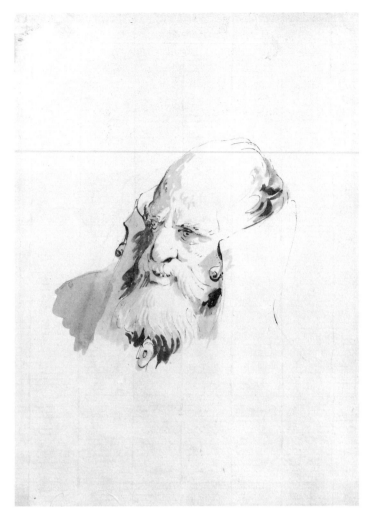

GIOVANNI BATTISTA TIEPOLO

237. *Head of a Man Wearing a High Collar*

Pen and brown ink, pale and dark brown wash, over traces of black chalk. Framing lines in graphite. 27.1 x 20.1 cm. Lined.

Numbered in pen and gray ink at lower left, *612.*

PROVENANCE: Richard Owen; Philip Hofer; Walter C. Baker.

BIBLIOGRAPHY: Virch, 1962, no. 58, repr.

Bequest of Walter C. Baker, 1971
1972.118.273

The drawing is one of a series of fantastic heads, of which ninety-three once belonged to Richard Owen in Paris. These heads may have come from the library of the Somaschi at S. Maria della Salute, Venice. Three further heads from this series are in the Robert Lehman Collection, The Metropolitan Museum of Art (George Knox in *Lehman Collection.* VI, 1987, nos. 78–80, repr., with comments on the provenance).

238. *Figure Studies*

Pen and brown ink, over black chalk, on beige paper. 25.1 x 34.1 cm. Scattered stains.

Inscribed in pen and brown ink on verso, *N⁰ 2265. X^r! 12*; above, in graphite, *487* (Bossi-Beyerlen "code number"; see Knox, 1980, I, pp. 200–207).

PROVENANCE: Giovanni Domenico Bossi; Maria Theresa Karoline Bossi; Karl Christian Friedrich Beyerlen; sale, Stuttgart, H. G. Gutekunst, March 27–28, 1882, lot no. uncertain; Victor Bloch; sale, London, Sotheby's, November 19, 1963, no. 95; [Colnaghi]; purchased in London in 1964.

BIBLIOGRAPHY: Frohlich-Bume, 1957, p. 57, repr.; *Annual Report*, 1964–1965, p. 52.

Rogers Fund, 1964
64.38.3

These figures seen in steep perspective are presumably studies for ceiling decoration; the summary facial notations and the stumplike treatment of hands and feet are typical of Giambattista's most abbreviated pen sketches. Such sheets are difficult to date, but the present example could be late rather than early. In any case the spacious *mise en page* may be contrasted with the crowded arrangement of heavy figures in a sheet with the same Bossi-Beyerlen provenance, now in Stuttgart, which Knox dates to the late 1720s (Stuttgart, 1970, no. 4, repr.).

239. *An Eagle with Wings Spread*

Black chalk, heightened with white, on blue paper. 34.7 x 24.8 cm. All four margins irregular. Scattered stains.

Inscribed in pen and brown ink on verso, *24 x^r! N⁰ 2938*; above, in graphite, *401* (Bossi-Beyerlen "code number"; see Knox, 1980, I, pp. 200–207).

PROVENANCE: Giovanni Domenico Bossi; Maria Theresa Karoline Bossi; Karl Christian Friedrich Beyerlen; sale, Stuttgart, H. G. Gutekunst, March 27–28, 1882, lot no. uncertain; H. Wendland; marquis de Biron; purchased in Geneva in 1937.

BIBLIOGRAPHY: Hadeln, 1928, I, p. 24, II, pl. 136; New York, 1938, no. 47, repr.; *Metropolitan Museum, Italian Drawings*, 1942, no. 46, repr.; Tietze, 1947, no. 90, repr.; Freeden and Lamb, 1956, p. 105, pl. 45; Knox, 1963, p. 328, fig. 56; Knox, 1970, no. 31, repr.; Morassi, 1970, p. 298, fig. 437; Stuttgart, 1970, p. 170, under no. 181; Bean and Stampfle, 1971, no. 154, repr.; Byam Shaw, 1971-1, p. 246; Weeks, 1978, no. 51, repr. p. 88; Knox, 1980, I, pp. 12, 281, no. M.604, p. 334, under no. X.73, II, pl. 32.

Rogers Fund, 1937
37.165.109

George Knox, who attributes this drawing to Giambattista, suggests that it is a study for the eagle that appears hovering in the sky in a ceiling fresco of 1743 in

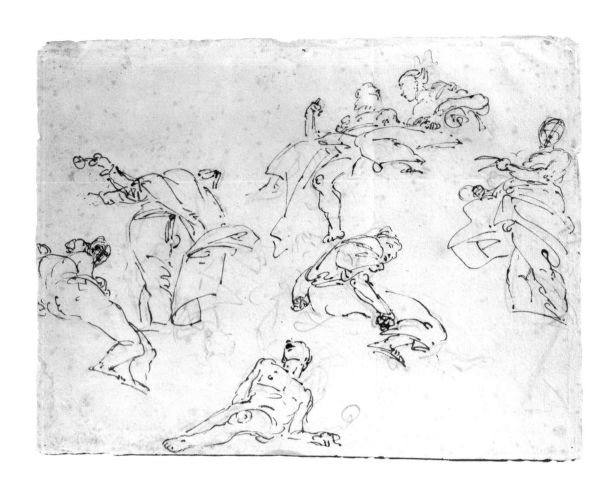

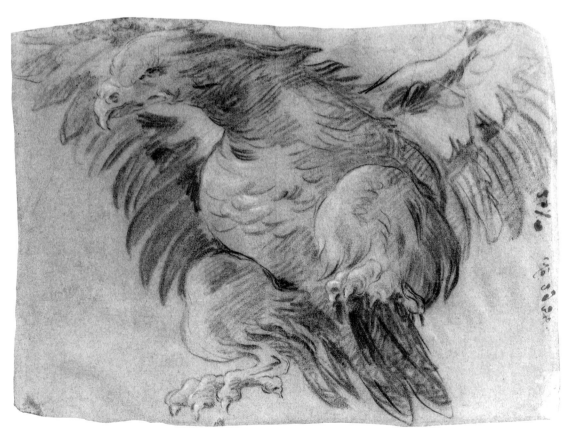

the Palazzo Pisani-Moretta a S. Polo, Venice (Morassi, 1962, fig. 259). The correspondence is indeed fairly close, and the possibility that the drawing is a copy —perhaps by Domenico—should not be entirely excluded. Knox records four further drawings that he associates with the ceiling of the Palazzo Pisani-Moretta (Knox, 1980, I, D.130, M.3, M.279, M.702, the latter repr. II, pl. 33).

240. *Three Dogs, after Paolo Veronese*

Black chalk, heightened with white, on blue paper. 33.3 x 23.3 cm. Horizontal crease at center. All four corners made up.

Inscribed in pen and brown ink on verso, . . . *X.^{ri} 12. N.^o 3103*; in graphite, *853* (Bossi-Beyerlen "code number"; see Knox, 1980, I, pp. 200–207).

PROVENANCE: Giovanni Domenico Bossi; Maria Theresa Karoline Bossi; Karl Christian Friedrich Beyerlen; sale, Stuttgart, H. G. Gutekunst, March 27–28, 1882, lot no. uncertain; H. Wendland; sale, Paris, Hôtel Drouot, salle 11, May 23, 1930, no. 66; marquis de Biron; purchased in Geneva in 1937.

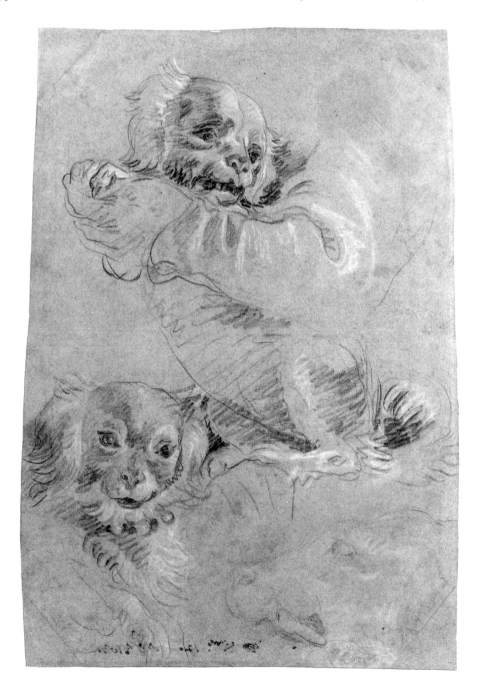

BIBLIOGRAPHY: Hadeln, 1928, I, pp. 23–24, II, pl. 135; New York, 1938, no. 46, repr.; Freeden and Lamb, 1956, p. 105, pl. 46; Knox, 1963, p. 328, fig. 59; Knox, 1970, no. 32, repr.; Morassi, 1970, p. 298; Bean and Stampfle, 1971, no. 153, repr.; Byam Shaw, 1971-1, p. 246, fig. 10; Byam Shaw, 1971-2, p. 269; Rizzi, 1971, p. 328, under no. 151; Knox, 1980, I, pp. 11–12, 280–281, no. M.603, II, pl. 30.

Rogers Fund, 1937
37.165.53

These three dogs' heads are, as George Knox pointed out, copied from Paolo Veronese's *Family of Darius before Alexander*. The two spaniels appear at the extreme left of Veronese's composition; the dog lightly sketched in profile at the lower right of the sheet appears at the extreme right in the painting. Knox catalogues two further chalk drawings after details of the painting by Veronese, one in Leningrad, the other in Melbourne. These he attributes, as he does the present drawing, to Giambattista Tiepolo (Knox, 1980, I, nos. B.6, M.220, respectively, the latter repr. II, pl. 31).

Veronese's painting is now in the National Gallery, London, but in the eighteenth century it hung in the Palazzo Pisani-Moretta a S. Polo, where Giambattista executed a ceiling fresco about 1740–1745 (see No. 239 above). Francesco Algarotti wrote in 1751 to P.-J. Mariette that he had intended to commission a copy of the "Famiglia di Dario dinanzi ad Alessandro della casa Pisani al Tiepolo" (Bottari and Ticozzi, VII, 1822, pp. 390–391). It is possible that the drawn copies taken from details of Veronese's picture may be associated with this proposed commission from Algarotti.

The two spaniels in our drawing reappear side by side and in reverse at the upper left in an etching inscribed *Io. Bapta Tiepolo inv. et pinx. / Io. Dominicus filius sculp.* (Rizzi, 1971, no. 151, repr.).

GIOVANNI BATTISTA TIEPOLO ?

241. *Caricature: An Elderly Couple*

Pen and brown ink, brown wash, over black chalk. 20.9 x 15.6 cm.

PROVENANCE: Marquis de Biron; purchased in Geneva in 1937.

BIBLIOGRAPHY: Benesch, 1947, no. 39, repr.; Byam Shaw, 1962, p. 57, note 2; Pignatti, 1970, p. 85, pl. XXIX, in color; Byam Shaw, 1971-1, p. 239, note 11, possibly by Lorenzo Tiepolo; Pignatti, 1974-1, pl. LVI, in color; Knox, 1975, p. 98, under no. 311.

Rogers Fund, 1937
37.165.8

The drawing has been generally accepted as a good example of Giambattista as a caricaturist. However, in 1971 James Byam Shaw suggested that "the wash lacks the transparency of Giambattista's, and the pen work is scratchy and of indifferent quality." He proposed that the drawing might be a copy by Lorenzo Tiepolo after a lost original by his father, Giambattista. Another drawing of this elderly couple, in the Victoria and Albert Museum, is a copy of clearly inferior quality (Knox, 1975, no. 311, repr.).

Byam Shaw has also pointed out that figures in this pose appear—the old woman shown younger and masked, the old man transformed into Punchinello—in *The Country Walk*, one of Domenico Tiepolo's Punchinello drawings (Gealt, 1986, no. 93, repr.).

GIOVANNI DOMENICO TIEPOLO

Venice 1727–Venice 1804

242. *The Three Angels Appearing to Abraham by the Oaks of Mamre*

(Genesis 18:1–3)

Pen and brown ink, brown wash, over black chalk. 40.0 x 27.6 cm. Upper and lower margins irregular.

PROVENANCE: Marquis de Biron; purchased in Geneva in 1937.

BIBLIOGRAPHY: Williams, 1938, p. 66, note 6, as Giambattista Tiepolo; *Metropolitan Museum, Italian Drawings*, 1942, no. 45, repr., as Giovanni Battista Tiepolo; Byam Shaw, 1962, p. 74, no. 12, repr.; Knox, 1965, p. 394, under no. 8; Rizzi, 1965, p. 61, under no. 14; Bean and Stampfle, 1971, no. 241, repr.; Byam Shaw, 1971-1, pp. 239, 246; Knox, 1975, p. 98, under no. 311; Weeks, 1978, no. 107, repr. p. 57.

Rogers Fund, 1937
37.165.5

This drawing figured in the Biron collection as the work of Giambattista. In 1952 Antonio Morassi recognized the sheet as an early work of Domenico, who has fairly closely copied a drawing by his father that is now in the Museo Civico, Bassano (Knox, 1965, p. 394, no. 8, pl. 23). Giambattista's drawing was one of a series of finished compositions engraved by Pietro Monaco (Knox, 1965, fig. 9).

243. *The Assumption of the Virgin*

Pen and black ink, gray wash, over red chalk. 37.6 x 26.7 cm. (the drawing itself). Strips of gray washed paper have been added at the irregular left and lower margins by a later hand.

Signed in pen and black ink at lower right, *Dom° Tiepolo f.*

PROVENANCE: Marquis de Biron; purchased in Geneva in 1937.

BIBLIOGRAPHY: New York, 1938, no. 73, repr.; Byam Shaw, 1962, pp. 33, 77, no. 25, repr.; Bean and Stampfle, 1971, no. 242, repr.; Byam Shaw, 1971-1, p. 246; Weeks, 1978, no. 111, repr. p. 25.

Rogers Fund, 1937
37.165.65

This subject was often represented by Domenico. The Virgin is shown either with hands clasped, as in a drawing in The Pierpont Morgan Library (IV, 151c; Byam Shaw, 1962, pl. 24), or with arms outstretched, as here and in another sheet in the Morgan Library (IV, 151d).

249

GIOVANNI DOMENICO TIEPOLO

244. *The Holy Family with Two Female Saints*

Pen and black ink, gray wash, over traces of black chalk. Framing lines in pen and black ink. 33.3 x 16.7 cm. Arched top.

Signed in pen and black ink at lower left, *Dom. Tiepolo.*

PROVENANCE: Eugène Rodrigues (Lugt 897); marquis de Biron; purchased in Geneva in 1937.

BIBLIOGRAPHY: *Metropolitan Museum, Italian Drawings*, 1942, no. 56, repr.; Knox, 1970, no. 98, repr.; Byam Shaw, 1971–1, pp. 246, 247, fig. 11; Weeks, 1978, no. 110, repr. p. 112; Knox, 1980, I, pp. 78, 237, no. M.213, p. 311, under no. P.190, II, pl. 315.

Rogers Fund, 1937
37.165.66

George Knox pointed out that this is a free copy by Domenico of his own signed altarpiece of 1777 now in S. Nicolò, Padua (Mariuz, 1971, p. 131, pl. 275). This painting was originally in the now-suppressed church of S. Agnese at Padua. The female saints are described in a late eighteenth-century guide as St. Frances of Rome and St. Eurosia (Brandolese, 1795, p. 182). Eurosia, whose intercession was invoked for protection against bad weather, is identified by the lightning bolt that appears at her breast in our drawing and in the sky above her in the painting.

The drawing is valuable as a record of the original composition, for in the painting a kneeling angel at lower left was added later by G. B. Mengardi. Knox identified in the Museo Correr, Venice, three chalk studies on blue paper for the hands of the Virgin and the female saints (Knox, 1966, nos. 98–100, repr.; Knox, 1980, I, p. 142, nos. D.114–D.116, II, no. D.114 repr. pl. 316), and he called attention to a related pen and gray wash composition study by Domenico in which St. Joseph is omitted and St. Eurosia on the right is shown with her hands and feet amputated (London, Sotheby's, June 25, 1970, no. 54, repr.; London, Sotheby's, March 23, 1971, no. 73, repr.).

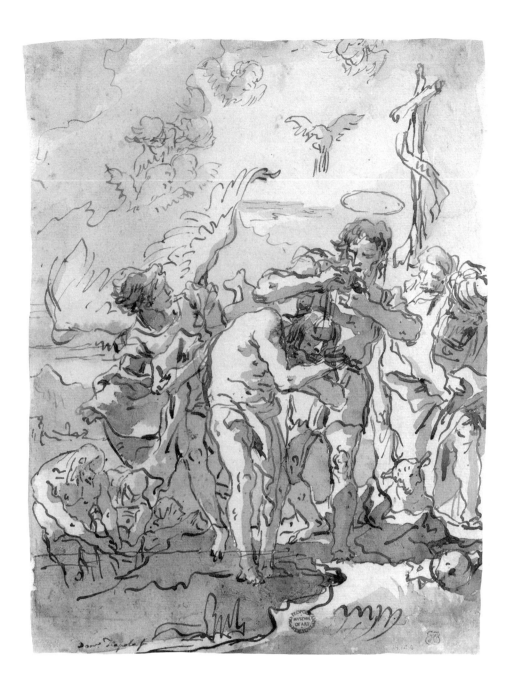

245. *The Baptism of Christ*

Pen and brown ink, brown wash. 25.7 x 19.8 cm.

Signed in pen and brown ink at lower left, *Domᵒ. Tiepolo f.*

PROVENANCE: Hamilton Easter Field (Lugt Supp. 872a); [Anderson Galleries]; purchased in New York in 1918.

BIBLIOGRAPHY: Bean and Stampfle, 1971, no. 243, repr.; Byam Shaw, 1971–1, p. 246, note 23; Bolger, 1988, pp. 83, 84, fig. 6.

Rogers Fund, 1918
18.144

Domenico Tiepolo repeatedly treated this biblical subject, introducing innumerable picturesque variations on the given theme. The Graphische Sammlung, Stuttgart, possesses thirteen such representations of the Baptism (Stuttgart, 1970, nos. 44–56, repr.), thirteen more were dispersed with the Beauchamp collection in 1965 (sale, London, Christie's, June 15, 1965, nos. 6–18, repr.), and six are in the Robert Lehman Collection here at the Metropolitan Museum (James Byam Shaw in *Lehman Collection*. VI, 1987, nos. 114–119, repr.).

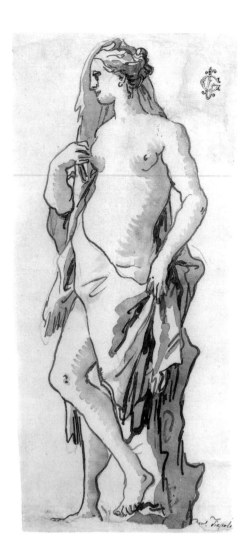

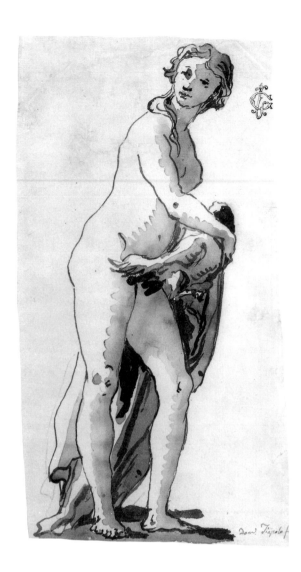

GIOVANNI DOMENICO TIEPOLO

246. *Study of a Garden Sculpture: Venus ?*

Pen and brown ink, brown wash, over black chalk. 27.7 x 12.6 cm. Narrow strips of paper have been added at irregular upper and lower margins. Repaired tear at upper right.

Signed in pen and brown ink at lower right, *Dom°. Tiepo* (the rest cut away).

PROVENANCE: Luigi Grassi (Lugt Supp. 1171b); sale, London, Sotheby's, May 13, 1924, no. 132; Robert Lehman.

BIBLIOGRAPHY: Byam Shaw, 1971–1, p. 246, note 23; James Byam Shaw in *Lehman Collection.* VI, 1987, under no. 136.

Gift of Robert Lehman, 1941
41.187.1

Four similar studies of statues of pagan deities, two of them from the Luigi Grassi sale, are in the Robert Lehman Collection at the Metropolitan Museum (James Byam Shaw in *Lehman Collection.* VI, 1987, nos. 135–138, repr.).

247. *Study of a Garden Sculpture: Leda ?*

Pen and brown ink, brown wash, over traces of black chalk. 25.5 x 13.6 cm. Narrow strips of paper added to irregular upper margin.

Signed in pen and brown ink at lower right, *Dom°. Tiepolo f.*

PROVENANCE: Luigi Grassi (Lugt Supp. 1171b); sale, London, Sotheby's, May 13, 1924, probably no. 129, "A Goddess turned to the right, holding a drapery"; Robert Lehman.

BIBLIOGRAPHY: Byam Shaw, 1971–1, p. 246, note 23; James Byam Shaw in *Lehman Collection.* VI, 1987, p. 166, under no. 136.

Gift of Robert Lehman, 1941
41.187.5

James Byam Shaw has suggested that this drawing represents Leda holding "a very small swan." The drapery behind the figure would have been intended as a support for the statue.

248. *Centaur Holding Up a Youthful Satyr*

Pen and brown ink, brown wash, over black chalk. 19.2 x 27.4 cm.

Signed in pen and brown ink at lower left, *Dom.º Tiepolo f.*; numbered in pen and brown ink at upper left, *132*; numbered in pen and brown ink on verso, *441*.

PROVENANCE: Marquis de Biron; purchased in Geneva in 1937.

BIBLIOGRAPHY: Byam Shaw, 1962, p. 41; Byam Shaw, 1971–1, p. 246; Cailleux, 1974, p. xxii, fig. 62, p. xxiii, no. 68; Gealt, 1986, p. 142, under no. 59; James Byam Shaw in *Lehman Collection.* VI, 1987, p. 171, under no. 140.

Rogers Fund, 1937
37.165.54

This drawing and the ten that follow are part of a large group of representations of satyrs and centaurs (with satyresses and centauresses) in landscape settings. The drawings in this series, all horizontal in format, are very numerous. Four are in the Robert Lehman Collection at The Metropolitan Museum of Art (James Byam Shaw in *Lehman Collection.* VI, 1987, nos. 140–143, repr.), nine are in the British Museum (Cailleux, 1974, nos. 7, 8, 38, 40, 46, 54, 58, 74, 78, repr.), six are in the Art

Museum, Princeton University (Cailleux, 1974, nos. 6, 14, 39, 55, 66, 67, repr.), and six are in the Uffizi (Cailleux, 1974, nos. 1, 2, 5, 9, 85, 86, repr.). More than sixty additional drawings of this kind are to be found in private and public collections here and abroad. These variations on a theme, painstakingly listed by Jean Cailleux, are rightly hailed by James Byam Shaw as perhaps the most charming and original of all Domenico's inventions.

The centaur and satyr represented here occur as well in one of the frescoes from the Tiepolo family villa at Zianigo, now in the Ca' Rezzonico, Venice (Mariuz, 1971, pl. 359), and in a drawing in the Punchinello series, in which the satyr becomes a young clown (Gealt, 1986, no. 59, repr.).

The sheet is numbered at upper left, *132*; a drawing in a private collection abroad bears the number *144*, and one of the drawings in the Robert Lehman Collection appears to be numbered *197*. Thus a good many of the centaur and satyr drawings seem to have disappeared.

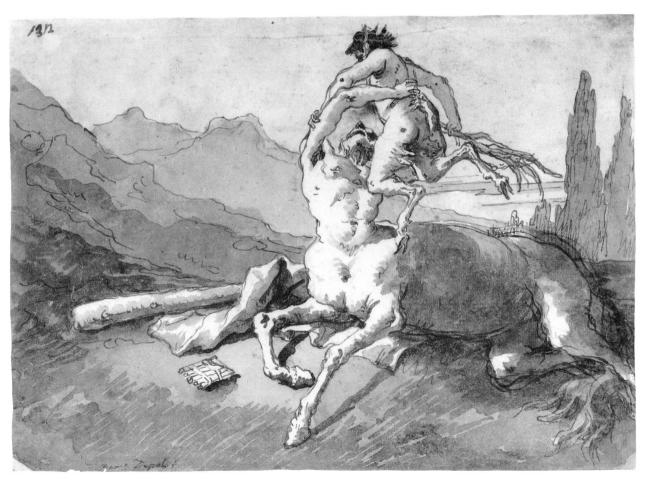

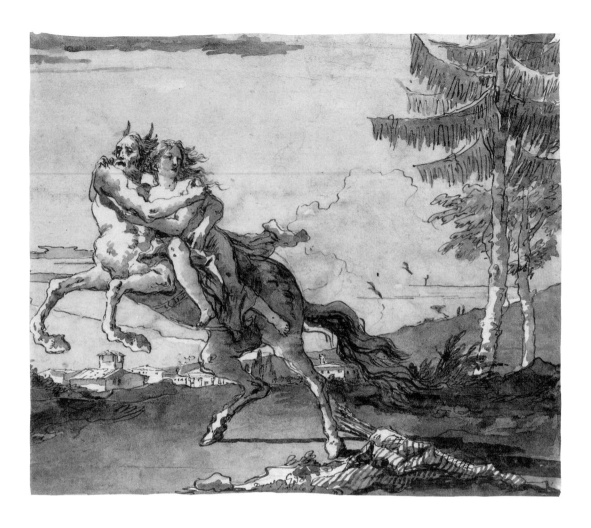

GIOVANNI DOMENICO TIEPOLO

249. *Centaur Abducting a Nymph*

Pen and brown ink, brown wash, over traces of black chalk. 19.5 x 23.1 cm.

Signed in pen and brown ink at lower center, *Dom.° Tiepolo f.*

PROVENANCE: Marquis de Biron; purchased in Geneva in 1937.

BIBLIOGRAPHY: *Metropolitan Museum, Italian Drawings*, 1942, no. 57, repr. (with erroneous inventory number, title, and description); Byam Shaw, 1962, p. 41; Byam Shaw, 1971–1, p. 246; Cailleux, 1974, pp. xi–xii, no. 13, fig. 16, p. xiii, under no. 22; Athens, 1979, no. 55, repr.; James Byam Shaw in *Lehman Collection.* VI, 1987, p. 171, under no. 140.

Rogers Fund, 1937
37.165.57

A similar centaur and nymph appear in a drawing in the Musée Fabre, Montpellier (Cailleux, 1974, no. 22, repr.). The Montpellier sheet is somewhat larger, nearly square in shape, and it is executed in a sketchier manner than our drawing.

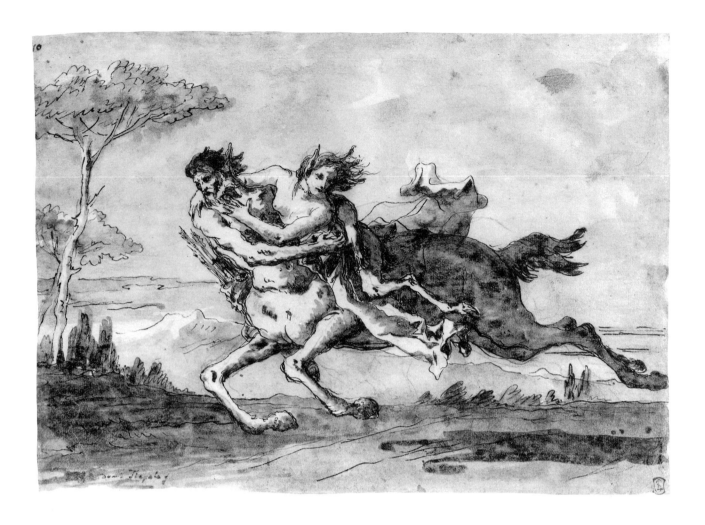

250. *Centaur Abducting a Satyress*

Pen and dark brown ink, gray-brown wash, over black chalk. 19.4 x 27.4 cm.

Signed in pen and dark brown ink at lower left, *Dom?. Tiepolo f*; numbered in pen and brown ink at upper left corner, *10* (possibly trimmed at left); numbered in pen and brown ink on verso, *350*.

PROVENANCE: Louis-Auguste, baron de Schwiter (Lugt 1768); Schwiter sale, Paris, Hôtel Drouot, salle 3, April 20–21, 1883, no. 144; marquis de Biron; purchased in Geneva in 1937.

BIBLIOGRAPHY: Sack, 1910, p. 322, no. 138; Byam Shaw, 1962, p. 41; Byam Shaw, 1971–1, p. 246; Cailleux, 1974, pp. xviii–xix, no. 51, fig. 44; Bordeaux, 1981, no. 141, repr.; James Byam Shaw in *Lehman Collection*. VI, 1987, p. 171, under no. 140.

Rogers Fund, 1937
37.165.62

This group reappears in a monochrome fresco by Domenico from the Villa Tiepolo at Zianigo, now in the Ca' Rezzonico, Venice (Mariuz, 1971, pl. 354).

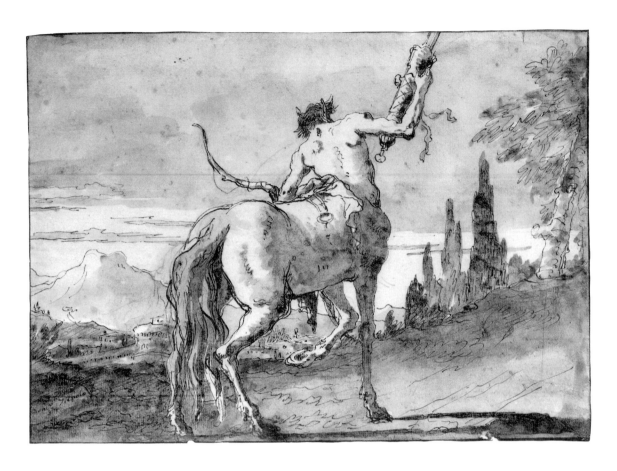

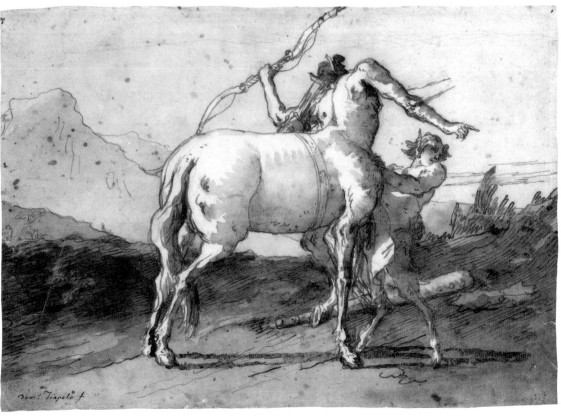

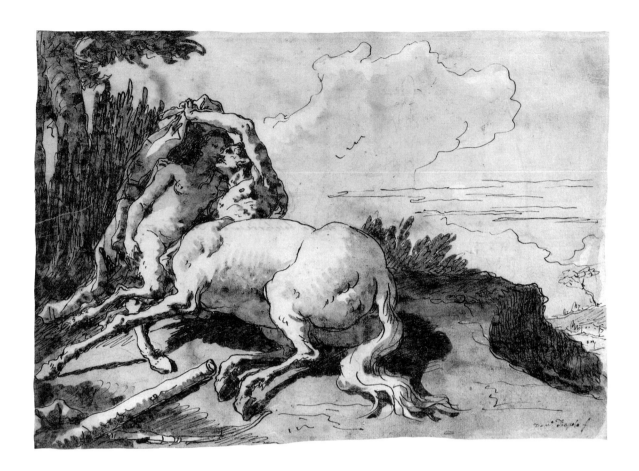

GIOVANNI DOMENICO TIEPOLO

251. *Centaur Holding Up a Quiver*

Pen and dark brown ink, gray-brown wash, over black chalk. Framing lines in pen and dark brown ink. 19.3 x 27.4 cm. Slight repaired losses at lower margin.

Signed in pen and dark brown ink at lower left, *Domᵒ. Tiepolo f.*; numbered on verso in pen and brown ink, *Nᵒ. 439*, in another hand, *340*.

PROVENANCE: Marquis de Biron; purchased in Geneva in 1937.

BIBLIOGRAPHY: Byam Shaw, 1962, p. 41; Byam Shaw, 1971–1, p. 246; Cailleux, 1974, p. viii, no. 3, fig. 5; James Byam Shaw in *Lehman Collection*. VI, 1987, p. 171, under no. 140.

Rogers Fund, 1937
37.165.55

252. *A Centaur and a Satyr*

Pen and brown ink, brown wash, over black chalk. 19.1 x 27.3 cm. Scattered stains.

Signed in pen and brown ink at lower left, *Domᵒ. Tiepolo f*; numbered in pen and brown ink at upper left, *7* (trimmed at left margin); numbered in pen and brown ink on verso, *278*.

PROVENANCE: Marquis de Biron; purchased in Geneva in 1937.

BIBLIOGRAPHY: Byam Shaw, 1962, p. 41; Byam Shaw, 1971–1, p. 246; Cailleux, 1974, p. xxi, fig. 59, p. xxiii, no. 71; James Byam Shaw in *Lehman Collection*. VI, 1987, p. 171, under no. 140.

Rogers Fund, 1937
37.165.56

253. *Centaur Embracing a Satyress*

Pen and dark brown ink, gray-brown wash, over traces of black chalk. 19.0 x 27.3 cm.

Signed in pen and brown ink at lower right, *Domᵒ. Tiepolo f*; inscribed in pen and brown ink on verso, *Gli amori di Centauri colle ninfe boschereccie. Disegno originale. / di Domenico Tiepolo col nome autografo*; numbered in pen and brown ink, *357*.

PROVENANCE: Marquis de Biron; purchased in Geneva in 1937.

BIBLIOGRAPHY: Byam Shaw, 1962, p. 41; Byam Shaw, 1971–1, p. 246; Cailleux, 1974, p. xvi, fig. 36, p. xvii, no. 41; James Byam Shaw in *Lehman Collection*. VI, 1987, p. 171, under no. 140.

Rogers Fund, 1937
37.165.58

254. *Centaur with a Club, and Two Satyrs*

Pen and dark brown ink, dark brown wash. 19.3 x 27.3 cm.

Signed in pen and brown ink at lower left, *Domᵒ. Tiepolo f*; numbered in pen and brown ink at upper left corner, 9 (possibly trimmed at left margin); numbered in pen and brown ink on verso, *273*.

PROVENANCE: Marquis de Biron; purchased in Geneva in 1937.

BIBLIOGRAPHY: Byam Shaw, 1962, p. 41; Byam Shaw, 1971–1, p. 246; Cailleux, 1974, p. xv, under no. 32, p. xxi, fig. 60, p. xxiv, no. 73; James Byam Shaw in *Lehman Collection*. VI, 1987, p. 171, under no. 140.

Rogers Fund, 1937
37.165.59

255. *Centaur with a Young Satyr*

Pen and dark brown ink, gray-brown wash, over traces of black chalk. 19.6 x 27.5 cm.

Signed in pen and brown ink at lower left, *Domᵒ. Tiepolo f*; numbered in pen and brown ink at upper left, *2*, beside an effaced number (*84?*); inscribed in pen and brown ink on verso, *Nº 8 / Fotografata dal Valencin / fa parte della Raccolta de 100 disegni originali di Tiepolo / gli amori de' Centauri colle ninfe boschereccie disegno originale / di Domenico Tiepolo col nome autografo fr. . . .* (an effaced number); numbered in pen and brown ink, *355*.

PROVENANCE: Marquis de Biron; purchased in Geneva in 1937.

BIBLIOGRAPHY: Byam Shaw, 1962, p. 41; Byam Shaw, 1971–1, p. 246; Cailleux, 1974, p. xxii, fig. 65, p. xxiii, no. 69; James Byam Shaw in *Lehman Collection*. VI, 1987, p. 171, under no. 140.

Rogers Fund, 1937
37.165.60

256. *Satyr Leading a Centauress Who Holds a Satyr Child*

Pen and dark brown ink, dark brown wash. 19.0 x 27.3 cm.

Signed in pen and brown ink at lower left, *Domᵒ Tiepolo f*; inscribed in pen and brown ink on old mount, *Nº 84 / fotografato dal Valencin / fa parte della Raccolta de' 100 disegni originali di . . .*

PROVENANCE: Louis-Auguste, baron de Schwiter (Lugt 1768); Schwiter sale, Paris, Hôtel Drouot, salle 3, April 20–21, 1883, no. 142; marquis de Biron; purchased in Geneva in 1937.

BIBLIOGRAPHY: Sack, 1910, p. 322, no. 137; *Metropolitan Museum, Italian Drawings*, 1942, no. 58, repr. (with erroneous inventory number, title, and description); Byam Shaw, 1962, pp. 41, 79, no. 38, repr.; Bean and Stampfle, 1971, no. 246, repr.; Byam Shaw, 1971–1, p. 246; Cailleux, 1974, p. xxvi, under no. 92, p. xxviii, no. 98, fig. 85; Bordeaux, 1981, no. 140, repr.; James Byam Shaw in *Lehman Collection*. VI, 1987, p. 171, under no. 140.

Rogers Fund, 1937
37.165.61

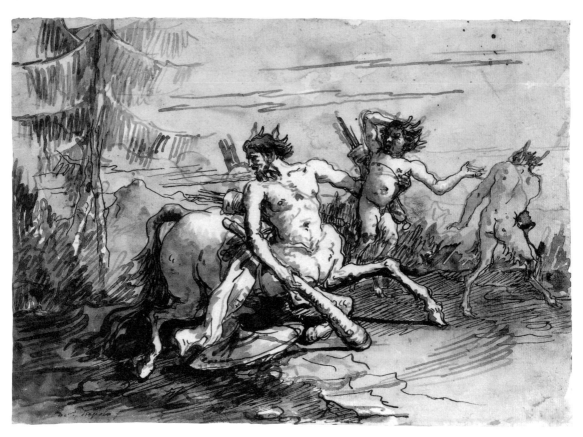

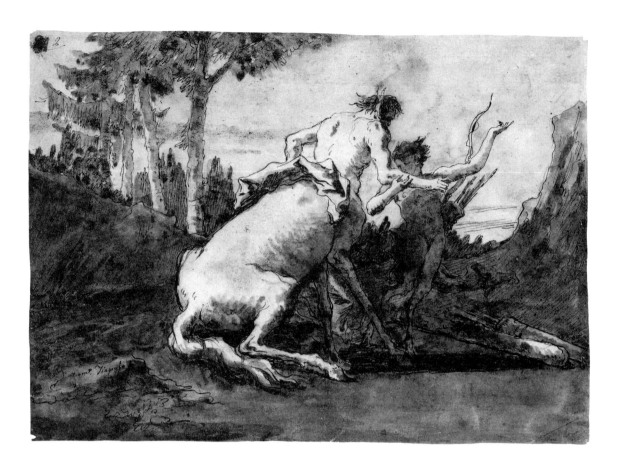

257. *Back View of Centaur Abducting a Satyress*

Pen and brown ink, brown wash, over black chalk. Framing lines in pen and brown ink. 19.3 x 27.5 cm.

Signed in pen and brown ink at lower right, *Domo Tiepolo f*; numbered in pen and brown ink at upper left corner, *120*; numbered in pen and brown ink on verso, *3*.

PROVENANCE: Marquis de Biron; purchased in Geneva in 1937.

BIBLIOGRAPHY: New York, 1938, no. 76, repr.; Byam Shaw, 1962, p. 41; Byam Shaw, 1971–1, p. 246; Cailleux, 1974, p. xx, no. 56, fig. 53; James Byam Shaw in *Lehman Collection*. VI, 1987, p. 171, under no. 140.

Rogers Fund, 1937
37.165.63

258. *Centaur with Shield and Two Satyresses*

Pen and brown ink, brown and gray wash, over black chalk. 19.6 x 27.5 cm.

Signed in pen and brown ink at lower right, *Dom°. Tiepolo f*; numbered in pen and brown ink at upper left, *8*; numbered in pen and brown ink on verso, *3*.

PROVENANCE: Marquis de Biron; purchased in Geneva in 1937.

BIBLIOGRAPHY: Byam Shaw, 1962, p. 41; Byam Shaw, 1971–1, p. 246; Cailleux, 1974, p. xvi, no. 37, fig. 33; James Byam Shaw in *Lehman Collection*. VI, 1987, p. 171, under no. 140.

Rogers Fund, 1937
37.165.64

259. *An Oriental Chieftain Resting*

Pen and brown ink, pale brown wash, over black chalk. 19.9 x 26.8 cm. The sheet has been trimmed on all four sides.

Signed in pen and brown ink at lower right, *Dom°. Tie* (the rest cut away); numbered in pen and brown ink at upper left, *69* (?, partly cut away). Canceled, thus illegible, inscriptions in pen and brown ink on verso.

PROVENANCE: Mrs. John Elliott Curran; purchased in New York in 1935.

BIBLIOGRAPHY: *Metropolitan Museum of Art Bulletin*, XXX, June 1935, p. 133; *Metropolitan Museum, Italian Drawings*, 1942, no. 59, repr.; Byam Shaw, 1962, pp. 40, 80, no. 42, repr.; Bean and Stampfle, 1971, p. 100, under no. 244 (with erroneous inventory number); Byam Shaw, 1971–1, p. 246, note 23.

Fletcher Fund, 1935
35.42.1

GIOVANNI DOMENICO TIEPOLO

260. *Oriental Horseman*

Pen and brown ink, brown wash, over black chalk. 18.5 x 25.1 cm.

Signed in pen and brown ink at lower margin left of center, *Dom°
Tiepolo f.*

PROVENANCE: Mrs. John Elliott Curran; purchased in New York
in 1935.

BIBLIOGRAPHY: *Metropolitan Museum of Art Bulletin*, XXX, June
1935, p. 133; Byam Shaw, 1962, pp. 40, 41, note 1; Bean and
Stampfle, 1971, p. 100, under no. 244 (with erroneous inventory
number); Byam Shaw, 1971–1, p. 246; Cailleux, 1974, p. viii, under
no. 1.

Fletcher Fund, 1935
35.42.2

Exactly the same turbaned lancer appears in the follow-
ing drawing, No. 261. Horse and rider have been trans-
formed into a centaur in a drawing in the Uffizi, Florence
(Cailleux, 1974, no. 1, fig. 3).

261. *Oriental Lancer Approaching a Town*

Pen and brown ink, pale brown wash, over traces of black chalk.
Framing lines in pen and brown ink. 28.6 x 41.1 cm.

Signed in pen and brown ink at lower left, *Dom? Tiepolo f.*

PROVENANCE: Louis-Auguste, baron de Schwiter (Lugt 1768);
Schwiter sale, Paris, Hôtel Drouot, salle 3, April 20–21, 1883, no.
149; marquis de Biron; purchased in Geneva in 1937.

BIBLIOGRAPHY: Sack, 1910, p. 322, no. 143; New York, 1938,
no. 75, repr.; Byam Shaw, 1962, p. 40; Bean and Stampfle, 1971,
no. 244, repr.; Byam Shaw, 1971–1, p. 246.

Rogers Fund, 1937
37.165.67

The turbaned oriental lancer is an exotic visitor to the
typical north Italian town seen at the left. This combi-
nation of the familiar and unfamiliar is a good example
of Domenico's taste for the bizarre.

262. *Elephant in a Landscape*

Pen and brown ink, brown wash, over black chalk. Framing lines in
pen and brown ink at right, left, and upper margins. 18.1 x 24.3 cm.

GIOVANNI DOMENICO TIEPOLO (NO. 262)

PROVENANCE: Eva B. Gebhard Gourgaud.

BIBLIOGRAPHY: Byam Shaw, 1971–1, p. 246, note 23.

Bequest of Eva B. Gebhard Gourgaud, 1959
60.12

The beast derives from Stefano Della Bella's etching of a more placid elephant (De Vesme, 1971, no. 699, repr.). In fact Domenico's chalk underdrawing follows Della Bella very closely, and the variations—the extended right foot and the raised trunk—were introduced when the drawing was finished in pen and wash.

263. *Scene of Contemporary Life: The Acrobats*

Pen and brown ink, brown wash, over traces of black chalk. 29.0 x 41.3 cm.

PROVENANCE: Beurdeley (according to Byam Shaw); *Succession D . . .*, sale, Paris, Palais Galliera, June 27, 1967, no. 161, repr., "Les acrobates"; [Cailleux]; [Colnaghi]; purchased in London in 1968.

BIBLIOGRAPHY: Byam Shaw, 1962, pp. 48, 86–87, no. 65, repr.; *Annual Report*, 1968–1969, p. 67; *Metropolitan Museum of Art Bulle-*

tin, XXVII, February 1969, p. 318, repr.; Bean and Stampfle, 1971, no. 263, repr.; Byam Shaw, 1971–1, p. 246, note 23; Cailleux, 1974, p. xxvii, under no. 94; Mirano, 1988, p. 300, under no. 7, repr.

Rogers Fund, 1968
68.54.4

This diverting composition is one of a large group of finished independent drawings representing scenes of contemporary life that are certainly Domenico's most considerable achievement as a draughtsman. These genre scenes are all of the same large horizontal format, and the date 1791 appears on at least twenty of them.

Two of our acrobats, the actress holding a fan, and several of the spectators behind the barricade reappear in *Pulcinella e i saltimbanchi*, one of Domenico's frescoes from the Villa Tiepolo at Zianigo, now in the Ca' Rezzonico, Venice (Mariuz, 1971, pl. 372).

264. *Caricature of a Gentleman and Other Studies*

Pen and brown ink, brown wash, over black chalk. 27.1 x 18.5 cm. Lined.

Signed in pen and brown ink at lower right, *Dom?. Tiepolo f.*

Rogers Fund, 1937
37.165.68

PROVENANCE: Marquis de Biron; purchased in Geneva in 1937.

BIBLIOGRAPHY: Chicago, 1938, no. 114; New York, 1938, no. 74, repr.; *Metropolitan Museum, Italian Drawings*, 1942, no. 60, repr.; Vigni, 1943, pp. 23, 24, fig. 10; Kozloff, 1961, p. 22, fig. 3; Byam Shaw, 1962, p. 90, no. 78, repr.; Bean, 1964, no. 49, repr.; Pignatti, 1965–1, no. 118, repr.; Pignatti, 1970, p. 86, pl. XXXV, in color; Bean and Stampfle, 1971, no. 247, repr.; Byam Shaw, 1971–1, p. 246; Vigni, 1972, p. 110; Pignatti, 1974–1, pl. LVII, in color.

Domenico's proficiency as a caricaturist is well exemplified by this sheet, which if it were not signed might easily be taken for the work of his father, Giambattista.

Above the standing gentleman appears a bouquet of the character heads that occur in many of Domenico's paintings and etchings; at the left border there are sketches of a hand and the tip of a quiver.

265

FELICE TORELLI

Verona 1667–Bologna 1748

265. *Death of St. Peter Martyr*

Brown and cream oil paint on paper, laid down on canvas. Varnished. 40.2 x 30.2 cm.

PROVENANCE: [Galeria del Caminetto, Bologna]; Paul H. Ganz; sale, New York, Sotheby's, April 7, 1988, no. 100, repr. as Francesco Monti; [Dance]; purchased in New York in 1989.

BIBLIOGRAPHY: *Burlington Magazine*, CXV, 1973, advertisement supplement, p. cxiii, repr., as Felice Torelli; *Annual Report*, 1988–1989, p. 24.

Purchase, Gifts in memory of Lawrence Turčić, 1989
1989.185

This monochrome oil sketch on paper was recognized by Dwight C. Miller as a *modello* by Felice Torelli for his painting of this subject in S. Anastasia, Verona, datable about 1727 (Miller, 1964, pp. 60 and 63, fig. 16). The principal difference between this sketch and the finished work is that in the latter the Virgin seated on clouds appears at the top of the composition. Another oil sketch attributed to Torelli, in the Detroit Institute of Arts (66.250, Gift of Mr. and Mrs. Richard E. Randall), includes the Virgin at the top of the composition and is in every way very close to the finished painting.

LUIGI VANVITELLI

Naples 1700–Caserta 1773

266. *St. Peter Enthroned*

Pen and brown ink, over graphite. 36.7 x 25.6 cm.

PROVENANCE: Paul Fatio (mark PF; not in Lugt); sale, Geneva, Rauch, June 18–19, 1962, no. 340; [L'Art Ancien]; purchased in Zurich in 1962.

BIBLIOGRAPHY: *Annual Report*, 1962–1963, p. 64; Garms, 1971, p. 229, note 19; Myers, 1975, no. 63, repr.; *Rome in the 18th Century*, 1978, n.pag. [18].

Rogers Fund, 1962
62.129.3

Jörg Garms was the first to recognize this drawing as Vanvitelli's design for a proposed new throne for the bronze statue of the Prince of the Apostles, generally attributed to Arnolfo di Cambio, in St. Peter's, Rome. In 1754 the old throne was judged inadequate, and Vanvitelli was commissioned to execute a new one to be made of bardiglio, an Italian veined marble. The throne following Vanvitelli's design was executed, but its rich baroque design failed to please, and two years later it was replaced by the chair in Quattrocento style that is still in place today.

The appearance of Vanvitelli's throne can be ascertained from a small model in the Archivio della Fabbrica di S. Pietro, which closely follows our drawing, except for the addition of a putto's head above St. Peter (Roberto Pane in *Vanvitelli*, 1973, pp. 83–89, figs. 208 and 209). The Cooper-Hewitt Museum possesses a pen drawing by Vanvitelli that is probably a project for the throne of St. Peter as we see it today (Dee, 1970, no. 52, repr.).

GIUSEPPE ZAIS

Forno di Canale (Belluno) 1709–Belluno 1784

267. *River Landscape with Two Mendicants*

Pen and brown ink, gray wash. 32.1 x 47.9 cm.

PROVENANCE: William Mayor (Lugt 2799); [Parsons]; Harold K. Hochschild.

BIBLIOGRAPHY: Mayor, 1875, p. 194, no. 958, as Francesco Zuccarelli; *Metropolitan Museum of Art Bulletin*, XXXV, August 1940, p. 156, as Zuccarelli; Pignatti, 1974–2, no. 95, repr.

Gift of Harold K. Hochschild, 1940
40.91.15

In the nineteenth century the drawing was attributed to Francesco Zuccarelli, but Larissa Salmina Haskell and Terisio Pignatti independently recognized the hand of Giuseppe Zais. Indeed, the loose pen work and soft gray washes may be found in the artist's signed landscapes in the Hermitage, Leningrad (Salmina, 1964, nos. 86, 87, repr.), in the Nationalmuseum, Stockholm (Bjurström, 1974, no. 104, repr.), and in the Cini Foundation, Venice (Bettagno, 1963, no. 124, repr.).

ANTON MARIA ZANETTI, the elder

Venice 1680–Venice 1767

268. *Landscape with a Town in the Distance*

Pen and brown ink, brown wash, over traces of black chalk. 37.7 x 53.0 cm.

Inscribed in pen and brown ink at center left, — *1766* — / *Principiacto alle | Gamb^e.: et | termin^t? a Fossa | Lovara.*

PROVENANCE: Princes of Liechtenstein; sale, Bern, Klipstein & Kornfeld, June 16, 1960, part of no. 345, as Anton Maria Zanetti, the younger; [Chiesa]; purchased in Milan in 1971.

BIBLIOGRAPHY: *Annual Report*, 1970–1971, p. 16; Bean, 1972, p. 24, no. 57; Bettagno, 1972, pp. 43–44, under no. 64.

Rogers Fund, 1971
1971.35.1

This and the following large imaginary landscape were executed in 1766, at the very end of the elder Zanetti's long life. The autograph inscription indicates that this drawing was begun at Gambarare and finished at Fossa Lovara; Alessandro Bettagno has kindly informed us that these were two country properties between Venice and

268

269

Padua that belonged to the collector, scholar, and amateur artist Anton Maria Zanetti, the elder. Our drawings come from the Liechtenstein collection, as do four others, similar in size and style, that are now in Italian private collections (Bettagno, 1972, nos. 64–67, repr.). All six drawings are inventions inspired by the pen and wash landscapes of Marco Ricci.

269. *Landscape with a Town by a River*

Pen and brown ink, brown wash, over black chalk. 37.7 x 53.1 cm.

Inscribed in pen and brown ink at lower margin, *Ant?. m?. Co: Zanetti q.m Girolamo a Fossa Lovara disegnò, et inventò — 1766 — in Ottobre.*

PROVENANCE: Princes of Liechtenstein; sale, Bern, Klipstein & Kornfeld, June 16, 1960, part of no. 345, pl. 59, as Anton Maria Zanetti, the younger; [Chiesa]; purchased in Milan in 1971.

BIBLIOGRAPHY: *Annual Report*, 1970–1971, p. 16; Bean, 1972, p. 24, no. 58; Bettagno, 1972, pp. 43–44, under no. 64.

Rogers Fund, 1971
1971.35.2

The artist has noted that this landscape was conceived and executed at Fossa Lovara.

GIACOMO ZOBOLI
Modena 1681–Rome 1767

270. *The Visitation of Our Lady*
(Luke 1:39–56)

Red chalk. Verso: faint red chalk studies for the figures of Joseph and Zechariah. 29.2 x 26.6 cm.

PROVENANCE: [Aldega and Gordon]; purchased in New York in 1986.

BIBLIOGRAPHY: Guerrieri Borsoi, 1984, pp. 22–23, no. 9, p. 65, recto repr.; *Annual Report*, 1985–1986, p. 23; Coleman, 1989, p. 27, fig. 3 (recto), fig. 4 (verso).

Purchase, David L. Klein, Jr. Memorial Foundation, Inc. Gift, 1986
1986.49

Composition study with slight variations for the principal figures—Elizabeth, the Blessed Virgin, Zechariah, and Joseph—in the *Visitation* in S. Eustachio, Rome. This large painting, in the left transept of the church, is signed and dated 1727 (Guerrieri Borsoi, 1984, p. 64, fig. VI; Titi, 1987, II, fig. 624). Six other chalk studies for figures in this *Visitation* are catalogued by Guerrieri Borsoi, and Coleman has reproduced a large chalk composition study in the Biblioteca Ambrosiana, Milan (Coleman, 1989, p. 27, fig. 2).

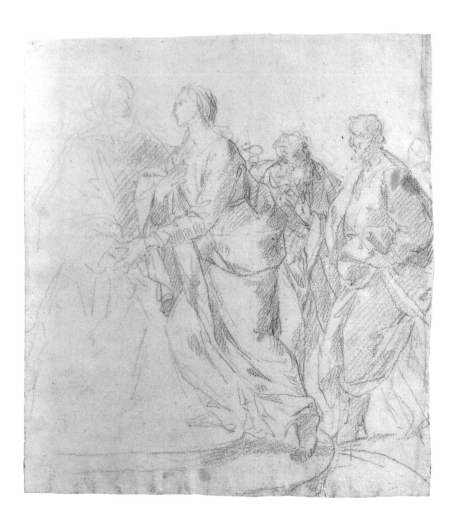

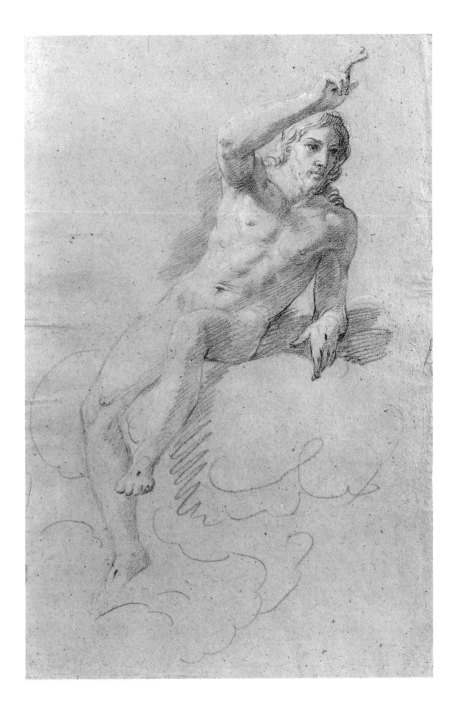

271. *Christ Blessing*

Black chalk, heightened with white, on grayish brown paper. Verso: faint black chalk study of the same figure and three studies for a left hand. 42.7 x 27.6 cm.

Inscribed on verso in pen and brown ink at lower right, *paoli 2*.

PROVENANCE: Margot Gordon and Marcello Aldega.

BIBLIOGRAPHY: *Annual Report*, 1985–1986, p. 22; Coleman, 1989, p. 28, fig. 7 (recto), fig. 8 (verso).

Gift of Margot Gordon and Marcello Aldega, 1986
1986.36

This figure of the risen Christ appears in the upper part of *St. Vincent Ferrer Performing Miracles of Healing*, an altarpiece in the left transept of S. Domenico, Modena. Another drawing for the risen Christ has survived; it differs from the present study in that the legs of Christ are covered with drapery, as is the case in the painting (Guerrieri Borsoi, 1984, pp. 82–83, the painting fig. XV, the drawing of the draped figure no. 45 r., repr.).

The old inscription *paoli 2* on the verso indicates the price or evaluation of the drawing. A *paolo* was a Roman silver coin first minted in the reign of Paul III Farnese. A number of Zoboli's drawings bear such prices, the figures ranging from one to four *paoli*.

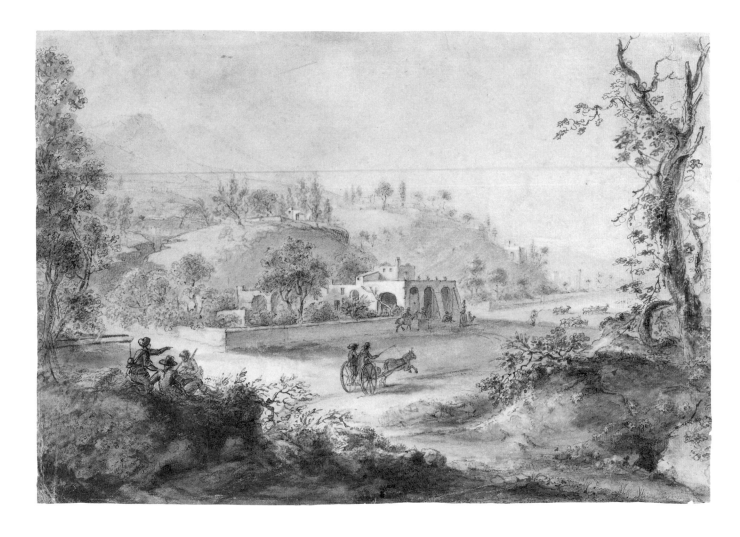

GIUSEPPE ZOCCHI ?

Florence 1711–Florence 1767

272. *Landscape Prospect with a Buggy and a Herd of Goats*

Black chalk, stumped, pen and brown ink, brown and gray wash, heightened with white, on blue-gray paper. 33.2 x 49.1 cm.

PROVENANCE: Count Grégoire Serguéievitch Strogonoff (Lugt 550); Efim Schapiro (Lugt Supp. 2343a); sale, London, Sotheby's, February 22, 1956, no. 35, as Francesco Zuccarelli; [Matthiesen]; Mathias Komor (Lugt Supp. 1882a); purchased in New York in 1961.

BIBLIOGRAPHY: *Annual Report*, 1960–1961, p. 64, as Francesco Zuccarelli; Jacob Bean, *Metropolitan Museum of Art Bulletin*, January 1962, p. 165, repr., as Zuccarelli.

Rogers Fund, 1961
61.57

Until quite recently this attractive landscape drawing has been somewhat tentatively attributed to Francesco Zuccarelli. In a letter of August 7, 1989, Marco Chiarini suggests a convincing alternative, remarking that the handling of pen and wash reminds him of drawings by Giuseppe Zocchi. The use of blue paper, however, is unusual—if not unique—for the artist.

GAETANO ZOMPINI

Nervesa (Treviso) 1700–Venice 1778

273. *St. Cajetan of Thiene Holding the Infant Jesus*

Pen and brown ink, gray wash. 22.7 x 17.4 cm.

Inscribed in pen and brown ink at lower margin by the "Reliable Venetian Hand," *Gaetano Zompini da Nervesa*.

PROVENANCE: "Reliable Venetian Hand" (Lugt Supp. 3005c–d); mark mistakenly associated with Pierre Crozat (Lugt 474); sale, London, Sotheby's, March 15, 1966, no. 38; [Colnaghi]; purchased in London in 1966.

BIBLIOGRAPHY: *Annual Report*, 1966–1967, p. 61; Bettagno, 1966, no. 119, repr.

Rogers Fund, 1966
66.53.6

On Christmas Eve in 1517 St. Cajetan had a vision in which the Blessed Virgin offered him the Christ Child. Cajetan is here identified by his attribute, a branch of lilies, and by the high-collared habit of the Theatine order, of which he was one of the founders.

Attributions to Gaetano Zompini inscribed in the "Reliable Venetian Hand" appear on five further drawings, all similar in style to the present example (Bettagno, 1966, nos. 118, 120–122, 183, repr.).

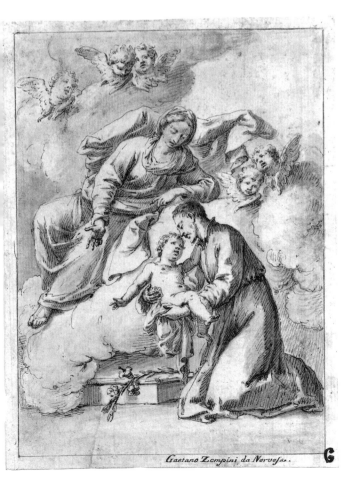

FRANCESCO ZUCCARELLI

Pitigliano (Grosseto) 1702–Florence 1788

274. *Five Young Women in a Landscape*

Pen and brown ink, brown and gray wash, heightened with white, over red chalk. Framing lines in pen and brown ink. 11.7 x 17.3 cm. Lined.

Initialed at lower left, F.Z.

PROVENANCE: Harry G. Sperling.

BIBLIOGRAPHY: *Annual Report*, 1974–1975, p. 50.

Bequest of Harry G. Sperling, 1971
1975.131.57

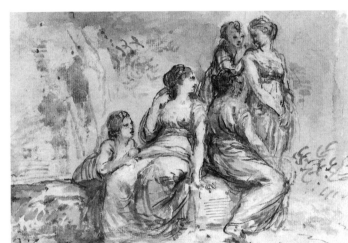

275. *Seated Girl in a Landscape*

Pen and brown ink, brown and gray wash, heightened with white, over graphite. Framing lines in pen and brown ink. 8.8 x 17.3 cm. Lined.

PROVENANCE: Harry G. Sperling.

BIBLIOGRAPHY: *Annual Report*, 1974–1975, p. 50.

Bequest of Harry G. Sperling, 1971
1975.131.56

FRANCESCO ZUGNO

Venice 1708/1709–Venice 1787

276. *Nobility Presenting an Infant to Venice*

Graphite. 14.6 x 14.2 cm. Lined.

Inscribed in pen and brown ink at lower left, *Zugno dis.*; in pen and blue ink at upper left corner of old mount, *N 501* (this number repeated on verso).

PROVENANCE: [Colnaghi]; purchased in London in 1964.

BIBLIOGRAPHY: *Annual Report*, 1964–1965, p. 52; Pignatti, 1965–1, p. 185, under no. 73; Pignatti, 1965–2, p. 31, under no. 114; Pignatti and Romanelli, 1985, p. 113, under no. 87.

Rogers Fund, 1964
64.38.5

This design was etched by Francesco Zucchi (1692–1764) as an illustration for COMMENTARII HISTORICI DE REBUS PERTINENTIBUS AD ANGELUM MARIAM S. R. E. CARDINALEM QUIRINUM (Brescia, 1764), a work celebrating the life and achievements of Cardinal Angelo Maria Querini (Venice 1680–Brescia 1754), who was created cardinal and named Bishop of Brescia in 1727. Querini was a distinguished bibliophile; he was for a time librarian of the Vatican, and in 1747 he founded the important Biblioteca Civica Queriniana in Brescia (for Zucchi's print see Brescia, 1980, p. 25, no. 7, repr.).

Many of the illustrations in this work were adapted by Zugno from grisaille paintings, executed by two local artists of modest talent, on the walls of the main staircase of the Biblioteca Queriniana. Our drawing represents the infant Querini being presented to Venice by Nobility, who is accompanied by Religion, Doctrine, and Liberality. The putto in the foreground holds a cardinal's hat above the Querini arms.

We know three other circular drawings for the etchings in this publication, all inscribed (or signed) *Zugno dis.* In the Museum of Fine Arts, Budapest, there is a drawing representing Querini as a student in the Collegio dei Nobili at Brescia (Fenyö, 1965, no. 98, repr.; for the print see Brescia, 1980, p. 26, no. 8, repr.). In addition, Janos Scholz possesses a drawing of Querini appointed to a Papal commission on Greek liturgy, and Joseph McCrindle has a roundel showing Querini created cardinal by Benedict XIII (Zucchi's prints repr. Brescia, 1980, p. 34, no. 16, and p. 39, no. 21, respectively).

Janos Scholz was the first to connect these drawings with Cardinal Querini, and we are grateful to Bernard Aikema for recently calling our attention to the 1980 exhibition catalogue *Iconografia e immagini queriniane*, which made possible the identification of the specific purpose of the drawings.

277. *Allegorical Figures of Religion and Venice Flanking an Empty Cartouche*

Graphite. Framing lines in graphite. 9.5 x 18.4 cm. Lined.

Inscribed in pen and brown ink at lower left, *Zugno dis.*; in pen and blue ink at upper left corner of old mount, *N 496* (this number repeated on verso).

PROVENANCE: [Colnaghi]; purchased in London in 1964.

BIBLIOGRAPHY: *Annual Report*, 1964–1965, p. 52; Pignatti, 1965–1, p. 185, under no. 73; Pignatti, 1965–2, p. 31, under no. 114; Pignatti and Romanelli, 1985, p. 113, under no. 87.

Rogers Fund, 1964
64.38.4

The signature *Zugno dis.* appears on a good many of the artist's drawings, such as a fine *Assumption of the Virgin* in the collection of James Byam Shaw (Pignatti, 1965–1, no. 73, repr.).

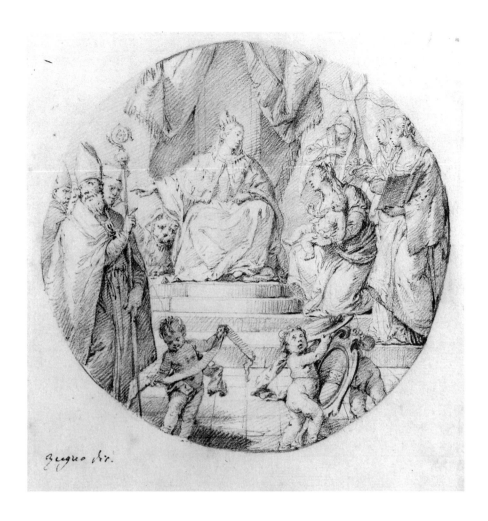

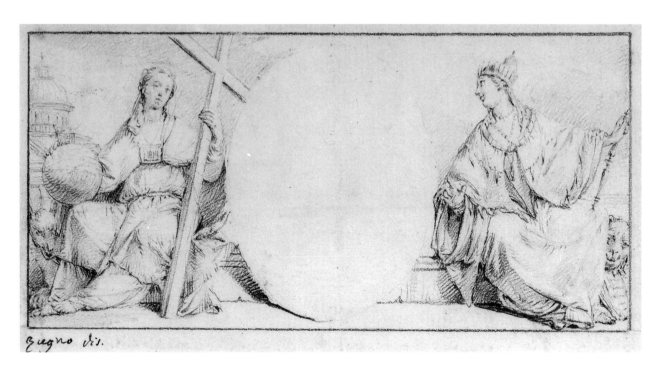

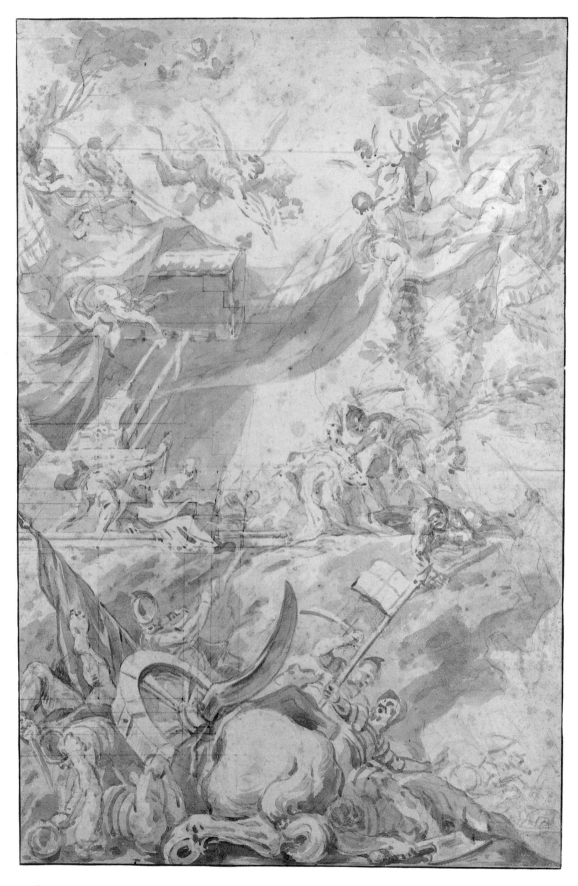

ANONYMOUS ARTIST

Neapolitan?

278. *Scene of Martyrdom*

Brush and red wash, over black chalk, heightened with white. Framing lines in pen and brown ink. 58.3 x 38.9 cm. Scattered stains. Horizontal crease at center.

Inscribed in pen and brown ink on verso, *Conca.M.256.*

PROVENANCE: Harry G. Sperling.

BIBLIOGRAPHY: *Annual Report*, 1974–1975, p. 50.

Bequest of Harry G. Sperling, 1971
1975.131.85

This large drawing, in which the forms are modeled in transparent red wash applied over summary indications in black chalk, appears to be Italian and to date from the eighteenth century. *Conca*, whose name is inscribed on the reverse of the sheet, may be excluded, although the drawing has a somewhat Neapolitan air.

We are unable to identify this tumultuous scene. At the center a priest and a bishop are about to be put to death by the sword, while an angel descends with the palm and crown of martyrdom. A violent military engagement occupies the foreground. The complex sto-reyed composition seen in exaggeratedly steep perspective looks back to late sixteenth-century Venetian prototypes, such as Jacopo Tintoretto's painting in the center of the ceiling of the Sala del Maggior Consiglio, Palazzo Ducale, Venice (Schulz, 1968, pl. 104).

ANONYMOUS ARTIST

Roman?

279. *Seated Mother and Child*

Pen and brown ink, over black chalk. Squared in black chalk. Framing lines in pen and brown ink. 21.4 x 17.5 cm. Lined.

PROVENANCE: Cephas G. Thompson.

BIBLIOGRAPHY: *Metropolitan Museum Handbook*, 1895, p. 41, no. 719, "Unknown.—A Mother and Child."

Gift of Cephas G. Thompson, 1887
87.12.49

Perhaps a study for a small devotional picture representing the Virgin with the Christ Child. Some thirty years ago Anthony M. Clark proposed the name of Agostino Masucci for this drawing, but the physical types seem somewhat heavy and the pen work rather coarse for this refined artist.

278

ANONYMOUS ARTIST

Roman ?

280. *Design for a Ceiling Painting*

Black chalk, pen and black ink. Squared in black chalk. 27.2 x 17.9 cm. Brown pigment stain at upper right. Scattered stains. Lined.

Numbered in black chalk along left margin, . 2 3 4 . . 7

PROVENANCE: Cephas G. Thompson.

BIBLIOGRAPHY: *Metropolitan Museum Handbook*, 1895, p. 46, no. 822, "Unknown (Late Roman School).—Mythological Scene."

Gift of Cephas G. Thompson, 1887
87.12.152

Jennifer Montagu kindly suggests that the principal figure may be an allegorical representation of Virtue. Certain of Ripa's requirements for *Virtù* are satisfied: she holds a spear in her right hand, the sun is present (though moved from her breast to the upper left corner of the composition), tiny wings seem to grow from her forehead, and a putto bears a cornucopia of fruit.

The steep perspective of the composition and the squaring of the sheet may indicate that the drawing is a study for a small ceiling painting rather than a book illustration. The draughtsman was no doubt a Roman artist of the first decades of the eighteenth century influenced by painters such as Giuseppe Chiari, Luigi Garzi, and Giovanni Odazzi.

ANONYMOUS ARTIST

Roman ?

281. *Youth Kissing an Outstretched Hand*

Red chalk, heightened with white, on beige paper. 19.8 x 22.2 cm.

PROVENANCE: Erasmus Philipps; Richard Philipps, 1st Lord Milford (Lugt Supp. 2687); Sir John Philipps; Harry G. Sperling.

BIBLIOGRAPHY: *Annual Report*, 1974–1975, p. 50.

Bequest of Harry G. Sperling, 1971
1975.131.8

In Harry G. Sperling's collection this fine study was attributed to Marco Benefial. However, the draughtsmanship seems tighter and more academic than Benefial's loose handling of chalk.

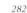

ANONYMOUS ARTIST

Venetian ?

282. *Three Nude Figures on Clouds*
VERSO. *Standing Bearded Man Wearing a Turban*

Pen and brown ink, brown wash, over black chalk (recto); brush and brown wash, over black chalk (verso). 29.1 x 25.0 cm.

Inscribed in graphite on verso, *Tiepolo*; numbered in blue pencil, *T44 / — 1*, and *372*; in red crayon, *372*; in graphite, *378*.

PROVENANCE: James Jackson Jarves; Cornelius Vanderbilt.

BIBLIOGRAPHY: *Metropolitan Museum Handbook*, 1895, p. 25, no. 372, "Tiepolo.—Designs for Ceilings"; Bernard Berenson, "Les peintures italiennes de New York et de Boston," *Gazette des Beaux-Arts*, XV, 1896, p. 203, as Giambattista Tiepolo; Breck, 1913, pp. 16, 17, as Domenico Tiepolo; Knox, 1970, no. 57, repr. (verso), the recto as Lorenzo Tiepolo, the verso as Giambattista Tiepolo, under no. 65, p. 223, fig. 8 (recto); Morassi, 1970, p. 298, the recto as Giustino Menescardi, the verso as Giambattista Tiepolo; Weeks, 1978, p. 54, repr. (verso), p. 90, no. 61, as Giambattista Tiepolo.

Gift of Cornelius Vanderbilt, 1880
80.3.372

Although George Knox attributes the drawing on the recto to Lorenzo Tiepolo and the sketch on the verso to

Giambattista himself, it seems to us that both sides are the work of the same hand, that of an unidentified imitator or copyist.

ANONYMOUS ARTIST

Venetian ?

283. *Nymphs Adorning the Statue of a Goddess*
VERSO. *River God with Three Nymphs*

Pen and brown ink, brown wash (recto); pen and brown ink, brown wash (verso). 22.5 x 28.3 cm.

PROVENANCE: [Colnaghi]; purchased in London in 1961.

BIBLIOGRAPHY: *Annual Report*, 1961–1962, p. 67, as Pietro Antonio Novelli; Pignatti, 1974–2, no. 51, repr. (recto and verso), as Jacopo Amigoni ?.

Rogers Fund, 1961
61.130.6

Although the names of Jacopo Amigoni, Antonio Carneo, Pietro Antonio Novelli, and Bartolomeo Tarsia have been proposed, for the present it does not seem possible to supply a fully convincing attribution for this attractive sheet.

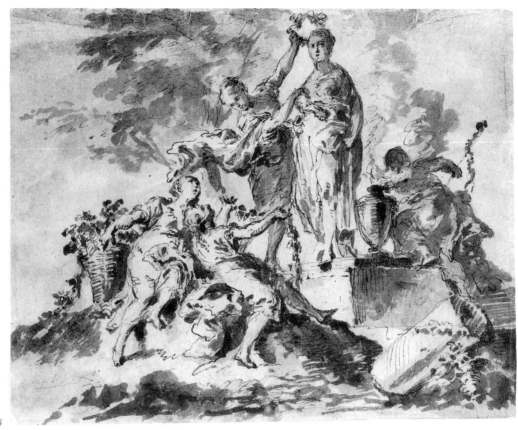

283

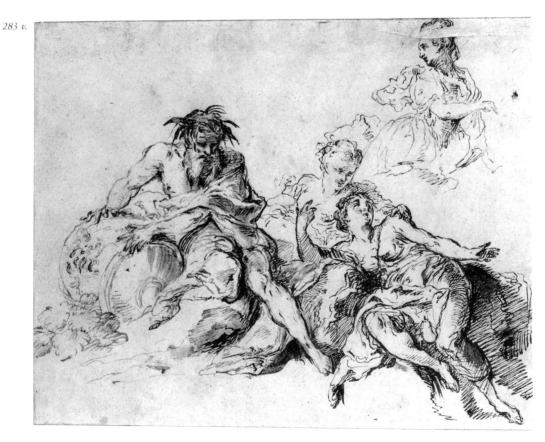

Index of Former Collections

Concordance METROPOLITAN MUSEUM OF ART ACCESSION NUMBERS

ACC.NO.	THIS VOLUME	ACC.NO.	THIS VOLUME	ACC.NO.	THIS VOLUME	ACC.NO.	THIS VOLUME
80.3.109	73	37.165.9	204	37.165.61	256	59.23.81	234
80.3.156	76	37.165.10	233	37.165.62	250	60.12	262
80.3.219	78	37.165.11	211	37.165.63	257	60.66.6	16
80.3.235	56	37.165.12	206	37.165.64	258	61.56.2	47
80.3.236	58	37.165.13	231	37.165.65	243	61.57	272
80.3.293	35	37.165.14	187	37.165.66	244	61.130.2	61
80.3.323	45	37.165.15	188	37.165.67	261	61.130.6	283
80.3.332	67	37.165.16	190	37.165.68	264	61.136.5	12
80.3.335	66	37.165.17	230	37.165.69	93	61.158.2	124
80.3.344	55	37.165.18	232	37.165.70	100	61.204	160
80.3.352	158	37.165.19	209	37.165.71	105	61.210	156
80.3.363	186	37.165.20	224	37.165.72	108	62.121.2	38
80.3.370	191	37.165.21	192	37.165.73	92	62.129.3	266
80.3.372	282	37.165.22	220	37.165.74	90	62.130.4	140
80.3.373	157	37.165.23	207	37.165.75	113	62.132.3	57
80.3.384	37	37.165.24	222	37.165.76	110	62.132.4	125
80.3.410	79	37.165.25	223	37.165.77	94	62.191	34
80.3.424	80	37.165.26	228	37.165.78	88	62.242	20
80.3.425	75	37.165.27	226	37.165.79	104	63.207.1	50
80.3.433	39	37.165.28	216	37.165.80	106	64.38.1	137
80.3.456	144	37.165.29	221	37.165.81	111	64.38.3	238
80.3.491	84	37.165.30	202	37.165.82	101	64.38.4	277
80.3.495	77	37.165.31	210	37.165.83	102	64.38.5	276
80.3.497	64	37.165.32	199	37.165.84	91	64.49.1	41
80.3.501	62	37.165.33	198	37.165.85	89	64.49.2	33
80.3.503	59	37.165.34	218	37.165.86	109	64.132.2	132
80.3.512	63	37.165.35	194	37.165.87	107	65.66.5	126
80.3.513	54	37.165.36	213	37.165.88	103	65.66.9	168
87.12.42	146	37.165.37	217	37.165.101	115	65.66.10	169
87.12.48	154	37.165.38	195	37.165.109	239	65.112.5	172
87.12.49	279	37.165.39	212	38.179.5	164	65.131.1	36
87.12.59	72	37.165.40	214	39.79	23	65.131.7	74
87.12.131	167	37.165.41	219	40.91.2	97	65.224	25
87.12.152	280	37.165.42	208	40.91.3	96	66.53.2	128
87.12.157	17	37.165.43	229	40.91.15	267	66.53.4	159
07.282.9	112	37.165.44	201	41.187.1	246	66.53.6	273
11.66.12	95	37.165.45	203	41.187.5	247	66.67	27
12.56.14	85	37.165.46	200	43.61	22	66.93.1	127
12.56.15	86	37.165.47	196	46.80.2	152	66.93.3	183
12.56.16	87	37.165.48	227	46.161	21	66.117.1	129
17.236.22	182	37.165.49	197	49.150.6	65	66.117.2	130
17.236.25	179	37.165.50	215	52.218.1	141	66.136	181
17.236.26	180	37.165.51	225	52.218.2	142	66.139.1	14
18.144	245	37.165.52	193	53.169	131	66.139.2	15
19.151.2	99	37.165.53	240	54.118	175	66.201	147
35.42.1	259	37.165.54	248	56.225.5	178	67.67	173
35.42.2	260	37.165.55	251	59.23.46	120	68.9	133
36.144	163	37.165.56	252	59.23.47	118	68.53	150
37.165.5	242	37.165.57	249	59.23.48	117	68.54.4	263
37.165.6	189	37.165.58	253	59.23.49	121	69.14.1	148
37.165.7	205	37.165.59	254	59.23.50	122	69.14.2	149
37.165.8	241	37.165.60	255	59.23.51	119	69.126.2	176

ACC.NO.	THIS VOLUME	ACC.NO.	THIS VOLUME	ACC.NO.	THIS VOLUME	ACC.NO.	THIS VOLUME
69.171.2	83	1972.118.262	143	1975.131.85	278	1987.288	48
1970.113.2	18	1972.118.266	161	1975.407.1	10	1987.307	49
1970.177	11	1972.118.267	162	1976.343	136	1988.28	177
1970.244.3	51	1972.118.269	165	1979.286.1	9	1988.145	2
1970.293	185	1972.118.273	237	1980.282	29	1988.150	1
1971.35.1	268	1972.118.274	236	1981.290	145	1988.250	4
1971.35.2	269	1973.67	71	1983.131.2	171	1988.253	19
1971.36	46	1973.156	6	1985.101	170	1988.254	32
1971.50	42	1975.131.5	5	1985.158.1	81	1989.25	3
1971.63.1	151	1975.131.7	8	1985.158.2	82	1989.58	26
1971.100	155	1975.131.8	281	1985.215	30	1989.108.1	53
1971.243	138	1975.131.23	31	1986.36	271	1989.108.2	52
1972.82	70	1975.131.31	98	1986.49	270	1989.115	43
1972.83	68	1975.131.32	116	1986.50	184	1989.153	44
1972.84	69	1975.131.42	153	1986.151	24	1989.172	166
1972.118.12	134	1975.131.46	174	1987.177	60	1989.185	265
1972.118.242	7	1975.131.52	235	1987.191	139	1989.198	28
1972.118.254	123	1975.131.56	275	1987.197.2	40	1989.285	135
1972.118.255	114	1975.131.57	274	1987.245	13		

Index of Artists